THE BAYEUX TAPESTRY

Carola Hicks teaches Art History at Cambridge
University. Her books include *Animals in
Medieval Art*, *Discovering Stained Glass* and
Improper Pursuits, a highly acclaimed biography
of the eighteenth-century artist and designer Lady
Di Beauclerk.

CAROLA HICKS

The Bayeux Tapestry

The Life Story of a Masterpiece

VINTAGE BOOKS
London

Published by Vintage 2007

2 4 6 8 10 9 7 5 3 1

Copyright © Carola Hicks 2006

Carola Hicks has asserted her right under the Copyright,
Designs and Patents Act, 1988 to be identified as the author
of this work

First published in Great Britain in 2006 by
Chatto & Windus
Random House, 20 Vauxhall Bridge Road,
London SW1V 2SA

www.vintage-books.co.uk

Addresses for companies within The Random House Group Limited
can be found at: www.randomhouse.co.uk/offices.htm

The Random House Group Limited Reg. No. 954009

A CIP catalogue record for this book
is available from the British Library

ISBN 9780099450191

The Random House Group Limited makes every effort to
ensure that the papers used in its books are made from trees that
have been legally sourced from well-managed and credibly certified
forests. Our paper procurement policy can be found at:
www.randomhouse.co.uk/paper.htm

Printed and bound in Great Britain by
Cox & Wyman Limited, Reading, Berkshire

Contents

List of Illustrations vi
Prologue x

I Embroidering History
1. The Plot 3
2. The Patron 22
3. The Project 40

II Lost and Found
4. The Missing Years 63
5. Antiquarian Approaches 69
6. The English Claim 80

III Revolutionaries and Romantics
7. Escaping the Terror 91
8. The Dictator's Display 95
9. Performing Propaganda 105
10. The Rival Camp 115
11. The Stothards' Story 121

IV The Gentle Touch
12. 'The Queens of England' 143
13. Visitor's Book 158
14. A South Kensington Scandal 166
15. The Ladies of Leek 180
16. Victorian Values 196

V The Great Escape
17. Yuletide for Himmler 205
18. Codename 'Matilda' 232

VI Global Image
19. Literary Life 251
20. The Norman Newsreel 262
21. Spin-Offs 268
22. Marketing the Middle Ages 282
23. Mysteries and Histories 288
24. Bayeux Today 298

Afterword 303

Notes 307
Bibliography 329
Acknowledgments 344
Index 346

List of Illustrations

Colour Plates

Scenes from the Bayeux Tapestry:

1 Harold's oath
2 Edward's deathbed
3 Disembarking the horses
4 Harold's coronation
5 Preparing the feast
6 Horses in the battle

7 Lions on a Persian woven silk, 7th-8th century
8 The opening scene of the Vaudeville *Tapisserie de la Reine Mathilde*, 1804
9 Jean-Francois Hue, *Napoleon visiting the camp at Boulogne in July 1804*, 1806
10 Illustrations for Jules Ferrario's *Le Costume ancien et moderne*, engraved by G. Bramatti, 1820
11 Charles Stothard's drawing of Harold and the comet, engraved by James Basire, 1820.
12 Victor Sansonetti's engraving of the death of Harold, 1838
13 Alfred Guillard, *La Reine Mathilde travaillant à la Telle de Conquest*, oil painting, 1849
14 Mary Newill, *Matilda and her ladies at work on the Tapestry*, stained-glass window, 1898, Birmingham
15 Elizabeth Wardle's signature under the panel she embroidered for the Leek replica, 1885
16 A scene from the *Overlord Embroidery*, 1974
17 Michael Farrar Bell, *Senlac* window, Battle parish church, 1984
18 William's Coronation, Michael Linton's steel mosaic, New Zealand, 1980–2005

Illustrations in the text

I Embroidering History
Part title: Edward's deathbed
From the Tapestry.

4 Edward & Harold
6 The embarkation
7 Harold before Guy
The messengers galloping
9 The quicksands
10 Harold's return sails back
11 Harold before Edward
12 Harold receives the crown
13 The comet
14 The channel crossing
15 The feast

The burning house
16 The Norman knights advance
The battle
17 The death of Harold
23 Bishop Odo
26 'Eustace' and William
28 Turold the dwarf
33 *In Praise of Queen Emma*: frontispiece, 1041
34 Edith at Edward's deathbed
48 The first join
49 The back of the Tapestry
50 Border motifs
52 The stitching technique
58 The camel in the border

II *Lost and Found*
Part-title: Border motif, fox and bird
71 Colour sketch by Nicolas-Joseph Foucault, 1690s
77 Engraved version published by Bernard de Montfaucon, 1720s
78 Drawing by Antoine Benoit, 1729
81 Portrait of William Stukeley

III *Revolutionaries and Romantics*
Part title: The Brittany campaign
98 Portrait of Vivant Denon, by Robert Lefèvre, 1808
107 Wicht's score for *La Tapisserie de la Reine Mathilde*, 1804
119 The winch in 1818
124 Stothard's plaster casts
125 Drawings by Charles Stothard, 1820
127 Portrait of Eliza Stothard
135 Engraving by Godefroy Engelmann for the frontispiece to the French
 edition of Ducarel's *Anglo-Norman Antiquites*, 1823.
136 Drawing by Victor Sansonetti, 1838

IV *The Gentle Touch*
Part-title: Border motif, cock and hen
149 Frontispiece to Agnes Strickland, *The Lives of the Queens of England*, 1840
167 The stolen fragment
186 Elizabeth Wardle and her team from the Leek School of Embroidery, 1880s
188 The final panel of the Leek replica

V *The Great Escape*
Part-title: Soldier on the rope
207 The concrete shelter in Bayeux, 1939
210 The Nazis admire the Tapestry, June 1941
225 Plan of the basement of the Chateau de Sources, June 1944
230 Himmler's letter

VI *Global Image*

Part-title: Setting the weather-vane

270 John Hassall, *Ye Berlyn Tapestrie*, 1915
271 Gordon Minhinnick, *D-Day cartoon*, *New Zealand Herald*, 14 June 1944
272 Les Gibbard, 'You English', *Guardian*, 4 September 1971
273 Nicholas Garland, 'Hic est Maggie,' *Daily Telegraph*, 24 October 1984
274 Clive Goddard, 'The Byers Tapestry', *Private Eye*, May 2002
 M. Pickles, Milk Tray cartoon, Punch 1990
277 Making the *Overlord Embroidery*
283 Guinness advertisement, 1966
284 Hovis advertisement, 1966
286 Buzz Airlines advertisement, 2002
289 The Tapestry: the clerk and the lady
300 Bayeux: Plaque on the wall
301 The gallery display

Picture credits

What They Said

'The noblest monument of English antiquity abroad' – *William Stukeley*

'Very curious and authentic' – *David Hume*

'Records one of the most memorable deeds of the French nation and preserves the memory of the pride and courage of our ancestors' – *Napoleon Bonaparte*

'The most interesting thing conceivable' – *John Ruskin*

'The work of very feeble amateurs' – *Charles Dickens*

'Very quaint and rude and very interesting – *William Morris*

'A story told with irresistible charm' – *Winston Churchill*

'Important for our glorious and cultured Germanic history' – *Heinrich Himmler*

Prologue

Bletchley Park. 18 August 1944. An ugly Victorian mansion and a proliferation of low wooden huts so bleak and institutional that locals assume they house the mad. But this is Station X, a city of 10,000 codebreakers, deciphering the enemy's radio signals with the aid of machines, brilliant minds and unremitting concentration. Top priority amongst the messages being intercepted today are those from Berlin to Paris, 11 weeks after D-Day, a time when the Allied forces are moving so rapidly that Hitler is planning to destroy the city rather than let it fall to them intact. Reichsführer-SS Heinrich Himmler, Hitler's second-in-command, has wired Carl Oberg, head of the Gestapo and SS in France. This urgent communication is decrypted by Hut 6, then passed on to Hut 3 where it is translated, analysed by a military adviser, evaluated by the duty officer and finally referred to higher authorities. But the message puzzles everyone, for it does not deal with troop movements or arrangements for the impending evacuation. It concerns the Bayeux Tapestry. 'Do not forget to bring the Bayeux Tapestry,' commands Himmler. He has had his eye on it for four years and has already had it moved to the Louvre from a safe place in the country. Before Paris is blown to bits, he wants the Tapestry out.

Four days later, two SS officers attempt to seize it from the Louvre, but they are too late: the Resistance has occupied the building and the Allies are about to enter Paris. If Himmler had sent his message just a few days earlier, the Tapestry would have been loaded into the back of an SS truck to begin a hazardous drive out of France, which it probably would not have survived. This is just one example of the miraculous survival, time and time again, of this familiar and well-loved hanging. Himmler's ominous desire to possess it reflects the fascination it has held for so many, a national monument, but one that different nations – English, French and German – have all claimed as their own. They have read in it what they wanted to find. Yet the greatness of the work lies in its ability to adapt to so many different interpretations without losing its own integrity. Its ambiguity remains its strength. This book tells the story of the effect it has had on people and the many different ways in which they have used or understood it over the centuries. Himmler was not alone.

I

Embroidering History

1

The Plot

The Bayeux Tapestry provides a far-from-impartial account of a political event, the last successful invasion of England. Its climax is the Battle of Hastings, 14 October 1066, when William, Duke of the Normans, defeated Harold, King of the English, and claimed the kingdom for himself. A masterpiece of spin, in every sense of the word, which had taken months to plan and hundreds of hours to make, the Tapestry was intended to recall the causes and course of the invasion at a time when the Norman regime needed support. To reinforce the legitimate case for William's tenure of the English throne, someone thought it desirable to record the events that led up to the victory in order to provide the target audience not merely with a vivid re-creation of the victorious campaigns they had fought, but with a carefully doctored account of recent history.

Although first described as a tapestry (*tapisserie*) in the eighteenth century, the work is not true tapestry (where designs are woven in by the mechanical action of shuttle and loom), but an embroidery, in this case a strip of linen hand-decorated by needle and woollen threads. But the old name is now an inseparable part of the work, and this book will refer to the Tapestry instead of the more accurate *Broderie de Bayeux*. The dimensions are remarkable: at least 70 metres long (the end is missing) by a mere 50 centimetres wide. This provides the framework for an epic frieze, history's first cartoon strip, a sequence of scenes that are not divided into separate frames but presented as a continuous narrative, one incident flowing

effortlessly into the next. The eye is carried along from left to right, not just by the excitement of the story but also by a whole series of sophisticated visual links: a character in one scene will point his finger towards the next, his body may be facing left, but his head or feet are already turning the other way. Trees and buildings serve as punctuation marks ending one incident and starting the next, yet the details enchant and delay. When you focus on any of the gesticulating groups of characters, a wealth of information about daily life emerges – clothes, tools and weapons, ornaments, digging a trench, planing a plank, how a horse clambers out of a ship, the trappings of falconry – all intricately depicted through dynamic little figures no more than a few centimetres high.

The story starts in the year 1064, when Edward, King of England (a man so devout that he would become known as Edward the Confessor), sends his most powerful subject, his brother-in-law Harold Godwinson, Earl of Wessex, on a mission to France. Edward, identified by the first of a series of 58 laconic inscriptions, is a bearded, dignified figure who sits enthroned, wearing his crown and bearing his sceptre of state: this is official business.

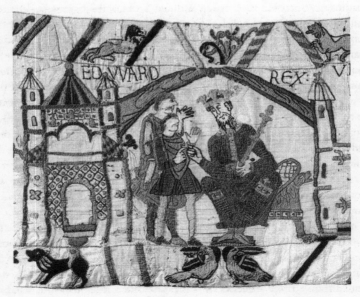

The story begins. King Edward commands Harold to go to Normandy. But why?

His exaggerated forefinger touches that of Harold, a galvanising gesture like that of God creating Adam on Michelangelo's Sistine Chapel ceiling: Edward's tactile command was the starting point for all that followed. The mission was evidently peaceful, for Harold and his retinue set off unarmed, taking with them hounds and hawk, those high-status accessories for hunting (Edward's favourite activity and the main leisure pursuit of the aristocracy) that served as standard gifts between men of rank: Harold was going on an embassy, which Norman sources announced was to pledge his loyalty to William, Duke of Normandy, Edward's kinsman and designated successor to the English crown. This purpose would be challenged by an English chronicler, who claimed that Harold went to seek the release of kinsmen whom William was holding as hostages.[1]

Harold and his men ride to his manor at Bosham, on the Solent, where they pray, then feast, while waiting for a favourable wind to set sail for Normandy. Their embarkation has delightful details: with hose removed and tunics rolled up, two men wade barefoot through the waves carrying the precious hounds and hawk on board. But the winds are too strong, blowing the English party off course to the east and forcing them to land in the hostile territory of Count Guy of Ponthieu, William's rebellious vassal. Guy and his soldiers seize Harold and strip him of his sword, symbolising his helpless position as a captive who could now be held for ransom. As well as this indignity, the wider menace is highlighted by the alien appearance of Guy and his threatening troops, all resembling skinheads, with very short hair shaved right up the back of the neck. This Norman-French fashion was in marked opposition to the style of the English, who had moustaches and much longer hair, cavaliers rather than roundheads. This effeteness shocked one French commentator in describing them 'with their combed and oiled tresses' as 'ladyboys' (*feminei iuvenes*) and 'reluctant warriors', a gender divide enhanced by the English fondness for short tunics in contrast to the Normans' breeches. And the English, for their part, assumed that all Norman soldiers were priests because of their bare faces and tonsure-like cropped heads.[2]

Fortunately for Harold, one of his men, identifiably English because of his moustache, has escaped to tell Duke William of their plight, and William makes his first appearance seated in state on an ornately carved stool; an elaborate costume also emphasises his rank, which sports the unique feature of tasselled garters worn just below the knee in this and in his next scene. (Evidently a demanding dresser, he subsequently displays

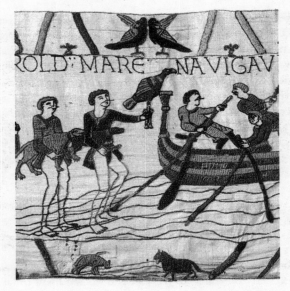

Harold and his men wade bare-legged to the boat, carrying their prized hunting dogs. The hawk's jesses (leather leg straps) are carefully shown. The border (below) illustrates one of Aesop's animal fables, the Wolf and the Lamb.

similar fancy tassels round his neck: such accessories were normally a feature of gold-embroidered vestments worn by the clergy.) William sends messengers who command Guy to release Harold and bring him to William. The count has to obey. These events take place in an apparently confusing chronological sequence, for we first see William's messengers negotiating with Guy, then William receiving the news of Harold's capture, and then the messengers galloping to Guy so rapidly that their hair stands on end. This could be an attempt to suggest the urgency or simultaneity of events, or perhaps record that William had to send a second demand, because Guy ignored the first. Or there is the simpler explanation that the designs for the separate scenes got accidentally transposed and irrevocably sewn. Another intriguing feature is a bearded dwarf who holds the reins of the messengers' horses. A caption above his head announces *Turold*, and his identity has been the source of endless but ultimately fruitless speculation, for the name may not apply to him at all, but to the figure of the adjacent messenger.

William, bearing his long-awaited hawk, and with his new hounds

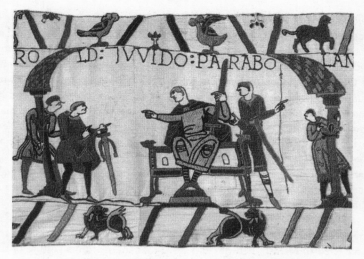

Guy of Ponthieu commands Harold, his captive guest, to disarm before their meeting.

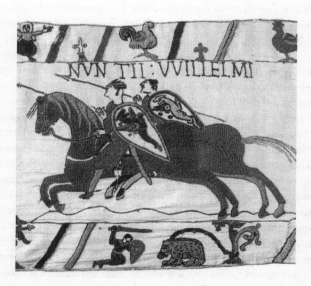

William's messengers gallop so urgently to Harold's rescue that the wind blows their hair on end.

gambolling alongside, escorts Harold to his palace at Rouen. Here there is a confrontation, with Harold poised vulnerably between William seated in state and a group of armed men. He turns towards William, but indicates with his other hand a bearded man, evidently not a Norman, so perhaps one of the hostages. The negotiations also seem to involve the woman who stands as if protected within a doorway whose carved jambs are topped by fierce animal heads. Yet her seclusion is being breached by a tonsured man whose hand touches her face. The inscription above, *Where a certain clerk and Ælfgyva*, lacks a verb, the only example of an uncompleted phrase in all the inscriptions. Like the other names in the Tapestry, 'Ælfgyva' is Latinised, a version of 'Ælfgifu' (Elf-gift), a popular Anglo-Saxon female name. The elided AE proved that the scribe who wrote the captions was familiar with English spelling. (The plate is in Chapter 23.)

Although the first audiences knew perfectly well what part she played in the events depicted, we can no longer be sure who she was, although many have tried to identify her. Some believe that the intrusive gesture of the clerk and the presence of suggestive nude figures in the border below hint at some complex sexual scandal widely known at the time. Others have thought she was the subject of the talks between William and Harold. Contemporary Norman writers claimed that Harold agreed to marry one of William's daughters, or offered his sister in marriage to one of the duke's followers as part of the deal ensuring his support. So Ælfgyva might have been one of William's daughters, here given an English name, or, more likely, Harold's younger sister, who was really called Ælfgifu.

There have also been more fanciful suggestions: the image is the flashback to a long-deceased royal consort, either Queen Emma-Ælfgifu (King Edward's mother) or Ælfgifu of Northampton (King Cnut's first wife), both ladies of doubtful reputation, inserted here to refer to the ambiguous nature of the succession. Yet she has also been identified as a nun, on the basis of her enveloping robes and the protective nature of the columns on either side, and even as the abbess being commissioned to make the Tapestry. All attempts to define the clerk's gesture – erotic chin-stroking, punitive face-slapping, unveiling, symbolically penetrating – have related to whichever historical person Ælfgyva was meant to be. But the designer's job was not to create new images. He drew on a repertoire of familiar motifs and his audience could see that the clerk was committing some sort of intrusion by his actual touch, while her raised hands were in the gesture that implied submission.

To what extent the decorated borders above and below contribute to the story in the central portion is also contentious. In this section, there seems to be a direct connection. Below and immediately to the left of the woman, the viewer's attention is drawn to a blatantly well-endowed nude male whose arms (one akimbo, one extended) copy in reverse the posture of the clerk. To the left of this little figure, another naked man, who bears an axe, advances threateningly. Is the border referring to the tough new order that William imposed? According to the contemporary *Anglo-Saxon Chronicle*, he was 'stern beyond all measure to those who resisted his will . . . if any man had intercourse with a woman against her will, he was forthwith castrated'. The axe-man and his intended victim might represent an ironical comment on this regime, making a veiled reference to an actual or attempted rape and perhaps confirming the sexual nature of the incident in the scene above.[3]

Whatever the scene meant, it did not prevent William and Harold from becoming companions in arms in order to campaign against William's enemy, Count Conan of Brittany. Harold demonstrates his bravery, especially when he saves two soldiers from the quicksands at the estuary of the Couesnon by Mont-St-Michel. This is a dramatic sequence where we see water levels rise, men and horses sucked down and the valiant Harold, a giant in size as in courage, heaving one soldier over his shoulder while he drags out the second. The Normans besiege the castle of Dol, Conan

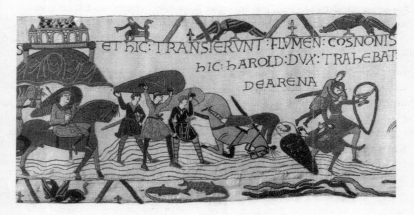

Harold the hero, rescuing soldiers from the quicksands. Fish and eels wriggle along the border below.

escapes to Dinan, but is forced to surrender to William before the town is torched. In the following scene, William presents arms – helmet, coat of mail, sword and lance – to Harold in recognition of his conduct; receiving this honour from such a great leader signals Harold's submission to William as his overlord. And he commits himself further in the next scene, whose caption simply reads *Where Harold made an oath to Duke William*, but tantalisingly refrains from stating what he pledged. The solemn nature of the oath is reinforced by the image of Harold touching two ornate shrines, which contained (according to the written sources) the bones and relics of the most powerful saints. Yet the scene also hints that Harold is under duress: the majestic figure of William, seated formally on his throne and bearing a sword, dominates and threatens. It would be no sin to break an oath that had been obtained by force.

Immediately afterwards, as if one event were contingent on the other, Harold sails back to England, those impatiently waiting for his return indicated by a row of little heads in profile watching from the windows of a tall building. He goes straight to King Edward, whose beard is now longer than in the first scene, and whose increasing frailty is indicated by the stick he grasps. But Harold seems to be in disgrace. He is submissively hunched, standing between two attendants who bear threateningly large axes: Edward is displeased with him. It is one of the enduring fascinations of the Tapestry that the king's intentions remain unclear, their very ambiguity perhaps designed to let those first spectators make their own interpretation. Had Edward changed his mind about appointing William as his heir, if this was what Harold had pledged himself to support?

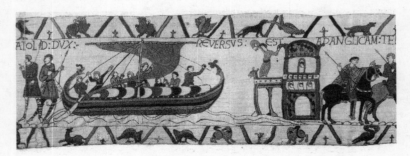

People watch anxiously for Harold's long-delayed voyage home. The border (above) shows Aesop's fable of the Crane's narrow escape from the Wolf.

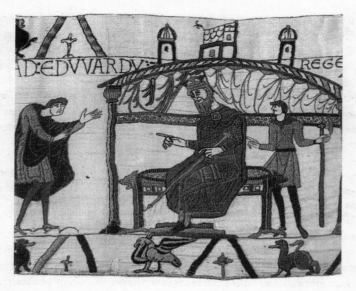

Harold's hunched, defensive posture suggests that he fears the king's response to his news. Edward sits majestically on an ornate cushion, and there are hangings on the wall behind.

This is the implication of the next group of scenes, showing Edward's death and funeral, followed immediately by Harold's uncontested succession in accordance with the king's last words. Two adjacent captions spell it out. (The plates are in the colour section.) The first is a message so important that it was placed, exceptionally, in the narrow border above, instead of being within the same frame as the figures to which it refers: *Here King Edward in bed speaks to his faithful followers.* Around the bed we see those who witnessed this final command – an attendant, a tonsured cleric, the queen and Harold himself, whose fingers Edward again touches with his own. In the next scene, the inscription reads *Here they gave the king's crown to Harold.* It could not be more obvious that he had not seized the crown, but was bequeathed it: the man who offers Harold the crown points back towards the dying king in another of those connecting visual devices that convey more than words.

This is another chronologically confusing sequence, for Edward's death is preceded by his funeral procession towards St Peter's at Westminster, the church he founded – so recently completed that the builder is still setting

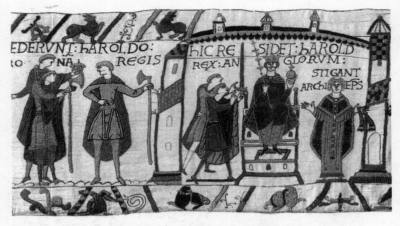

Harold accepts the crown in accordance with Edward's dying command.

the weathervane in place and the hand of God hovers above to indicate divine approval. The building was consecrated on 28 December 1065, just a week before Edward's death on 5 January 1066. The deliberate dislocation speeds up the narrative, for Harold's coronation immediately follows his receipt of the crown. Enthroned and crowned, he holds the orb and sceptre, and accepts the sword of state from a pair of witnesses. The Archbishop of Canterbury attends him, significantly labelled *Archbishop Stigand*, a man already excommunicated by the current Pope following his unlawful appointment to the see by a disgraced predecessor. So the coronation ceremony, however splendid, could be invalid.

Next comes an uneasy Harold, still enthroned, but now hunched sideways and framed by portents of doom. In the upper border is an object captioned *The Star*, which was really Halley's Comet (seen on 24 April, 1066). This is matched in the lower border by a fleet of ghost-like ships, ethereal because they are stitched in outline only, with no coloured infill. These hint at a future seaborne invasion, either that of William, or perhaps that of the King of Norway, another claimant to the throne, in alliance with Harold's estranged brother Tostig.

Although Harold has been the leading character so far, William takes centre-stage in the second half of the unfolding drama. News of Harold's accession reaches Normandy, where William sits in conclave with a tonsured figure, his half-brother Odo, Bishop of Bayeux. Although the caption says

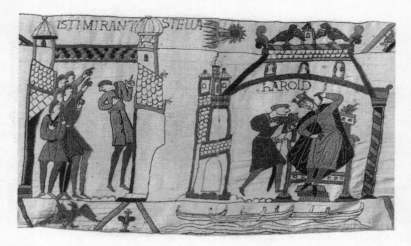

'Uneasy lies the head'. Harold hears bad news: the comet above is a sinister omen which heralds the invasion fleet that looms below.

Here Duke William ordered the ships to be built, it is the bishop who relays the instructions to the chief shipwright, a man holding an adze. Then a lively sequence summarises a massive operation, the medieval equivalent of preparing for D-Day: tree-felling, planing timbers, the construction of clinker-built sailboats, dragging them to the sea and loading them with armour (suits of chainmail, helmets and swords, arrows and shields) and vital provisions. The most precious is a great keg of wine, so important that one of the captions mentions it: *Here they are pulling the cart with wine and weapons.* The Channel crossing is a magnificent panorama of striped ships with Viking dragon-head prows. The troop ships display a row of shields slung along the side, but others are carrying warhorses (crucial to the success of William's campaign, for the Normans, unlike the English, fought on horseback). Smaller ships, placed in the gaps above those bearing horses or men, may represent an innovative attempt at perspective and certainly give a sense of depth and distance.

Once landed, the immediate activities of the invading army proved that, then as now, it travelled on its stomach. The troops loot, cook and serve food – spit-roast meat and chicken on skewers, newly baked bread, a stew.*

*The large cooking pot bears a remarkable resemblance to the field-oven used by Argentinian troops in the Falklands conflict, now on display in the Imperial War Museum at Duxford, Cambs.

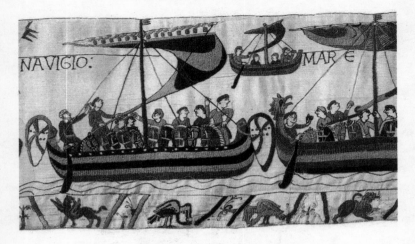

The last successful invasion of England. William's fleet contained nearly 800 ships, many specially adapted for the revolutionary transport of warhorses, the Normans' secret weapon.

Ordinary soldiers eat off a table made out of a shield supported on trestles, while their leaders enjoy a grander meal at a round table, after Bishop Odo has blessed the food and wine in a solemn image that the designer almost certainly copied from a Last Supper illustration in a manuscript at Canterbury. William then holds a strategy meeting with Odo and his other half-brother Robert, after which, we are told, *He ordered defences to be dug at Hastings,* the Norman base. Then follows a poignant image, not specific to this conflict, but a general comment on all wars: a woman and her young son, innocent victims of conflict, flee their home when soldiers set it on fire. Torching villages was an integral element of William's official policy of punishing those 'stupid people' who did not immediately surrender to him.[4]

The Tapestry telescopes time. Harold's adventures in France may have lasted several months, while nine months passed from Edward's death to the invasion of the Normans. Yet the last third of the Tapestry covers just one day, 14 October 1066, the closely fought Battle of Hastings. The designer has excelled, producing a unique visual record of an event that changed history, with daring and dramatic handling of the massed groups of men and of horses, scenes of bravery and violence, toppling figures, a hail

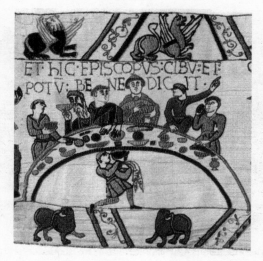

The Norman leaders sit down to a civilised dinner to celebrate the unopposed start to their campaign. Bishop Odo blesses the meal.

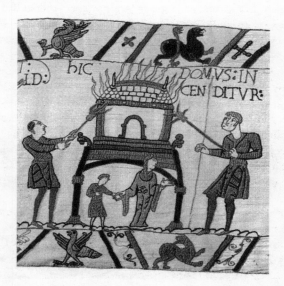

Casualties of war. A woman and her son escape from their blazing house torched by the soldiers.

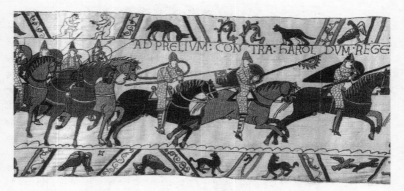

The Norman cavalry lines up at the start of the battle, preparing to charge the axe-wielding English foot soldiers.

of arrows, the hazardous uneven terrain. The sequence starts with the advance of the Norman cavalry, moving forward in speed from walk to gallop. Inspired by a speech from William, they charge the English army, who flourish battleaxes and spears and protect themselves by the

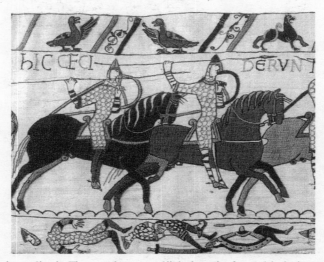

The realities of battle. These graphic images fill the lower border, as if the bodies were being trampled underfoot.

formidable shield-wall. Harold's brothers Gyrth and Leofwine are killed, but the English, advantaged by their hilltop position, continue to hold their own. A caption impassively announces *Here the English and the French fell at the same time in the battle*, which is almost literally underlined by the lower border, which shows the real horrors that both sides suffered, shocking scenes of butchered men and horses, dismembered limbs, corpses being looted for their armour, men fighting for possession of a dead man's shield, bringing graphically to life the later chronicler's vision: 'the mangled bodies that had been the flower of the English nobility and youth covered the ground as far as the eye could see'.[5]

When rumours spread that William has fallen, Bishop Odo rallies the flagging Norman troops. As a man of the church, he is not meant to wield a blood-shedding sword, but gets round this by brandishing a mace. Then the duke reveals himself by raising the face-piece of his helmet, a courageous action in the middle of battle, and a new wave of Norman archers tip the balance, until *Those who were with Harold fell*. The next caption, *Here King Harold was killed* spans two figures, the familiar mail-clad

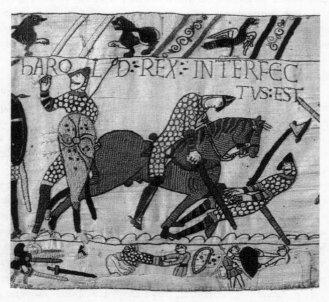

The death of Harold. After a hail of Norman arrows, a Norman sword hacks him down.

warrior seemingly clutching the arrow that has penetrated his helmet, and then a second being cut down by the sword of a mounted Norman. The death of the leader meant the end of the struggle. One of the written sources described the fate of the English: 'Their ranks broke and they fled with all speed, to suffer divers fates. Some tried to escape on horses they had managed to catch, others on foot, either on the roads or through the untrodden wastes.'[6] These are the images, as far as can be reconstructed, at the tattered end of the Tapestry. The last part is missing altogether, already lost when the hanging was first illustrated in the early eighteenth century. It may have shown the surrender of the English and the coronation of William in Westminster Abbey on Christmas Day 1066, a concluding regal image to match those of Edward at the beginning and Harold in the middle.

The whole Tapestry is a narrative tour de force, an epic told by images rather than words. The layout heightens its meaning, for the central portion where the story unfolds has narrow borders above and below, decorated with pairs of animals and birds and some anecdotal scenes, all set in separate compartments, which may or may not refer to the events they frame. Although they were embroidered in the sturdy wool and linen of north-west European tradition, the source of many of these images lay in precious woven silks from the eastern Mediterranean world, the products of Byzantine, Syrian and Islamic workshops. These precious fabrics were coveted and collected in the West, where local craftsmen – stone sculptors, mural painters, metal workers and manuscript illuminators – lovingly imitated their designs. Framing the tale of Harold and William with motifs that originated in a more luxurious medium enhanced the value of the Tapestry for its first viewers, who could imagine that it was just such a silk. In the same way that its coloured wools used a stitching technique devised for expensive gold thread, so its rows of paired animals adopted the loom's symmetrical repetitions and ignored the freedom of embroidery. The other border scenes copied manuscripts. Together they provided a constant source of entertainment and intrigue by combining fashionable ornament with subtly complex meanings and references. The spectator's eyes could read the hanging from left to right, but the border motifs also required them to move up, down and diagonally. When the main story needed more space, the designer ignored the boundaries: the panorama of the Channel crossing took over the entire upper border, while the battle spilled into the lower one.

The third component of the Tapestry is the series of inscriptions that refer to scenes and to individuals. Written in Latin, the common language of the church, they were tempered by Norman-French and Anglo-Saxon, composed perhaps by a continental cleric for manufacture in England. The inscriptions were used as labels to identify people – *King Edward, Duke William*, and so on – and places, such as *Bosham, Bayeux, Mont-St-Michel*. They also described in brief phrases what happenened in the various scenes: *Where Harold and Guy are talking*, or *Here the troops set out from Hastings*.*

The captions seem to have been inserted in the original design after all the figures, background details and borders had been laid out. The words can be awkwardly placed, split in two, abbreviated or squeezed into totally inadequate spaces between the figures. This raises two questions: was the text an integral part of the original scheme or an afterthought? And was the person who decided the content of each scene also the one who drew the figures? There may have been a whole team of assistants who scaled up the original drawings, and others who copied the captions. This would account for the variants of lettering and the spelling of names: WILLEM, WILLELM, or WILGELM; EDWARD or EADWARD; plus the distinctively Anglo-Saxon forms ÆLFGYVA and GYRÐ. The words often appear to state the obvious – sometimes so obvious as to be superfluous – yet occasionally image and text disagree. So the inscriptions are, for us, a frustrating shorthand, indicating something that did not need to be spelt out, either because of political discretion or because the first spectators were thoroughly familiar with the deeds of the famous people depicted.

The real key to the meaning and purpose of the Tapestry is understanding why this particular version of events was commissioned. Contemporaries, and authors writing a generation or so later, provided several accounts of the Norman Conquest. The interpretation depended upon the nationality of the writer. The Norman line, set out by the monk-historian William of Jumièges in his *Deeds of the Norman Dukes* (completed in 1070), and even more strongly by the Conqueror's own chaplain and legal expert, William of Poitiers, in his *Deeds of William* (c.1074), was that Edward had promised

*The *Where* (*Ubi*) and the *Here* (*Hic*) are initially used fairly interchangeably, and the verbs that follow can be in the past or present tenses without any particular consistency. But about one-third of the way through, from the scene of Harold's oath, *Ubi* is abandoned and only *Hic* is used, plus an occasional *Iste* (*That man*) or its plural. This all suggests that more than one scribe was involved.

the succession to his kinsman William and sent Harold to Normandy to pledge his loyalty. When Harold broke the oath sworn on holy relics, he became an official enemy of the church, as well as a traitor and usurper: William therefore had the backing of the law and of the Pope when he claimed the throne.

Considering the outcome of Hastings, the English response could only be muted, but the *Anglo-Saxon Chronicle* implied in its entry for the year 1066 that since Edward had appointed Harold his successor, William's invasion was an act of aggression. And it briefly noted the resulting violence. It made no mention of Harold's visit to Normandy. *The Life of King Edward*, commissioned by Queen Edith, his wife and then widow, and compiled between 1065 and 1067, also stressed that Edward had entrusted the kingdom to Harold.

In the early years of the twelfth century, with the Anglo-Norman kingdom more soundly established, a new generation of historians approached the subject with a little more detachment and sympathy, and less concern with justification. They inevitably drew on the earlier versions, but contributed new details and glosses. William of Malmesbury's *Deeds of the English Kings* (c.1124) suggested that Harold had set sail on an innocent fishing trip, but got blown off course. His enforced oath to William was the only means of returning to England. The extensive and well-researched *Ecclesiastical History* of Orderic Vitalis, writing at St-Evroul in Normandy in the 1120s, conceded that Harold had committed perjury, but also criticised the Normans, especially Bishop Odo, and revealed the dreadful conditions in England after the occupation, which Orderic had witnessed as a child. Eadmer, a Canterbury monk, had a more biased view. His *History of Recent Events in England* (1110–30) looked back nostalgically to pre-Conquest times and reported that Harold was Edward's appointed heir, who went to Normandy only to reclaim the hostages, although he did agree to marry William's daughter. A generation later, Robert Wace, a canon of Bayeux Cathedral, wrote the *Roman de Rou* (1160s), a poetical account of the deeds of Rollo, the founder of Normandy, and his descendants, which repeated that Edward had promised William the succession. As Wace's father had fought at Hastings, he had a direct link to the past.

As a historical text, the Tapestry also puts a particular viewpoint. It has distinctive features that do not occur in any of the written sources: it names Bosham as the site of Harold's departure; it gives an exceptionally thorough

account of the Brittany campaign (and shows Conan being besieged in Dol, rather than besieging the town), Harold receiving arms and swearing his oath after this campaign rather than before it, and the location of his oath at Bayeux. But the use of images rather than words produces ambiguous readings, and though it recounts recent history in a different medium and manner, there can be no doubt that this embroidered version was as slanted as the texts. The depiction of William's hard-won victory and seizure of the kingdom was meant to celebrate the achievement of a final solution to the constant problems of the succession, which had dominated English affairs over the past 50 years. Although William became King of England as the direct result of victory in a legally justified campaign, the Tapestry's viewers would also have appreciated that his claim was based upon his kinship with Edward, for both men were descendants of Count Richard I of Normandy, William's great-grandfather and Edward's grandfather. The work was created to put a positive gloss on a confused situation by emphasising William's entitlement at a time when the Norman grasp on England was still precarious. One way of reconciling the still-disaffected English was to provide some public resurrection of Harold's reputation. Who might have wanted to do this?

2

The Patron

In the Middle Ages a work of art did not spring to life in the mind of its maker, but in that of its patron, the person who commissioned and paid for it and frequently remained involved throughout the various stages of production. There have been various candidates for the patronage of the Tapestry, their cases argued with differing degrees of conviction. The first was William's wife, Queen Matilda, believed by many, from the eighteenth century onwards, to be the Tapestry's instigator, designer and embroiderer. It is still her name that informs tourists to Bayeux that they have reached the holy of holies. '*La Tapisserie de La Reine Mathilde*' is inscribed on a shiny plaque (*c*.1983) in the wall outside the exhibition centre. Inside, however, the explanatory captions repeat the official line that Odo of Conteville, Bishop of Bayeux, commissioned the work. The other usual suspects are characters named in the Tapestry – the three Normans, Wadard, Vital and Turold, and Count Eustace of Boulogne. Curiously, the leading character, William himself, the person who really needed this visual justification of his cause, has attracted few advocates, his claim perhaps so obvious that it has been overlooked.

One of the main reasons why Odo is the long-standing favourite for patron is that the Tapestry gave him a greater role in the campaign than contemporary writers did. He appears in four scenes, including the ordering of ships to be built, and is captioned in three of them; the other Normans

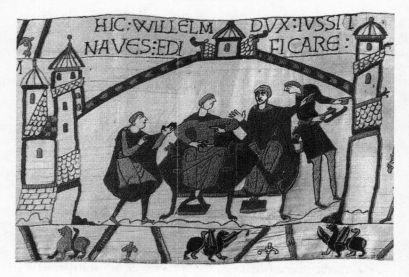

HIC·WILLELM DVX·IVSSIT
NAVES:EDI FICARE:

Bishop Odo plays a crucial role in the campaign. Here he passes on William's orders to start building the invasion fleet.

named may also have been his tenants and particular supporters in England. Perhaps the most effective argument is the Bayeux connection. The Tapestry sets the scene of Harold's crucial oath in Odo's own diocese, captioned *Bagias*. This is in direct conflict with William of Poitiers, who locates it at Bonneville, and with Orderic Vitalis, at Rouen. Odo's new cathedral was consecrated in 1077, and it was here that the Tapestry was recorded in the fifteenth century, its first ever mention, hung around the nave once a year to celebrate the Feast of Relics. So the suggestion that Odo commissioned the Tapestry specifically for the consecration and setting is plausible. Interpretations of his character provide the secondary evidence – his vanity, his ambition, his role as patron of the arts and lover of fine things. 'In this man, it seems to me, vices were mingled with virtues, but he was more given to wordly affairs than to spiritual contemplation,' wrote Orderic Vitalis, venturing unheard-of criticism of a controversial character.[1] More practically, as Earl of Kent after the invasion, Odo had access to the rich artistic heritage of Canterbury, where the Tapestry could well have been designed and made.

Odo was William's younger half-brother. Their mother gave birth to

William by her lover, Duke Robert of Normandy, and was later rewarded by a respectable marriage to Herluin, Viscount of Conteville, by whom she had two legitimate sons, Odo and Robert. Odo's meteoric career was due entirely to William, who appointed him Bishop of Bayeux at an absurdly youthful age and, after the Conquest, regent of England in William's absences, the second most powerful man in the Anglo-Norman kingdom. The English view of Odo was irredeemably hostile: 'He was the foremost man next the king and when the king was in Normandy, then he was master in this country . . . he built castles and distressed the wretched folk and always after that it grew much worse.' In addition, 'in the accumulation of wealth he was a great double-dealer and showed great cunning'.[2] Odo acquired extensive estates, amassed gold and had no scruples about plundering churches and abbeys to furnish his own foundations in Normandy: this was standard practice for ostentatious patrons and connoisseurs of art. Indeed, looting England's wealth was one of the reasons for the Norman Conquest.

If Odo commissioned the Tapestry, it was because he wanted something for public display, not just a demonstration of the rightness of the invasion and of William's might, but also a discreet reminder of his own influential role in the campaign at a time, perhaps, when his conduct was giving cause for concern. It helped viewers recall that his seat at Bayeux was the location of Harold's oath, whose breaking sanctioned the Norman invasion. It was also in his own interests to bolster the king's position in a period of rising tension. By 1068, William 'found many Englishmen whose fickle minds had turned away from loyalty by sinful conspiracy. Throughout the country, bandits conspired with the intention of slaying the soldiers whom the king had everywhere left behind to defend the kingdom.'[3] A retrospective view was even blacker: 'England was exhausted by tribulation after tribulation, suffering at the hands of Englishmen and foreigners alike. Fire, rapine and daily slaughter brought destruction and disaster on the wretched people and utterly laid waste the land . . . everywhere the law of God was broken, massacres of wretched people increased, souls were imperilled by the sins of envy and anger and in their thousands swept away to Hell.'[4] William's apparently swift subjugation of England provoked widespread resistance. Rebels in Yorkshire joined up with Danish invaders, the Normans lost control of York and there were uprisings in the Midlands and the West Country. Indeed, it looked as if William's whole enterprise was threatened. In a brilliant and brutal campaign during 1070, he devastated the north of

England, then attacked Danish and English rebels in the east. Edgar, a kinsman of King Edward, challenged William's claim to the throne, with the backing of the Scottish king Malcolm, who harassed the north. In 1071, William threatened to invade Scotland, Malcolm withdrew and Edgar fled.

William faced further problems in the mid-1070s following the combined efforts of various enemies in Scandinavia, England and France to destabilise him. An imagined speech attributed to one of the English rebel earls voiced the spirit of opposition that the Tapestry may have been intended to neutralise: 'The man who calls himself king is unworthy, since he is a bastard, and heaven has made it plain that it is not God's pleasure that such a leader should govern the kingdom . . . he is attacked by his own kin as much as by strangers and is deserted by his closest followers in the thick of battle.'[5] So it seemed that Normans as well as English still needed to be convinced. The Tapestry could have served as a necessary propaganda tool, deliberately made portable so as to be displayed to as many potential allies as possible. The mobility of court life meant that hangings were not restricted to one location, but could be transported to be admired by more viewers. Textiles did travel safely, wrapped in waxed linen covers then placed in leather bags or purpose-built wooden chests. Such a chest survives today in the Treasury of Bayeux Cathedral in which, it is claimed, the Tapestry was stored between its annual showings in the nave.

Some advocates have argued that Odo had even more motivation for commissioning the Tapestry in the period after 1082, when he fell from grace suddenly and spectacularly. William had him arrested, stripped of the Earldom of Kent, taken back to Normandy and imprisoned at Rouen. The alleged reason was his ambition to become Pope, using means that included bribery and the threat of violence, when he tried to persuade William's soldiers to follow him to Italy to help enforce his claim. So Odo might have commissioned the Tapestry during his imprisonment as a gift for William in an attempt to regain the king's favour. On the other hand, it would not have been tactful for someone in such a weak position to draw attention to William's obligations to him, quite apart from the logistics of organising a complex work to be made in England. And the events shown were surely intended to appeal to those who had been recently involved in them. By 1082 and beyond, it was old history. Released after William's death in 1087, Odo led a revolt against the next king, his nephew William Rufus, and was banished again.

*

The arguments for Odo's connections with the Tapestry have been so persistent that those who did not believe it was commissioned *by* him assumed it was a gift *for* him. One such alleged donor is Eustace, Count of Boulogne, who fought beside William at Hastings in a key role as commander of the Flemish troops, one of the many non-Norman contingents who joined William's invasion force. However, his actual appearance in the Tapestry (and therefore his connection with it) depends entirely upon the deciphering of his name in a particularly mangled and mended portion of the border. This comes immediately above the critical moment in the battle when William risked his safety by pushing back his helmet to contradict the rumour of his death. The caption *Here is Duke William* is reinforced, as if shouted out, by the gesture of a knight who is pointing at the duke. Although inscriptions never normally occur in the border, there is one here, a name over the figure, whose fragmentary '*E . . . us*' nineteenth-century restorers expanded into *Eustatius*. However, William's gallantry in this

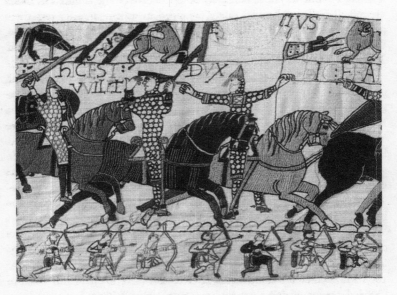

William reveals himself in the heat of battle. The warrior on the right has been identified as Count Eustace of Boulogne, on the basis of the very fragmentary inscription above.

particular sequence is also shown as depending on Odo, who is brandishing a club (or baton of command) labelled *baculum*, with which he *encourages the troops* until William reveals himself. As a bishop, Odo's role should not have meant riding into battle, but only attending 'with many monks and clerks, whose duty was to support the fight with their prayers and counsel'.[6]

There were conflicting versions of Eustace's role at Hastings. William of Poitiers claimed that Eustace urged Duke William to retreat, and was shamefully wounded in the back when fleeing himself. However, Guy of Amiens, who may have composed his verse epic *The Song of the Battle of Hastings* as early as 1067, portrayed Eustace as a hero, always in the thick of battle, who saved William's life, gave up his own horse to the duke, and was one of the three knights who assisted William in hacking Harold to the ground, then butchering his body. Guy was not Norman but French, uncle of the Count of Ponthieu, who had captured Harold. His praise for an old ally could have been an attempt at rehabilitation after Eustace committed a cardinal error in 1067 by attacking Odo's headquarters at Dover Castle. He may even have fancied that his family's claim to the throne was better than William's, for he and his wife Godgifu, sister of King Edward, were both descended from Alfred the Great. So the attack on Dover Castle might have been the first stage of a rebellion, backed by Kentish men, against William. Failing to breach the well-fortified garrison, Eustace escaped to Boulogne, at which point William outlawed him and stripped him of his English possessions. However, they were reconciled by the mid-1070s, when William awarded him the substantial lands that were recorded in the Domesday Survey. Did Eustace commission the Tapestry to get back into favour with Odo, and therefore with the king? Perhaps only someone who was not a Norman could give such a sympathetic presentation of Harold.[7]

The main flaw in the case for Eustace, if indeed the character can be so identified, is that he could not have commissioned the Tapestry (presumably with the support of his former Kentish followers and with access to the Canterbury workshops) until after his reinstatement. But this chronology turns the Tapestry into a reward rather than a bribe for Odo's hypothetical intervention, an implausible scenario considering the extensive planning and outlay involved. Gold or precious relics would have been far more immediate and effective. Nor was Odo, even before his own disgrace, popular at Canterbury, where Archbishop Lanfranc opposed his attempts to encroach on the ancient liberties of St Augustine's Abbey: any monastic project in his honour would have been controversial.

*

The other frequently cited potential patrons, the three Normans named in the Tapestry, were allegedly working in collaboration with and on behalf of Odo. This attribution depends on the assumption that Wadard, Vital and Turold are also the people listed in the Domesday Book as land-holding tenants of Odo, through whom they accessed the rich pickings of England. In 1086, William commissioned this survey of the lands and resources of his conquered territories in order to assess how much taxation to extract. Comparing the position before the Conquest with that of the present day, it made clear the vast extent of the Norman land-grab and the hierarchical nature of tenure. A great magnate like Odo was at the top of a pyramid, supported by a mass of followers and dependants who owed him knightly service in return for the lands he had granted them. This was the system already operating in Normandy and it now embraced English estates as well – rewards that reinforced loyalties.

Wadard in the Tapestry is the knight who supervises the assembling of provisions after the invasion fleet has landed. The Domesday Book

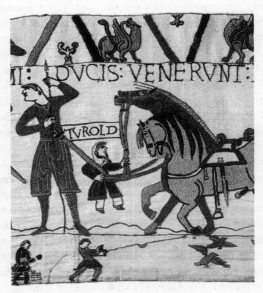

Turold could be the bearded dwarf holding the messengers' horses. Or the tall man with the spear. Putting his name on the label suggests that he was important to the story.

recorded that Odo, as Earl of Kent, gave extensive lands and properties to a Wadard, who had probably been a tenant of his in Normandy and who now possessed more houses in Dover than any other tenant, as well as estates and manors all over the south of England. He was clearly a man who had made his fortune from the Conquest by following his feudal lord from Normandy. The Tapestry Vital is the knight whom William is questioning about the approach of Harold's army, while the Domesday Vital is another long-standing tenant who had followed Odo from Normandy and was duly rewarded with many properties in Canterbury.

The man labelled 'Turold' may be the enigmatic dwarf holding the horses, or the figure next to him, William's messenger demanding Harold's release. If the dwarf, he may have belonged to Guy of Ponthieu's entourage and therefore had no connection with William or the invasion at all. There were several Turolds in the Domesday Book, but this was a common Norman name (perhaps a Latin version of the Viking Thorvald or Thorold), so the alleged association with Odo has less foundation than the other two, whom the Tapestry showed participating in the campaign.

Although the naming of men who were also his tenants was one of the main reasons to attribute the Tapestry to Odo, a circular argument then turned them into the patrons themselves: Wadard, Vital and Turold were so grateful at becoming Odo's tenants in England that they jointly commissioned the Tapestry as a gift for his new cathedral. An alternative version suggests that they oversaw it on his behalf when he was struggling to rehabilitate himself after the disgrace of 1082. That they are named in the Tapestry suggests that they were all people of significance, but their association with its making is completely tenuous because nothing is known about their intentions. It really arises out of a modern need to have a name, to tell a story.

There is one person who has never previously been considered, despite fulfilling the criteria for the other patrons: someone who appears in the Tapestry, an important person directly concerned with the events shown, who had well-honed political instincts and first-hand knowledge of the complex histories involved; someone who had the motive, means and opportunity, and who had already successfully commissioned a major piece of propaganda – and the only one with expertise in the selected medium, embroidery. Those earlier historians who assumed that Queen Matilda made the Tapestry did so on the grounds that mere sewing, even of so unusual a piece, was women's work. But embroidery was a high-status art,

and those who practised it also commissioned works of art as an expected function of their rank. So I would like to add another woman to the list of possible patrons: Edith Godwinson, widow of King Edward, sister of King Harold, friend of King William.

Planning such a work required political sophistication and an intimate knowledge of recent history. Described as 'intelligent as a man' by the chronicler William of Poitiers, Edith was formidably educated and highly literate, 'a woman in whose bosom there was a school of all the liberal arts . . . you were astonished by her learning.' She was also accustomed to power, wealth and influence. Officially consecrated as a queen, Edith had her own throne and played a more than ornamental role in her husband's court: she was an official witness of formal events and ceremonies, and stood in for Edward, such as when he was too ill to attend the dedication of Westminster. She held lands in her own right, as well as those that she owned as queen, and was actively involved in the allocation of tenancies to her followers. She also manipulated her position, accepting 'gifts' in return for interceding with her husband, and she intervened wherever possible to further the careers of her brothers. Running the royal household gave her further status and responsibilities, which included supervising the official wardrobe.

A key scene in the Tapestry is the deathbed of King Edward. Edith is present (one of only three women depicted in the whole central narrative), seated at the end of her husband's bed in the conventional image, borrowed from manuscript illustrations, of a grieving widow wiping away her tears with her veil. But she was also there as one of the four official witnesses to Edward's final decision about the succession, doubly involved, not only as Edward's wife and imminent widow, but also as sister of the man he was designating his successor. The following scene shows Harold accepting the crown in accordance with Edward's last words. This is a very sympathetic presentation of Harold's dilemma: he did not seize the crown illegally, but had to decide between keeping an oath made under duress and obeying the final command of his sovereign. As the second most important member of the royal household, Edith was directly involved in this drama.

One basis of the case for Edith is that, unlike the majority of the English, she survived and prospered under the new regime, yet retained an interest in presenting an English point of view. There is also the chronology. She died in 1075, so if she were involved, the Tapestry must belong to the first decade of the Conquest, a time when the validity of William's claim to the throne was under threat and when its theme of reconciling English and

Norman interests was most relevant. Its story reinforced the solidarity and fellowship of old campaigners, but also helped newer supporters of the Norman cause, with Edith herself a prime example, to justify their drastic shift of allegiance. At the same time the reinstatement of Harold's reputation also directly benefited her. If Edith presented herself properly, she could become a symbol of unity. Collaborating with the invaders was better than losing her estates and treasures, the fate of most of the defeated English. It also suited William to behave magnanimously to the widow of an anointed king and kinsman, whom he claimed had appointed him his heir. So it was in both their interests to reach an accommodation. This was in striking contrast to William's general policy towards the English: 'he found almost none of them trustworthy, behaviour which so exasperated his ferocity that he deprived the more powerful among them first of their revenues, then of their lands, and some even of their lives'.[8]

The Domesday Book proves Edith's successful survival strategy. Hers is one of the very few English names included, the exception that proved the rule about the extent of the Norman takeover. Unlike other English aristocracy after Hastings, she remained wealthy because she retained most of her estates. She held large parts of Wessex as well as lands in Buckinghamshire, East Anglia and the Midlands, which suggested exceptional charity from William to his predecessor's widow. (This contrasted with the fate of Edith's mother, who remained hostile to the Normans. Having lost four sons in battle and, according to one source, being refused by William even the right to bury Harold's body, Gytha 'secretly gathered together a large store of treasure' and fled to Exeter in the as yet unconquered west. When this city was besieged by William and his troops, she escaped with a group of other rebel Englishwomen to the island of Flatholme in the Bristol Channel, then sailed to exile in the Flemish port of St-Omer.)[9]

In the months following his coronation, William demanded surrender and payment of tribute from the cities of the south-west. These included Winchester, which Edith held as part of her widow's dower from King Edward. Consulted by the city elders, she negotiated a peaceful settlement by offering fealty to William and paying her share of the tribute he demanded. As a result he allowed her to retain her rights of residence there. William celebrated Easter at Winchester in 1068, and continued to do so during the years that he was in England. William of Poitiers approvingly noted Edith's support for William and even alleged that she had backed his

claim to the throne, in preference to that of her brother Harold, perhaps something she had conveniently leaked to the Normans. Her apparent collaboration aroused the hostility of an English writer a generation later, who considered that 'she had a bad judgement in wordly matters and . . . a certain lack of personal humility'.[10]

Commissioning the Tapestry could have been another way for Edith to profess her loyalty to William, as well as including flattering references to the equally powerful Odo. The creation of a narrative intended for the eyes of the new order in England, both Norman and English, a court-based audience that included the kin of warriors who had fought on both sides at Hastings, is the only way to account for many of the ambiguities that divide commentators today. Did the Tapestry favour William or Harold? Was it made so that Normans could impress the subjugated foe? Or so that the English could flatter, yet secretly insult, the victors? These conflicting aims could be convincingly reconciled by someone with a foot in both camps, an English person who accepted the Norman occupation but who was still concerned to provide a dignified defence of Harold's conduct. Edith was already a mistress of the selective presentation of information, with a magnificent role model in the person of her tempestuous mother-in-law Queen Emma.

For Emma had once commissioned a carefully edited history of her own life and times, In Praise of Queen Emma (Encomium Emmae Reginae), to set the record straight for her critics – a woman reinventing history for her own ends. Glossing over scandal, disloyalty and even murder, its grand climax was the reunion of Emma and her two sons in 1040, after the sickly, childless Harthacnut (her son by King Cnut) had invited his older half-brother Edward (her son by King Æthelred) to return from exile in Normandy as co-ruler. As a piece of special pleading and blatant flattery, Emma's Encomium had no precedent. It was not the biography of a long-dead saint, but dealt with recent political events and the deeds of herself and her contemporaries. Its frontispiece places Emma centre-stage, queen to two kings and queen-mother to two more, receiving the actual manuscript from its tonsured author (probably a Flemish monk in her household), who kneels at her feet. Harthacnut and Edward watch from the side, spectators and not participants. Images were more effective than words. But this vision of family good will masked the reality of what was to come. Harthacnut died in 1042, and Edward became sole king. Within a year he took long-awaited revenge on the manipulative mother who had once abandoned him: he confined her to her estate at Winchester and deprived her of all lands and treasures.

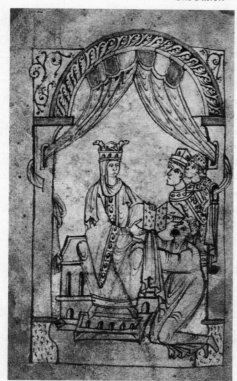

The frontispiece of Queen Emma's book gives her pride of place. Did this inspire her daughter-in-law, Queen Edith?

Twenty years later, Edward's wife Edith followed Emma in putting a spin on posterity, for she commissioned another book that massaged recent history. It took *In Praise of Queen Emma*, with its ability to ignore awkward facts, flatter the central character, condemn opponents and above all celebrate a dynasty, as a clear model. Edith's book, which only later got known as *The Life of King Edward*, could well have been called *In Praise of the Godwins*, for its real purpose was to present Edith's family in the most favourable light and the true hero was her father, the late Earl Godwin, Edward's most powerful councillor, here the virtual father of the kingdom as well. Its underlying intention was to help her family retain power after Edward's death, for there were various candidates for the succession (indeed, Edward seemed to have taken pleasure in keeping his options open) and the childless Edith wanted to nominate one of her brothers,

Tostig or Harold, as heir apparent. William's claim was not particularly strong at this time; it was only subsequent Norman writers who argued that he had always been Edward's main choice.

Although *The Life of King Edward* was begun before the king's death, it had to be completed in the light of dramatically changed circumstances – the destruction of her brothers, the defeat of the English, the triumph of the Normans. But Edith had been adept at walking a political tightrope most of her life, well taught by Godwin, who managed to change sides and keep in favour with a new regime on several occasions. Dedicating the book to Edith, its patroness, the author gave fulsome praise to the woman who had rescued him from poverty by commissing this work. Guided by information clearly provided by her, the author produced a very flattering biography which managed to present Edith as a paragon – 'a woman to be placed before all noble matrons or persons of royal or imperial rank as a model of virtue and integrity'[11] – and her husband simultaneously as a saint and a weak man. This was a brilliant projection, which turned Edith's failure to produce an heir into a positive celebration of Edward's alleged celibacy.

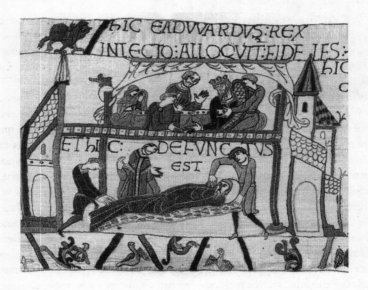

A weeping Edith witnesses her dying husband appointing Harold the next king. This is also a key scene in the book that she commissioned about her husband and family.

Ignoring the more likely reasons of infertility or mutual loathing, the book celebrated his sanctity and her innocence, describing her as like a daughter to him and not a wife: her apparent chastity gave William his lawful claim to the English throne.[12] Similarly, it turned the time when Edward temporarily managed to rid himself of the whole Godwin clan, sending her brother and nephew as hostages to Normandy and banishing Edith to a nunnery, into an emotional triumph: 'with grief at heart' she had been awaiting 'the day of salvation for almost a year in prayers and tears'. When the king recalled her, 'there was deep joy, both at court and in the whole country'.[13]

The book gives a detailed account of Edward's deathbed, with Edith very much present, weeping and warming the dying king's feet in her lap as she 'ceased not from lamenting to ease her natural grief'. His last speech provided an ominous vision of 'fire and sword and the havoc of war', but praised her zealous care of him and commended her and the kingdom to Harold's protection.[14] Being described 'like a beloved daughter' might even have been an ambitious attempt to have herself defined as the king's heir in her own right.

But this was a fantasy, and after Edward's death she had to settle for status as royal widow and the new king's sister. When the latter role so suddenly came to an end, she opted to become mentor and beloved kinswoman to William. Edith maintained this position so successfully for the next nine years that when she died at Winchester in December 1075, William gave exceptional honour to her body: 'by his care she was buried in Westminster Abbey near her husband, and has a tomb lavishly decorated with gold and silver'.[15] Despite scurrilous gossip that both 'during her husband's life and after his death, she was not free from suspicions of misconduct', she was determined to die with her reputation intact. 'On her deathbed, she satisfied those who stood round on oath, *at her own suggestion*, of her perpetual virginity.'[16]

Having already commissioned such an effective piece of propaganda in *The Life of King Edward*, could Edith not have achieved another, this time in a medium that she could control? As queen, she ran a royal embroidery workshop that produced textiles for churches as well as Edward's robes of state. The *Life* lauded her sewing and painting skills, as great as her literary and linguistic talents. She was responsible for the king's wardrobe: 'she clad him in raiments either embroidered by herself or of her choice, and of such a kind that it could not be thought that Solomon in all his glory was thus

arrayed . . . no count was made of the cost of the precious stones, rare gems and shining pearls that were used'. This passage goes on to describe his gold-decorated mantles, tunics, boots and shoes. However, the ascetic king was not suitably grateful, but only wore these trappings for state occasions, when he reluctantly displayed 'the pomp of royal finery in which the queen obligingly arrayed him. And he would not have cared at all if it had been provided at less cost.'[17]

There are glimpses of Edith and her household in the post-Conquest years. She lived mainly at Wilton, always her favourite foundation, the Wiltshire nunnery where she was educated, and after whose tenth-century saintly foundress she was named. Here her staff and tenants included educated men and skilled craftspeople, among whom were goldsmiths and an embroiderer. In her dower city of Winchester there were trained monk-artists, cloth manufacturers and dyers, in fact all the necessary resources. She had appointed a suitably pliant cleric to write *The Life of King Edward*. A similarly sensitive designer-draughtsman planned the Tapestry's narra-tive, someone who interpreted the patron's intentions sympathetically, whether or not he agreed with them. The designer almost certainly had a monastic background, for he was well trained in the conventions of manuscript illustration and familiar with the repertoire of standard images, many of which compared directly with examples produced in the celebrated Canterbury scriptoria of St Augustine's Abbey and Christ Church.[18] Information would also have been available from those who had been directly involved in the events depicted. Harold must have given Edith herself a full account of his adventures in France. The first half of the Tapestry tells the story from Harold's point of view, and it also reveals Edward's reactions. His deathbed scene is an immediate illustration of the version written down in the *Life*. The second half of the Tapestry concentrates on William, and its details – the building of the great invasion force, the Channel crossing and the battle itself – could have been easily obtained from participants. So the designer had no problem in finding out what had happened, then re-creating it in the format of existing artistic conventions.

Harold and William are both presented as heroes, but fate brings Harold down, a brave man who was the victim of circumstance. The winds blew him off course, William rescued him and did not allow him to go home until he had sworn allegiance. Because of Edward's deathbed command, Harold had to become king even though he knew William would seek vengeance.

Other members of the Godwin family appear too. The Tapestry records the battlefield deaths of Edith's other brothers Gyrth and Leofwine, the bearded man who is the subject of Harold's discussions with William at Rouen may be her brother Wulfnoth, the hostage; and of course the crucial deathbed scene includes the weeping figure of Edith herself.

Perhaps the most compelling argument is Edith's understanding of embroidery and its potential. She was one of those many Englishwomen whose needlework expertise was so admired that the general term *opus anglicanum* (English work) became the specific name for the exquisite vestments and hangings, minutely embroidered in gold thread, silk and precious stones, that popes and kings coveted and collected for the next two centuries. The production of fine embroidery was an almost compulsory activity for elite women, whether they were wives or nuns, for it demonstrated industry and virtue, as well as providing textiles of the highest quality for public and private consumption, for display or devotion. Even for the less privileged, sewing was a means of post-Conquest survival and the acquisition of status. According to the Domesday Survey, Ælfgyd of Buckinghamshire was allowed to retain her land as long as she continued to train the (Norman) sheriff's daughter in embroidery; and in Wiltshire, Leofgyd managed to keep her estate because she embroidered for the king and queen. Matilda employed other English embroiderers, including the wife of one Alderet of Winchester, who decorated the vestments that Matilda left in her will to her foundation of St-Trinité at Caen. William of Poitiers was also impressed by the national skill: 'the women of England are very skilful with the needle and in the matter of tissues of gold'.[19]

Among renowned aristocratic embroiderers were Cnut's first wife, Ælfgifu of Northampton, who sewed altar-cloths for the abbeys of Croyland and Romsey, and Ælthelsitha, granddaughter of Earl Byrhtnoth, who 'rejected marriage and was assigned Coveney, a place near the monastery of Ely, where in retirement she devoted herself, with her maids, to gold embroidery', according to the chronicler Thomas of Ely. He was also impressed by Queen Emma's sewing skills, whose 'needlework seems to excel in worth even her materials'.[20] Edith's virtuous contemporary, Queen Margaret of Scotland, ran a whole artistic workshop in her palace, and supervised her women as they embroidered ecclesiastical garments.

A woman brought up to this tradition was certainly capable of organising and undertaking a project such as the Tapestry. Edith also had access to a suitably trained workforce in the nunneries, which were the main source of

large-scale embroidery production. This was not only through her immediate connections with Wilton but also because, as queen, she had general responsibility for communities of nuns. (The enjoyment that religious women clearly obtained from such work aroused anxieties in male clerics. In 747 the Council of Clovesho recommended that nuns should spend more time on singing psalms and reading religious texts and less on sewing. An ambiguous response, for embroidery was also a form of devotion to God through the production of beautiful priestly vestments and fittings for the church, as well as being the enemy of idleness.) There was little change after the Conquest. Nunneries remained communities of well-born women, headed by members of noble and powerful families. Entering a nunnery did not have to be an expression of devotion, but could simply provide the means of living in a genteel society without having to be subject to a husband or face the constant risks of childbirth. It could bring the companionship of equals, intellectual stimulation, and the opportunity for career advancement by becoming abbess. Nor was virginity a compulsory criterion, for religious communities admitted those who had been widowed or repudiated by their husbands. Numbers swelled following the dreadful disruption of lives after Hastings and the Norman occupation, when a nunnery became the only place of refuge after the slaughter of husband, father or son and the seizure of their estates. Harold's daughter Gunnhild, for example, was brought up at Wilton. Many occupants of nunneries in the years after the Conquest, whether as committed or pragmatic members, were women from great English families who had been directly involved with the events depicted in the Tapestry and who, as noblewomen, were noted for their sewing skills. They could deal easily with the vigorous, secular, masculine subject matter, let alone the exuberantly phallic border figures and warhorses, which caused Victorian viewers such anguish.

In the civilised Wilton, the difference between becoming a nun and merely wearing a veil for expediency was made clear when one privileged inmate, Matilda, daughter of King Malcolm of Scotland, could only be betrothed to King Henry I after pointing out to Anselm, Archbishop of Canterbury, that she was not a proper nun, but had been forced to wear a veil 'to preserve me from the lust of the Normans, which was rampant and at that time ready to assault any woman's honour'. Anselm had to agree that in the immediate aftermath of the Conquest, William's Norman followers 'began to do violence not only to the possessions of the conquered but also where opportunity offered to their women, married and unmarried alike, with

shameful licentiousness. Thereupon a number of women anticipating this and fearing for their own virtue betook themselves to convents of Sisters and taking the veil protected themselves in their company from such infamy.'[21] Another chronicler confirmed the appalling position of English women after the Conquest: 'Noble maidens were exposed to the insults of low-born soldiers, and lamented their dishonouring by the scum of the earth. Matrons, highly born and handsome, mourned the loss of their loving husbands and almost all their friends.'[22] Such women might hope to rebuild their shattered lives in a safe supportive community of women, coming together to provide the specialist workforce necessary to produce the Tapestry.

There were other high-status nunneries in Wessex besides Wilton, such as Romsey, Amesbury and Wherwell, where King Edward's half-sister was an abbess. The grandest was Shaftesbury, whose first abbess was the daughter of King Alfred, and its wealth, prestige and reputation easily survived the Conquest. There were also major houses for women at Canterbury and Winchester, the Nunnaminster at St Mary's Abbey. Nearer London was Barking Abbey, whose nuns were famous for their sewing.

Women of Edith's rank – such as her sister-in-law Countess Judith, mother-in-law Queen Emma and Godiva, wife of the Earl of Mercia – were accustomed to commission important works, which included finely illustrated bibles and gospel books embellished with ornate gold and silver covers, lavishly decorated containers for saints' relics, gem-studded crucifixes and rich ecclesiastical textiles. Such high-ranking women could ultimately outdo their husbands in generous patronage by personally embroidering some of the hangings they donated. These might well include sewn narratives of recent history. Ælfflaed, widow of the East Anglian earl Byrhtnoth who was killed by the Danes in 991, presented to the monastery at Ely a hanging depicting her husband's heroic campaigns, which she may have worked herself.

Edith's patronage of the Tapestry cannot, of course, be proved, any more than that of Odo, Eustace and the others. But her particular skills and experience, and the shifting loyalties in her own life, can all be paralleled in the making and the ultimate ambiguities of the hanging. Women sewed, women commissioned works of art and literature, women were capable of arguing their own case. What can be reconstructed of Edith's character and career makes her a plausible candidate, too.

3

The Project

Made from the workaday fabrics of linen and wool, the Tapestry has often been described as an uncharacteristically humble artefact when compared to other works of the period, even an example of quaint folk art. Yet this apparent lack of material value is one of the reasons for its survival, for looters cut up textiles sewn with gold, silver and gems or stripped them of their expensive adornments. Paradoxically, the Tapestry's components were not of low status at the time, and the skills invested in its manufacture derived from generations of practice by the most able craftsmen.

Linen, the very foundation of the Tapestry, has its own long history. The procedures required to make this almost miraculous material – whose texture varied from luxurious gauze soft enough to wear next to the skin down to a fabric tough enough to provide the billowing sails of a ship – meant that it was always highly valued. The ancient Egyptians found linen's sweat-absorbent and cooling properties so divine that they referred to it as 'the emanation which clothed the gods when they appeared' and attributed its invention to the goddess Isis.[1] With the advent of Christianity, its symbolic purity, as well as soft luxury, made linen the cloth of choice for priestly garments. So its selection as the background demonstrated the function of a cloth that was admired in the early Middle Ages not just for its texture and quality, but also because of its status.

Linen is a product of the versatile flax plant (botanical name *Linum usitatissimum*, 'the most useful'). In the eleventh century its seeds were eaten – chewed whole for digestive purposes, cooked into a porridge, ground up to make flour for flatbread, or consumed in the liquid form of linseed oil as a remedy for arthritis and gout. This oil was also an important item of artists' equipment. It was made, according to one early manual, by drying the seeds, pounding them in a mortar, heating the pulp with water, wrapping it in a cloth, then extracting the oil in a press. The coarse outer bark of the plant's fibrous stalks was used to weave baskets or mats, or to provide wicks for tallow lamps. Only the inner fibres were pliable enough to be transformed into fabric. The plant was first cultivated in western Asia, but easily adapted to the varying climates of Europe. Those producing the Tapestry's linen almost certainly grew it somewhere in the south of England, where it was a popular crop that normally succeeded oats in the annual rotation cycle. Sown after Easter, it was harvested three months later, just after the seeds had fully ripened, because this resulted in a better fabric. Like all medieval industrial activities, which were time-consuming and controlled by long-established practices, the young plants were pulled up by hand (never cut, because this damaged the stems), their stalks soaked till they were decomposing, dried out, then smashed with mallets to separate the outer bark from the inner fibres. These were spun into thread on a hand spindle. Spinning was an almost constant activity for medieval women; they attached a bundle of flax fibres to the cone-shaped top of a pole, the distaff, while the other end was tucked under the arm, or even into a waistband. They drew the fibres out from the top, twisted them onto a weighted whorl, then spun them tightly into a single thread.

The resulting skeins were woven into lengths of fabric on a loom. The commission to weave the linen required for the Tapestry must have been a demanding and prestigious one. The hanging consists of nine separate sections sewn together after being embroidered, and the two longest strips each measure nearly 14 metres. This was a tour de force by the weaver, who had to plan and position an exceptionally long warp setting (warp is the length, weft the width). The other sections of the Tapestry are much shorter, between 8 and 6 metres long, with the final two both under 3 metres; they probably started as longer pieces and were only later divided. The original lengths were woven a metre wide, then cut horizontally to provide strips 50 centimetres in width, which is just about the maximum comfortable extent for embroiderers to work with. The texture was fairly

41

fine, 18 or 19 threads per centimetre, woven in the most basic construction called 'tabby' (*toile* in French), which alternates single horizontal and vertical threads in an over-and-under pattern. Although the peasant households that grew the flax probably also spun it into linen thread, it was more likely that a professional weaver turned them into lengths of fabric on a horizontal treadle loom. This was a more advanced machine than the standard household upright warp-weighted loom used to make woollen cloth, because it left the hands free and could produce a longer strip of material. The Chinese invented this sophisticated loom in the second millennium BC in order to process the very long filaments of silk drawn from the cocoon. The new technology had reached western Europe, via the Persian silk industry, by the eleventh century, and here the treadle loom was adopted for linen and wool, because it provided more flexible lengths than the short rectangles of fabric produced by the old-fashioned upright model.

Once woven, the lengths of linen required further processing to improve their texture and colour, from the natural brown of the flax stems to the desired creamy-beige tone. They were bleached by being boiled in a solution of water alkalised by the addition of ash from wood, fern or seaweed, then stretched out on frames for exposure to light and air for a week or so, although they still had to be kept damp. Neutralisation followed, soaking in a weak acid solution made from sour milk, buttermilk or water fermented by rye or bran. Finally the fabric was pounded with a piece of marble or glass to make it smooth and silky.

Against the pale tones of the linen ground, the Tapestry's ornament was embroidered in strands of coloured worsted (spun wool), the end product of another ancient and complicated process. It required an enormous amount of wool, at least 45 kilograms.[2] So effective was the dyeing that the original wools have retained their colours more consistently than some of the chemically based dyes of its nineteenth-century repairs, as well as remaining more resistant to moth. The head of the sewing workshop would have ordered the worsted as a special commission from those most secretive and defensive of craftsmen, with almost magical skills – the dyers. Dyeing processes were long and complex, producing such appalling odours and noxious waste-products that the location of dyeing workshops was strictly controlled. Early medieval cities such as York and Winchester monitored the impact of the trades and crafts practised there, and isolated

unpleasant or potentially dangerous activities from the rest. This all added to the atmosphere of secrecy and mystery surrounding the art of the dyer.

Good-quality wool, like that on the Tapestry, came from the longer hairs of the sheep and was spun from fleece that had already been dyed whole, because this provided richer and more consistent colour tones. Selected fleeces had to be cleaned and de-greased by plant-based soaps and an alkaline liquid made from a solution of wood-ash or stale urine. To make the fibres receptive to the dye and able to absorb the colour permanently, they were soaked in a solution called a 'mordant' made from salts of minerals, in this case alum. Dye ingredients came from animal, vegetable or mineral products, generally acquired locally, but if necessary imported from further afield, to be crushed, simmered and concentrated in order to extract the very essence of the hue. Fabrics made from animals (like wool) normally absorbed colour more effectively than those made from plants (like linen). They were cold-dyed by soaking them in wooden tubs, or hot-dyed by simmering them in metal containers over a fire. The Tapestry's ten main tones come from just three plants, their dyes most skilfully blended into a subtle palette of two reds, a yellow and a beige, and three tones each of blue (blue-black, navy and mid-blue) and of green (olive, sage and laurel). The slight variations within these result from different dyeing batches, for many fleece were needed to provide enough wool for this massive venture.

Beige and yellow came from the flowers and leaves of weld (*Reseda luteola*), a plant so versatile that it was called 'the dyer's herb'. To make the greens, the weld was mixed with the leaves of the native flowering plant, woad (*Isatis tinctoria*), which also produced the blues. Grown in England for its powerful dye since the Iron Age, when a horrified Julius Caesar noted how the native Britons used it to stain their skin, woad was difficult to cultivate and exhausted the soils it grew in. Picked when young, with the potash from its roots and stems a useful by-product, each load of leaves was crushed, ground and turned to pulp by a wooden mill, a process that took at least an hour and a half. This mixture was rolled into large balls, which were allowed to dry out and were stored until needed. In order to extract the appropriate quantities of dye, the balls were ground into a powder that had to be fermented, preferably in urine, for several weeks. This caused such a stench that woad dyers had to work even further away from inhabited areas than other dyers. In the sixteenth century, Queen Elizabeth I banned the production of woad within 5 miles (8 kilometres) of any of her properties.

The reds came from the madder plant (*Rubia tinctoria*), whose roots,

which had to be at least two years old, were ground into a powder, then heated and simmered with added chalk or lime at a constant temperature for not more than two hours. Once the fleece were all dyed to the requisite colours, the hand spindle turned their fibres into bales of worsted.

Although there is of course no contemporary account of how the Tapestry was made, medieval craftsmen provided some clues in the treatises they wrote. These works tried to combine the theory of classical writers on art and architecture, such as Pliny and Vitruvius, with the practices of hard-pressed workshops competing for survival in the real world. Later texts echoed earlier ones, not because medieval artists were afraid to innovate, but because even by the late eleventh century most had already mastered their techniques so effectively that they hardly needed further refinement. Although 'Theophilus' (a classical-sounding and therefore academically respectable pseudonym) did not mention embroidery in his otherwise comprehensive manual *On the Various Arts (De Diversis Artibus)*, written in around AD 1100 in the masculine environment of a German monastery, his descriptions of the layout of workshops, the division of labour and the meticulous preparation of ingredients and equipment give insights into the planning and organisation of any large project.

The first stage was for the designer, who might also run the workshop, to draw the patron's scheme on a small scale. The key to good drawing, according to *The Craftsman's Handbook* by fifteenth-century Paduan artist Cennino Cennini (whose father had been trained by Giotto's pupils), was to work in a decent light coming from the artist's left. It was also essential to prepare your materials properly. Artists drew on parchment, the skins of sheep, goats or calves (the term vellum applies only to calf-skin), soaked in spring or well water until soft enough for the hairs to be scraped off, then stretched taut by fastening them to a plank with small nails. Once dry, you smoothed the surface by dusting it with a fine powder made from chicken bones, then brushed the surplus off with a hare's foot.

The designer could use any combination of drawing tools. A lead-and-tin stylus had the advantage that mistakes could be erased by a rolled crumb of bread, but errors in charcoal could be brushed out by the feather of a hen or goose. The best sort of charcoal, according to Cennini, was made from willow twigs, 'dry and smooth . . . cut into pieces as long as the palm of the hand or the little finger', then split and tied together by copper wire into bundles, placed in a covered pipkin and put overnight in the

baker's oven 'when he has finished baking the bread'. The artist did not hold the charcoal directly in his fingers, but attached it to a stick (an early version of the porte-crayon). Cennini advised that the additional length was 'a help in composing'. (Nothing went to waste in the medieval workshop. Theophilus describes how to stick wooden altar panels together with a glue made of old cheese, soaked and then pounded to a paste. With such enticing ingredients, mice obviously thrived, so cats were important members of the workshop. Over two centuries earlier, an Irish scribe wrote a poem in the margin of the manuscript he was copying, praising his hard-working companion: 'I and Pangur Ban my cat/ 'Tis a like task we are at/ Hunting mice is his delight/ Hunting words I sit all night.')

The fine brush for ink-drawing was often made from the hairs of a squirrel's tail, called miniver. The tails had to be baked ('the furriers will tell you so' – Cennini) and then the longest hairs tweezed from the tips, soaked in water, squeezed out and tied with a silk thread into bundles of different size. These were held in one end of a little tube made from a quill, the other end of which gripped the handle, a small stick of 'maple, larch or chestnut or any other good wood'. Other favoured hairs came from the tails of marten, badger or cat, or the mane of a donkey. Instead of a brush, the artist might use a nibbed drawing pen cut from the versatile goose quill (removed perhaps from the entire goose wing tied to a piece of wood recommended by Theophilus as bellows for the coal-fires that melted enamel).

Ink, diluted as necessary with water, also had to be just right. 'To make ink,' advised Theophilus, 'cut yourself some wood of the hawthorn – in April or May before they produce blossoms or leaves – collect them together in small bundles and allow them to lie in the shade for two, three or four weeks until they are fairly well dried out.' This was just the start. Pounded with mallets, the bark was removed from the branches, then steeped for days in barrels of water until the sap was drawn out, and the resulting liquid heated and reduced until it thickened. Mixed with 'a third part of pure wine', the potion was further reduced and finally put in small parchment bags to dry into a powder. 'When it is dried, take from it as much as you want, mix it with wine over a fire, add a little iron vitriol, and write.'

With such equipment, the designer produced small drawings on parchment for the patron's approval or modification. The repetition of established formulae combined easily with the creation of new subject matter, for copying was an entirely virtuous practice. Artists and patrons were happy to adhere to familiar artistic conventions because they provided

greater moral authority. Truth was stressed through familiarity. But to tell the Tapestry's tale, many new devices were needed, despite issues of sensitivity to the creation of secular, and therefore potentially profane, images.*

Once approved by the Tapestry's demanding patron, and probably also discussed with the head of the workshop, these drawings might have been scaled up by the designer and assistants into full-sized ones (known as cartoons) on a series of separate pieces of parchment, each reused a number of times as an economy measure. Paper (made out of hemp or linen rags) was a commodity unavailable in western Europe until the twelfth century, but it was possible to make a sort of tracing paper out of parchment by scraping it so thin as to be almost transparent, then rubbing it in linseed oil and allowing the whole to dry, a process that took several days. In this way the designer might have made more than one version of the preliminary drawings so that several assistants could have worked on the scaling up. If cartoons had been used, the outlines would have been transferred to the linen by the technique of 'pricking and pouncing', so effective that embroiderers still use it today. Dots of pounce (a powder still made from ground charcoal and cuttlefish) were blown through hundreds of tiny holes pricked through the parchment on to the linen panel, which was already stretched taut on a wooden frame. Then the dots were joined up by brush and ink to reproduce the original outlines. This might explain occasional discrepancies in the Tapestry, where cartoons could have been put the wrong way round. However, it is just as likely that the assistants did not use cartoons, but simply copied the original drawings directly on to the linen: Cennini described how artists producing designs for embroidery drew charcoal outlines on the fabric, then added details in pen and ink. The assistants may have been allowed some independence in drawing the border designs, while following the designer's general brief to use motifs from a range of recommended manuscripts to produce symmetrical creatures and anecdotal scenes. But he might have left the selection and distribution up to them.

The designer was unlikely to have painted the original drawings in colour, which would have wasted time and materials, but might have

*St Bonaventure would attempt to justify the problem of inventing new images some two centuries later: 'they were introduced on account of the transitory nature of memory, because those things which are only heard fall into oblivion more easily than those things which are seen'.

indicated the main colours by a letter or symbol, as was the practice with stained-glass cartoons. Or he may have planned them with the head of the sewing workshop, who knew what was available locally and could order as necessary. The Tapestry's colours were not particularly naturalistic, for realism was not the main concern: colours did carry meanings and symbolism, but their permutations here derived from the need to obtain contrasting effects from a limited palette. The embroiderers probably had considerable autonomy.

Each of the Tapestry's nine strips of linen was mounted onto an individual rectangular wooden frame of adjustable length. Before the designs could be applied, the fabric had to be stretched taut by a strong thread, which zigzagged between the edge of the fabric and the frame. The short ends were attached to rollers whose position could be adjusted by pegs. A series of trestles supported the panels in their frames, so that the embroiderers could reach both sides of the fabric as they pushed their needles in and out, one hand always on top and the other beneath. They did not unroll the whole length of the section they were working on, for this depended on the number of people available. A group of perhaps eight to ten women, who would have got to know each other very well in this long collaboration, worked on each section. They sat diagonally opposite one another on either side of the narrow linen, so that half the team would see the design upside down. When they had completed one area, they removed the lacing thread and wound the fabric on, putting a cloth over the areas not currently being sewn, to keep them pristine.

How the workshop tackled this complex task depended on the numbers employed, the working space available and the pressures of time. There might have been different teams embroidering the separate linen strips concurrently, possibly even in different premises, intending to join them together after they were all finished. Alternatively, there might have been one team that embroidered each strip consecutively; when one panel was almost completed, they joined it to the next one, then concealed the seam with the continuing flow of the embroidery.

One clue to what actually happened comes from the clumsy junction between the first and second sections, which were undoubtedly joined after both had been completed. There must have been a major row in the workshop when it became embarrassingly clear that the upper border of the first section was very slightly wider than that of the second section. Only

perceptible after the two strips had been sewn together, the discrepancy (even though just a few millimetres wide) was suddenly and glaringly obvious, but too far gone to be remedied. The designer and workshop head must have held an inquest, reviewed the sequence of production and insisted upon the absolute necessity of double-checking all measurements before sewing, because the problem did not recur. The subsequent junctions were immaculate, virtually imperceptible until you know where to look. Not until the late nineteenth century did anyone realise that the Tapestry was made from more than one piece of linen, and it was not until 1983 that an extra seam was found, proving there were nine, not eight, sections. At the first, flawed junction, the designer had deliberately left a clear space in the central zone where the two sections were to be joined, with covering-up embroidery only needed in the borders. But this did not work visually, for the uncharacteristically blank area imposed an awkward space in the otherwise crowded canvas. An even more blatant error was the inconsistency in the layout of the upper border. The first section displayed individual animals in separate compartments, while the second section initially had pairs in each compartment. Even more carelessly, an essential diagonal line had been omitted, so that the compartment incorporating the join actually contained three creatures – a single bird and then a pair of birds in the slightly narrower space.

Oops! Someone didn't check the border measurements before joining the first two sections together. This careless mistake was not repeated.

None of this happened again. Given the greater lengths of the first two pieces, the workshop may have planned the Tapestry to be made from five strips of linen of approximately equal dimensions of 14 metres each. But they found this too unwieldy, quite apart from the problems of the join. So they divided the three further intended strips into seven shorter ones, the last two of which may even represent the division of what was meant to be the final one, so that two teams could work side by side to save time. They paid more attention to the junctions, no longer leaving blank spaces but putting in details to conceal much of the seam, even though this meant that the designer must have had to modify some of his original designs. And they looked more carefully at the consistency of the border pairs. Nearing a junction, it now looked as if the team sewed up the seam, then went back and embroidered over the whole area. The most imperceptible seams are those most densely sewn over.[3]

The unity of style and craftsmanship was so great that it is not really possible to define the work of different hands or groups within the various sections, although close examination of the back in 1983 provided evidence of 'disparate skills; some areas are very skilfully done, showing a

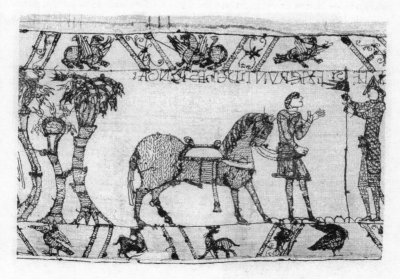

Seen from the back, this spider's web of woollen strands makes a fascinating contrast to the dense blocks of colour on the front of the linen.

great economy of stitching, while others are positively disordered'.[4] The techniques and quality of the central zone are consistent, suggesting a team or teams working under tight control and regular supervision. There are a very few discrepancies, mistakes and puzzles, but the only real hint of the embroiderers' individuality can be found in their treatment of the sprigs of foliage and diagonal lines that separate the repeating animal pairs. The master designer probably did not provide these, but allowed the teams a free hand and, as a result, there is considerable variety. In the first strip, the diagonal lines alternate directions to create a chevron pattern, and there is no consistency between the upper and lower borders (which of course were being sewn by different people). The chevrons in the upper margin enclose very small sprigs of foliage, some of which hang upside down, while the lower margin has none until almost at the join. A different team may have made the second section, which uses simple cruciform shapes. In the third, there are either fleshy, lobate scrolls, like those in contemporary manuscripts, or very delicate, linear forms. The last part of the third section and the whole of the fourth and fifth sections have elaborate motifs almost like candelabra, which no longer grow like plants from the baseline, but flow and scroll between the two diagonals. The sixth repeats some of the fleshy tendrils, while the seventh to ninth sections (upper border only, because the lower has been taken over by the battle) have more geometrical scrolls. So the embroiderers were able to speak a little. Working from the centre outwards, in order to maintain the tension of the fabric, they followed the designs that had been drawn on the surface, then crossed into the margins,

The embroiderers were probably free to choose different leafy motifs to give variety and richness to the borders. Here they frame one of the frequent griffins.

completed the bodies of confronted animals and birds, and were finally free to create leafy embellishments of their own choosing.

They did not sew the centre zone, borders and inscriptions in separate sessions, for the same wools pass from one category to the other. The terseness and cramped layout of the inscriptions were already part of the design, and did not arise because they were last to be stitched. But in two places only inscriptions appear in the upper border, which must represent changes to the original design, because this disrupts the otherwise careful sequences of paired animals. (One is the scene of Edward's deathbed, so cramped there was no room for lettering, so the inscription had to be inserted in the upper border, thereby eliminating one of a pair of griffins. The other is where William *orders the ships to be built*, but the towers of Rouen palace overflow into the border and the roofline pushes the inscription into the space above.)

In the same way the embroiderers decided the border foliage, they also had some autonomy over the colours of the captions. In the first four sections, all the letters are in dark blue-black, but in the later sections terracotta and green alternate. These variations could of course result from the simple necessity of using up surplus wool.

Embroidered threads give a remarkable sense of texture and relief to a flat woven fabric. The Tapestry's combination of wool on linen is technically known as crewel embroidery, after the 'curl' or effect of resilience in the twist of the wool, and the fascinating property of its main stitch, laidwork (also called couched stitch, laid-and-couched work or Bayeux stitch) is that it creates an almost three-dimensional world: the rippling, uneven surfaces and contrasting zones of colour combine the qualities of painting and sculpture. This effect comes from laying threads in close parallel lines, anchored by little 'couching' stitches at right-angles to the main direction, then outlining these patches of colour in stem stitch. Needlewomen devised this method in order to make the most of the expensive gold thread they used for the exquisite ecclesiastical embroideries of the earlier Anglo-Saxon period: instead of passing wastefully (because unseen) along the underside of the material, the strands remained almost entirely on the surface, only going through to the back for a tiny securing stitch at each end. Those who were accustomed to sew with gold now applied this striking, yet economical method to worsted on linen. It was also a fairly rapid way of covering large spaces – medieval craftspeople wasted nothing, neither time nor materials. The embroiderers worked in stem stitch to

Laidwork is an economical embroidery technique which keeps most of the threads on the visible surface of the fabric, secured by tiny stitches coming through from the back.

outline the patches of laidwork and for the detailed 'drawing' of facial features and other delicate lines, and also used chain stitch and split stitch.

The patron and workshop supplied linen and wool, but the embroiderers might have preferred to use their own needles and scissors. Such items never occurred in the later account books listing the expenses incurred by royal or ecclesiastical patrons, but in Anglo-Saxon cemeteries women were often buried with the tools of their work skills – little wooden boxes containing threads and scraps of fabric, together with shear-like scissors of iron, needles of bronze, copper or bone, and iron pins and the inevitable spindle-whorls. Needles for worsted sewing required quite a large eye, because it was not good to drag the thread through too narrow an aperture. It was also easier to work with fairly short threads because long needlefuls pulled at the material and caused the worsted to fray or knot. The embroiderers would have used thimbles (one for each hand when working on a frame), the more smoothly worn, the better. Those made of silver could mark the fabric if hands got sweaty, so they preferred ivory, or even little protective shields of leather. They probably kept these personal items in small baskets attached to the frame, as was the practice in the nineteenth century.

Sewing time was confined to the hours of daylight. The first written regulations, compiled by the Paris Guild of Embroiderers and Embroideresses in 1303, but enshrining long-established traditions of quality control, banned anyone from working by candlelight, but 'only as long as daylight lasts, for work done at night cannot be so well or skillfully done as that by day'.[5] The official working day lasted from sunrise to Vespers, the early

evening service (in the winter) or the later Compline (in the summer). Work was banned on Sundays and on the various feast and fast days. Another regulation specified the use of top-quality materials, and the guild fined those breaching these rules. To obtain maximum light, the workshop windows would almost certainly have been unglazed, for domestic window glass was a luxury in the eleventh century. Low winter temperatures would have slowed fingers down or even frozen them, so major projects like the Tapestry would have taken place between spring and autumn to benefit from better light and temperatures. Later records suggest that, in extreme weather, workshop windows were covered with canvas or linen, but this would drastically have cut down the light so essential for the tiny details.[6]

A medieval patron funded a project by providing all materials and equipment, and by paying the workforce. One major commission assembled a sewing team of 112 people to create three luxurious counterpanes for the first public appearance of Queen Philippa, wife of Edward III, following the birth of the heir to the throne in 1330. This was costed on daily rates of pay. There were two artist/designers in charge, the senior of whom earned 8¼ pence per day, almost twice as much as the 70 male embroiderers, who received 4½ pence. The men earned more than the 42 women, who received only 3¼ pence.[7] This represented long-established professional practice.

Making a textile frieze was not a new idea. What is remarkable about the Tapestry is not its creation, but its survival. The sources lie in a range of other hangings, embroidered and woven, for homes and churches, for keeping out draughts, and for giving walls colour and meaning from Bible stories or the legends of heroes. The Tapestry is unique because it has lived at least nine lives, yet is still intact. But there are fragments or descriptions of similar works.

In Viking-age Scandinavia, the rich tomb of Queen Asa, who was buried at Oseberg in Norway around AD 850, included silks imported from the eastern Mediterranean and locally made hangings. Like the Tapestry, these combined wool and linen, here woven (not embroidered) to create a sequence of battles fought by warriors bearing shields, swords and spears, on foot and on horseback; these perhaps narrated tales from Norse sagas. Proportions and layout, especially the patterned borders at top and bottom, are similar to those of the Tapestry, though even narrower, and the weaving technique achieves the same effect of patches of colour in

relief. Contemporary documents described medieval Scandinavian halls decorated with two sorts of hanging, *tjald* and *refil*: the *refil* had more elaborate scenes and was suspended at a higher level than the frieze-like *tjald*, which ran along the back of the benches placed against the walls. After the adoption of Christianity, the same sort of hangings decorated churches.

While the materials and nature of the Tapestry related to the whole Scandinavian culture that survived in Britain as part of Cnut's Danish legacy, its embroidery techniques reflected the equally powerful Anglo-Saxon heritage whose wealth so attracted the Normans. The poem *Beowulf* had an account of gold-embroidered wall-hangings in the great hall; their craftsmanship meant that such items were status symbols as potent as jewellery or fine metalwork, intended to impress by their expensive fabrics and superb workmanship. Every inch of an Anglo-Saxon textile might be covered with threads of silk or gold, set with precious or semi-precious stones, pearls, cameos, sequins. The aim was to create glittering illumination for the gloomy interiors of church or chamber, the light-bearing or shiny effects being admired as much as the craftsmanship. Being portable, they were part of the baggage of the mobile aristocracy, travelling with an entourage of retainers and followers, quickly creating an ambience of comfort and luxury in new surroundings. As such, they were welcomed as high-status gifts and instruments of diplomacy.

The Tapestry's first audience might have noted its relative restraint in comparison with such textiles. (Eighteenth-century scholars even believed it was unfinished because the plain linen background was not filled in.) But they would have appreciated how the design and the sewing masked the use of less ostentatious materials. The animal pairs in the borders copied the woven silks of the eastern Mediterranean, whose symmetrical patterns arose from the mechanical repetitions of the loom: it was infinitely more costly in time for these to be sewn by hand. The rippling, uneven surfaces of the laidwork recalled the relief effects of gem-embroidered silks.

Viewing the Tapestry now, in the crowded yet reverential ambience of a major tourist attraction, with our embedded history-book images of plunging horses and the arrow in the eye, its delicacy and subtlety still amaze. For the original audience, the impact must have been stunning. Many not only appreciated what was going on, but had taken part in the drama. So it flattered and involved those who could recognise themselves amongst the huge cast of characters. The epic, chivalric nature of the story

made the Tapestry most convincingly intended for display in one, or indeed several, of the great halls occupied by great men. The Norman settlement led to a wave of prestigious building projects, churches and abbeys, but more importantly castles, a new type of structure in England, which combined menace with status and enabled the Normans to make their presence seen as well as felt. The great hall was the focal point of the castle, where people came together for the administration of justice and the celebration of fellowship.

The dimensions of such a hall, as far as can be reconstructed, are eminently suitable for displaying the whole Tapestry, and the rectangular ground plan meant that viewers could appreciate the panoramic nature of the work, hung around all four walls, at first glance.[8] Its arrangement would depend upon the axis of the hall, whether the main door was placed in the long wall or the shorter one. In either case, the beginning and end, brought Edward and, very likely, William enthroned, together on either side of the entrance. The related image of the doomed Harold on his throne comes towards the middle of the Tapestry. So someone entering the hall could see Edward on his left, William on his right and Harold opposite. The contrast between the pale linen background, luminous against the stone walls of the hall, and the cast of densely coloured, slightly raised figures was deliberate: the Tapestry was designed to be seen in such a setting.

Spectators were drawn in further by the glances and gestures of the characters, who communicated not just with each other, but also with the audience. The designer's treatment of his actors' movements meant that they were speaking a visual language whose meaning was clear: indeed, once the sign language has been grasped, the inscriptions become almost superfluous. The first audiences could understand the characters' relationships with each other from their postures and specifically from the hands. The designer acquired some of these gestures from the classical world, like so many other elements of medieval art, through surviving manuscripts and sculptures, or copies dating from Charlemagne's ninth-century revival.

At Canterbury, late Antique illustrated books became a rich storehouse for eleventh-century scribes, and manuscripts copying illustrations from classical plays may link the set gestures of the Roman stage to those of the characters in the Tapestry.

The Roman gesture for grief or mourning was touching the face, just as Edith does with her veiled hand at Edward's deathbed. Hands with outstretched fingers clearly separated from the thumb indicated awe or respect

to a superior, such as the messenger who informs William of Harold's capture. A closed fist with only the little finger pointing was the sign of an eavesdropper, just like Harold's servant who escapes to tell William of his master's capture. A clenched hand with one finger raised represented supplication, Harold's way of seeking the hostages' release. One finger pointed at the person's own face meant surprise, as when Harold receives the news of the comet.

Another useful clue was that when someone pointed one finger at another character, this showed that it was the latter who was speaking: this works consistently throughout the Tapestry. When Harold and Guy confer, they point at one another, which is unnecessarily reinforced by the inscription *Where Harold and Guy are talking*. In the adjacent scene, the two messengers point at Guy to prove that he is refusing to hand over his captive. At Harold's oath-taking, all three witnesses point at him, evidence that he is speaking false words. On his return to England, he adopts the posture of apprehension, while the pointed fingers of Edward and an attendant indicate they are listening to his account of the fatal mission.

People in the Tapestry seldom touch one another. If they do, it is evidence of a significant relationship. When someone's finger makes contact with that of another, this means a sacred command has been given, for the motif originated in the gesture of Christ healing. Edward touches Harold twice in this way, to send him on his mission at the start of the story and to pass on the succession in the deathbed scene.[9]

Monasteries used another form of sign language, in which speaking with the hands was a way of obeying, yet subverting, the silences decreed by St Benedict in his rules for the conduct of his order. Monks and nuns developed a repertoire of simple signs first recorded in a mid-eleventh-century manuscript from Christ Church, Canterbury. By employing a range of agreed hand signals, inmates could communicate with one another on occasions when ordinary conversation was forbidden – in church, at mealtimes, and in the dormitory – creating that 'speechless pandemonium' so vividly conjectured by Eileen Power.[10] These movements indicated objects rather than ideas, nouns rather than verbs, but always reaffirmed the existence of fluent communication through the precise placing of hands and fingers.

Another source of gesture might have been the contemporary performance of plays. By the twelfth century, scenes from the Bible had already developed from liturgical dialogues inside the church to self-contained

playlets presented with the aid of costumes, properties and scenery. The first actors were monks. Given the classical heritage of so much monastic literature, this was another way of re-creating the antique theatre.

So the Tapestry spoke to its spectators in many ways, and their ears reinforced their eyes. In the great hall of the castle, feasting guests, whose acquired Norman-French sophistication had not obliterated their exuberant Viking ancestry, could have recalled their victory (or surrender, for those English nobles who had thrown in their lot with the Normans) with the aid of music and the voice. It was the role of the jongleur, a professional entertainer, to sing or chant long stories in verse, the *chansons de geste* that told of battles, brave deeds, divided loyalties and betrayal, perhaps accompanying himself on a stringed instrument. This was a popular form of courtly entertainment in eleventh-century France, and Wace's *Roman de Rou* (although written nearly a century later) claimed that the jongleur Taillefer inspired the Norman troops the night before Hastings. The song he sang, the *Chanson de Roland*, brought to life the Battle of Roncesvalles, fought between Christians and Muslims in Spain at the time of Charlemagne: it featured a traitor, Ganelon, who had forsworn an oath of loyalty to his lord. (There have even been confusing attempts to associate the *Chanson's* composer, Turold, with the individual named in the Tapestry.)[11]

So the Tapestry could have taken its place in this tradition of public entertainment, and its inscriptions may have given an added dimension as prompts or *aides-memoires* for the reciter. It has even been suggested that the diagonal framing lines in the borders were also there to provide rhythm, a form of musical notation or accent marks for the jongleur, as a basis for improvising from the too-brief inscriptions.

The designer and his team drew on a vast range of sources from different media. The narrative strip had firm classical roots in the carved friezes of the Roman world, like those on the columns of Trajan or Marcus Aurelius. Their images of warfare would have fascinated a travelling monk-artist or a potential patron. Harold was just one of many English visitors to Rome, and Odo aspired to remain there permanently as Pope.

The Tapestry included artistic conventions that had worked their way into early medieval art by many different routes. The equestrian statue gave a mounted emperor height and power; the Tapestry's images of William showed him frequently on horseback. Early Christian artists adapted the

strip format of the imperial columns to tell stories from the Old and New Testaments in manuscript, sometimes in a continuous frieze made out of sheets of parchment pasted together. Carolingian scribes inherited the format, and such manuscript rolls became a source for wall-paintings, brightly coloured and action-packed, like the Tapestry.

There were also more local sources for an elongated story, such as the fragment of a stone frieze from Winchester's Old Minister (where Cnut and Emma were buried) carved with a mail-clad warrior remarkably like those on the Tapestry. Remains of another stone frieze, from Canterbury, were decorated with animals and foliage motifs resembling those in the borders. This all implies a lively interaction between the makers of sculpture, manuscripts and textiles, and the borders themselves provide remarkable proof of the encyclopaedic repertoire of the designer.

Many of the animals are unsettling imports to a western, Christian world from an eastern culture of predatory beasts and monstrous hybrids. Theologians attempted to harness the dangerous powers of this threatening and devouring menagerie by turning them into exemplars of good or evil, as described in the popular illustrated bestiaries. A western artist was unlikely ever to have seen some of the more exotic border creatures, such as lions, camels and peacocks. Others were fantastic – winged horses, dragons, phoenixes – or hybrid monsters such as the centaur, griffin (half-

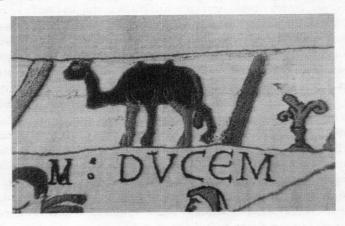

This camel in the border copies exotic animals on the luxurious woven silks that were imported from the east, but may also represent a Christian symbol from the Bestiary.

lion, half-eagle), amphisbaena (a dragon whose tail ends in the head of another beast) or senmurv (the sinister Persian dog-peacock). Such unnatural mixtures outraged men of the church because they subverted the natural order of things and symbolised forces of evil infiltrating the world that God had created.

Some seem to represent the creatures inspiring the famous tirade of the austere Cistercian, St Bernard of Clairvaux, in his attack on the dangerous and decadent (as he saw it) art of the wordly Benedictine order: 'What profit is there in these ridiculous monsters . . . to what purpose are those unclean apes, those fierce lions, those monstrous centaurs, those half-men, those striped tigers, those fighting knights, those hunters winding their horns?' Writing a generation or so after the Tapestry, at a time when intricate carvings of this unnatural world of writhing monsters and fierce beasts covered Romanesque churches and cloisters, Bernard could well have been describing the border animals, whose exotic nature and con-fronted symmetry originate in eastern textiles.

The West had been importing decorated silks for several hundred years. In Canterbury Cathedral, the little bags that held the precious seals which validated deeds and charters were sewn out of highly prized scraps of silk from Persia, Byzantium and Spain, whose main decoration was confronted pairs of powerful beasts, such as eagles and peacocks, griffins and lions. There was further momentum after the Normans occupied Sicily in 1061 and absorbed the local Islamic culture, including a woven silk industry that had assimilated the decorative arts and craft skills of the eastern Mediterranean. Such influences worked their way in northern monastic settings – in Durham Cathedral, for example, the tombs of St Cuthbert and Bishop William of St Carilef contained pieces of Islamic silk. This was how local designer-monks took the opportunity of incorporating exotic motifs into their own artistic repertoire.

Although they contributed to the overall ornamental scheme, some of the Tapestry animal pairs also had specific meanings illustrating the texts perused in monastic libraries. Classical lore and eastern legends fused with Christian allegory to create the Bestiary. This didactic catalogue of animals, both real and fantastic, described their appearance and behaviour, which were intended to serve as a mirror for man to contemplate his own moral conduct. Some of the border pairs fit easily into this format: lion, griffin, centaur, camel, ostrich, cock, peacock, wolf, dragon, amphisbaena – all had a role as symbols of virtue or vice. They could be masks for Christ (the

camel whose back is designed to bear burdens) or for the Devil (the dragon, with vainglorious crest and deceptively powerful tail).

So the Tapestry's animals had a dual source, in silks and in manuscripts. Other border scenes also came ultimately from classical literature, acting out the subversive anecdotes of Aesop's fables. These stories were immensely popular in the Middle Ages, and the illustrations often appeared alone because they were so well known. In the Tapestry, a sequence of nine scenes from Aesop appeared side by side in the lower border, as if the artist was copying them from a book that was to hand. These included the Fox who persuaded the Crow to sing and drop its piece of cheese (moral: never trust flatterers) and the Crane who pulled the bone from the Wolf's throat (do not expect gratitude for a good deed). Other lively scenes, perhaps copied from manuscripts such as calendars and herbals, followed this section, while more fables and anecdotes were scattered sporadically over the upper and lower borders. Among these intriguing little motifs are a knight fighting a bear, and a fox running off with a cockerel in its mouth, an early version of the Reynard epic.

There are also naked figures, male and female, blatantly displaying breasts or genitalia. These relate to a fairly widespread group of similarly exhibitionist nudes carved on many eleventh- and twelfth-century churches. Although modern commentators have interpreted these characters as snide comments on Anglo-Saxon morals, or alternatively as the symbolic rape of England by the Normans, the juxtaposition of moral and profane fitted easily into early medieval art and thought: such imagery, inspired perhaps by the frustrations of celibate patrons and designers, had the highly moral purpose of warning against the sin of lust. This was hardly the Tapestry's main theme, but the presence of the squatting nude man under the Ælfgyva scene, with its hint of impropriety between cleric and woman, does suggest that the spectators were meant to read the sub-text too.

So the unknown patron and anonymous designer came together, fusing art and ideology, drama and display. Building on familiar formats and established conventions, they produced a work that must have been a masterpiece in its own time. The later history of the Tapestry and its miraculous survival will show that its subsequent spectators, so far removed emotionally and chronologically from those early Anglo-Normans, would appreciate its originality and skill just as much as its first audiences, but in very different ways.

II

Lost and Found

4

The Missing Years

Despite the many claims, ranging from plausible to outlandish, about its sources and patronage, political nuances and secret agendas, the true history of the Tapestry only starts in 1476. In that year, an inventory of the treasury of the Cathedral Church of Notre-Dame of Bayeux made the first mention of a 'very long and narrow hanging of linen, embroidered with figures and inscriptions representing the Conquest of England, which is hung around the nave of the church on the Feast of Relics [1 July] and throughout the Octave [the eight days following a religious festival].'[1] This brief and bald account was in stark contrast to the lavish, even sensual descriptions of the other prized possessions: gem-encrusted gold- and silver-ware, altarpieces and reliquaries, crystal vases, sapphires, pearls, beryls, coral and enamel inlays, and the gold-embroidered, pearl-strewn chasubles, copes and tunics, each more magnificent than the next, culminating in the sumptuous mantles worn on their wedding day and donated by the wills of William and Matilda. These textiles were stored in the vestry among the huge selection of hangings, carpets, curtains, altar-frontals and other liturgical silks that decorated the choir on feast days. Yet the plain linen frieze of the Conquest was notable to the compilers only for its odd dimensions and lower status, for it was hung in the nave where ordinary people worshipped, rather than in the choir, which was reserved for the clergy. The inventory was drawn up at the command of the bishop, Louis d'Harcourt, who had the king's mandate to refurbish and refortify the town

of Bayeux following the devastating effects of recent wars and plague. Recording the priceless contents of his cathedral was just one way of taking control.

The fact that the Tapestry was being hung around the nave once a year in 1476 gives no clue to the antiquity of this custom, which was only one of many such rituals. (For example, in 1499 the chancellor donated a set of tapestries showing the life of the Virgin, to be hung annually to commemorate the Festival of the Conception and Annunciation, which he had just established. He also donated an oak chest in which to store them for the rest of the year, together with money for the costs of hanging up and taking down.)[2] When and how the Tapestry came to Bayeux is a mystery. It could have been at any time in the previous 400 years. Its political nature and distinctive dimensions suggest that it was meant for display at eye-level and in a secular context, a topical strip-cartoon for the court, not high up in a cathedral. In the early eighteenth century, members of the chapter and other local clerics could not even identify the subject matter of the hanging. Whoever commissioned the Tapestry, the most likely destination was William's court. In the early years of his reign, he moved between England and Normandy, but later he spent most time in Normandy, where he died in 1087. It did not feature in his will, or that of Matilda, although they both left embroideries and textiles to the various religious foundations they supported. His palace at Rouen, the capital city and seat of the Dukes of Normandy, certainly displayed hangings, for some were looted after his death, according to Orderic Vitalis and Wace.[3] So it is possible that the Tapestry began its life here.

One intriguing hint that it may have survived within this secular, aristocratic family setting is a poem that included a full description of a wall-hanging narrating the events of the Conquest which, the poet imaginatively claimed, decorated the chamber of Adela, Countess of Blois, youngest daughter of William and Matilda. Her birth, soon after her father's coronation in December 1066, made her a symbol of his victory. The poem *To the Countess Adela* was composed around 1100 by an ambitious cleric, Baudri, Abbot of Bourgeuil. He was in search of a secure niche; she was celebrated as a patroness of the arts. For a prolific writer, whose output included erotic verse in the style of Roman poets, saints' lives, histories and a travel journal, getting a post in a cultured court at the cutting edge of Romanesque humanism was far preferable to the strains of provincial monastic life, where, Baudri complained, his monks were more interested

in eating onions than in writing. His poem for Adela was a florid epic designed to flaunt classical rather than Christian scholarship by drawing heavily upon Ovid and Virgil, and comparing her to a goddess. He also flattered her by describing her famous father as superior to Xerxes, Hector and Achilles. Begging for admittance to her presence in order to sing her praises directly, Baudri demonstrated his appreciation of her learning and beauty with a lyrical account of the chamber housing this paragon – the constellations painted on her ceiling, the world map on the floor, the symbols of education carved on her bedstead, and the historical scenes (the Trojan War, the Old Testament) that tapestried her walls. To this great panorama of knowledge surrounding her, he added the final element, a minutely detailed account of a hanging embroidered with scenes of the Norman invasion and the Battle of Hastings, the triumph of a modern hero who was also her father.

Although Baudri's verses were flights of fancy, not meant to be taken literally (it is not even clear whether he had actually met Adela, let alone being familiar with her chamber), his description of the hanging had enough points in common with the Tapestry, beyond the historical outline of the Conquest that he could have gleaned from written sources, to suggest that he had actually seen the original. Some of the things he described, such as the crowd's horrified reaction to the comet, the practical details of trees being cut down and boats built, horses travelling in certain ships, and inscriptions to make everything clearer, are specific to the Tapestry. Only someone who had had the opportunity to study them at leisure and in a good light could have noted and recalled such details. Baudri then strategically edited the story to omit Harold's earlier adventures (inappropriate in a paean to William) and made it fit for a princess by turning it into a hanging woven from silk and gold and embellished with precious stones, like the luxury fabrics in the cathedral inventory or in the classical texts he quoted. Such a close viewing would have been impossible if the Tapestry was already being hung high in the nave at Bayeux for just nine days a year. Baudri's abbey at Bourgueil was in the Loire district, as was Adela's seat at Blois, but he had travelled in Normandy and was not a shy recluse, but a worldly writer.

Had he seen the original in the great hall at Rouen? Its tale of the triumph of the Duke of Normandy shed glory not only on the Conqueror's illustrious daughter, but also on his less-than-glorious son and successor, Robert Curthose, the current occupant of the palace of Rouen, a city that featured as prominently in the Tapestry as Bayeux.[4]

If the Tapestry was indeed in Rouen, then the many threats to Bayeux and the cathedral would not have endangered it. There was terrible destruction in 1106 when William's youngest son, King Henry I of England, invaded Normandy, marched on Bayeux, which was held in Duke Robert's name, and burned the town down when it refused to surrender. The cathedral suffered further damage from fire in 1159 (although the 1476 inventory proved how many precious and delicate contents had managed to survive over the years). One suggestion – that the disgraced Odo concealed the Tapestry in the crypt, which was then sealed up by a later building phase and not unblocked until 1412 – does not take account of the potentially destructive effects of damp and mould during such a long incarceration.[5] A better reason to suspect the hanging was not there at all in the twelfth century is the fact that Wace, a canon of the cathedral, did not follow its particular version of events, or even mention it in his history of the Normans, the *Roman de Rou,* that William's grandson, Henry II, commissioned in the 1160s. As a stylish writer and a historian with a royal patron, Wace would surely have made some reference to its craftsmanship and significance, as Baudri had done, if he had ever seen it. Bayeux continued to pass between English and French hands, and in 1335 was again reduced to ashes by another English king, Edward III.

There is a tantalising reference to a hanging of the Conquest at Dijon, the seat of the Dukes of Burgundy, in a 1420 inventory of their treasures. This mentions 'a large good quality tapestry, without gold, the history of Duke William of Normandy, how he conquered England'.[6] The important phrase is 'without gold', something unusual enough to deserve comment. And the subject, relatively recent history with little apparent relevance to Burgundy, in contrast to the standard biblical or mythological themes of other hangings, is also striking. Normandy and Burgundy were linked in the late fourteenth century when Philip the Bold, Duke of Burgundy, took control of Normandy and Paris as part of the defence of France during the minority of his nephew, the boy-king. If the duke had lived in the palace at Rouen, the capital of his new command, he might have come across the quaint old sewn history of William and carried it off to his own palace at Dijon. The parallels with a duke who became a king were apt, for this duke became the virtual ruler of France during the king's bouts of madness. A generation of bloodthirsty disputes between Burgundy and France followed, culminating in a Burgundian-English alliance against the French monarchy.

Supposing the Tapestry was in Dijon during these years, how did it get to Bayeux in time to be catalogued in the cathedral's 1476 inventory? One link might be the theologian Nicolas de Clamanges, who in the 1420s became cantor of the cathedral, second in rank to the dean. Clamanges was a distinguished but controversial man who moved in exalted circles, having taught at the University of Paris and served as secretary to two popes in a period of schism and crisis. This inspired him to write angry treatises calling for reform, one of which he dedicated to Philip the Good, who had become Duke of Burgundy in 1419 and who commissioned the Dijon inventory that included the Conquest tapestry. Might the well-connected Clamanges have visited Dijon, recognised the significance of the hanging the duke had inherited from his grandfather, and negotiated its acquisition for Bayeux Cathedral? Philip had hundreds of tapestries and hangings: more than 30 on show in his great hall alone, and so many altogether that he had to build a special warehouse to store them.[7] The Bayeux inventory listed a number of items donated by senior members of the chapter, a custom expected of the office. If Clamanges presented the Tapestry to the cathedral, he could have appointed a relevant festival – that of the sacred relics of the saints upon whom Harold swore his oath – as the most appropriate occasion for its annual display.

Firm evidence of the Tapestry's remarkable powers of survival came during the civil and religious wars that caused havoc in the sixteenth century, when French Calvinists ransacked the buildings associated with Catholicism and looted or destroyed the precious remains of the past. In Bayeux, on Sunday, 10 May 1562, a mob stormed the cathedral, bringing the Mass to a brutal end, firing pistols, then slicing off the ears or even cutting the throats of the officiating clergy, smashing all the relics and treasures they could lay hands on, and desecrating the ancient tombs. The bishop painfully recorded this orgy of violence in the report he compiled of the destruction, which reads like a terrible inversion of the 1476 inventory. This time he listed all the treasures destroyed or stolen, the gold and silver chalices and candelabra, treasures presented by Odo himself, reliquary caskets set with precious stones, the silver-covered wooden crown of thorns 5 metres high, hidden stores of jewelled crucifixes. There were also gold-embroidered vestments of velvet and silk hangings, which the chapter unsuccessfully tried to conceal in one of the canons' houses and in the town hall, from where the rioters looted one of the tapestries that normally hung in the choir. The bishop mournfully described how they smashed the

stained-glass windows, destroyed the organ, and broke into the chests and cupboards that stored vestments and other prized possessions.

Yet the Tapestry escaped. As the month was May, it was not on display in the nave, but was stored away somewhere. According to eighteenth-century accounts, it was traditionally kept in a chest in the south-transept side-chapel dedicated to St Thomas à Becket. Perhaps the mob simply overlooked it there, for they certainly tore open the chests that were in the vestry. (A cedarwood chest, dated to the late thirteenth or early fourteenth century, is exhibited in the cathedral Treasury today, as the one that housed the Tapestry. Its dimensions are suitable, if the hanging was laid in concertina folds, and so is the wood: cedar was appreciated from ancient times for its moth-repelling properties, and cedarwood balls and shavings are still a popular natural way of protecting clothes in drawers and wardrobes.)

Peace was eventually restored, and the old rituals resumed. In a building almost totally devoid of decoration and texture, hanging the Tapestry in the nave brought a welcome splash of colour.

5

Antiquarian Approaches

The annual display of the Tapestry carried on unquestioned for decades. The clergy and the citizens of Bayeux barely appreciated its subject matter, but the brief airing evaporated any residual damp, and a gentle shaking helped shed those threatening larvae that had resisted the winter cold or pungent cedar fumes. It was not until the early eighteenth century that this peaceful routine came under the scrutiny of sharp new eyes.

During the seventeenth century, the discipline of history was challenged by a rival way of studying the past, which used completely different techniques. Its practitioners called themselves 'antiquaries', those who studied ancient remains, the material relics of cultures and beliefs. This called for new methods – no longer just reading books or manuscripts, but collecting the physical evidence and trying to order and understand it, from coins to cooking pots, tombs to textiles. And these pioneers might enquire into times other than Greek or Roman, and areas that went beyond the mediterranean world. Historians, however, looked sceptically on what they considered to be an inferior branch of their ancient and honourable profession: the gulf between words and things was deep.

In France, as in England, there was a new interest in the Middle Ages, no longer an awkward pre-Renaissance hiatus with 'barbarous' art and architecture, but a period worth studying in its own right. Medieval abbeys and chateaux came into focus, engraved and published in folios containing copious views and plans, and images of historical costume, armour and

jewellery. Statuettes, metalwork, ivories and stained-glass panels became objects of scholarship or status symbols for display. Learned men toured the provinces, made sketches, wrote up their notes and communicated their findings to colleagues in the local or national societies springing up to feed these passions. Most prestigious of all was the *Académie des inscriptions et belles-lettres*. Founded with the official backing of Louis XIV in 1701, its aim was to enhance the prestige of the crown by studying the monuments of France and the remains of her famous sons. Membership was restricted to 40 *savants*, so election was a mark of real distinction. Meetings were on Tuesdays and Fridays in a room in the Louvre overlooking the Cour Carrée, where members delivered scholarly discourses on a range of subjects, some still classical, but gradually widening to include topics that reflected the developing shifts in interest.

Personally nominated for membership by the Sun King was Nicolas-Joseph Foucault, regional governor of Normandy and committed antiquary. This eminent public servant had already come across the Tapestry in Bayeux Cathedral, although no one knew it at the time. Born into a family of loyal courtiers (his father was a trusted colleague of chief minister Colbert, his mother came from a dynasty of royal architects), Foucault managed to combine the evolving interest in national antiquities with a distinguished career as an administrator. He served for more than 30 years as a regional *intendant*, or governor, and achieved the most desirable (because of its proximity to Paris) posting, Normandy, in 1689. Normandy needed a safe pair of hands at this time because England's 'Glorious Revolution' of 1688 had sparked fears of a similar uprising across the Channel. (Foucault even had to entertain the ex-king James II, in flight after the Battle of the Boyne, and noted that James seemed quite unconcerned about the dreadful state of his affairs.)[1]

During his 15-year stint, Foucault was based at Caen, the regional capital, but he had to travel all over the province. This was ideal for antiquarian research. According to his eulogist, 'it often happened that he learned from the inhabitants of a town or province that they possessed remarkable monuments to which they paid no attention or had not the least idea about'.[2] One influential contact was the Bishop of Bayeux, whom Foucault saw frequently. So it was very likely that the bishop, aware of the governor's interest in historical remains, told him about the cathedral's ancient relic, the hanging in the nave. When Foucault first saw it, probably some time in the 1690s, he realised that he was in the presence of

something quite remarkable: the Tapestry was not just a quaint old piece of embroidery, but a monument whose recording and publication could enhance his reputation as a patriot and scholar. His immediate reaction was to commission a drawing to record this vital but fragile work. Although gentlemen were trained how to draw, it is more likely, given the scale of the task and his own busy life, that Foucault commissioned a professional artist. How this was organised can only be guessed. If the draughtsman tackled it in the brief July window of opportunity, he would have had to perch on a ladder in the nave to make preliminary drawings which he later scaled up and coloured; or perhaps the Tapestry was later unfurled for him in a better light. (It would take a subsequent, highly experienced artist three six-week seasons with permanent access to produce a full-size copy.) Foucault's commission evidently suffered from lack of time because only the first part of the story, from the meeting between Edward and Harold up to Harold's rescue from Guy of Ponthieu, was completed.[3]

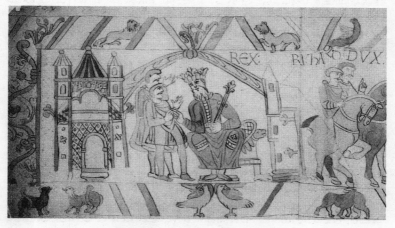

The start of Foucault's drawing. The source of the original baffled French scholars until Montfaucon tracked it down to Bayeux Cathedral in 1728.

Then the drawing abruptly stopped. Perhaps the artist intended to wait until the following July, and then the competing demands on Foucault's time meant that he never organised the next phase. In 1705, he returned to Paris, where, smooth and elegant, he chaired some meetings of the *Académie*, presiding like a king or the head of a family. When he died in

71

1721 at the age of 78, the *Académie's* Secretary, Claude Gros de Boze, delivered a public eulogy that praised Foucault's distinguished career and antiquarian pursuits. He then began the task of going through the books and manuscripts that Foucault had left the *Académie*, together with a substantial collection of antiquities – coins, medallions and statuettes – housed in eight glass-fronted cabinets. De Boze was puzzled to find a huge coloured drawing, 10 metres long and more than 40 centimetres high, unidentified by any written explanation beyond its own inscriptions which clearly named Edward, Harold, Guy and William. He showed it to Antoine Lancelot, a fellow-*Académicien* who specialised in French medieval history. Familiar with the documentary sources, Lancelot at once realised that the events were immediately prior to the Norman invasion. Although the drawing's origin remained a mystery, Lancelot decided to show it to the members of the *Académie* in the hope that someone might recognise it. On 21 July 1724, he delivered a paper called '*L'explication d'un monument de Guillaume le Conquérant*' (part of a season whose other topics included centaurs, the siege of Troy, Roman towns, the Chinese language, the silk trade, and the origins of chess). Foucault's drawing was displayed at the lecture, and the audience inspected it with great interest.

Lancelot's paper proved he was familiar with Norman and English chroniclers of the period, and he pointed out when the drawing confirmed or contradicted them. His perceptive conclusion on the date – 'the more I have studied this monument, the more I am convinced that it dates from the time of, or very soon after, the events represented' – is that of all serious scholars today. Realising that the drawing was incomplete, he correctly predicted that the rest would show the whole story of the Conquest, but confessed that he did not even know what he was studying or where it had come from. It might be 'a bas-relief, a sculpture around the choir of a church, round a tomb, on a frieze, a fresco, a design for windows or even a tapestry'. And he wondered if it might have come from St-Étienne at Caen, which William founded but the Calvinists destroyed in 1562 – perhaps carvings from the Conqueror's tomb, or even stained-glass windows. As his own researches in Caen had drawn a blank, the source of the drawing had, for the moment, to remain an unsolved puzzle.[4]

His talk led to the rediscovery of the Tapestry. Among the audience was someone who had at his fingertips a better range of contacts; it took a man of the church, a member of the widespread network of the Benedictine order, to put the right questions to the right people, those who might be the

guardians of the enigmatic monument – his fellow-monks. Father Bernard de Montfaucon was no ordinary cleric, but by the 1720s was a scholar of international reputation. The younger son of an aristocrat, he had intended to follow a military career (he campaigned for two years, and even fought a duel of honour), but promised at the deathbed of a beloved captain to give it all up. Instead he became a Benedictine in the vigorous reforming faction called the 'Congregation de Saint-Maur', whose mission was to divide their time between prayer and research – this could incorporate antiquities and ecclesiastical history. Montfaucon's intellectual quest took him to Rome, where he began to appreciate how material remains could bring past societies to life, and wrote a completely new sort of book, *Antiquity Explained*, whose ten volumes and 1,120 plates demonstrated every aspect of daily life in classical times. When it was published in 1719, the Duc d'Orléans, regent for the boy-king Louis XV, was so impressed that he nominated Montfaucon to the *Académie*.

Here Montfaucon's avid mind assimilated the members' forays into post-classical subjects, and he planned a more daring project, a history of France using its artistic remains as evidence equivalent to written sources. Spurred on by Lancelot's revelation of the fragment of 'a monument of William the Conqueror', in 1725 Montfaucon issued the prospectus for an ambitious series that would encompass the Monuments of Kings and Princes, then of the Church, of Daily Life, of Warfare and of Tombs. He was then aged 69, completing a long supplement to *Antiquity Explained* and continuing work on a 13-volume edition of the writings of St John Chrysostom. His new project would cover the still unfamiliar period of the Middle Ages, from the first Merovingian kings down to Henry IV, ancestor of Louis XV. The text would be in French, but he would provide an entire Latin translation in footnotes so that foreigners could read it too. It was tactical to obtain royal patronage, so Montfaucon angled for an invitation to Versailles, where he showed the young Louis XV illustrations of some significant works that would appear in the first volume, and the king graciously permitted the work to be dedicated to him.

Montfaucon might have shown the king Foucault's drawing, for he was consulting the latter's archives (now in the Royal Library) for general background on Normandy, and had decided to include the original, whatever it was, in his book: he could not omit evidence of one of the most crucial events in the history of the monarchy.

As a meticulous scholar, Montfaucon was reluctant to discuss a work that

was still unidentified, so he determined to track it down. He knew that Foucault had toured Normandy, and that Lancelot had failed to find the fragment in Caen. But Montfaucon had better connections and the logical mind of a detective. In an appeal for subscribers and as a request for information, he had already sent the prospectus to all the Benedictine houses in France, whose collaboration was essential. In September 1728, he wrote (as Lancelot had already done) to a fellow-Benedictine, the Prior of St-Étienne at Caen, Romaine La Londe, who again denied any knowledge of the source of the drawing, having only served in the district for five years. Because the second request came from someone of Montfaucon's reputation, La Londe now took the trouble to approach longer-serving colleagues. The most senior was an elderly monk, Dom Nicolas Flays, who had been at St-Etienne for nearly 30 years. Flays recollected having seen something of the sort in Bayeux Cathedral. So La Londe forwarded Montfaucon's letter to the head of the Benedictine community in Bayeux, Mathurin Larcher, the Prior of St-Vigor. Larcher approached the cathedral chapter himself, and one of the canons confirmed that they hung 'tapestries' around the nave 'from the feast of St-Jean to the end of July' in order 'to air them during the nice weather'. This was a very different reason from the 1476 account of the Tapestry being hung to celebrate the Feast of Relics, and suggested that the chapter no longer understood the subject matter or the tradition. Larcher passed this interesting news to La Londe, and confirmed that he had once noticed the hanging himself, but as he had not known it was anything to do with the Conqueror, he had not bothered to look at it in detail. He now recalled that it was extremely flimsy, the colours were still quite bright, it was very narrow, and went all the way round the nave. Local tradition apparently attributed it to the hand of Queen Matilda herself. So this must the source of Montfaucon's mystery drawing.[5]

La Londe sent this to Montfaucon in Paris, adding in a covering note that Larcher had advised him informally there was little point in asking to see the work now it was off display, as this would have to be approved by the whole chapter, who were not then on the best of terms with the St-Vigor Benedictine community. (There had been a disagreement with the recently deceased bishop over the controversial Papal Bull *Unigenitus*, which condemned support for the more evangelical approach that some Benedictines favoured.) However, the installation of a new bishop was imminent and a letter to the influential Abbé de Pibrac might do the trick. If this hinted at a defensive and uncharitable spirit amongst the chapter,

there was worse to come, for La Londe, who was in regular correspondence with Montfaucon over other local monuments, told him on 22 October: 'you could easily, from what I have learned, arrange to have the tapestries sent to you from Bayeux Cathedral, where they are folded up and entrusted to a man who doesn't take much care of them'.[6] Fortunately, Montfaucon was too busy writing to take up this offer, otherwise the Tapestry might have suffered a risky journey to Paris.

Early the next year, Larcher gained access to the Tapestry, which its carefree guardian unfolded for him so that he could copy all the inscriptions for the *Monuments*. Now he had discovered the original, Montfaucon was faced with a dilemma: he wanted to broadcast his discovery and put it in the right place in his book, but as the Tapestry was so much longer than the portion already illustrated, waiting for the additional 60 metres to be drawn would seriously delay his publication schedule. So he decided to give a preliminary account of the Tapestry in the first volume, where it belonged chronologically, illustrated by an engraving of the Foucault drawing. Full discussion and illustrations of the rest would follow in Volume II.

Montfaucon commissioned the artist Antoine Benoit to go to Bayeux and draw the 'new' portion. Benoit's genteel behaviour impressed the Prior of St-Vigor: 'I was charmed by his modesty, his conduct and his manners. I saw with pleasure everything he had drawn, and may I add that we must hope the engravers are precise and put nothing else in to embellish the ornament, as they so often do.' However, either Montfaucon had failed to give the admirable Benoit an adequate advance, or perhaps he had spent it rashly, for another of the *Monuments'* researchers, a monk from Bec, reported that he had to loan Benoit 15 livres in order for him to return to Paris without embarrassment.[7]

Volume I of *The Monuments of the French Monarchy* came out in July 1729, starting with a fulsome dedication to Louis XV, whose engraved equestrian image graced the title page as the ultimate personification of the subject. Montfaucon's prologue suggested that he was still struggling to make an unfamiliar period palatable and defended his use of material culture as historical evidence, which no one had ever tackled on such a scale: 'however crude these monuments may be, they provide information about many things we would not otherwise have discovered. The different styles of sculpture and various types of painting must be included as historical facts.'[8] He was the first person to use 'Gothic' as an adjective indicating simply medieval construction rather than a term of abuse.

After a long haul through the Merovingian, Carolingian and Capetian kings, Montfaucon at last reached the Tapestry, which he called '*Un Monument d'Harold*', on page 371. He acknowledged the help of de Boze and Lancelot, but drew particular notice to his own success in tracking it down 'after much research'. As he had not inspected the original, he based his account of it on the engravings, which had transformed Foucault's fairly truthful copy into the ornate and illusionistic style of the day in order to provide it with the depth and solidity that an eighteenth-century viewer, brought up to appreciate Renaissance art, found lacking in medieval design. Trying to correct its 'primitive' nature, the engraver turned the two-dimensional, stylised narrative into a flowing, sculptured frieze that might have come from a Greek temple or Roman arch. The poised, elegant figures looked as if they were modelled in deep relief, the carefully pleated drapery of their garments indicating rounded forms beneath, and an imaginary source of light cast shadows on the ground. The horses flared their nostrils and pawed the ground, the little lions in the borders had the manes and muzzles of real animals and, instead of the simple parallel lines representing the sea, these rolling waves had breaking crests.

Montfaucon's text similarly laid emphasis on the classical heritage, as part of his general attempt to downplay the strangeness of medieval art. The short cloaks, he claimed, were what 'the ancients' called the *chlamys*; the colon sign that separated some of the words resembled Athenian script of the fifth century BC; trees separated the scenes in the manner of Roman triumphal columns or bas-reliefs; the drinking horns recalled Xenophon's description of Persian ones; the lookout in the tree was wearing a Phrygian cap. Montfaucon agreed that Edward had named William as his successor, but provocatively commented that the union between England and Normandy that commenced here 'caused infinite evils to the kingdom of France over the next four centuries'.

Volume II followed just a year later. Montfaucon started with a long discussion of the Tapestry, unapologetically announcing that the whole subject was of such interest that he was returning to it, and repeated how he had personally traced it to Bayeux. He defined it as the Trajan's Column of barbarian history, then explained the whole story, relating the scenes to contemporary historical texts. Citing more classical parallels was a determined attempt to offset his obvious unease at 'the gross and barbarous style' of the original, revealed all too clearly by the new, rather more accurate engravings, which showed how Benoit had re-created the

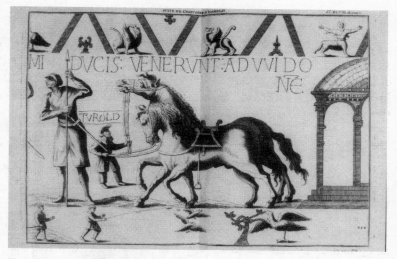

How Montfaucon's engravers tried to add detail, light and shade to make this 'gross and barbarous style' more acceptable to eighteenth-century taste.

true spirit of the embroidery, its vigour and angularity, distorted figures and exaggerated gestures. Montfaucon announced that the work was unfinished, not merely lacking an end but an entire background: 'the spaces that we see between the details are nothing but plain canvas which has not yet been filled in . . . those who started this did not have time to complete it'.[9] He added that local tradition attributed it to Queen Matilda, and so its uncompleted state was due to her death. Although made in a period when the arts were at their nadir, it was still as important as a written document for the history it told.

In Bayeux, the bishop and chapter were beginning to grasp the significance of their ancient treasure. They examined its physical condition and decided to strengthen it by attaching a lining and a backing strip, which numbered the 58 scenes in green ink, based on a list of inscriptions compiled by the bishop's secretary.[10] Lancelot reported these facts in a second paper to the *Académie*, in which he claimed that the work was known locally as the *Toilette du Duc Guillaume*, although he believed Matilda made it as a gift for Odo's cathedral: this would account for the prominence that the narrative gave to the bishop. The *Académie* published Lancelot's first paper in 1729 and the second in 1732, but in each case he was overshadowed by Montfaucon's volumes.

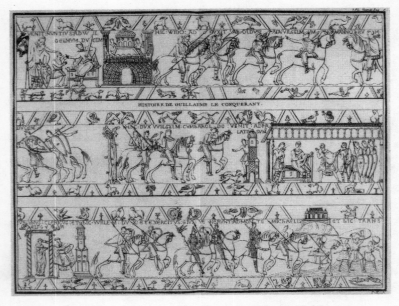

A portion of the drawing that Benoit made in 1729, as published in Montfaucon's *Monuments*.

Both authors inspired one M. de la Roque, who had toured Normandy in 1714 and was now belatedly publishing his travel letters in the journal *Mercure de France*, to update his own reactions. He agreed with Montfaucon that this 'instructive and most curious monument' was unfinished, and he assumed that the background was meant to be filled in with gold or silver threads. However, his artistic response was more sophisticated: 'Considering the times in which it was made, the figures left almost nothing to desire except a very little correction of the drawing.' Everybody knew that Matilda had made it to immortalise her husband's deeds.[11]

The publisher Gaudouin of Paris produced the first five volumes of *The Monuments of the French Monarchy* with a speed that matched Montfaucon's amazing industry, issuing one a year from 1729 to 1733. Montfaucon started work on his next series, *The Monuments of the Church* (while also continuing to edit theological texts), and was about to submit the former for publication when he died suddenly in December 1741, just two days after

cheerfully announcing to fellow-*Académiciens* that in another 13 years he would be 100. His books and his reputation survived, and his revelation of a monument that brought the Norman Conquest alive reached the English antiquarians who subscribed to the *Monuments*. The work was of such interest that an English translation appeared in 1750. Well before then, however, one man's views on the Tapestry would have disastrous consequences for Anglo-French relations.

6

The English Claim

William Stukeley, scholar and eccentric, is best known today as the man who discovered the Druids. Contemporaries jokingly called him the 'Arch-Druid' because of his obsession with the history and beliefs of the Celtic priesthood. His involvement with the Tapestry is less appreciated, yet he was the first English person to write about it, and his dogmatic views triggered an unlovely row between French and English experts, which dragged on for the next 150 years. Stukeley was not even especially interested in the Middle Ages, although as a man of wide-ranging antiquarian pursuits, even by the magpie standards of the time, he became aware of the hanging and its significance through the pages of Montfaucon. Stukeley's opinions had weight in this area only because of his reputation in other fields. Born in 1687, he studied at Cambridge University with the intention of becoming a doctor, but discovered his real love was studying antiquities in the countryside. His pioneering records of Stonehenge and Avebury, assumed since the seventeenth century to be 'temples of the Druids', laid the foundations of modern field archaeology. In 1721, a respected scholar, he became the first secretary of the Society of Antiquaries of London, a body whose function was to 'cultivate the knowledge of the antiquities of England'.

In contrast to the royal-backed, precisely regulated Paris *Académie*, the London Society was a laid-back body where eccentric amateurs mingled happily with professionals. Informally created at the start of the eighteenth

century 'by a few gentlemen, well-wishers to Antiquities that used to meet once a week and drink a pint of wine at a tavern for conversation', there was one main criterion for Fellowship: 'care was taken that the candidate should hold the rank of a gentleman'.[1] Fellows were the clergy, the younger sons of the aristocracy, wealthy (often obsessive) collectors, academics and other serious practitioners, all drawn together by a fascination for the relics of the past. They held weekly meetings, initially in the Mitre Tavern in Fleet Street – quite a contrast to the Louvre. Here Fellows delivered exhaustive papers on their particular enthusiasms, which were later published in the Society's journal, *Archaeologia*. The sirs, reverends and doctors spoke on topics such as 'A Very Ancient Greek Manuscript on Papyrus', 'Some Broken Lids of Stone Coffins Discovered in Cambridge' and even 'A Letter from the Pope to Mary Queen of Scots'. Their antiquarianism was all-embracing. For Stukeley, it was an opportunity to meet kindred spirits and become a part of London's clubland, which wonderfully combined conviviality with intellectual pursuits. In 1726, however, he abandoned his medical career in order to enter the church. His aim was to reconcile Christian doctrine with that of its alleged pre-

William Stukeley, the first English scholar to write about the Tapestry. He upset the French by claiming it as 'the noblest monument of English antiquity abroad.'

decessors, the Druids. It was a tribute to the 'broad church' of the day that the Archbishop of Canterbury was content to ordain Stukeley on these grounds. From then on, the once-careful field archaeologist developed strange theories about the Druids: for him, the direct descendants of Abraham, ancient Phoenicians who came to Britain soon after the Flood and whose doctrines predicted the Trinity.

Stukeley brought the Tapestry to general attention when he compared it to some mysterious underground carvings that he, the all-purpose expert, had been asked to date. In the summer of 1742, builders in Royston, Hertfordshire came across a man-made cave, a circular underground chamber whose chalk walls were carved in low relief with strange figures and signs. Stukeley hurried to the site (a bewigged, frock-coated, white-trimmed clergyman in his middle fifties, having to insert himself through an almost vertical shaft, then down a wooden ladder to reach the ground nearly 5 metres below) and sketched the curious panorama. He published this a few months later in a pamphlet that firmly associated the structure and its decoration with a real local person, the Lady Roisia de Vere, whose grandfather had come over with the Conqueror. The cave, he announced, was the private hermitage or oratory of this virtuous widow, which she 'adorned with imagery of crucifixes, saints, martyrs and historical pieces . . . the work is done with little art but in the taste of the age'. He dated these carvings to the 1170s or 1180s and identified, among various 'historical' figures, members of her family, and Henry II defeating the treacherous French king Louis VII. He drew a patriotic moral: 'we see the faithless, inconstant and perfidious disposition of the French and their behaviour towards us. We see, then as now, the genius of the English, brave, generous, honest and true. We may learn hence never to trust the bonne foy of that nation, but expect they will still be the same, as from the beginning.'[2]

In 1744 a Norfolk clergyman, the Reverend Charles Parkin, challenged Stukeley's confident attribution of the figures to the later twelfth century in a pamphlet that claimed a much later date and was sarcastic about these 'mean and low' carvings, inferior to anything being produced on the continent. An enraged Stukeley revisited the cave, then wrote a thunderous denunciation, A Defence of Lady Roisia de Vere against the calumny of Mr Parkin.[3] ('This, good reader, is the method wherewith some people treat mankind.') He made the Tapestry the keystone of his defence, admitting that he had not seen the original but was using Montfaucon's Monuments, that 'pompous book dedicated to the French king'. The hanging was the

most important thing in it because it showed 'the usages of the times' and contained much information not provided in the histories. He linked its simple style with his enemy's reaction to the carvings: 'had Mr Parkin ever seen this work, he would have sneered at it . . . he that pretends to be an antiquarian should know the value of things does not altogether go in proportion to their fineness'.

This was standard sparring, but some of the assertions that followed became embedded in Tapestry studies and led to grave misunderstandings. While apparently accepting Montfaucon's assertion that the people of Bayeux believed the work to have been made by William's Queen, Stukeley created ambiguity by choosing to call this lady Maud. He then linked its style to that of the carvings: 'the truth is, the drawing in this famous piece of tapestry is so extremely like that of our Lady Roisia's . . . that at first sight we discern they are of a country, and age, and hand, very little distant and different'.

At a stroke, he had reclaimed the Bayeux monument as English, even though it was in the hands of the perfidious French. 'As Maud's tapestry is indubitably the noblest monument of English antiquity abroad, so is our Royston cave the noblest monument of English antiquity that is in England.' And he confused matters further by associating Lady Roisia with another royal Maud/Matilda, the mother of Henry II, whom he hailed as patron of Roisia's family. Stukeley refuted Parkin's arguments for a date of around 1400 point by point, citing examples of head-dresses and weapons and even claiming to have spotted an inscription in the cave whose letters were 'exactly of the same manner as those in the Tapestry'.

As an antiquarian used to taking the longer view of things (the Flood, Bronze Age monuments, the Romans) and not a medievalist, which no one properly was at that time, Stukeley saw no inconsistency in dating the carvings to the 1180s, yet confirming this on the evidence of something made in the lifetime of the Conqueror. What was a mere 100 years or so? He referred throughout to 'Queen Maud's Tapestry', probably a deliberate blurring of the boundaries in his mercurial brain between the earlier and later Mauds, in order to confirm his case for a twelfth-century date for the carvings. If the closely related Tapestry was English and made by a queen, then she easily metamorphosed into the later Maud/Matilda, grand-daughter of the Conqueror, Empress of Germany, claimant to the English throne and mother of the Plantagenets.

This second pamphlet was nearly three times as long as the first. It should

have been published in 1745, but Stukeley reluctantly postponed it to 1746 because of the Jacobite Rising. Parkin defended himself in 1748 with *A Reply to the Peevish, Weak and Malevolent Objections brought by Dr Stukeley*, but mercifully Stukeley did not respond as he was off on another wild-goose chase, hoaxed by a forged medieval transcription of a Roman itinerary and map of Britain. He would have loved the modern interpretations of the Royston cave, which connect it with the Knights Templar, the Holy Grail, Freemasons, sacred geometry, the snake goddess and all sorts of pagan cults definitely involving Druids. Could the carvings even be another eighteenth-century hoax aimed at the gullible antiquary?

Stukeley's association of the Tapestry with a 'Maud' validated its later date, and therefore greater Englishness, in the eyes of historians compiling a new sort of work, a broad, synthetic survey of English history. The first to cite the Tapestry as a documentary source was the Scottish philosopher David Hume, who included it in his *History of England*, the controversial work that turned him from unsuccessful scholar into bestselling author. By reviewing the origins of the English constitution, he provided a new interpretation of the past, which challenged the prevailing Whig view of Parliament as the long-standing defender of ancient English liberties. Hume wrote his *History* in reverse chronological order, starting with the Stuarts, then going back to the Tudors. It was his final volume, *The History of England from the Invasions of Julius Caesar to the Accession of Henry II* (1762), that dealt with the earliest period and considered the Tapestry's evidence. He had not even intended to cover the Middle Ages, but was persuaded by a massive advance of £1,400 from his publisher, the first he had received and the largest that had ever been made. (This would later enable him to turn down the request for a sequel, on the grounds that 'I'm too old, too fat, too lazy and too rich.')[4] Tackling the barbarous and obscure medieval period was his way of proving that the Norman Conquest and the introduction of feudal law represented a complete break with everything that had gone before.

Concerning William's entitlement to the throne, Hume claimed that the Tapestry contradicted those writers (he meant William of Malmesbury) who suggested that Harold's voyage to France was only a fishing expedition from which he was blown off course: 'Harold is represented as taking his leave from King Edward in execution of some commission, and mounting his vessel with a great train. The design of redeeming his brother and nephew, who were hostages, is the most likely cause that can be assigned.' Hume, who had spent

three years in France in the 1730s, had obviously seen the drawings published by Lancelot or Montfaucon of 'this very curious and authentic monument lately discovered'. But he had obviously not checked his facts when he described it as 'a tapestry preserved in the ducal palace of Rouen', and gave the fatal attribution that suggested he had been reading Stukeley as well: the work was 'supposed to have been wrought by the order of the wife to the Emperor'. Since French writers firmly ascribed the Tapestry to the wife of the Conqueror, Hume was deliberately challenging received opinion by proposing this later candidate, whose life he described in some detail, referring to her, however, as Matilda rather than Stukeley's 'Maud'.[5]

Hume's *History of England* went down well in France, where he spent the next three years as private secretary to the British ambassador in Paris and was fêted as a celebrity. The royal family warmly approved of his apparent restatement of the rights of kings, and the ten-year-old Duc de Berry personally congratulated him. This boy became King Louis XVI, and cited the book in his fatally unsuccessful self-defence when the National Convention put him on trial in 1792.

The Tapestry continued to intrigue antiquarians as well. Smart Lethieullier, nicknamed 'the Antiquary of Essex', was a Fellow of the Society of Antiquaries, and his life revolved around the collection and study of antiquities. From 1732 to 1733 he lived in Paris and became intimate with the group of *Académiciens* rediscovering the Middle Ages: Lancelot, de Boze and Montfaucon. Fascinated by their work on the Tapestry, he wrote a full account of it in English, closely based on Lancelot's second article. He probably intended this for publication in *Archaeologia*, to which he was a regular contributor, but seems never to have submitted it. When he died in 1760, his books and manuscripts were sold at auction, and the article came into the hands of another Fellow, Andrew Ducarel, who incorporated it into his own book, *Anglo-Norman Antiquities* (1767).

Ducarel might have acquired his antiquarian interests from Sir Hans Sloane, the royal physician whose collections would form the core of the British Museum, who cared for him when he lost an eye in an accident at Eton. The book was patriotic in the extreme, for Ducarel was determined to prove that Normandy's fine remains were entirely due to English influence, a point of view that deeply annoyed the French when the book was translated 50 years later. Although he acknowledged the help of many French scholars, he expressed fears for the future of their monuments

because of age, fragility and the negligence of their owners. He listed all the English elements that underpinned Norman art and design and claimed that the Normans were a conservative, not an innovative, race: the seal of William the Conqueror copied that of Edward the Confessor; Odo was Earl of Kent as much as Bishop of Bayeux; the two countries were so closely linked that it was essential to know Normandy's heritage in order to understand English history.

Ducarel described Bayeux as a run-down little town with unattractive buildings, its economic decline caused by the prosperity of its neighbour Caen (although he was impressed by the poorhouse, which at least kept the beggars and their disgusting infirmities off the streets, and by the lace-making school for pauper children). Even the cathedral was disappointing, starkly decorated, with mediocre paintings and stained glass. He had viewed the famous embroidery with difficulty, after the cathedral's own priests had tried to deny its existence. Only after his explanation that it was the one connected with William the Conqueror that was hung round the nave once a year did they grudgingly unlock it from the chest in the side-chapel and allow him to inspect it. Either the chapter had lost interest in it again, a generation after Montfaucon, or perhaps someone was being deliberately unhelpful to a patronising Englishman who demanded to see the *Toilette du Duc Guillaume* instead of asking for it by its now 'correct' name, the *Toile St-Jean*. Ducarel got his own back by noting its coarse execution, clumsy colouring and poor standard of drawing, which he compared to that of Chinese and Japanese porcelain. But he conceded that it was an excellent historical record, full details of which followed in his late friend Lethieullier's admirable description, which was included as an appendix. The accompanying plates were courtesy of the Duc de Nivernois, French ambassador in London, without whose intervention with the *Académie* Ducarel would have been unable to include the engraving of the work first published in Lancelot's 1732 article. Owing entirely to the duke's pressure, the previously obdurate body somehow found itself able to run off another 400 sets for the book.

Although the antiquarian Ducarel spelt out the Matilda/Odo/Bayeux connection clearly, a second historian chose to ignore it. George Lyttelton's main intention in writing his *History of King Henry II and the Age in which he lived* (1767) was to redress the damage he thought Hume had done. The first Baron Lyttelton was a devout Whig, recently retired after a lifetime in politics, and his book was the product of years of research. Without naming

Hume, he launched an attack on modern historians: 'there is no branch of literature in which the English have less excelled though surely there is none which deserves more to be cultivated by a free people'. More specifically, he criticised Hume's acceptance of the Tapestry's evidence when it contradicted those of the chroniclers, asserting that the 'truth' should be deduced from texts and not from objects: 'I apprehend that this boasted monument was rather formed upon vulgar tradition than history and deserves no credit against the testimony of a good contemporary writer. Tapestry-makers are bad historians.' Lyttelton also revealed his contempt for antiquarians in general, as well as for the most famous French one: 'their common fault is to lay more stress on any discovery of this kind than is really due to it, as Montfaucon seems to have done in the present instance'. To further undermine the Tapestry's authority, he thought it safe to ignore the local tradition associating it with William's Matilda, and he mocked Montfaucon's claim that it was 'an authentic evidence of the truth of the facts therein represented'. Paradoxically, he ended up agreeing with Hume: 'from several reasons I should judge that it was rather made by the order of the Empress Matilda, who resided long in Normandy, and that the makers of it were not accurate with regard to the facts'. His next work, *History of England from the earliest dawn of authentic record,* suggested that despite his hostility to antiquarians, Lyttelton was a fan of Stukeley, for he not only called William's wife and William's granddaughter 'Maud', but glowingly described the Druids as 'a public blessing to the nation which they inhabited'.[6]

Although these historians gave the Tapestry a later date, most antiquarians seemed content with the earlier one, with one exception. Sir Daines Barrington, polymath and one-time vice-president of the Society of Antiquaries, unconvincingly cited it to prove his theory that the longbow originated in the time of Edward III: 'in the Bayeux Tapestry indeed, the Normans are represented as drawing the long bow, but it is conceived that this arras was woven many centuries after the Norman invasion, and when that weapon was used in France.' (This was the period when the arch-medievalist Horace Walpole scathingly referred to the Society of Antiquaries as 'foolish' and to *Archaeologia* as 'old women's logic.')[7] Another vice-president was Sir Joseph Ayloffe, keeper of the State Paper Office of the Treasury, and a man so eminent that he was called 'the English Montfaucon'. In 1770, he delivered a paper on the royal patronage of national monuments and their role as historical documents, in which he

speculated on the making of the Tapestry. He accepted that it had been produced 'by command of Queen Matilda, represented in painting, and afterwards, by her own hands and the assistance of the ladies of her court, worked in arras and presented to the Cathedral of Bayeux.'[8]

Ayloffe's piece culminated in a description of the Anglo-French rapport demonstrated in a painting of the Field of the Cloth of Gold. But the Tapestry was having the opposite effect. Despite its rediscovery by the French, English scholars were now very involved, even proprietorial. For example, Joseph Strutt cited it as evidence in *A Complete View of the Dress Habits of the People of England* (1796), with its closest parallels in English manuscripts. If all these antiquarians and historians had been able to predict its adventures in the turbulent years that lay ahead for France, they would have been campaigning for its return to England.

III

Revolutionaries and Romantics

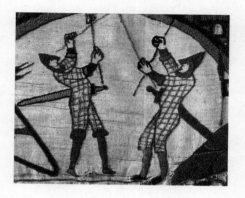

7

Escaping the Terror

Surviving the French Revolution proved once more that Fate (if that term includes the intervention of individuals) was looking after the Tapestry. For many revolutionaries, destroying the art of the past was one of many ways to wipe out old history in order to make a better future. On 2 November 1789 the National Assembly passed a decree nationalising all church property, followed by one on 20 March 1790 that suppressed the abbeys. These measures had the drastic effects intended. The state seized the contents of churches, abbeys and monasteries, and the abandoned buildings were looted and allowed to fall into disrepair. Monks had the choice of reverting to secular status, in return for a meagre pension, or of internment. Many fled to England, where they found shelter with religious communities or Catholic families. Some of the treasures they had cared for became the responsibility of a new Monuments Commission, which removed them for safety to local or Parisian depots; there was much debate over whether these objects should be displayed to the public or sold off.

What happened to the Tapestry has to be pieced together from contradictory reports and a few surviving letters. Safe in its chest in the corner of a dark side-chapel and not glittering ostentatiously beside an altar, its monarchical (though not blatantly religious) subject matter was not immediately provocative. Other monuments were not so lucky. Most of the statues and paintings in the cathedral and parish churches of Bayeux were destroyed. There was a later rumour that a priest concealed and preserved

the Tapestry, or, more specifically, that the bishop hid its chest in his study.[1] But a report compiled in 1838 told a much more exciting story, based apparently on the eye-witness account of the man who saved it from the mob.

In 1792, the National Assembly issued a general call to arms in response to an anticipated English invasion. In Bayeux, volunteers rushed to join the 6th Calvados Battalion, requisitioning carts and wagons to carry their equipment. Needing canvas covers, someone remembered the long old hanging stored in the cathedral. The municipal council granted permission for its use, and the Tapestry was seized and placed on a wagon. But M. Lambert Léonard-Leforestier, local administrator and commissioner of police, sprang to the rescue by running to his office and dashing off an order to retrieve it. Armed with this, he managed to exchange the precious relic for sheets of sacking. After that, he kept the Tapestry in his own office as a precaution.*

Its next narrow escape was during the celebration of a civic festival – for the rituals of the state had simply replaced those of the church – in February 1794. According to one concerned citizen, 'a zeal more enthusiastic than enlightened was about to cut up this work, regarded as having no merit beyond being a strip of linen to be used for the first purpose which came to hand'.[2] In this case, it would mean it being chopped into bits to decorate a float carrying the Genius of the Arts in a procession round the town. This time it was rescued by the newly appointed art commissioners for the Bayeux district, members of a national network set up to preserve the monuments of France. In Paris, the National Convention established a new Commission for Arts (replacing the former Monuments Commission) under the enlightened presidency of Deputy Jean-Baptiste Mathieu, who called, in an impassioned speech to the Convention on 18 September 1793, for the preservation of works of the past. As an essential measure, he determined to establish a register of works of national importance worthy of protection in Paris, an enlightened approach to the care of art in dangerous times. He encouraged local groups to rescue, inventory and provide safe-storage depots for vulnerable possessions formerly cared for in churches and chateaux. Their only worry was that the best might be removed for display in the new art museum being established in the former palace of the Louvre.

*Leforestier's portrait hangs in gratitude in the entrance hall of the Centre Guillaume le Conquérant, Bayeux, today.

In Bayeux, the four commissioners for the district were respected local men: J.-B. Delauney was a lawyer who had served on the States-General in Paris; the secretary, Le Brisoys-Surmont, was another lawyer; Bouisset became a professor of literature at Caen; and Moisson de Vaux was a botanist. One of their first priorities was the Tapestry. They wrote to the mayor and municipal council on 27 April 1794 (a date they gave as 8 floreal II, in accordance with the new Republican calendar that began in September 1792, following the king's execution; this became year I, and the 20-day 'months' received neutral names based on the weather, rather than on pagan gods). This letter formally requested them to hand it over to the commissioners, who would place it for its own safety in one of the designated art depots: 'As our duty, Citizen, involves the investigation of everything which can contribute to public education and the protection of such monuments, we cannot overlook an object whose possession under the *ancien régime* honoured our community. The conquest of England by the Normans has contributed to our national pride. Today, when all parts of the Republic have the same interest in glory, this record of the Conquest has become public property which can evoke memories that are also relevant to our current circumstances . . . we hereby request you to tell us where the tapestry is kept.'[3]

The mayor ignored this, as he did two further letters. So the commissioners instructed the administrative director of the Bayeux district to bring official pressure to bear. This worked, and the commissioners were permitted to retrieve the Tapestry from the sacristy of the former cathedral, now redesignated a Temple of Reason. Anxious to defuse its royal connections, they continued to stress the historical significance of the English defeat, the information provided about costume, and general evidence of how the arts had developed since that barbarous period.

Local commissioners had to submit their inventories to the Paris Commission for Arts, but the first list from the Bayeux team evoked Citizen Mathieu's displeasure when he found no mention of the Tapestry. In August he wrote to the district director expressing his concern that it was not included. The Bayeux commissioners' response was that they intended to list it in the inventory of 'antiquities' they were still compiling, being more appropriate than in that of paintings and sculptures already submitted. They apologised humbly if this had been an incorrect decision and expressed their deepest gratitude for the confidence he had already placed in them.

At the same time they wrote to the district director, defensively stating their reasons for classing the Tapestry as a monument of antiquity, rather than an *objet d'art*, and reminded him that they had reported their progress in tracking it down, together with an ivory casket from the cathedral, in their previous letters. And they claimed full credit for saving it from imminent destruction at the civic festival. Being a commissioner of art was a delicate business: having to keep the balance between Paris and Bayeux resulted in mistrust from both sides. But perhaps there was another reason, a reluctance to bring their precious relic to the attention of the Paris authorities at all, for fear of it being snatched from Bayeux to join other national treasures liberated from their former owners – the royal family, the aristocracy and the church. The Louvre, prestigious site of the new state art collections, opened to the public in August 1793 to exhibit just such possessions.

On 26 August, the commissioners examined the Tapestry, gave it a good dusting, then compared its actual state with the version published by Montfaucon. They duly reported to the district director that, in accordance with the decree of the Commission, they had now listed the Tapestry and the ivory casket on their inventory of portable antiquities. A few weeks later, the commissioners submitted this to the 'public instruction' section of the National Convention with a covering letter that reminded members of that body of 'the monuments which our researches and our care have rescued from neglect and destruction'. The Tapestry had faced so many threats over the years, from the Calvinist sacking of 1562, when 'an irruption of vandals destroyed almost all the contents of the cathedral', down to its recent narrow escape. But it was now safe in one of the national depots, waiting to become 'the chief ornament of the local museum'.[4]

Their evident fear of losing the Tapestry was unfounded. Mathieu, perhaps aware that he had ruffled local feathers, reassured the Bayeux team that their care was so excellent it did not need to be looked after in Paris. It was also likely that the incomprehensible style of the Tapestry and its simple materials, quite apart from its awkward subject and size, saved it from being swallowed up by the acquisitive Louvre. The commissioners had successfully kept it in Bayeux for the moment. But they were powerless to resist the next demand.

8

The Dictator's Display

Napoleon Bonaparte, the 'Corsican tyrant', as the English liked to call him, appreciated the function of propaganda from the very beginning of his career. It was then no surprise that, in 1803, after the military hero had become the head of state, he harnessed the Tapestry to his campaign to glorify France, and himself. Just as William had advanced from duke to king, so Napoleon's meteoric rise would culminate in his coronation as emperor the following year. His ambitions were wide-ranging and often contradictory, but one constant aim was to demonstrate the domination of France over its ancient enemy and too-close neighbour, England. While his ultimate role models were those legendary imperial unifiers of Europe, Julius Caesar and Charlemagne, Napoleon started by projecting himself as the reincarnation of William the Conqueror, successful invader of England. He justified his policy of aggression with a series of accusations: the English were fermenting revolt, plotting his assassination, publishing lies and attacking without provocation. The Bayeux Tapestry proved William's triumph: Napoleon selected it to predict his own.

The Treaty of Amiens, signed in March 1802 to bring an end to hostilities between England and France, resulted in a period of official peace when relations were uneasy, but tolerable. In August that year, Napoleon consolidated his powers when he became First Consul for life, with the right to appoint his own successor. He offered reconciliation to those exiled by the Revolution. The clergy were able to resume their former

95

positions and reintroduce the old liturgical rituals. He encouraged émigrés to return to France, with all their rights and some of their possessions restored; they obtained posts in the new regime while their wives attended the gaudy new court surrounding Mme Bonaparte in the Palace of the Tuileries and their daughters were married off to Napoleon's most trusted officers. But a renewal of conflict with England threatened at the beginning of 1803 when, like a set of collapsing dominoes, the interlocking impositions of the Treaty of Amiens were breached. Napoleon planned to reoccupy Egypt, just vacated by the English, and England retaliated by impounding French commercial shipping. The French interpreted this as piracy and a deliberate flouting of the Treaty. In May 1803, England began to wage 'preventative' war on France by blockading French ports and re-occupying ceded territories in the West Indies. Napoleon decided that the only way to avenge this deceitful behaviour and challenge the enemy's maritime supremacy was through invasion: he would become the new William the Conqueror.

He sent the army to reoccupy the huge camp at Boulogne, which he had put up in 1798 as a base, even then, for the planned invasion of England (or, some feared, as a launching pad for an attack on the rest of Europe). Such a massive concentration of troops, professionals and conscripts, called the 'Army of England' and apparently poised to cross the Straits of Dover, naturally aroused much alarm because it far outnumbered the British army. But given his enemy's superior naval strength, Napoleon had to tackle the logistics of getting his troops across the Channel. Should he first clear it of the British navy by gunboats and armed barges, and then transport the army on merchant ships? But there were not nearly enough of these to carry almost 170,000 men. How had this been achieved before? What had William the Conqueror done? Napoleon was formidably self-educated. He devoured relevant works of literature and history and was well aware of past precedents, like the 1066 invasion fleet. His knowledge of the Tapestry (or that of his advisers) would have come from Montfaucon's *Monuments*, whose engravings made it clear that boat-building was the first stage of William's campaign. Napoleon ordered an ambitious programme in Boulogne and the other Channel ports, with the goal of constructing 700 transport barges in just a few months: William had built and assembled a fleet of at least 800 ships between January and July 1066.[1]

The inevitable delay and the huge costs needed some pre-emptive publicity. In that autumn of 1803, Paris was hosting a brilliant social season,

a time when Napoleon commanded balls and parties, the theatres revived after the restrictions of the Republic, and public art exhibitions demonstrated the cultural aims of the new regime and its glorious leader. Yet it was an uneasy, dazzling society of new loyalties, unthinkable alliances and post-war gaiety combined with pre-war jitters, a time when people were concerned, as one observer noted, solely with new titles, fine clothes, elaborate liveries and expensive carriages. It was to this frivolous yet submissive world that Napoleon brought the Tapestry, snatched from its safe depot under the care of the Bayeux authorities to provide a blatantly public demonstration of how France had once conquered England and would do so again under the right leader – all to justify his inauguration of a risky and very expensive enterprise.

Napoleon and his entourage visited Boulogne for ten days in November 1803 to review the troops and inspect the uncertain progress of the boat-building. His thoughts turned to the use of historical parallels for the invasion, to help him retain popular support. On 12 November, immediately after his return, the government-backed daily newspaper *Le Moniteur* reported two significant discoveries at Boulogne. After an account of military manoeuvres, the paper noted that while digging the camp foundations, someone had excavated a battle axe 'which had probably belonged to the Roman army which invaded England'; and, on the very site of Napoleon's tent, 'some medals of William the Conqueror' had been found. The article pointed out that these were remarkable coincidences, especially when it was recalled that Napoleon himself had discovered a cameo of Julius Caesar in Egypt. This story (which also stressed how comfortable the soldiers were in their camp, said to be the size of a city) had obviously been planted on Napoleon's instructions.[2] It must now have occurred to him that the Tapestry itself could provide an even more effective analogy with the Conqueror. But there was no chance of swaying a mass audience as long as it was hidden away in Bayeux.

Less than a week after the *Moniteur* report, the sub-prefect for the Bayeux district was probably surprised and shocked to receive two letters. One, written on 19 November, was from his immediate superior, Charles Caffarelli, Caen-based prefect of the Calvados region. This informed him bluntly that the Minister of the Interior, their ultimate boss, intended the Tapestry 'on which Matilda embroidered the military exploits of her husband' to be exhibited for several days in the Musée Napoléon in Paris. Refusing was not an option: this exhibition would be of 'enormous interest

to all those who supported national glory'. The Tapestry would be safely returned to the people of Calvados, but must now be sent immediately to Citizen Vivant Denon, director of the Museum. The second letter came from Paris, and was from Denon himself: on the Minister of the Interior's orders, Matilda's tapestry must come to Paris without delay because the government attached the highest importance to its exhibition in the Museum. It could either be put on the *diligence* (a huge stagecoach with a separate compartment for luggage) or entrusted to a baggage-wagon, as long as it got to him promptly. In an irresistible two-pronged attack, the Minister of the Interior also commanded the Bayeux art commissioners to secure the support of the mayor and council. The commissioners' subsequent letter to the mayor stressed, a little uneasily, that this was not their decision, that they had already protected it effectively and had resisted previous attempts to take it, but 'public interest' now demanded its temporary move to the Musée Napoléon. They had no doubt it would come back safely.[3]

Portrait of Dominique Vivant Denon, by Robert Lefèvre (1808). As Napoleon's Director-General of Museums, he organised the 1803 exhibition of the Tapestry in the Louvre.

Whatever risks the journey entailed, it was clear that these were over-ruled by the need to obey Napoleon immediately. He intended to exhibit the Tapestry in the most prestigious venue in Paris, run by one of his smoothest operators, the Director-General of Museums. Napoleon's

appointment of Dominique Vivant Denon (who had strategically changed his name from the more aristocratic De Non during the Terror) to such a new and prestigious post was completely unexpected. A man best known as a dandy and a libertine seemed little qualified to become, at the age of 55, a full-time public servant and virtual Arts Minister, responsible for implementing Napoleon's barely formulated plans for grandiose display and self-promotion. Yet Denon had already lived many lives: smooth courtier to Louis XV; diplomat and spy in St Petersburg and Naples; author of travel books and of a decadent novella that Balzac and the Goncourts would admire; Italian-trained painter and engraver, whose works included the popular *L'Oeuvre Priapique*, erotic etchings inspired by ancient Pompeian pornography; dilettante and lover of many women.

Denon gained the First Consul's respect when, already middle-aged, he served with the team of official artists on the gruelling Egyptian campaign of 1798, about which he wrote and illustrated a bestselling book sensibly dedicated to Napoleon. Published in 1802, this work set the fashion for Egyptian style and design, and Napoleon rewarded him with the post of Director-General of Museums at a salary of 12,000 francs a year. Responsible for developing the Louvre and other collections too (French Monuments, the French School at Versailles, the Government Galleries, artistic control at the Gobelins and Sèvres works), Denon was also Director of Coins and Medals, with the crucial role of promoting approved images of Napoleon, many designed by Denon himself. In addition, he served as private artistic adviser to Napoleon and Josephine. An amateur in the fullest sense of the word, Denon had the opportunity to flaunt all the qualities that attracted the culturally insecure First Consul – the ability to harness pre-Revolutionary court stylishness, good taste and rococo refinement for Napoleon's grand schemes: the First Consul was learning to use people just as much as he used objects.

The location of the exhibition could not have been more significant. The Revolution turned the former Palace of the Louvre into the people's museum, accessible to the general public for three days out of the new ten-day week (the other days were reserved for more important people and for artists). Still partly colonised by studios and craft workshops, it now also housed the spoils of Napoleon's campaigns – classical sculptures from Italy, such as the *Laocoön* and the *Apollo Belvedere* looted from the Vatican collection; sphinxes, statues and columns from Egypt; oil paintings by all the Old Masters of Europe; plus countless books and medals. By

displaying all these treasures, Napoleon sought to make Paris the new Rome. Meanwhile, the great exhibition space needed a new name to express its eminence. Calling it the 'Musée Napoléon' was the spontaneous expression of the nation's will, according to the Second Consul, Cambacères, who authorised Denon to carve these words on the frieze over the main entrance. Napoleon, whose idea it probably was, did not demur.

Barely a week after Denon's letter to Bayeux, two newspapers published identical articles announcing the Tapestry's arrival in Paris, intended to whet the public's appetite for the forthcoming exhibition. The equivalent of a modern press release, this was probably composed at Napoleon's instigation and was easy to place, for his government controlled both papers, the broadsheet *Le Moniteur* and the tabloid *Journal de Paris*. It appeared in the *Journal* on 28 November and in the 'Beaux-Arts' column of *Le Moniteur* on 29 November, a day when the front page led with the paper's London correspondent describing the growing tension: all foreigners were instructed to report to magistrates, George III was reviewing parades of volunteers in Hyde Park, and there was general doom and gloom and fears of tax rises to pay for the forthcoming French war.

The article began by stating that William's queen Matilda and her ladies had embroidered the Tapestry, and summarised the events depicted. Then it made the purpose of the exhibition absolutely clear: 'this fragile monument seems to have been miraculously preserved in Bayeux in order to reveal to our eyes what is going on today; it could not more directly predict the same outcome to the same enterprise'. And it went over the top by claiming that Napoleon was not merely as brave a hero as William the Conqueror, but would be more successful because he was even more masterful. The writer compared the Tapestry itself to a range of antique sources that complimented Napoleon further by reminding readers of the earlier places he had conquered – 'the long friezes of an Egyptian king sculpted on a temple at Thebes', the columns of Trajan and Marcus Aurelius, the murals of Pompeii – and also helped offset the fact, reluctantly conceded, that the Tapestry's figure drawing was rather stiff. However, it was still a great achievement, noble and chivalrous in concept and execution, and a monument to the virtuous medieval women who had stitched it.

Then there was a summary of the guide to the exhibition hastily prepared by the Museum's distinguished Curator of Antiquities, Professor Ennio Quirino Visconti, a classical scholar who had been tipped for the director-

ship, but was not sufficiently French. Born in Rome to an archaeologist father (the city's Prefect of Antiquities and successor to the German Hellenophile J.-J. Winckelmann), Visconti helped compile the first catalogue of the Vatican Museum, and became curator of the Capitoline Museum in the 1780s. This was when he got to know Denon, who was spending a couple of years in Rome keeping a low profile after being sacked from the French Embassy at Naples for illicit dealing in antiquities and works of art. (His collection almost rivalled that of the British Representative at Naples, Sir William Hamilton, whose lovely wife Emma often modelled for Denon.) In 1798, Visconti, a devout Republican, entered politics when he was elected one of the consuls of the short-lived Roman Republic, but had to escape to Paris as a political exile after the Austrian army invaded Italy. Here he was welcomed for his Republicanism as well as his scholarship. When Napoleon put Denon in charge of museums, Denon made his old friend the curator of the Louvre's classical antiquities, his task to arrange the display of the hundreds of works Napoleon had acquired in Italy.

Visconti was unlikely to have appreciated the Tapestry very much. An example of primitive, medieval, northern European art in a low-status medium normally associated with women could hardly compare with the idealised beauty and perfect human form of the Greek marble sculptures he studied. But Denon needed an experienced and respected scholar to compile at very short notice an important and politically sensitive publication. Visconti did not even have time to view the original, but simply used Montfaucon's *Monuments*, where the first set of engravings, quite apart from the text, already placed the Tapestry firmly within the classical context that Visconti understood. Critics trying to interpret unfamiliar art styles to a potentially hostile public always relate them to something that is familiar, and this is exactly what Visconti did. His dilemma with the Tapestry was that its message was crucial, but its art was crude. Almost certainly guided by the wily Denon, he provided a scene-by-scene account of the action, which made suitable references to current affairs and also cleverly related them to the great empires of the past.

The Tapestry, he declared, showed one of the greatest and most successful expeditions ever undertaken. Experts agreed that it was contemporary with the events depicted, and attributed the design to Matilda herself. Here came the first classical parallel, for he compared her to Homer's Helen of Troy, who, with needle on canvas, painted the deeds of the Greeks and

Trojans. Then Visconti made one antique comparison after another, considerably extending Montfaucon's range: the rows of overlapping shields on the sides of the ships were like those on wall-paintings at Herculaneum; headwear resembled Phrygian caps; the Hand of God could be seen on medallions of Constantine; the bodies of the dead were like those of defeated Amazons on a Greek sarcophagus. He thus elevated the Tapestry to the highest category of art. But Denon and Visconti were also capable of providing an up-to-date slant. The most politically nuanced part of their text had no classical analogies, but threatened modern detractors: regardless of the timidity of some advisers, William's invasion plan was the correct course because he would not allow English treachery to go unpunished.

Visconti's guidebook, *Notice historique sur la tapisserie brodée par la reine Mathilde, épouse de Guillaume le Conquérant*, had 20 pages of text, plus all the inscriptions in Latin and in French. There were two editions: a basic unillustrated one, and a more lavish version (which cost 12 francs) with gold-edged pages and seven fold-out colour plates copied from Montfaucon and rather inaccurately hand-coloured with dominating tones of pink and pale blue.

Denon displayed the Tapestry in one of the finest spaces of the old palace, the very long Galerie d'Apollon designed by Lebrun, architect of the Hall of Mirrors at Versailles. In the eighteenth century this gallery had served only as a storehouse for the king's paintings, but was opened to the public in 1797 to exhibit more than 400 drawings from the former royal collections, including works by Raphael, Michelangelo and Poussin. The Tapestry now temporarily replaced these masterpieces.[4]

Napoleon himself viewed the exhibition when it opened on Monday, 5 December. He was escorted by Denon and Visconti, two smooth operators whose careers depended upon the favour of this unpredictable little man, who had no confidence at all in his own appreciation of the visual arts and needed sophisticated mentors. Napoleon's opinion of the artistic merit of the Tapestry was almost certainly unenthusiastic. His taste was for the monumental and the idealised, the trophies and triumphs of the ancient and classical world, not for the small-scale, intricate details of medieval life, which only dedicated antiquarians could appreciate. Indeed, contemporaries noted that he was hardly ever moved by the impact of the fine arts and, when escorted round the Louvre, would not linger in front of any exhibit unless something was pointed out to him. Prudish in his response to naked classical statues, he would have noted with disgust the nudes in the borders.

However, it was an excellent press opportunity. The *Journal de Paris* reported the visit the next day, making just the right points and generating further political mileage: on viewing the scene where the newly enthroned Harold sees the comet predict his doom, Napoleon asked how many months this was before his defeat in battle. Visconti and Denon replied, wrongly, two and a half to three months (it was really six), and Napoleon contemplated the image with renewed interest. In case any reader was still missing the point, a footnote spelled it out, repeating a news item from an English correspondent in Dover published a few days earlier: 'we saw, yesterday evening, towards nine, a fine meteor which rose in the south west and travelled north; it had a tail around 30 *aunes** long. The whole country was lit up for many miles around, and when it disappeared there was a strong smell of sulphur.' That evening, reported the loyal correspondent, Napoleon went to the Opéra: 'the more he appears in public, the more applause he attracts'.

The following day, 7 December, *Le Moniteur* gave up most of its first two pages to the Tapestry, printing an abbreviated but in many parts word-by-word version of Visconti's guidebook. For a daily newspaper whose front page normally carried reports from foreign correspondents in the capitals of Europe in a time of conflict, this was exceptionally privileged treatment. The exhibition also attracted the attention of reviewers beyond Paris. In Frankfurt, for example, a city where French influence was strong, the twice-weekly newspaper *Rheinländische Zeitung*, which safely concentrated on cultural rather than political matters (although, being written in German, it managed to avoid the detailed scrutiny of Napoleon's censors), mentioned the exhibition on 14 December. The article repeated the press release, with its points about the Tapestry's miraculous survival, its antique simplicity and the domestic virtues of medieval needlewomen. But, the writer obediently pointed out, its real significance was for the present day, because of the parallels between William the Conqueror and Napoleon.[5]

As well as promoting patriotism, the exhibition generated some scrutiny of the Tapestry's style and subject matter. Egyptologist François Sallier wrote a scholarly piece for *Le Moniteur* on 18 December (this followed an enthusiastic review of M. Pierre and his amazing mechanical swan), which analysed for the first time two chronological puzzles, the apparent transposition of scenes when William's messengers rescue Harold, and when

*The *aune* was an archaic measure of length, 1.188 metres.

Edward dies (these are still argued about today). And he criticised some inaccuracies in the original engravings. A long article in the *Journal des Arts* examined the historical background of the Breton campaign, and praised the contribution of the Tapestry's loyal needlewomen. A more independent-minded weekly, *La Décade philosophique, littéraire et scientifique*, which reviewed books, plays and exhibitions, provocatively pointed out that there was no evidence to associate the Tapestry with Matilda at all, and that it had been called the *Toilette du Duc Guillaume* in Bayeux. The writer daringly referred to the exhibition space by its previous name, the Musée de Paris, and even claimed to be unimpressed by the textile: although precious, 'as a work of art it offers nothing very interesting. It is typical of those eras when the arts are either still in their infancy or have entirely declined. It is easy enough to understand, and makes an imaginative use of figures but lacks proper perspective.' However, the French view of Harold was more sympathetic than English attitudes to William, and the work certainly deserved to be studied because of the detailed information it provided about the invasion, which many historians ignored.[6]

A critic who sensibly remained anonymous launched a different sort of attack in the *Journal des bâtiments, monuments et arts*. This not only mocked the primitive quality of the work and complained of the 'bizarre spirit' of those who had chosen to cover up the museum's Old Master drawings for a month, but expressed shock at the obscenity of the figures: 'the public, deceived by the lavish publicity, have hardly been able to contain their anger. Decency itself demands that the exhibition should be closed.' If this was really the work of Matilda, then 'those who believe that queens exemplify discretion and modesty must have suffered agonies when viewing these pictures . . . indeed, we still blush for her 800 years on!' Far from being a monument to female industry and virtue, the Tapestry revealed the decadence of the Norman court.[7]

9

Performing Propaganda

As a result of the exhibition, the extensive press coverage and Napoleon's evident approval, the Tapestry was so famous that it became the subject of a play. The First Consul was fully aware of the persuasive power of the most popular medium of all, the theatre. A passionate play-goer (and versatile performer of his own varied roles), he laid out large sums of money to make the theatres his mouthpiece, from the smallest boulevard stages to large establishments such as the Comédie-Française and the Opéra. He distributed particularly generous subsidies to the big houses, which were less profitable because of their greater overheads and the fact that few people now wanted to watch the ponderous, declamatory dramas of the past. As another encouragement, he paid favoured actors extra money in the form of guaranteed state 'pensions' to augment their precarious wages. Theatre managements putting on the right sort of play received a lump sum per performance, plus a bonus for the authors. To keep an eye on all this, he put the various theatres under the control of the palace prefects, headed by the *Superintendent des Spectacles*, M. de Rémusat, a former lawyer who, by keeping it down, had quite literally kept his head during the Revolution.

Apart from these financial incentives, there was the equally effective disincentive of being shut down for putting on the wrong sort of play. So managements supported the new regime by repeating approved classics whose noble heroes could be interpreted as precursors of Napoleon, or by inserting flattering references to him into existing scripts. By 1803 he was

tightening control, and all managers had to submit their proposed schedules every three months to the Bureau of Theatres that the Ministry of the Interior had established, whose main function was to censor plays. The Minister of the Interior, Chaptal de Chanteloup, instructed Amaury Duval, head of the fine-arts division (who happened to be a friend of Vivant Denon), to summon together all the playwrights and ask them 'in the name of the fatherland for a few works capable of stimulating the public spirit'.[1] This would obviously be a welcome source of income for hard-up writers and directors.

The immediate product of this initiative was *La Tapisserie de la Reine Mathilde*, a one-act musical play that opened at the Théâtre du Vaudeville, rue de Chartes, on 14 January 1804. Composed at great speed in the last two weeks of December 1803, it shamelessly cashed in on the topicality of the exhibition in order to respond to Duval's demand. Its co-authors were Jean-Baptiste Radet, François Desfontaines (a nom-de-plume) and Pierre-Yves Barré, ex-lawyer and director of the Vaudeville, which he founded in 1792; many new theatres started life during the Revolution, when the proclamation of Liberty included freedom for the stage. This new breed of people's theatre produced a new type of play, a one-act piece that combined songs with spoken and sung dialogue, termed a 'vaudeville' (what we would now call an operetta). The format was genuinely innovative because it ignored the elitist old classics and dealt with modern themes for modern times. The Théâtre du Vaudeville was one of the most successful, although its very popularity gave it a reputation for badly behaved audiences, resulting in complaints to the National Assembly. There was just one hiccup when *Susannah*, by Radet and Desfontaines, which contained the provocative line 'If you are the accusers, you cannot also be the judge', opened at the same time as the trial of Louis XVI. The authors were temporarily thrown into prison, but released after writing a patriotic song about the Paris commune. From then on their work adopted a strong revolutionary line.[2]

The Vaudeville continued to flourish after the Revolution, well able to respond to the pressures of combining popular appeal with nationalism. Barré and his colleagues soon learned how to focus on Napoleon. *Girouette de St-Cloud* commemorated the *Brumaire coup d'étâtre* of 1799, which disbanded the Republic and declared him First Consul. *René le Sage* celebrated his ratification of the Treaty of Amiens. For these old hands, the presence of the Tapestry in Paris was an obvious source of inspiration for keeping in Napoleon's good books by making the right sort of parallels with

William the Conqueror. They might have come across a late eighteenth-century play, *The Battle of Hastings*, performed (with no great success), at Drury Lane in 1776. Admittedly this made no mention of the Tapestry, and obviously ended tragically since Harold was the hero, but it was one of the first dramatic works to show the potential of the earlier Middle Ages. (The author, Richard Cumberland, was a difficult man and an often impenetrable writer. His ode in praise of the poems of Thomas Gray was so obscurely written that when David Garrick read it out loud at Topham Beauclerk's, Beauclerk 'desired him to read it backwards and try if it would not be equally good; he did and it was'.)[3]

Cover of Wicht's score for the operetta *La Tapisserie de la Reine Mathilde* performed at the Vaudeville Theatre, Paris, in 1804. The Tapestry is an essential part of the scenery.

But in Paris in 1804 it was the Tapestry that had the starring role. The play's very first stage instruction set the scene: *When the curtain rises, we see Matilda, surrounded by her women, all busy embroidering. A portion of the Tapestry is hung around the stage.* The surviving drawing of the performance and its set shows this very moment. A whole length of the Tapestry hangs around the back curtain while the ladies, in fashionable *directoire* frocks, which make them resemble Greek nymphs rather than medieval Normans, stitch away at one panel extended over a table.

The play opens with a song praising their busy fingers recording great deeds, for they are creating an instant report of the campaign upon which William has only just departed. Matilda's uncle, Count Roger, enters and admires the scene of Harold, *that treacherous Englishman*, swearing his false oath on the relics of Bayeux, and her ladies boast about the figures they are embroidering:

Claire: *How do you like my horse?*
Gertrude: *I'm very pleased with my boat.*
Ragonde: *What do you think of my soldier?*

There is a strategic reference to the comet that so impressed Napoleon, for Roger reports that a comet has been spotted moving towards England, *lighting up the soldiers' route*, and Matilda responds *We will put it in the Tapestry*, to show that William is protected by a sign from heaven.

The slender plot involves the discovery of Raymond, the secret love-child of William by the long-deceased Irene, brought up by a mysterious hermit. When he sees the Tapestry, he decides to become a soldier like his father. His soliloquy describing its marvels – *What workmanship! What figures! Soldiers, sailors, workmen . . . I think it will survive for a very long time* – voices the reaction of visitors to the original in the Louvre. And he realises that, by joining his father's army, he too will be recorded for posterity by the delicate fingers of Claire, Matilda's niece, with whom he falls in love (despite being only 13). He announces his decision: *I will do brave deeds and you will embroider them.* The play ends with their betrothal and his departure for England, for news has just come of William's successful landing at Pevensey.

As if comparisons with the present situation were not clear enough, the script rubbed them in. Roger's concluding song expressed the excitement of a great leader invading England, and its final verse encouraged today's soldiers to emulate their predecessors:

> *Yes, in the footsteps of our Conqueror,*
> *Our brave boys are following our fathers.*

This was sung to the tune of a popular song of the day. And Matilda spoke the final speech directly to the audience: *From the shelter of the Vaudeville, happy and free, we celebrate our heroes.*

The audience response was all that could be desired: 'all of the allusions to present circumstances were especially applauded', according to a report made to the chief of police. For all plays were monitored, discreetly or otherwise, by secret agents seated in the audience to check their content and reception. Another enthusiastic reviewer noted the appropriate parallels: 'Soon their stage business will be ratified by the sword and our cries of joy will ring out all the way to the Thames . . . we have started singing on the stage the hymn of triumph that our troops will finish on the battlefield.'[4]

The play made such positive comparisons between William and Napoleon that it earned the rare honour of a long review in *Le Moniteur*, although this was unusual enough for serious plays and almost unheard of for a boulevard one-acter. The reviewer began by complimenting the theatre's patriotism: 'the Vaudeville was born French and therefore finds it a pleasure rather than a duty to celebrate actions which honour its country . . . these deeds excite the admiration of contemporaries and create a glorious memory'. Then he praised the structure of the work and noted its enthusiastic reception: 'It would be necessary to quote almost all the verses to let the reader know which the audience appreciated most.' To sum up, the authors' collaboration was truly inspired and 'this delightful play deserves all the brilliant success it has already achieved'. This review added to the general momentum, and the play remained in the repertoire until the middle of April, receiving 20 performances, more than any other that season, as proof of its continuing box-office appeal. And the theatre made even more money by selling copies of the score, at 1 franc 30. Another reviewer, in the same issue of *La Décade philosophique* that discussed the exhibition, noted the timely use the authors had made of the real Tapestry on display in Paris, and found the play charming. The *Journal des Arts* also praised it.[5]

Barré and his colleagues did very nicely out of *La Tapisserie*, for they received pensions of 4,000 francs each, as well as bonuses for each performance. That same season they created another two patriotic plays about former French heroes, *Bertrand du Guesclin* and *Duguay-Trouin*,

Prisonnier à Plymouth, whose cast included 'Sir Bifteck' and 'Madame Prattler'. *Le Moniteur* gave this a rave review, too.

But comparing Napoleon to great historical Frenchmen was not an automatic guarantee of success. Mme de Rémusat, lady-in-waiting to Josephine and wife of the *Superintendent des Spectacles,* reported how other 'attempts were made to excite the public mind against the English by dramatic representations: scenes from the life of William the Conqueror were re-created at the theatres'.[6] One such attempt was that of playwright Alexandre Duval, who had offended Napoleon in 1802 when audience spies interpreted his *Édouard en Écosse,* a drama about the House of Stuart, as being sympathetic to the overthrown Bourbon monarchy: it was, unfortunately, very popular with the amnestied royalists recently back from exile. Duval had tactfully removed himself from Paris for a while, but his brother Amaury, the civil servant responsible for encouraging patriotic plays, now encouraged him to tackle the politically correct subject of William the Conqueror as a way of getting back into the First Consul's good books.

Duval laboured for ten days and nights on *Guillaume le Conquérant,* a five-act drama, but it only survived for two performances at the Théâtre-Français, on 4 and 5 February 1804. There was a non-committal paragraph in *Le Moniteur* after the first night: the reviewer was clearly trying to cover his back until official reaction was known, by postponing until the following day a full review of 'this work, which was not without its faults but whose merits the public noted with loud applause'. It was unfortunate, however, that through having to 'squeeze within the bounds of five acts a great historical event, the author did not confine himself to the rules of *our* theatre'. That is to say, Duval had chosen to ignore the dramatic unities of time and place that French classical dramatists rigorously imposed; it was not a good time to be imitating the looser Shakespearean structure. (Lady-in-waiting Mme de Rémusat recorded a great faux pas when she spoke enthusiastically about *Othello* to Napoleon, for it was a mistake to praise anything English in front of him, and he had a particular contempt for Shakespeare.)

No full review of Duval's play followed, for the police spy in the audience that first night must have reported unfavourably to Napoleon's chief agent Ripault, whose job it was to analyse the reception of all new plays within two days of their opening. The very next day the theatre received an order banning any future performances, signed by M. de Rémusat in his dual

capacity as general director of theatres and as the prefect responsible for the subsidised Théâtre-Français. (The Rémusats' son would recall in his memoirs a childhood privileged by many more visits to the theatre than normally experienced by the average six-year-old. A less happy memory was of having his ears tugged by a pasty-faced, ungainly little man in military uniform who, he later learned, was the First Consul himself.)[7] Despite the promising title of Duval's play, Napoleon's sensitivity over the projected invasion could not endure the historically attested (Duval must have looked at the *Roman de Rou*) but tactless mention that before the Battle of Hastings, William's soldiers had sung of the death of an earlier hero, Roland. Worse, the character of William himself did not appear in the best light, for he revealed emotion when, as part of the convoluted plot, Harold's wicked mother Gytha kidnapped and threatened to kill Matilda and her daughter Ælfgyva. And the flawed characters of Odo of Bayeux and Stigand, Archbishop of Canterbury, offended the clergy. Duval tried to correct these errors in a hasty rewrite for the second performance, but it was too late.

The independent-minded *Décade philosophique* cited the Tapestry in a vain attempt to gain a reprieve for Duval's play. Its brave critic, 'X', pointed out that 'amongst all the heroes honoured by France, William the Conqueror is the one who, under the present circumstances, is the most appropriate for our admiration; engaged in another war instigated by English treachery, he triumphs and regains his rights. All the facts are clearly shown in the Tapestry, believed to be the work of Matilda, which has just been exhibited.' This was what had inspired Duval, that distinguished man of letters, whose only motive was 'zeal to promote our national glory'. The characters were well drawn, any flaws in them 'are easy to correct, and the author did so on the second performance'. In fact, the only fault conceded concerned the leading actor: 'Baptiste was rather tall to play William, and his costume was slightly ridiculous.'[8]

Another Tapestry-inspired play that opened just a few days later did toe the correct political line. With scenery copied directly from the original, especially a backcloth showing William's fleet crossing the Channel, and some spectacular stage and lighting effects, the three-act melodrama *Guillaume le Conquérant, duc de Normandie* received its first performance at the Théâtre de la Gaieté on 9 February. It was the final scene that undoubtedly ensured its success, when a prophetic vision of the First Consul ascended through a trapdoor to be crowned with a laurel wreath by the

allegorical figure of Victory. The cast was also well chosen. Harold was played by the famous tragedian Talma, a very old friend of Napoleon's, who gave him much-needed lessons in elocution and deportment – after he made himself emperor, Napoleon reasserted his own status by advising Talma, from direct experience, how to act more convincingly in the imperial roles of Julius Caesar and Nero. Mlle Georges, at that time Napoleon's mistress, played Queen Matilda, in between visiting him secretly at night in an upstairs chamber at St-Cloud while poor Mme de Rémusat tried to calm the suspicious Josephine, weeping and pacing the floor below.[9]

To the relief of its citizens, Napoleon restored the real Tapestry to Bayeux on 18 February 1804, after an exhibition that had lasted two months, rather more than the 'few days' alleged in the original demand. One of its later curators, writing in the 1870s, claimed that 'important people' wanted to keep it in Paris permanently, but that Napoleon himself ordered it to be returned. Perhaps its simplicity, perceived by many as crudity, saved it from a future amongst the more ostentatious works amassed in the Louvre, while the great space needed for its proper display must also have been a factor. Denon wrote a gracious letter of thanks to the sub-prefect of Bayeux: 'the First Consul has studied with interest this precious monument of our history; he praises the care which the people of Bayeux have given it over the previous seven and a half centuries; he has asked me to pass on to them his total satisfaction, and to return it to their safe-keeping. And please ask them to give even more care in the future to the protection of this fragile monument which records one of the most memorable deeds of the French nation and also preserves the memory of the pride and courage of our ancestors.' Together with the Tapestry, he enclosed 350 copies of the ordinary guidebook, plus two of the illustrated edition.[10]

Following the return of their treasure, the town council of Bayeux met on 13 March and passed two resolutions, neither of which was kept. They agreed to house the Tapestry in the library of the local college, under the joint supervision of the director of education and the mayor, and to exhibit it in the cathedral for two weeks each summer, to revive the ancient custom. But the mayor pulled rank and took the Tapestry to his official headquarters in the Hôtel de Ville, where he made it available for public viewing in the month of September and otherwise by appointment. There is no evidence it was ever shown in the cathedral.

Back in Paris, the plays about the Tapestry and William continued to run.* Napoleon decided that the invasion troops waiting patiently in Boulogne for their transport ships to be built should have the opportunity to appreciate these patriotic works. To keep his officers and men motivated and happy, he laid on various entertainments, which included a tour by the Vaudeville company. So *La Tapisserie de la Reine Mathilde* came to the camps at Boulogne, St-Omer and Wimereux in the summer of 1804 and the soldiers watched the story of their successful predecessors almost within sight of the white cliffs of Dover. In Boulogne, ten boxes in the town theatre were reserved for the most important members of the audience, although it was noted that Napoleon himself did not bother to attend. For their greater enlightenment, Denon, who had clearly overestimated the print-run of Visconti's guidebook, distributed 200 copies of it to the officers in the camps. (The Vaudeville company so impressed Napoleon that he commanded them to entertain the troops the following summer. For the 1805 season, Barré and colleagues devised a Pirandello-esque piece about the Vaudeville company going to Boulogne.)

But Napoleon's grand invasion plans began to disintegrate when his chief admiral pointed out that no more than 100 of the transport ships, out of an estimated fleet of more than 2,000, could leave Boulogne harbour on any one tide, and that their safety and stability depended on calm weather, which could never be guaranteed in the Channel. Bad weather had delayed William's fleet by six weeks (and would even cause the postponement of the Allied landings in June 1944, despite modern might and advanced technology). By the summer of 1804, whatever the play's message, the great invasion was uncertain, even though its very threat had caused the English government to collapse. Pitt headed the new ministry, reorganised the coastal defences and expanded the militia, all additional factors that Napoleon took into account. The invasion receded further.

Monarchy and aristocracy were back. No longer satisfied with the Republican title of consul, Napoleon used the threats from England, including alleged assassination attempts on his life, to secure his elevation to hereditary emperor. This, he claimed, was to protect the government of the republic he had established, and the new constitution was agreed in May

* Napoleon's 'support' for the theatre turned out to be a poisoned chalice. In 1806, he imposed further restrictions on the choice of play, and in 1807, he reduced the 33 theatres of Paris to eight, each with tightly prescribed subject matter.

1804. Although invading England had now taken a back seat, the image of the Conqueror remained potent. By defeating the English, William had exchanged the rank of duke for that of king. The Tapestry lacked a final image of William enthroned, but it began with Edward seated in state and did show Harold's coronation; it also demonstrated the Pope's support of William, by the banner on his flagship. When Napoleon designed his own coronation, which took place on 2 December 1804, he harnessed the Pope's reluctant support and presence, but marked his own domination by crowning himself.

As emperor, Napoleon continued to promote approved artistic subjects. The terms of reference for a sculpture competition in 1806, for example, included scenes from the history of France, with anything that humiliated England especially recommended, and William the Conqueror cited as ideal. Denon created for Napoleon two vainglorious monuments which perhaps even showed the indirect influence of the Tapestry. In designing the columns of Vendôme (in Paris) and of the Grand Army (at Boulogne), his main inspiration was Trajan's Column, but he was also aware that Montfaucon and Visconti had cited that monument, with its narrative frieze of campaigns and battles, as a crucial source for the Tapestry. Made between 1806 and 1810, the Vendôme column was 44 metres high, cast from the bronze of the 1,250 cannons captured at the Battle of Austerlitz. Surmounted by a statue of the emperor, it recorded in a narrow spiral band the glorious victories of Napoleon and his army. The Grand Army column, begun in 1807, specifically celebrated the German campaign of the autumn of 1805 that he launched from the camps at Boulogne. The emperor's statue at the summit has symbolically turned his back on England: he faces inland, no longer towards the Channel.[11]

10

The Rival Camp

As a result of the publicity resulting from its Paris exhibition, the Tapestry began to excite new rumblings of scholarly interest on the other side of the Channel. But it was sometimes hard to separate the motivation of pure antiquarian research from that of propaganda in yet another period of hostilities between two old enemies. Although Napoleon had commandeered the Tapestry to press his cause, the English now fought with words to claim it as theirs. The debate was first waged in *The Gentleman's Magazine*, a lively weekly journal that easily blended current affairs with obscure points of scholarship. It started on 26 December 1803 with an account by 'Antiquariolus' (noms de plume were de rigueur) of a recent visit to the Louvre. Sandwiched between a letter on the cow-pox and a humorous invitation from John Bull to Napoleon ('the Lord-Mayor is eager to *press* you to dine in the Tower with the beef-eaters') was a detailed description of the Tapestry, copied substantially from Visconti's guidebook. The English response was to mock the foe: it repeated how Napoleon had been 'particularly struck' by the scene of Harold and the ominous comet, on which he 'ruminated for some time with great gravity'. But, sneered Antiquariolus, 'it is a pity he has not the old tapestry in the House of Lords representing the dispersal of the Spanish armada. His soothsayers would be sure to find in it abundant omens of victory.'

Antiquariolus was outshone by 'S.L.', on 31 December, who denied the French origins of the Tapestry altogether: Matilda may have directed the

115

project, but English noblewomen made the work in their own country. A brief history of their contribution to the art of embroidery culminated in a tribute to the sewing skills of the daughters of George III, bravely stitching away despite 'the vain inglorious rantings of the ambitiously mad Corsican tyrant'. A third correspondent, 'Antiquarius', took up his pen on 7 February 1804, to try and score points by disagreeing with some of Antiquariolus' interpretations, while 'H.D.' returned to the real enemy in April: Montfaucon may have claimed that the Norman invasion was the making of England, but Napoleon should not dream of emulating this dangerous precedent for he 'holds out nothing but destruction in every possible mode, without the slightest claim of right to our throne or an iota of our property'. These loyal gentlemen would have been even more outraged if they had seen the rollicking musical *La Tapisserie de la reine Mathilde*, now running in a boulevard theatre. There were evidently many English visitors to Paris at this time. One was the Reverend Robert Tomlinson, who wrote to a friend in March 1804 that 'among the immensity of curiosities shown in Paris is an old-fashioned and remarkable rag, ycleped [called] the tapestry of Queen Matilda'. Tomlinson noted the hawk on Harold's wrist, the moustachioed, beardless English, and the dwarf Turold, and he echoed Visconti's comparison of the shield-hung ships with paintings from Herculaneum.[1]

Continuing popular interest, directly stimulated by the exhibition, also encouraged more serious study. The first scholar who dared to challenge the official interpretation by Visconti and Denon did so on more than academic grounds. Before the Revolution, the Abbé Gervais de la Rue was a canon of Bayeux Cathedral and Royal Professor of history at the *Académie des sciences, arts et belles-lettres* at Caen, where he specialised in Anglo-Norman history and literature. Like so many other clerics, he fled to England in 1793 at the height of the Terror, endangered by his faith and by his companion, the young Marquis de Mathon, to whom he was guardian and tutor during their time in England. Here the abbé studied historical manuscripts in Oxford, Cambridge and London, and, in tribute to his learning and reputation, was honoured by being elected a Fellow of the Society of Antiquaries of London.

Here the abbé found himself among kindred spirits genuinely enthusiastic about the Middle Ages. Welcomed as a political refugee, he made a point of stressing his own Norman rather than French nationality. Despite his academic position, he had reached the age of 35 without having published anything, but quickly remedied this during his enforced

sabbatical: he delivered four papers at the Society's meetings, which were subsequently published in *Archaeologia*. These made it obvious that the abbé had a strongly anti-French intellectual agenda. His aim was to emphasise the English contribution to so-called Anglo-Norman literature by proving that Normandy owed far more to England than France during the twelfth and thirteenth centuries, and he sarcastically dismissed the findings of French scholars, though claiming with false modesty that 'it little becomes me to lay down a positive opinion on so important a subject'. He reassessed Wace's *Roman de Rou* and its patron, Henry II: 'though esteemed as one of the most ancient monuments of French literature, France owes these precious relics to a king of Great Britain'. Another article pointed out that 'I have already intimated that the French are indebted to England and its monarchs for the most eminent poets that we know of in their language.' And he even proposed that the poetess Marie de France composed her major works in England. Though he must have known of the Tapestry's annual hanging in the cathedral, the abbé seemed at this time only superficially aware of it as a source of evidence. He mentioned it very briefly in relation to Wace, and failed to compare its Aesopian border scenes to the fables he claimed Marie had discovered in England.[2]

After nine years spent absorbing English attitudes and scholarship, the abbé returned with his protégé to France in 1802, after Napoleon invited émigrés to return without sanction. He remained a corresponding member of the Society of Antiquaries, and resumed his professorship in Caen. It was here that he gave a lecture in 1805 in which he made the dangerous claim that the Tapestry was not contemporary with the Norman invasion at all, but dated from almost a century later. The abbé formulated his theory after examining it far more thoroughly in the Hôtel de Ville than had ever been possible in the cathedral nave. The Tapestry was now all too accessible, without taking up much space, for it had been attached to two spools on stands, so that the custodian could wind it from one to the other for visitors just by turning a handle. The abbé must also have resented the appalling fact that Napoleon had presented his cathedral's former prized possession to the secular authorities, quite apart from fetching it to Paris in order to publicise his intended attack on England, the country where the abbé had found refuge and the respect of fellow-scholars.

His lecture proclaimed that the ancient Bayeux tradition that associated the Tapestry with a Matilda was correct. However, the lady was not William's wife, but his granddaughter, the Empress Matilda. To dissociate

the Tapestry from the hands of the Conqueror's wife, at a time when Napoleon had still not entirely ruled out invasion, was provocative. It also flaunted the subversive views that the abbé had acquired during his time in England, for these were the theories of Stukeley, Hume and Lyttelton. Wisely, he did not publish the text of his lecture in the Caen Académie's proceedings until 1811, when the matter was less sensitive. In that same year, he sent an expanded version to London for communication to his colleagues in the Society of Antiquaries, a belated acknowledgement of his time there.

The recipient was his old friend Francis Douce, a Fellow since 1779. A former Keeper of Manuscripts in the British Museum, Douce had a special interest in medieval literature, but collected every sort of antiquity. He was a noted eccentric whose will specified that after his death, his head should be cut off or his heart removed 'so as to prevent any possibility of the return of vitality'. In November 1812, Douce read to the Society his translation of the views of 'our learned, worthy member' the abbé, that there was nothing to connect the Tapestry with William's Queen Matilda or eleventh-century Bayeux, and that the Empress Matilda had commissioned it to glorify her grandfather. Linguistic details in the inscriptions and the outstanding reputation of English needlework of the time confirmed this. Douce warmly supported these opinions and added some embellishments of his own. The abbé's conclusion – 'it remains therefore for reason and sound criticism to decide whether the Tapestry of Bayeux must continue to be regarded as a monument of the French nation' – must have thrilled the Antiquaries' hearts.[3]

Published in Archaeologia for 1814, the paper inspired another Fellow, Hudson Gurney, to go and see for himself. Gurney was a typical antiquary, a wealthy man with a fascination with English antiquities and literature and a library of 15,000 books, all of which he claimed to have read. He travelled to France during the period of peace that followed Napoleon's banishment to Elba in 1814, when a flood of culturally deprived English tourists rushed across the Channel, heading mainly for Paris to see the art treasures looted from Europe and the Near East on display in the Louvre, still under the directorship of Denon, whom Napoleon had made a baron in 1812. (Louis XVIII and the Allies allowed Denon to remain in charge of the Louvre, but he backed Napoleon during the Hundred Days, and then tried to resist Wellington's orders to return the contents to their countries of origin, until bayonet-wielding Grenadier Guards threatened his staff. He resigned in

October 1815.) Gurney spent just a few hours in Bayeux and almost failed to find the Tapestry, until he discovered that he should have been asking for the *Toile St-Jean*. Or perhaps the French were being deliberately unhelpful again.

An outraged English visitor sketched how the Tapestry was displayed in the Hôtel de Ville, Bayeux, in the early nineteenth century.

He learned that it was now in the Hôtel de Ville, 'coiled around a machine like that which lets down buckets to a well'. Impressed by its colours, 'as bright and distinct as if of yesterday', and by the drawing skills that presented considerable 'likeness of the individual' despite the 'rudeness of the execution', Gurney disagreed with the abbé's dating and argued that the Tapestry was much earlier, because it provided a contemporaneous defence of William's claim and showed no trace of the pointed arches of the thirteenth century. It must have been made by Queen (not Empress) Matilda, though certainly with the aid of English needlewomen. The only real way to resolve the issue was for English scholars to study the Tapestry in a version more reliable than the inadequate drawings of Frenchmen.

In July 1816, Gurney reported these concerns in a lecture that was also a

clarion call for the Society of Antiquaries to Do Something: 'I have said enough to prove how very insufficient the prints we have of it are to convey any accurate idea of the Bayeux Tapestry, being in fact merely copies of copies of the one sketch of Father Montfaucon's draughtsman.' Although many people considered the Society to be in rather a stagnant state at this time, with complaints of apathy, subscription arrears, unpredictable attendance at the weekly meetings in Somerset House and a dearth of decent papers, the Tapestry galvanised them into action. The Fellows were so fired by the need to establish the truth, especially if it proved the Tapestry might be English, that on 8 July 1816, just four days after the lecture, the Council (on which Gurney sat) decreed that their historical draughtsman, Charles Stothard, 'be directed to make drawings of the Bayeux Tapestry during the summer, if it suits his convenience, for the use of the Society'.[4] They could not have chosen a better man.

11

The Stothards' Story

Charles Stothard, then aged 30, was the second son of the well-known artist Thomas Stothard, RA. Schoolboy reading of Shakespeare and history had filled Charles with a romantic vision of the Middle Ages and he 'lamented that there were now neither knights nor tournaments, nor glittering arms'. He trained as an artist in the Royal Academy schools, but realised he was not cut out for a conventional career, for he admired the unfashionable Blake and Fuseli, and was too concerned with truthful recording to become a successful society portrait painter. A fascination with 'antiquarian' subjects led him to history painting, and he exhibited a well-researched *Death of Richard II in Pomfret Castle* in the Academy's 1811 Exhibition. Having so enjoyed copying Richard's effigy in Westminster Abbey, he decided that his mission in life must be 'the study of our national antiquities' and planned an ambitious series, *The Monumental Effigies of Great Britain*, inspired by etchings of medieval monuments in Paris destroyed during the Revolution. In an essay prefacing the first volume, he stated as his aim: 'to give the most *correct* representations of the subject, to supply what the pencil cannot perform by minute description and to afford illustrations and remarks whenever they may be usefully applied . . . how securely will such a foundation assist and support those who wish to make collateral or deeper researches'. Prophetic words, for it was Stothard's expertise in the art and culture of the Middle Ages that obtained him the prestigious commission to copy the Tapestry.

Meanwhile, he trudged all over the country sketching tombs, brasses, tiles, sculptures and stained glass, coping with the hazards of getting close enough to draw his subjects accurately, often 'elevated between 30 and 40 feet from the ground, standing upon a ladder, with both hands engaged, one in holding the drawing board and the other the pencil'. He did fall from a ladder in Canterbury Cathedral, but was unhurt.[1]

Stothard's wife, Eliza, a spirited girl with a passion for history and a mass of brown curly hair, has had a bad press over the accusation that she snipped off a small portion of the Tapestry as a souvenir of her honeymoon in Bayeux. Born into that robust Georgian England that evaporated into Regency sensibility and was extinguished by Victorian values, she may seem more typical of the third era, the dutiful widow who wrote devoted memorials of the life and works of her first and second husbands, artist and vicar respectively. But her early life showed her to be resourceful and adventurous, a gallant companion to Stothard in his gruelling quests for medieval remains, experiences that she later recycled when writing historical novels. Her early passions were literature and drama, and she was a keen amateur actress. She and her brother Alfred performed regularly to an audience of friends, including Stothard, who was then starting work on his Monumental Effigies. They fell in love and became engaged in 1814. She was then 24 and he was 28, but a poor marriage prospect because of the financial problems of his project, which had attracted few subscribers. Eliza failed in her attempts to earn a living by going on the stage professionally (nerves and a bad throat) and, had it not been for the Tapestry, the young couple's engagement might have lasted indefinitely. (Eliza's autobiography gives a fascinating account of this unexpected episode in her past.)[2]

As well as doing his own unprofitable work, Stothard was illustrating the Lysons brothers' Magna Britannia: a Concise Topographial Account of the Several Counties of Great Britain. His sensitive and accurate drawing so impressed Samuel Lysons, then a very active vice-president of the Society (of which the brothers had been Fellows since the 1780s) that in 1815 he nominated Stothard for the vacant post of historical draughtsman. Permission to attend the Society's meetings indicated his status as a gentleman-and-scholar artist rather than a mere craftsman. And when the Council authorised bills for payment, Stothard's name never appeared under the heading of 'Tradesmen's bills' with the Society's other artists and engravers, but was always listed separately. Although this post did not pay a regular salary, the fees earned from the Society's exciting new project would

make it possible for him to marry Eliza. The Council Minutes of 8 July 1816 recorded that: 'Mr Stothard was directed to make drawings of the Bayeux Tapestry during the summer'. And the Society approached its distinguished corresponding member, the Abbé de la Rue, to use his influence to obtain the necessary permission for access from the mayor and council. The abbé pulled the right strings and, in September 1816, Stothard set off for Bayeux.

The first visit was shorter than he intended because it was a particularly cold autumn, which made it difficult to work for too long in the Hôtel de Ville. The condition of the Tapestry shocked another visitor in the same year, who noted how 'the Tapestry is coiled around a cylinder, which is turned by a winch and wheel; and it is rolled and unrolled with so little attention that if it continues under such management as the present, it will be wholly ruined in the course of half a century. It is injured at the beginning; towards the end it becomes very ragged and several of the figures have completely disappeared. The worsted is unravelling too in many of the intermediate portions.'[3]

Stothard was unimpressed by the company in the run-down little town of Bayeux. The Revolution had reduced its original 18 parish churches to four and had demolished all its convents. It was full of rootless English, he wrote to his father, the flotsam of war, 'principally persons with broken-down fortunes, and officers of the army and navy on half-pay. It appears to me that this is not a voluntary exile.' He did not like the natives, either. Eliza commented how 'he was by no means a general admirer of the French. He detested the instances that he so often met with of their egotism and impertinence.' Nor did he like the food: 'France is not the country for me; I am not so well as in England; I am not equal to the same exertion. I attribute this to their manner of cookery; our habits of cannibalism are far preferable.' Complaining about a lack of meat was hardly fair comment on a shattered country trying to pull itself together after years of war. But Stothard did concede that 'I found but too much destruction and ruin . . . churches, abbeys and chateaux in ruins or perverted from their original intention . . . antiquity in France has received such a blow as it can never recover.' An addict of Gothic art and architecture, he was rather more excited by discovering 'lost' Plantagenet monuments at Fontevrault than by the Romanesque style of the Tapestry, which he described as 'barbarous but very interesting.'[4]

It was perhaps in response to this 'barbarism', as well as the literally mangled conditions at the end of the Tapestry, that he had no

compunction in cutting off and keeping two small fragments, for which crime Eliza was later accused. Another even more dubious intervention was his use of wax 'squeezes', which he used to make plaster casts. However, these provided remarkable, low-relief, thread-by-thread facsimiles, giving every detail of the worsted embroidery stitches and the very weave of the linen itself. The casts proved Stothard's understanding of the technical processes of recording – he was also reported to use a *camera lucida* for greater accuracy – but showed a reckless disregard of its fabric. He was employing a technique devised to replicate hard objects like coins or seals, and not medieval textiles: he pressed hot wax (the type used by professional modellers for taking impressions) into areas of the linen measuring 13 by 11 centimetres, and then peeled them off, either furtively or even under the eye of a negligent custodian. These wax impressions provided 'negative' moulds onto which he poured a thin layer of plaster of Paris; once set, he removed the wax. Then he painted these casts, capturing with extraordinary delicacy the colours of the original, which revealed the brownish tones that the linen then bore and the exact shades of the wool, down to the subtlest contrasts between olive and sage-green. If the Tapestry had not survived its subsequent adventures (for there are more to come), these casts supply a precise reproduction of its techniques, texture and thread-count, far more effective than any two-dimensional version. (The collector Francis Douce, whose translation of the abbé's paper for the Society had set off the whole enterprise, acquired the casts, together with one of the fragments, whether by gift or by purchase we can only speculate, and left

Charles Stothard's plaster casts of William, Harold, and a Norman soldier. They show every detail of the fabric and stitching.

124

them in his will to Dr Samuel Meyrick, another Antiquarian who had also written about the Tapestry in *Archaeologia*. He exhibited them in the 'Doucean Museum' in his home at Goodrich Court, Hereford.)[5]

Back in England, Stothard completed the first set of drawings and was paid £115 for them by the Society of Antiquaries in February 1817, plus a further £33 a few months later. In August 1817, he returned to Bayeux, taking with him the first set of drawings to colour. He visited and drew other antiquities en route, especially his beloved Plantagenet tombs, to which the Tapestry had to take second place: 'I have made this in some degree subservient to my purpose in procuring drawings for my own work from the effigies of our Kings and Queens at Fontevrault.' Once that was finished, he moved on to Bayeux, where he worked flat out on the Tapestry for four weeks, although, as he reported to his father, without much enthusiasm: 'indeed I have found no time for any thing but this, as you may imagine, having in hand a drawing 30 feet in length, containing more than 100 feet of the Tapestry. I have two reasons for close application; one because I must do as much as possible before I lose my heat, there being but little fuel in the above work, and the other because I do not intend to be surprised by the cold weather, which I dread here.' He was working in the '*bureau* of the Municipality' (an office in the Hôtel de Ville), which he described as 'very circumscribed'. That season he reached the start of the Channel crossing, about two-thirds of the way through. 'I am at present

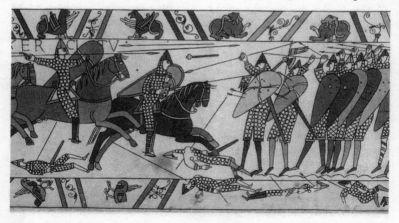

Stothard's careful drawings were engraved, coloured and published in the 1820s by the Society of Antiquaries of London.

engaged in building the fleet for the invasion of England: when this is done and I have embarked the troops, I shall follow myself with all speed.' His hard work on the town's famous monument that summer impressed the locals. He was staying in the Hôtel de Luxembourg, the best hotel, whose landlady told another English visitor that 'Le brave M. Stothard' had been working 'like four devils'. This rare French compliment to an Englishman so delighted the tourist that he celebrated by ordering a bottle of Beaune with his supper, rather than his usual *vin ordinaire*.[6]

In addition to working on the Tapestry and his own *Monumental Effigies*, Stothard was still drawing for Samuel Lysons. All this meant constant separations from Eliza, and a third long visit to Bayeux was pending. They could not face another parting. After the Society paid his fee of £226 11s 6d for the second season's work, they married in February 1818. But the Antiquaries were getting restive. The Tapestry was controversial and topical, generating more papers and articles in *Archaeologia*. He had to finish the drawing. The first portions were already on display in the Society's headquarters in Somerset House, for Thomas Amyot referred to 'the striking and elegant delineations which now adorn our walls' as visual aids to the paper he delivered in February 1818 on the Tapestry's historical sources. Such citations would be even more effective when the whole set was available. The Council of the Society composed a carefully worded minute on 1 July 1818 'that Mr C. A. Stothard be desired to proceed to France during the present summer for the purpose of completing the drawings of the Baieux [sic] Tapestry for the use of the Society'. He agreed to go, but this time Eliza would accompany him: completing the work was just one part of their honeymoon in Paris, Normandy and Brittany.

Characteristically Eliza prepared for her first trip abroad by reading Froissart's Chronicles, and by brushing up her French and sketching. She promised to write to her mother every day, with the hope that 'the description of the curious record of the Norman invasion preserved at Bayeux will perhaps afford you some interest'. However, Eliza's real interest was the French. With a sharp eye and a talent for character description, she portrayed the old enemy now on its knees, yet still infuriatingly exuberant and pleased with itself. She drew a picture of post-war deprivation and poverty, faded pre-Revolutionary beaux and belles in tattered dress and mask-like make-up, survivors of the Revolution and the name that was no longer spoken – Napoleon. Like her husband, she was horrified at the destruction of the past, noting the mutilated statues and demolished

churches, and the dreadful state of the present: 'the beggars are without number, they are bold, insolent and importunate; you are followed and sometimes absolutely beset by more than eight or ten at a time'. Travelling conditions were gruelling and the inexhaustible Stothard a demanding companion. It is impossible not to admire Eliza's questing spirit in such new surroundings, although she recognised she was just part of a tourist trend: 'After the late peace with France, it has become a fashion with the English to visit that country,' she informed her mother.[7]

They reached Bayeux in late August and rented a house for the two months that Stothard needed to complete his work. Their landlord and next-door neighbour was an abbé, a canon of the cathedral who, like so many of his kind, had led Scarlet-Pimpernel-like adventures during the Revolution. Betrayed before he could follow his bishop to London, he went underground, sometimes dressed as a woman, hidden by his loyal housekeeper in a secret loft, lurking in a rat-infested cellar, smuggled past pursuers in a chest of clothes. Every evening, the gentle abbé visited the Stothards and strolled with them on the terrace admiring the peaceful prospect of the cathedral. As normal life resumed, the street names of Bayeux reverted to their pre-Revolutionary titles and the saints took sway

Portrait of Eliza Stothard, c.1820. On her honeymoon, she 'minutely examined the whole Bayeux Tapestry and copied the inscriptions.'

again, their names inscribed on porcelain plaques – no longer the rue de la Convention, but rue St-Jean; rue Marat reverted to rue St-Malo; the rues du Bonnet Rouge and de la Liberté became those of St-Laurent and St-Sauveur.[8] While Charles drew, Eliza explored and made new friends. She noted the sights and sounds of Bayeux, the women in their starched lace and muslin headdresses, the constant clattering of their wooden sabots.

She also made a detailed scrutiny of the Tapestry, reporting to her mother: 'You may believe it has occupied much of my attention . . . I have minutely examined the whole and copied the inscriptions.' She then devoted 11 pages to a description. Noting that its original white ground had acquired 'the tinge of brown holland', she agreed with Stothard about the primitive nature of the pre-Gothic style: 'the drawing of the figures is rude and barbarous; no attention has been paid to the correctness of colour in the object depicted. The horses are blue, green, red or yellow: this circum-stance may arise from the limited number of worsteds employed.' Aware that 'historians are of various opinions' concerning the interpretation of the events shown, she competently summarised the ongoing debate and came down on the side of early dating and manufacture by Queen Matilda, although she recognised some English bias in that 'whoever wrought the work appears to have rendered justice to Harold'. She marvelled at its survival during the recent terrible times: 'It is most fortunate that this curious memorial escaped destruction during the Revolution. Its surrender at that period was demanded for the purpose of covering the guns; a priest, however, succeeded in concealing and preserving it from destruction.' This was an interesting variant, perhaps reported by the abbé, on the story of its entirely secular rescue by M. Léonard-Leforestier. And she learned that the cathedral's other precious textiles (the cope, maniple and stole of St Regnobert) had been hidden in a large earthenware container, half-buried in a garden and concealed by straw.

Her letters reported an underlying edginess, for the years of chaos had left many scars on the quiet little town. 'The Revolutionaries were like Fiends let loose to prey on France . . . not a town, not a village but furnishes some new anecdote of outrage and barbarity.' During their time in Bayeux, drunken French soldiers tried to murder an English couple in nearby St-Vigor. And they discovered that an eccentric but erudite recluse whom Stothard had met the previous year was a renegade abbé who had joined the Revolutionary forces and now lived on as a pariah on the outskirts of the town.

Stothard finished his work and the weather broke. They travelled on to Brittany, a truly primitive place with terrible roads and a population 'with an excessive dislike of the English', who lived like animals and were even worse than the Welsh. After two weeks of strenuous sightseeing, they crossed from Boulogne to avoid the mobs of English troops returning from Calais. It had all been a great adventure. Eliza returned with that 'sincere and augmented love of my own country' which could only truly be experienced by those returning from France. Encouraged by a meeting with the antiquarian Dawson Turner, who had also visited Bayeux that summer and was now writing up the journal of his Norman tour for publication, she decided to turn her letters home into a book, illustrated by her husband's drawings of the buildings and people.

She set to work revising and expanding her letters, and submitted her manuscript to the gentleman publisher John Murray, who invited the Stothards to one of his literary salons. Here, while some of the guests viewed a drawing of Teresa Guiccioli, the 'favourite, but not very respectable friend of Lord Byron' (Murray's most famous author), the Stothards were introduced to Sir Walter Scott. 'Not exactly knowing what to say, [he] good-naturedly ventured upon the first thing that came into his head, and asked Charles if he happened to have about him his drawing of the Bayeux Tapestry. As the drawing in question was somewhat about two-and-twenty feet long, the absurdity of the question was palpable.' Murray rejected Eliza's manuscript on the grounds that he had already rejected Dawson Turner's, but Longmans took her on. In November 1820, slightly delayed because of the media attention reserved for the trial of George IV's Queen Caroline ('it would be useless to publish any new book at this time'), *Letters written during a Tour through Normandy, Brittany and Other parts of France in 1818 by Mrs Charles Stothard* was published. 'I was about to *become an author*!' And there was private happiness too, because she was expecting her first child the following summer.[9]

Turner's rival journal came out at much the same time and, despite his negative opinion of Bayeux – unattractive and otherwise devoid of interest – contained a whole section on the Tapestry. Turner reviewed its recent history, reporting how it had been hidden away during the worst excesses of the Revolution and then taken to Paris where 'this ancient trophy of the subjugation of the British was proudly exhibited to the gaze of the Parisians ... many well-sounding effusions in prose and verse appeared, in which the

laurels of Duke William were transferred by anticipation to the brows of the child and champion of Jacobinism'. He shared the reservations of the Stothards and others about its style, lamenting the total disregard of perspective, and the absence of light and shade, and compared it to a girl's sampler, though he conceded that the drawing was of better artistic quality than sculpture of the period. Given the 'rude style' of the workmanship, 'more individuality of character has been preserved than could have been expected'. The work should definitely be attributed to William's Queen Matilda, 'the female most nearly connected with the principal personage concerned in it', on the grounds that some of the details were so specific that they could only be contemporary. He warmly supported the bishop and chapter in their recent application to have the Tapestry restored to the cathedral, and applauded the Society's patriotic initiative: 'the Society of Antiquaries, justly considering the Tapestry as being at least equally connected with English as with French history, and regarding it as a matter of national importance that so curious a document should be made known by the most faithful representation, employed an artist fitted above all other for the purpose, by his knowledge of history and his abilities as a draughtsman, to prepare an exact facsimile of the whole'. This was essential because the poor French drawings were 'calculated not to inform but to mislead the inquirer.'[10]

Another English visitor in 1818 was Thomas Dibdin, an avid book collector, who published his impressions of the Tapestry in yet another travel journal. This took the form of a lively and opinionated series of letters, grandly entitled *A Bibliographical Antiquarian and Picturesque Tour of France and Germany*. He spent the two 'most gratifying days' of the whole trip in Bayeux, where a mysterious stranger – 'Speak softly for I am watched in this place' – offered to help Dibdin gain access to the Tapestry (only available without appointment in September, but this was May) through an uncle who was apparently able to influence the authorities. The gentleman turned out to be the reclusive revolutionary abbé whom Stothard had met the previous year, still lying in wait for interesting foreign visitors. He insisted that Dibdin dine with him in his 'hermitage' on the outskirts of Bayeux, claimed to be working on the Tapestry himself, and fundamentally disagreed with the Abbé de la Rue's chronology. Dibdin tried to defend de la Rue: '"He is your great antiquarian oracle" observed I. "He has an over-rated reputation" replied he.'

Dibdin made his own arrangements to view the hanging, and asked

permission for Mr Lewis, the professional artist recording his travels, to copy a very small portion. This could only be granted through the auspices of the mayor, 'a very Caesar in miniature. He received me stiffly and appeared rather a priggish sort of gentleman'. The mayor pointed out that Stothard had already spent months 'on the same errand and what could I want further?'

Although the Tapestry was 'treasured as the most precious relic in the city', Dibdin too was shocked by its condition and how it was being displayed. 'The first portion of the needlework is comparatively much defaced, the stitches are worn away and little more than the ground, of fine close linen, survives . . . the last few feet are in a yet more decayed and imperfect state.' He got Lewis to draw a damning image of the way it was rolled on the destructive winch. He was also appalled by its previous treatment under Napoleon, not just because it had been 'taken to Paris to awaken the curiosity and excite the love of conquest among the citizens', but also because he believed it had actually been displayed on the stage and taken around 'one or two sea-ports'. This must be Dibdin's mistaken conflation between the real thing and the Vaudeville company's tour of *La Tapisserie*. The error would become a canonical element of the Tapestry's history.

Otherwise, Dibdin was a perceptive viewer. He noted exactly how the stitches were constructed, and was the first to suggest the integrated function of the borders, 'a running allegorical ornament', in which he identified some of the Aesopian fables. And he did not patronise it as a primitive work, but criticised Ducarel's eighteenth-century lack of enthusiasm. He even spotted that the well-proportioned figures and drapery folds showed that the designer was aware of the conventions of Roman art, a more sophisticated way of recognising ultimately classical influences than the direct comparisons that Montfaucon and Visconti tried to find. He felt that the arguments over the date were really of secondary importance, but agreed with those English commentators who disputed the connection with the Empress Matilda. At last able to compare the original with Stothard's drawings, Dibdin decided that the copy 'was executed with great neatness and facility but probably the touches are a little too artist-like or masterly'. But the new drawing of Harold that he commissioned from Lewis was 'one of the most perfect things extant'.

In Caen, where, he believed, 'men whose moral character and literary reputation throw a sort of lustre' on the town (despite constant brawls

between locals and a community of English drop-outs), he managed to meet that 'lofty eminence', the Abbé de la Rue. But the abbé refused to dine with Dibdin on the grounds that his religious order did not permit him to eat in taverns, and parted from him arrogantly, a bulky figure striding off down the street. However, Dibdin included a portrait of the abbé amongst the book's illustrations, which he obtained from their mutual friend Francis Douce.[11]

The following year, 1819, another journal-writer visited the Tapestry. This was Danish historian Hector Estrup, whose interest in Normandy arose out of his researches into Viking culture. He commented on the hostility the French felt for the Normans, whom they regarded as deceitful, and pointed out that, due perhaps to their common Germanic roots, the English were less hated by the Normans than by other French. Elsewhere in France, Estrup was taken for an Englishman and accordingly insulted with 'Goddam, bifsteak aux pommes de terre!' but this did not happen to him in Normandy. In the Hôtel de Ville, he interrogated the Tapestry for evidence of Nordic features and found them in the moustaches of the English, the drinking horns, the dragon-decorated shields, the type of boat and William's own costume, which imitated that on the tomb of his Viking ancestor, Rollo. He was unimpressed by Bayeux, which, he conceded, lacked old buildings because it had been burned down so often, but was not quite as ugly as it had been described. However, the Hôtel de Luxembourg (where Dibdin had also stayed) was excellent and cheap. Contrary to Eliza's impression the year before, Estrup claimed that Napoleon was still admired there.[12]

In March 1819, Stothard completed his great project. The Society of Antiquaries paid him £185 6s 6d, and instructed him to oversee the engraving process: the plates were to be reduced in scale to one-third of the original size, hand-coloured under his supervision, and sold to Fellows at ten shillings a set, on a print run of 500 copies. He gave a paper proposing an early date for the Tapestry, and this was published, together with several related articles, in *Archaeologia* in 1821. An appreciative Fellow gloated that 'the whole subject of the Tapestry is fairly before us . . . a faithful and elegant copy of this matchless relic, affording at once a testimonial of the taste and liberality of our Council and of the diligence and skill of our artist'.[13]

The Antiquaries rewarded Stothard with election as a Fellow, but again realised he was getting too immersed in other activities. In February 1820, they had to remind him 'according to his engagement' to monitor the

progress of the Society's engraver, James Basire, on the project. Early in 1821, the first sets of hand-coloured engravings were ready. The Abbé de la Rue received one of these, at the request of Francis Douce, and the Society sent other sets as gestures of goodwill and useful exchanges to antiquarian societies in Britain and on the continent. Colouring the engravings was a long-running project that would carry on for another eight years. Mr Martin, the Society's colourist and printer, did most of the painting for fees that totalled more than £700. Enterprising purchasers of the set could join them up and back them with linen in order to have their own complete miniature version. (One of these survives in the Guildhall Library, where it used to be kept wound on a roller in a wooden box, from which it could be extended by turning the handle; another is in the Southend Museum.)[14]

In June 1820, Stothard received £250 for the more absorbing work that had been taking up his time, copying the recently revealed thirteenth-century murals of the 'Painted Chamber' in the Palace of Westminster. These had sensationally come to light in 1819 and would be completely destroyed in the fire that burned down the Houses of Parliament in 1834. Without the Society's initiative in commissioning the copy, no record would have survived.

Stothard's reputation was now so high that his powerful patrons, the Duke of Norfolk and his brother Lord Molyneux Howard, planned to nominate him for the prestigious position of Herald in the College of Arms the next time a vacancy occurred. In April 1821, he went to Devon to make more drawings for Samuel Lysons. Among the sites he visited was the church at Beer Ferrers, whose east end contained the tomb and carved marble effigies of Sir William Ferrers and his wife, together with their images in the stained-glass window above. In order to get close enough to trace the glass, Stothard borrowed the gardener's ladder. It was a fatal mistake. When he was perched high above the ground, his hands occupied with pencil and paper, the rung on which he was standing snapped and he fell to the ground, smashing his skull on the ornate moulding of the Ferrers' tomb below – killed by one of his beloved monumental effigies. His body was found hours later after he failed to turn up for dinner at the vicarage.

The news was broken to Eliza, then seven and a half months pregnant: 'there are moments that do the work of years; that leave an impression that no time can erase and change in their visitation the natural course of things'. She had even sent him off with a light-hearted list of safety instructions: 'Do not clamber up rotten walls or tottering monuments. Take

care not to fall from high places.' She composed the epitaph for his tombstone – 'he was humble, modest, unostentatious; an example of benevolence and simplicity at heart' – and threw herself into writing his biography, interrupted only briefly by the birth of a daughter just five weeks after Stothard's death. She dedicated *The Memoirs, including Original Journals, Letters, Papers and Antiquarian Tracts, of the Late Charles Stothard* to George IV, royal patron of the Society of Antiquaries, and Sir Walter Scott was one of the subscribers. Her book included a full account of Stothard's work on the Tapestry. It was published in 1823 to general acclaim, and this success, combined with the compliments over her character drawing in *The Letters*, encouraged Eliza into her subsequent career as a historical novelist.

Her brother-in-law, Robert Stothard, inherited the vacant post of historical draughtsman to the Society of Antiquaries. But he had less status than Charles, his name being simply included amongst the 'tradesmen' listed in the Council minutes. Eliza got some money from the Society when she requested the difference between the £250 that they had paid Charles for his drawings of the Painted Chamber and the 250 guineas for which he had apparently meant to ask. She also sold off his collection of antiquities to Sir Gregory Page Turner of Bedfordshire. Her autobiography (written in 1843, but not published until 1884) curiously made no mention of the Tapestry. But it had not quite finished with her.

Stothard's drawings intensified the Tapestry debate. They provided fuel for the endless arguments over date, provenance and purpose, and generated new minor feuds about most other aspects – hairstyles, costume, heraldry, architecture, lettering. Everyone had an opinion. The basic French–English antipathies remained as strong as ever, but there were now more complex internal struggles, with some scholars seeking to establish their reputation by demolishing that of others in the traditional academic manner. It often seemed as if the two nations were in competition to see who could generate or regurgitate the most copious outpourings. The French made the running but the English sniped away from every angle.

In 1823, for example, French antiquarian A. Léchaudé d'Anisy translated and updated Ducarel's *Anglo-Norman Antiquities* with the aim of challenging his pro-English stance. He complained of Ducarel's 'inaccuracies and omissions' over the Tapestry and criticised more recent commentators, the Anglophile Abbé de la Rue in particular. He found its artistic style uneven,

Queen Matilda supervises her ladies embroidering the Tapestry in the very nave of Bayeux Cathedral. Engelmann's imaginative reconstruction for the frontispiece to the French edition of Ducarel's *Anglo-Norman Antiquities*.

and yet 'there is a sort of purity in the primitive forms, especially considering the state of the arts in the eleventh century'. To illustrate the Tapestry, he commissioned a new set of engravings (from Godefroy Engelmann, a pioneering Swiss who invented the early colour-printing technique known as chromolithography) in which he hoped to reinstate the simplicity and linearity of the original designer before its distortion by the clumsy needles and coarse threads of the first embroiderers.

Included in this volume was a pamphlet by Honoré Delauney (son of one of the Bayeux arts commissioners who kept the Tapestry safe during the

Revolution), which challenged Queen Matilda's involvement. This was on the basis of morality rather than chronology. Shocked by those border images 'which the innocent could not contemplate without blushing', Delauney pronounced that 'without wounding the laws of decency, the Tapestry cannot be the work of a woman because it contains things to which no woman would have put her hand'. Given the Bayeux connection, it must have been the worldly Odo who commissioned the work, for he was the only person capable of installing such a profane monument in a sacred place. Another novel suggestion was that Harold was the character killed by the arrow in the eye, and not the adjacent one being hacked down by a knight.[15]

The combative Abbé de la Rue could not let this pass. Not a man who took criticism mildly, he issued a 90-page pamphlet reaffirming the attribution to the later Matilda and attacking everyone, English or French, who disagreed with him. Then an Englishman proposed an even later date, which led to a Frenchman calling for a halt to this 'self-propagating scandal extending itself even further'. Bolton Corney, amateur antiquarian, claimed in 1836 that the Tapestry was not made until after 1204, when Normandy was united with France. Commissioned by the cathedral chapter

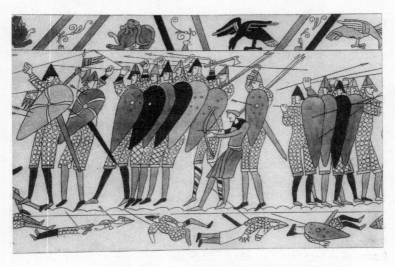

A scene from Sansonetti's 1838 copy of the Tapestry. He was trying to improve on Stothard's version.

as a defiant memorial of the province's past, its archaic nature was the product of deliberate historicism. This ingenious argument provoked a hostile review in *The Gentleman's Magazine* for May 1839, which restated the early dating on the basis of the primitive style and 'the coarse and grotesque character of some of the subjects which adorn the border', although paradoxically the reviewer did concede that these undermined the case for association with the genteel Matilda. Corney defended himself in a jaunty and sarcastic letter to the editor which complained that 'antiquarians are too apt to argue in a circle . . . at least I have introduced some novelty on a question which has engaged more able persons!'[16]

A heavyweight contribution to Tapestry studies was the substantial chapter in Achille Jubinal's *Les Anciennes Tapisseries Historiées* (1838). A professor of Italian and Spanish Literature at the University of Montpellier, Jubinal had already expressed concern over the damaging effect of the winch mechanism at Bayeux, and called for a replica to be made by the Gobelin works. The book included a comprehensive and impartial selection of the key authors, and Jubinal's professionalism slipped only once, in a footnote that accused Thomas Dibdin of making unfair comments about the mayor of Bayeux, and of abusing French hospitality, and which referred to Stothard's theft of the fragment now being flaunted in the Meyrick collection. It was illustrated by a whole new set of drawings commissioned from Victor Sansonetti, a distinguished 'former pupil of M. Ingres', which reflected the rigorous training he had received from that great master of line and tint. Whether this indicated Jubinal's desire to supersede the work of a thief, the Sansonetti version had more life and movement and more subtle tones than Stothard's sometimes rigid figures. More importantly, it revealed some of the gaps and tears in the linen that Stothard had 'restored'.[17]

Meanwhile, Bayeux was trying to cope with an expanding throng of visitors, who still had to make an appointment to see the famous monument. For example, in the autumn of 1838, poet laureate Robert Southey and a group of travelling companions (after an excellent breakfast of local ham and sausages) 'had to queue in the precincts of the cathedral till permission was obtained for seeing the Tapestry'.[18] Henri Stendhal managed to visit it that same year, and noted briefly in his journal that the figures were very clear. But Victor Hugo, on a fleeting trip to Bayeux in July 1836, did not have time to queue, even though his historian brother had advised him to see it. The municipal council also worried about the

destructive nature of the winch system and was aware that too many tourists were removing loose threads as a souvenir. In 1835 it set up a committee to consider the future care of 'Queen Matilda's Tapestry' and by 1838 a new, permanent exhibition gallery, the Galerie-Mathilde, was under construction in the municipal library in the place du Château. This was funded by money from the government, the town and from an ideal local sponsor, Count d'Houdetot, a Deputy for Calvados, who had been seriously wounded at Trafalgar, and whose ancestor was one of the Companions of the Conqueror who fought at Hastings. Edouard Lambert, municipal librarian, was appointed the first curator, and in 1840 the state declared the Tapestry a National Historical Monument.

The new gallery opened in 1842, after conservation that included replacing the old lining and adding some new sewing, based on Stothard's drawn restorations. The council and curator solved the problem of hanging a 70-metre strip in a room only 18 metres long by suspending it around the outside, then around the inside of a rectangular display unit with an opening in one of the long sides. It was placed at eye-level and was at last protected by glass panels. Tourists could also appreciate the 'thousands of curiosities, natural and artificial, fictile and fossil, from various parts of the province'[19] – the typical contents of a local museum, which were arranged in the copious shelf-room below. The radical historian Jules Michelet, who visited in July 1845, advised calling the room the *Salle de la Conquête* to give some coherence to a very confusing exhibition space. Michelet found the original less primitive than it looked in the reproductions, and incorporated it into his revolutionary *Le Peuple* (1846), which celebrated the character and dignity of the French working class, as illustrated for the very first time in the Tapestry.

As an official National Historical Monument, it became the responsibility of the Inspector-General of Monuments, the author Prosper Mérimée, who was extremely impressed by the 'marvellous effect' of the new display: 'I saw a hundred more details than I had ever noticed when winding it between the two spools.' In a period of increased state subsidy for repairs (which at last included the restoration of historic cathedrals from damage suffered during the Revolution), the government awarded an additional conservation grant of 5000 francs in 1853. This resulted in further additions to the fabric in the new chemically dyed, machine-spun wools, whose harsh colours did not always match the soft tones of the original.[20]

The arguments went on. The editor of the *Revue Anglo-française* called for a commission of French and English scholars to determine the age and provenance of the Tapestry, and stirred things up by publishing an article by Curator Lambert, which attacked the whole sequence of English interventions: 'we cannot seriously consider the evidence of Hume and Lyttelton', who had never seen 'this precious monument which celebrates our Norman nationality'. And he doubted whether the Abbé de la Rue, whom he dismissed as an honorary Englishman, had ever looked at it properly, but had probably based all his arguments on Montfaucon's poor drawings. Lambert concluded that the Tapestry was undoubtedly contemporary with Matilda, and had been made for Odo to hang in the new cathedral. He did not even deign to respond to the greatest maverick of all, Edelestand du Méril, who proposed in 1862 that the Tapestry was intended as a monument to Harold and had been made by the loyal monks of his foundation at Waltham Abbey, where his remains were said to be buried. English and French scholars alike found this interpretation so implausible that no one bothered to challenge it at all, which was surely the ultimate insult.[21]

The citizens of Bayeux, viewing their relic at last secure in a brand-new gallery in the charge of a dedicated curator, must have marvelled that it was there. Some could even remember the Revolution, the desecration of the cathedral and the mortal threats to turn the work into the cover for a wagon or the bunting for a float. No wonder they had suspected the intentions of the well-meaning, but dangerous, Paris-controlled arts commissioners who took it into care. Then they had really lost it, kidnapped by command of Napoleon Bonaparte to be paraded in the Louvre to further his imperial ambitions. Yet after its merciful return, they had inadvertently put it at greater risk by making it accessible to an over-enthusiastic public. Despite unsettled times, their Historical Monument was at last safe – preserved behind glass, every detail copied by Stothard, researched and written up by the experts. Was there anything left to say?

IV

The Gentle Touch

12

'The Queens of England'

While French and English scholars waged their debates, a new group of specialists was looking at the Tapestry from a completely different angle. These upstart and confident viewers were women who combined a passion for history with the sewing skills imposed upon all well-brought-up girls, and they discussed the Tapestry with a direct experience of embroidery. This strengthened the case for the attribution to Queen Matilda, whom they hailed as a role model – not just as a highly skilled needlewoman, but as a powerful female patron.

Attitudes to embroidery were ambivalent. Perceived as an activity that defined a lady, in the mid-nineteenth century it was constantly recorded as such in novels of modern life (including *Shirley*, *The Mill on the Floss*, *Wives and Daughters*, *Jane Eyre*, *The Woman in White*, *The Tenant of Wildfell Hall* and *David Copperfield*). But whether it was presented as an enhancing or a restrictive task often depended on the gender of the author. On the one hand, it was approved as desirable and class-reinforcing, the accomplishment of genteel and aristocratic women; on the other, it was attacked as passive, sedentary, a means of retaining the submissive feminine ideal, the only 'work' that society permitted women of a certain class to undertake. Poems by Christina Rossetti and Elizabeth Barrett Browning showed a marked lack of enthusiasm.[1]

Mary Wollstonecraft had already made the point in *A Vindication of the Rights of Woman* (1792). This passionate feminist pioneer – whose own life

broke all the bounds of respectable behaviour, by earning a living, writing for money, taking a lover and having an illegitimate child – claimed that embroidery degraded women by reinforcing their perceived fragility and self-absorption: 'this employment contracts their faculties more than any other that could have been chosen for them by confining their thoughts to their persons'. Middle-class women should not ape the aristocracy in the vanity of elaborate dress. And worse, 'sedentary employments render the majority of women sickly'. Instead of weakening their minds and bodies sewing frivolous ornament, women should extend their physical and intellectual skills by 'gardening, experimental philosophy and literature'. Her vision of a privileged woman was one who 'from having received a masculine education, has acquired courage and resolution'.[2]

Mary Lamb, better known for collaborating with her brother Charles on *Lambs' Tales from Shakespeare*, reinforced Wollstonecraft's onslaught. She wrote a challenging article, 'On Needlework', under the provocative nom de plume of Sempronia (a learned but radical Republican Roman matron who flouted convention to become a political agitator), a heartfelt piece arising directly out of her own earlier enforced career as a sempstress. This appeared in a lively monthly journal, *The British Lady's Magazine*, for April 1815, during the period of Napoleon's escape from Elba; the same issue expressed horror at the wholesale adoption of French fashions by English ladies. Lamb defined domestic sewing as 'self-imposed slavery' and an instrument of women's oppression. Her mission was to 'lighten the heavy burthen many ladies impose upon themselves' and she singled out decorative embroidery as a futile and damaging activity, which was 'in a state of warfare with intellectual development'. In addition, 'if needlework were never practised but for money', useful paid employment would be reserved for the poor, while genuinely stimulating spare time would be freed up for better-off women – the equivalent of that 'proper leisure' to which men had always been entitled.[3]

Another early campaigner for women's rights was Sarah Ellis, who extended the anti-sewing argument in her passionate tract *Women of England* (1839). Declaring firmly, 'I do not, I will not believe that women are inferior to what is called the noble sex', she demanded better education generally, and training for middle-class women so that they could earn a living. Rather than wasting time on the 'useless stitchery' they did at home, they should receive professional training in drawing patterns for printed fabrics.[4]

Other nineteenth-century women writers, however, used the history of embroidery, starting with that earliest surviving and most famous example, the hanging in Bayeux, to lay claim to female power and authorship by highlighting a medium that had previously been dismissed precisely because of its association with women. This new approach developed out of the whole background of the Gothic Revival, which reawakened interest in medieval styles and techniques and deliberately re-created the craftsmanship of the Middle Ages. Embroidery was women's particular contribution to the movement. The other crafts so laboriously rediscovered – stained glass, metalwork, tiles, stone- and wood-carving – were the products of men. Paradoxically, the Revival risked reinforcing women's dependent status at a time of their demands for greater equality, for they were meant to take their allotted place as adored and helpless creatures in the chivalric ideal integral to Victorian medievalism. Yet the creation of fine embroidery for ecclesiastical or secular use became an instrument of liberation: it gave women a specialism of their own to practise and to publish.

In her 1820 *Letters from Normandy* Eliza Stothard became the first woman to write about the Tapestry. It was another 20 years before others turned to it. In 1840, two women authors provided contrasting approaches to the Tapestry in particular and embroidery in general, representing society's polarised attitudes towards sewing.

Elizabeth Stone gave the Tapestry two whole chapters in *The Art of Needle-Work from the Earliest Ages*. She was an ambitious and versatile young writer, who, like the Brontës, had employed an ungendered nom de plume to help sell her work. As Sutherland Menzies, she had already written a popular horror story, *Hugues the Wer-Wolf (a Kentish Legend of the Middle Ages)*, for *The Lady's Magazine and Museum* (1838), a seminal piece of fiction that started a whole genre of Gothic werewolf tales. In the same year as this success, she signed a contract with the opportunistic and influential publisher Henry Colburn, a leading Grub Street figure, founder of journals and commissioning editor, to write a history of sewing. This was not published under her own name either, but was attributed on the title page to the genteel editorship of the Countess of Wilton, for Colburn was keen to exploit every possible aristocratic connection in a book aimed at a female readership.

Stone (alias Wilton) was the very first author to tackle the history of needlework. As she proudly pointed out in the introduction, 'I have

experienced no trifling difficulties in obtaining material for this. I have spared no labour, no exertion, no research. I have toiled through many hundreds of volumes for the chance of finding even a line adaptable to my purpose.' After citing a range of biblical, classical and 'Dark-Age' references, she reached the Tapestry, 'the oldest piece of needlework in the world and the only piece of that even now existing'. Her sources included Ducarel, Gurney, Dibdin and de la Rue, and she noted the ongoing debates over its date and origins. Another source must have been Hume's *History of England* because she repeated his erroneous location of the Tapestry in Rouen, where it was apparently exciting 'little local interest'. And she managed an anti-French jibe that Napoleon had failed to invade England despite his propagandist display of the Tapestry in Paris. One odd mistake was locating Harold's coronation in St Paul's Cathedral, which implied that, despite references to Stothard's and Jubinal's engravings, she had not really read commentaries on the work, but only the general discussions. Although the style was 'stiff and rude' when judged by modern standards, she lauded Queen Matilda, creator of this 'proud tribute of a fond and affectionate wife', a virtuous woman who was also capable, in her generous portrayal of the forsworn Harold, of forgiving her husband's enemy.

Stone dedicated the book to a royal patron, the dowager Queen Adelaide, widow of William IV, whose exceptional devotion to embroidery had apparently succeeded in single-handedly reforming 'the morals of a court which, to our shame, had become licentious'. Throughout, she stressed the morally improving function of embroidery and its association with other industrious royal ladies, such as Mary, Queen of Scots and Queen Charlotte. However, she revealed a pioneering, proto-feminist attitude in her claim to have written the book to provide the necessary history of a neglected but unifying activity practised by all classes of women. 'From the stateliest denizens of the proudest palace to the humblest dweller in the poorest cottage', women were ignored by (male) historians unless 'forced into a publicity little consistent with their natural sphere': their dilemma was that embroidery was an essentially private, domestic activity. Stone's ambiguities were fascinating. An instinctive social historian, when this aspect of the subject was barely in its infancy – though Thomas Carlyle had daringly proposed in 1832 that the Workshop and the Social Hearth might tell us more about the past than the Battlefield and the Court – she stated how 'it is entirely of insignificant details that the sum of human life is made up' and heralded needlework as 'a fitting subject of historical and

social record'. She added a defensive or perhaps ironic coda, 'fitting at least for a female hand'.[5]

Because *The Art of Needle-Work* broke such new ground, it received wide coverage from a press that gave much space to literary and cultural matters. The reviewer for *Tait's Edinburgh Magazine* rather patronisingly recognised the book as 'a graceful and acceptable contribution to refined and refining literature', but disagreed with the association of the Tapestry with Matilda. He (it was surely a he) came down on the side of the provocative Bolton Corney, that 'acute modern writer remarkable for attacking and demolishing the hypotheses of his contemporaries, whether they be original or traditional . . . [his views] appear to us the best supported of any theory on the subject. This gentleman would strip both Duchess and Empress of their imputed honours to confer them upon the rightful donors, thus depriving women of the merit of this beautiful and elaborate work.' The reviewer mildly chided the author for including too much historical information about the Conquest 'until the subject is fairly exhausted to all but antiquarians'.[6]

This article referred only briefly to the Countess of Wilton's editorship, which doubtless contributed to the general 'refinement' of the book. The reviewer for the weekly *Athenaeum* was more critical, attacking the noble lady for allowing her distinguished name to obliterate that of the 'unknown compiler' for what were clearly marketing purposes: 'It is really surprising that persons of rank and status should not perceive how little it is to their credit to countenance these tricks of trade . . . the aristocracy know little of the world.' But the real author was equally to blame for sheltering behind the Right Honourable Countess and it was disgraceful that 'any person of sense and education can imagine that literary fame is to be acquired in such a way'. The review was damning, too. It complained about the excess of 'antiquarian' background, and disapproved of the retrograde potential of needlework 'to seduce the sex from revolutionary reading and writing and to subdue their natures to servile drudgery'. How fortunate it was that this book appeared 'at a time when such an attempt has but little chance of success'.[7]

There is no such thing as bad publicity. *The Art of Needle-Work* became so popular that three more editions were issued in 1841 and a revised version in 1844, even though the Countess of Wilton's name still remained on the title page. (A later work on embroidery, published in 1856, still referred to 'the admirable book of the Countess of Wilton'.)[8] Stone

managed to build on her anonymous reputation to write a further 17 books, including fiction, biography and history.*

Though Stone proposed that embroidering the Tapestry demonstrated Matilda's feminine virtues, this was not the view of the indomitable Agnes Strickland, co-author of *The Lives of the Queens of England*, the work that made her into a bestselling historical writer. This was another successful venture by Henry Colburn, riding on his bandwagon of women writing about women for women, and aware of a reading public avid for history books that traced reassuring parallels with the past in an uncertain present. The biographical approach to history was considered, by male historians anyway, to be less rigorous because it required insight into characters rather than causes, so becoming more like fiction and therefore appropriate for the gentle sex to write as well as read. Colburn realised that a series of English queens' lives had a guaranteed market, and he published the first three (of twelve) volumes in 1840. The life of Queen Matilda began the whole sequence.

In this biography, Strickland dealt quite briefly with the Tapestry connection, which took up just three out of 84 pages, though previously it was almost the only thing that made the queen famous. Instead, she presented Matilda's reputation for needlework as a minor component of her wider learning and role as a patroness of the arts, who counteracted her husband's devastation of England by introducing 'her Flemish artisans to teach the useful and profitable manufactures of her native land to a starving population' and brought in architects for a major reconstruction programme. But far more important was her political role as able regent of Normandy or England, a function completely ignored by the modern historians Strickland consulted. Dr John Lingard's 12-volume *History of England* (1837), for example, mentioned Matilda just once in his long account of the Norman Conquest.

Strickland unenthusiastically described the famous hanging as 'this curious monument of antiquity', and there was a sceptical tone in her account of Matilda's labours as a 'stupendous work of feminine skill and

* Under her own name she published the feminine-sounding novels *Angels* and *The Young Milliner*, but she retained the tougher sounding persona of Sutherland Menzies to compete in the world of school textbooks, producing 'young people's' histories of France, Germany and the Ottoman Empire, as well as the more controversial *Political Women* and *Royal Favourites* (i.e. mistresses), improper topics for a lady.

Matilda & the Bayeux Tapestry

Queen Matilda at her needle, the title page vignette for *The Lives of the Queens of England*. For its author Agnes Strickland, Matilda was not merely sewing but composing 'a most important historical document'.

patience'. Nor did she think Matilda began it until quite some time after Hastings, because she had more important things to do than to be 'occupied in the labours of the loom, or the fabrication of worsted pictures'. Such greater priorities also meant that the Tapestry remained uncompleted at her death. Strickland also criticised the work on artistic grounds, sarcastically describing the comet as being far too big and looking near enough to 'singe the noses' of the gesticulating spectators. This novel interpretation of queen and Tapestry reflected Strickland's own view of needlework. She certainly could, and did, sew – a sister defensively described her as doing the popular sort of embroidery called Berlin woolwork – but her literary career, frequent travels and social life make it hard to believe that she was dedicated to her needle, and she later abandoned sewing altogether. Her failure to understand the medium is implied by her incorrect reference to the Tapestry as being made in cross stitch, which *was* however the technique of Berlin woolwork.

These independent attitudes stemmed from an unconventional Regency

upbringing as the second of six daughters of an impoverished Suffolk gentleman, whose only dowry to his girls was that same 'masculine education' advocated by Wollstonecraft – Latin, mathematics, literature and, above all, history. 'Papa approved of educating girls upon the same plan as boys because he thought it strengthened the female mind,' wrote Agnes, and five of the sisters became published writers. Marriage did not seem to have been an option she ever considered, and her domineering personality, unconventional looks and deep, mannish voice might have put off most potential suitors, quite apart from her independent spirit and commitment to study. She certainly attributed her success to the fact that 'a female author is wiser to remain unmarried'.[9]

Like Colburn, she grasped the marketing potential of royal women, and her first published work, a lament on the tragically early death of a popular princess, Charlotte, heir to the throne, was a great success. Invited by sister Eliza, then editor of The Court Journal, a gossipy magazine about London social and cultural life, to write articles about past English queens, Agnes proposed turning them into books. She knew Anna Jameson's Memoirs of Celebrated Female Sovereigns (1831), which was intended to give 'an idea of the influence which female government has had generally on men and nations'. As Colburn had published that, she sent him her proposal: he realised that he was onto another winner, and signed her up on terms that would turn out to be less than favourable to the author.

Though underwhelmed by Matilda's sewing skills, Strickland used the Tapestry in this crucial first life to warn contemporary male historians against venturing into the feminine field of embroidery. Despite their tedious arguments over its date and origins, 'it is a matter of doubt to us whether one of the many gentlemen who have disputed Matilda's claims to that work, if called upon to execute a copy of the figures on canvas, would know how to put in the first stitch'. This was her revenge on the late daters de la Rue and Corney and the rest of those 'learned individuals who are determined to deprive Matilda of her traditional fame as the person from whom this specimen of female skill and industry emanated'. Familiarity with its needlework techniques was one way of demonstrating women's entitlement to write history in their own distinctive way – her revenge upon those who wanted to put women writers down. They were not in a ghetto, but in a rival camp: 'the lords of creation . . . would do well to direct their intellectual powers to more masculine areas of enquiry and leave the question of the Bayeux Tapestry (with all other matters allied to needle-

craft) to the decision of the ladies, to whose province it particularly belongs'.

She also regarded the work as more than mere needlework, and demanded its recognition as 'a most important historical document in which the events and costumes of that momentous period are faithfully presented to us by the indefatigable fingers of the first of our Norman queens . . . in the clearest and most regular order'. Thus Matilda was no mere sempstress, for she had elevated her needle into a pen and turned herself into a historian, a role model for the present day. And the Tapestry was no longer a piece of sewing, but a significant text written by a woman.

Strickland knew Montfaucon's *Monuments* but based her own view on the Stothard engravings for the Society of Antiquaries, 'who, if they had nothing else to merit the approbation of the historical world, would have deserved it for this alone'. She claimed there was a Norman tradition that the Tapestry was designed for Matilda by Turold, the dwarf artist, who, 'attracted by the natural desire in claiming his share of the celebrity which he foresaw would attach to the work, has cunningly introduced his own effigies and name'. For this information, she inaccurately credited French historian Augustin Thierry, whose *Histoire de la conquête de l'Angleterre par les Normands* (1830) – ultimately inspired by reading Walter Scott's *Ivanhoe* – actually denied that it had any association with Matilda, which he dismissed as a recent tradition. And she patriotically, though sympathetically, speculated that defeated Anglo-Saxon women helped with the sewing, 'employed in recording the story of their own reverses and the triumphs of their haughty foes'. Strickland concluded her section on the Tapestry with a bleak moral: the fact that it remained unfinished was a 'comment on the uncertainty of human life – the vanity of human undertakings . . . arrested in full career by the hand of death'.[10]

Strickland established her reputation with *The Lives of the Queens of England*. The timing could not have been better, as Colburn also realised, because Victoria (the first female sovereign since Anne) succeeded her uncle William IV in 1837, was crowned in 1838 and married Albert in 1840. The queen graciously accepted the dedication of the work, a strategic yet generous act because she had been annoyed by Strickland's inaccuracies in another book, *Victoria from her Birth to her Bridal*, the first modern royal biography, shamelessly commissioned by Colburn and rushed out in time to cash in on the royal wedding. In that same year, Strickland was presented at court, dressed in 'violet velvet lined with primrose over Brussels lace and white satin . . . an agitating but gratifying day'.[11]

Queen Victoria herself was the first contemporary reader to realise that there were two authors of *The Lives*: although published only under Agnes' name, it was a joint work with sister Eliza, who, however, was too modest, or feared the resulting publicity, to allow her name to appear on the title page. *The Lives* were published over the next eight years to glowing reviews, with a boost to sales when clergymen denounced the sympathetic treatment given to Mary Tudor and suggested that women and children should be banned from reading the life of Mary Beatrice, Catholic wife of James II. The work was so popular that several revised, updated and illustrated editions were published over the next 20 years. As well as these, the inexhaustible sisters went on to produce *The Letters of Mary, Queen of Scots* (1842–3), *The Queens of Scotland* (1850–9), *The Bachelor Kings of England* (1861) and *The Lives of the Last Four Stuart Princes* (1872).[12]

If Strickland thought that Matilda had better reasons to be remembered than for her embroidery skills, other women writers disagreed. In 1842, Frances Lambert published her *Hand-book of Needlework*, which combined a general history drawn heavily from Stone's *Art of Needle-Work* with a thematic survey of the techniques involved. Lambert offered a qualified acceptance of the Tapestry's attribution: 'the celebrated needlework of Bayeux . . . is *supposed* to have been the work of Matilda, Queen of William the Conqueror, and her maidens' for presentation to Bayeux Cathedral, while a patriotic footnote reinforced Strickland's point that 'the greatest part of it was most probably executed by *English* ladies, who were at this period, as we have before stated, celebrated for their needlework'. She expressed some reservations about the style: 'this curious piece of work appears to have been wrought without any regard to the natural colours of the subjects depicted . . . for instance a blue horse has two red legs and a yellow mane, whilst the hoofs are also of another colour'. However, while accepting that some commentators called the work rude and barbarous, 'in the needlework of this age, we must not look for the correct outline of the painter . . . taking the whole as a piece of needlework, it excites our admiration, and we cannot but wonder at the energy of the mind which could, with so much industry, embody the actions of a series of events ever memorable in the pages of history'. Lambert returned to the Tapestry two years later in *Church Needlework* (1844), a sequel commissioned by her publisher John Murray in response to the growing demands of Gothic Revivalists for accurate and authentic source material. She now managed

to bring in the ecclesiastical connotations of the Tapestry, 'originally suspended on festival days against the wall of the cathedral from which it takes its name'.[13]

A general image prevailed of the medieval embroiderer as a noble lady stitching away alone in some lofty turret, for whom the only way 'to enliven her tedious hours' was by 'depicting the heroic deeds of her absent lord'.[14] *Treasures of Needlework* (1855) gave this class-ridden perspective a more progressive interpretation. The authors were two professional needle-women, Mrs Warren and Mrs Pullan, who designed, made and sold everything for home sewing from Mrs Pullan's London shop. Their preface suggested that the prophecies of Mary Lamb and Sarah Ellis had at last been fulfilled: in the Middle Ages, 'the higher or picturesque gradations [of needlework] were confined to the delicate fingers of queens and court ladies', and they paid homage to Matilda, 'the accomplished consort of William the Conqueror, who has left a memorable achievement in the Bayeux Tapestry, a wondrous work, full of beauty . . . interesting and spirited'. But now, any woman could emulate these aristocratic skills with the aid of a properly illustrated manual such as theirs. Its enthusiastic demonstrations of what to make revealed the authors' conservative views on the status of women. Matilda should be emulated as dutiful wife rather than powerful regent ('to toil for those we love can never be a dull or painful task for a woman'). Then there was a daunting list of the products of love – a crocheted Stilton-cheese serviette, a doily for a round cruet-stand, a mat for a hyacinth glass – solutions to 'that frequently asked question, "what will be the most valuable thing I can make for a Fancy Fair?"' But they did recognise the need to sell such goods for profit and for that reason recommended the highest possible standards because amateurish work was neither acceptable nor marketable.[15]

A year later, Mrs Wilcockson's *Embroidery, its History, Beauty and Utility* (1856) tried to combine 'plain instructions for learners' with a historical survey. Again, it presented embroidery as a socially levelling process – 'the needle is as becoming in the palace as in the cottage' – and she praised that great equaliser, Berlin work. She also approved of the Tapestry, 'a work which, for its early date, the greatness of the design and the ability with which it is executed, stands unrivalled'. Set in the context of its times, 'the drawing is coarse and unnatural because there were no artists in that age capable of producing a good picture; and the want of a variety of colours and the knowledge how to blend them has given a barbarous appearance to the

whole piece'. But it was invaluable as a historical document. In a footnote, Mrs Wilcockson challenged its connection with Matilda and suggested that the design was 'monkish' in origin.[16]

Most women accepted the conventional attribution, which not only underpinned their accounts of the Tapestry, but also established a popular historical format. Another work the ever-enterprising Colburn commissioned was Mary Anne Green's *Lives of the Princesses of England from the Norman Conquest* (1849). Dedicated to the antiquarian Dawson Turner, who had written up his own visit to the Tapestry in 1820, her preface defined the topicality of the subject: 'the domestic annals of female royalty are the more eagerly welcomed at a time when the throne is occupied by one who fills with equal grace the position of queen, and wife, and mother'. Green began with the daughters of William and Matilda, and mentioned the Tapestry in her study of Adeliza, Harold's alleged betrothed. She disagreed with Douce that the Tapestry's Ælfgyva represented this princess: 'this conjecture is rendered improbable by the fact that the figure in question is that of a woman, whereas Adeliza was a child at the time'.[17]

The problematic issue of Ælfgyva's identity was an integral element of the first historical novel about the Tapestry. *Les broderies de la reine Mathilde, épouse de Guillaume le Conquérant* epitomised the worst fears of male historians: 'we do assuredly lament that people should be found to write history who ought to be writing novels . . . we must plead guilty to a great dislike for the growing tendency among women to become writers of history . . . what they produce is at the best a pretty phantasmagoria of coloured figures'.[18] It presented history as romantic fiction, and its author was a Frenchwoman, Emma Liénard. Published in Bayeux in 1846, the novel celebrated the accessibility of the Tapestry in its new museum, where she had clearly been able to examine it thoroughly. Her book confidently and innovatively blended fiction with history, for she added a formidable range of end-notes, which demonstrated an impressive grasp of Norman and French documentary sources.

The heroine, Margaret d'Anscarise, was fictional, but the other main characters were real. Much of the story took place in William's palace at Rouen, where the orphaned Margaret became a companion to 'Elgiva', daughter of William and Matilda in the early months of 1066. Here Matilda and her circle had already started work on the Tapestry. Liénard provided an ingenious and touching reason for its detailed account of Harold's

adventures in France, events hardly mentioned in the chronicles and whose depiction in the Tapestry has never been satisfactorily explained: Matilda planned the hanging to celebrate her daughter's love for Harold. Begun after their betrothal, the project helped ease Elgiva's broken heart after Harold assumed the throne of England and William broke off the engagement.

The Tapestry played a key role throughout. Margaret's first meeting with Matilda and Elgiva took place in the 'Tapestry Gallery' in the palace, where the noble ladies supervised the women embroidering the linen, which was 'stretched on frames extending the whole length of the room'. This was a more accurate image than those nineteenth-century paintings that showed Matilda and her ladies stitching away at strips draped loosely over their laps, proving that Liénard understood the techniques she was describing: Matilda drew and stitched the outlines, then her assistants filled in the patches of colour. The novel defined the work as distinctly non-Norman. Matilda had the high-quality linen especially imported from her native Flanders, in response to Harold's suggestion to make the work, for he told Matilda how Anglo-Saxon ladies 'were always occupied at home in embroidering pieces of tapestry'. Because he had studied the sewing techniques of his beautiful and talented sister Edith, he could explain the stitches to Matilda, and even suggested that he should become the subject. Liénard sided with Harold rather than William: it was unreasonable Norman influence on Edward that made him banish the Godwins, and he did not leave the crown to William, but to Harold, his acknowledged successor. William was a duplicitous bully, only kept in check by Matilda's skill and guile. Harold came to Normandy to retrieve the hostages, but William cheated him into swearing an oath whose full implications he did not realise till too late. The project so impressed Odo that he wanted to hang it in the cathedral that he was just starting to rebuild.

Liénard's detailed studies encouraged her to come up with explanations for some of the puzzles – the chronologically reversed sequences of William's messengers (a genuine mistake), and Edward's funeral (breaking news). The Ælfgyva scene was of course the betrothal, showing Elgiva with the clerk who drew up the contract. But after Harold realised that William had tricked him over the oath, he renounced her and returned to England. Elgiva tried to ease her pain by embroidering his coronation herself. The rest incorporated eye-witness accounts, hot news brought by the gallant Vital, Margaret's lover, whose image she also stitched herself. But Elgiva

fell into a decline when she saw the image of Harold's death, not by an arrow in the eye, but by a Norman sword. Sent by her father to marry King Sancho of Spain, she died on the voyage (this was a dramatic exaggeration of the alleged betrothal of one of William's daughters) and, in accordance with her last wish, was buried in Bayeux Cathedral where the Tapestry, the memorial of her love, would hang on feast days. So Matilda refused to sew the final scene, even though it was meant to hang around the nave of Westminster Abbey to celebrate William's coronation.

Like other contemporary viewers, Liénard did not admire the workmanship unreservedly, but considered it good for its time. Although 'a rude work' today, this was a period when 'art and science have multiplied objects of comparison a hundredfold . . . it is easy to criticise these early attempts'. But it was direct and moving to those who made and saw it.[19]

Reclaiming the Tapestry from its female appropriation was a schoolteacher from Newcastle upon Tyne, the Reverend Dr John Collingwood Bruce. A spare-time archaeologist, antiquarian and expert on Hadrian's Wall, he was inspired by 'a holiday ramble in Normandy' in 1851 to offer a series of lectures to the cognoscenti of the Newcastle Literary and Philosophical Society. As visual aids, he created, with the help of his pupils, a series of panels showing the whole Tapestry at full size (only omitting the rude bits), scaled up on paper from the set of Stothard engravings that the Newcastle Antiquarian Society had acquired. Bruce made 30 panels in all, outlining the designs in ink and painting them in watercolour, then mounting them on linen set in wooden frames. He used these as an essential accompaniment to his lectures, for he suspended them by loops on the wall and one of the boys indicated key scenes with a pointer. In 1856, he published these talks as *The Bayeux Tapestry Elucidated*. It was the first full account of the Tapestry in English.

Here Bruce mocked Agnes Strickland's demand that those who studied the Tapestry must first understand embroidery. Conceding that 'the needle of the high-born dame' was one way of recording history, he still considered worsted stitches as surprising tools for 'so important a document', although admittedly they were the only way a dutiful wife such as Matilda could support her husband. While accepting her role in the project, and therefore its early date, Bruce contrived to make it as English as possible by suggesting that she was assisted by the wives and daughters of the Anglo-Saxon nobles whom William took with him as hostages on his first return trip to Normandy after Hastings. However, though women had sewn it, they were

certainly neither capable of designing it (which was probably done by an artistic cleric) nor of composing the Latin inscriptions, which 'required the assistance of some educated person'. And he rightly challenged Strickland's suggestion that the dwarf Turold was the designer: 'I have been unable to meet with any authority for this statement.' With even less authority, however, Bruce invented an Italian designer, on the alleged basis of links between Normandy and Italy at that time. A footnote claimed that 'in a short visit which I made to Italy in the winter of 1853–54, I have seen a *vetorino* [a coachdriver], when protesting that his exorbitant charge was a most reasonable one, throw himself into all the contortions exhibited in the Tapestry'. Turning to Strickland's unreasonable requirement – 'before we argue, she wants to know if we can sew' – Bruce humorously admitted that he would not like to be put to that test, 'and therefore it may be as well at once to exercise the best part of valour and beat a hasty retreat'.[20]

Historian Edward Freeman unleashed a savage critique of Strickland in his magisterial five-volume *History of the Norman Conquest of England* (1867–76). As she had done, he accepted the Tapestry as an historical source of the highest authority, on the grounds of its contemporaneity to the events shown, its broadly pro-Norman stance (which was not, he pointed out, as extreme as some of the chroniclers suggested) and its possible association with Odo (although definitely not with Matilda). He suggested the designer might have 'seen the scenes which he thus handed down to later ages'. And he challenged the earlier authorities who had queried its early date. But he reserved his worst scorn for the celebrated lady historian – 'I suppose I am not expected to take any serious notice of some amusing remarks on the Tapestry made by Miss Agnes Strickland' – and attacked her unsubstantiated attribution of its design to Turold: 'Perhaps even "a lord of creation" may venture to ask where that Norman tradition is to be found.' He believed that 'the needle was a bad instrument for surmise and insinuation' and concluded with another sneer before 'I return to the everyday world in company with Dr Collingwood Bruce'. Freeman knew the original well, unlike Strickland, and did not hesitate to rub this in. Stothard's drawings were good enough but 'I doubt whether anyone fully takes in what the Tapestry is till he has seen it with his own eyes.' He had personally examined it on three separate visits to Bayeux in the 1860s, and commended the present display, 'stretched out around the room at convenient height where it may be studied with the greatest ease.'[21]

13

Visitor's Book

Housed in its new gallery, the Tapestry was a major tourist attraction that placed the remote, sleepy little town of Bayeux firmly on the map. It got a good write-up in the *Hand-book for Travellers in France,* compiled by publisher John Murray the Third in 1843. The fact that France now merited a substantial English guidebook was evidence of a profound cultural change. Though Paris had always been a magnet, eighteenth-century Grand Tourists generally hurried through the rest of the country en route for Italy. During the Revolutionary and Napoleonic Wars, France was virtually out of bounds to most British visitors. But now there was peace and a wider social mix of tourists, whose travels were made easier by the advent of the railways and who were more interested in medieval monuments than Roman remains or Renaissance palazzi. So Murray's *Hand-book* not only fulfilled a need, but positively encouraged more visitors by making it all sound so easy.

Murray listed Bayeux on Recommended Route 26 (Caen to Cherbourg via Bayeux) of his three-week itinerary of Normandy, a region 'decidedly among the most attractive portions of France . . . [with its] varied outlines of swelling hills waving with corn [and] beautiful valleys abounding in orchards and rich pastorage . . . above all for remains of antiquity'. Bayeux was still relatively inaccessible because France had 'allowed herself to be outstripped by her neighbours' in railway development. In 1843, there was only one useful line, Paris to Rouen, although Rouen to Le Havre was under

construction. So Caen was best reached by steamboat from Le Havre, and Bayeux by the daily *diligence* services from Caen or from Cherbourg via St-Lô. The *diligence* was 'a carriage as heavy as the largest piece of field artillery without a skid to lock either of the wheels', as one Normandy tourist described it, powered by six horses, and so massive that it managed to fit four different classes of passenger on one set of wheels.[1]

According to Murray, Bayeux (where the Hôtel de Luxembourg was the only approved accommodation) was 'a quiet and dull ecclesiastical city, with much the air of some cathedral towns in England. Its only curiosities are its Tapestry and its Cathedral.' He applauded the recent move of the Tapestry from the Hôtel de Ville, 'where it used to be unwound by the yard from a roller, like a piece of haberdashery, and subjected to the fingers as well as the eyes of the curious', to the municipal library in the Place du Château. Here it was 'more carefully preserved and quite as conveniently exhibited under a glass case'. Naïve spectators might 'look upon it merely as a long strip of coarse linen . . . rudely worked with figures worthy of a girl's sampler', but, the *Hand-book* sternly advised, you should overlook the red and blue horses, concentrate on the spirited drawings and appreciate it as 'a curious historical record of peculiar interest to an Englishman' because it was politically biased 'to present Harold as a usurper and William as the rightful heir to the crown'. And worse, when Napoleon of hated memory was planning to invade England, he 'caused the Tapestry to be transported from town to town and exhibited on the stage of the playhouses between the acts, to stimulate the spectators to a second conquest'. This was an embellishment of the misunderstanding first voiced by Dibdin in 1821, based on memories that the play *La Tapisserie de la Reine Mathilde* had toured the Boulogne camps.[2]

The *Hand-book for Travellers in France* was so popular that Murray revised and updated it in 1847 and again in 1848. It was this latest edition that a newly-wed couple took with them on their tour of Normandy that year. The husband, a respected art writer and critic, had already worked for John Murray by contributing the essential Paintings section to the 1847 *Hand-book for Travellers in Central Italy*. However, this trip was to enable John Ruskin to renew acquaintance with the cathedrals of northern France, his interests shifting from painting to architecture as he contemplated the wider relationship between art and society. Mr and Mrs Ruskin had been married for four months, although their marriage had not yet been (and never would be) consummated. It was 19-year-old Effie's first trip across the

Channel and only the second time that 29-year-old John had ventured abroad without his possessive elderly parents.

The year 1848 was a year of revolutions in Europe, but by summer it was safe enough to travel to France, whose political upheavals had culminated in the declaration of the Second Republic in February. The rapid expansion of the railway network, now providing lines from Boulogne to Paris, and from Dieppe to Rouen, enabled the Ruskins to reach Normandy easily, although they had to use the *diligence* (travelling 'first-class' in the private coupé section at the front) to get around the west of the region. On 21 September they drove from St-Lô to Bayeux to spend the day there, as they intended to sleep that night at Caen. Ruskin would have liked longer in the cathedral, but made time to see the Tapestry, which he described as 'the most interesting thing in its way conceivable – and delightfully visible and preserved'. This was in a letter to his father, to whom he wrote almost daily (often apologising for the extra expenses, blamed on his young wife, incurred during their four-month tour). His valet and general assistant, George, was also impressed, and copied into his own journal the inaccurate information from Murray's *Hand-book* that Napoleon had toured the work around France.[3]

Its images remained fixed in Ruskin's photographic mind, for he kept returning to it in later works. In *The Stones of Venice* (1853) he compared it to one of the early mosaics in the north transept of St Mark's Cathedral, a busy procession scene 'closely resembling in its treatment the Bayeux tapestry . . . one of those bold pieces of picture history which we in our pride of perspective, and a thousand things beside, never dare attempt'. This proved how the most sensitive of critics accepted it on its own terms, unlike the majority of spectators, who were bothered by its lack of pictorial realism. And he returned to it in a discussion of the treatment of water in art, from Egyptian frescos down to the mosaics of Torcello: the Tapestry's undulating lines represented transparency in 'a manner absolutely identical' to the others. As well as admiring its artistic effects, Ruskin was fascinated by the wider concepts of weaving and spinning, and several times compared Matilda's labours to those of Homer's Penelope or the legendary Arachne, the first creator of woven stories. In one of the very last works of his increasingly troubled mind, *The Storm Cloud of the Nineteenth Century* (1884), he defined needlework as necessary for the prosperity of a nation: embroidery stitches drew 'the separate into the inseparable', their culmination being 'the needlescripture of Matilda the Queen'. This was 36 years after his visit to Bayeux.[4]

Murray in hand, encouraged by the ever-widening railway network now covering France like a spider's web, more and more English tourists flocked to the town's chief attraction. The amateur artist George Musgrave, on a sketching holiday in Normandy in 1855, bribed the authorities for a private view. To make the most of it, he 'borrowed a light chair from the good-natured old woman who kept the Porter's Lodge' and spent two-and-a-half hours in solitary contemplation and sketching. For someone trained in the conventions of life drawing, he felt the Tapestry lacked realism: 'some of the particulars of this artistic chronicle are exhibited in so ludicrous a style of portraiture as to provoke immediate laughter'. But it reinforced a nostalgic patriotism: 'I think the generality of British travellers will always, more or less, behold with a feeling akin to regret, the defeat and death of Harold.' Musgrave was not impressed by Bayeux, 'a goodly city . . . but un peu triste and rather too lifeless for any but reading men, painters and other sedentary subjects'. Yet this was when the Hôtel de Luxembourg was so packed with officers en route for Caen to celebrate the Emperor's fête that the landlady kindly let Musgrave sleep in a makeshift bed behind the bar.[5]

Had he been in Bayeux just a week earlier, his private view might have been interrupted by three Oxford undergraduates who were already acolytes of Ruskin. William Morris and Edward Burne-Jones came to Bayeux with their friend William Fulford on the visit to northern France in 1855 when 'the grandeur of French churches, the beautiful statues and the stained glass and the cliff-like buttresses' conjured up visions of medieval romance and inspired them to abandon planned careers in the church in order to devote their lives to art. Did seeing the Tapestry contribute to this decision?

It was meant to be a walking tour, and the purist Morris, ignoring unsuitable shoes and aching feet, raged against the newfangled railways spawning their way over the countryside. Despite their best efforts, he was forced to travel to his glorious Rouen 'by a nasty brimstone, noisy, shrieking railway train . . . verily railways are ABOMINATIONS and I think I have never fairly realised this fact before our tour'. After an epic walk of 40 kilometres from Rouen, they took a boat from Le Havre to Caen, then the *diligence* to Bayeux, where they stayed from 4 to 6 August 1855. Despite annoyance at being denied access to parts of the cathedral, where the choir and transepts were at last undergoing restoration, Morris loved the Tapestry and reported to his mother that it was 'very quaint and rude, & very interesting'.[6] It definitely had an impact on his own work, not just in his general fascination with textiles, embroidery and real tapestry – all products of the firm he founded in 1861 – but more immediately.

Oxford and the church abandoned, he and Burne-Jones took lodgings in Bloomsbury, whose unfurnished bleakness they transformed into an eccentric medieval playground of massive wooden furniture that they painted with flowers and figures, pieces of armour, swathes of rich fabrics and general artistic clutter. Morris determined to cover the walls with panels of linen embroidered with worsted (the Tapestry's fabrics), designed and made, at least partly, by himself. For period authenticity, he commissioned an old-style embroidery frame, and had wools dyed to the desired subtle shades, with which he sewed laidwork stitches with a darning needle (the only eye wide enough for the thick ply). Having mastered these techniques for himself, an essential preliminary to all his design work, Morris taught them to 'Red Lion Mary', their long-suffering housekeeper, and supervised her work. Although his hangings did not copy the narrative subject matter of the original, he did use animal and foliage patterns in the borders, taken from a manuscript of Froissart's *Chronicles*.

When Morris was furnishing his first married home, the Red House, in 1859, he devised a set of wool and linen hangings for the drawing room depicting medieval heroines, and trained his wife Jane and her sister Bessie to embroider them in laidwork, with the aid of visiting friends like Georgie Burne-Jones. He also designed curtains for the bedroom which Jane and Bessie decorated with a daisy-pattern that showed how well they had mastered the textured stitch.

In 1858, the Tapestry became even more accessible to tourists when the Caen-Cherbourg railway line was completed. Napoleon III made the inaugural journey in August, and the poet and journalist Théophile Gautier reported the trip for *Le Moniteur*. Gautier described his visit to Bayeux in more detail a few years later. 'Have we time to see the famous Tapestry? – Yes, the train doesn't leave till 5.00.' Having heard and read so much about the iconic work, he decided that the drawing style of the original reminded him of the primitive art of the Etruscans, or of figures on Greek vases. He compared Matilda's endeavour to that of Helen of Troy, who sewed the Trojan Wars, and marvelled that, despite 'vicissitudes and revolutions, this little piece of canvas has survived for 800 years'.[7]

Seeing the Bayeux masterpiece made a lasting impact on the poet laureate, Alfred, Lord Tennyson, who transmuted its images into verse. The Tennyson family visited the museum in the summer of 1864 at the end of a touring holiday that had taken in Paris, Chartres and Brittany. Lady

Tennyson, whose external fragility concealed a steely and protective devotion to her husband, kept a journal whose ultimate purpose was to fulfil her wifely duty to posterity by recording the life of a great man – just like Matilda. On 1 September, she wrote: 'The Bayeux Tapestry extremely interesting. It gives one a feeling of perfect truthfulness. The horses very spirited many of them. The houses great and small with the rounded arches such as we saw in Brittany. The object of the pieces seemed to be the justification of William. A good wife's deed. The oath is very fine. Alfred is, I hope, glad to have been here.'[8]

This second Matilda's anxious 'I hope' was superfluous. The Tapestry so impressed Alfred, who absorbed every detail and nuance, patch of colour and dramatic gesture, that it provided an essential backdrop to his tragedy *Harold*, written ten years after the heady distillation had time to mature. Some passages were inextricably linked with what Tennyson had seen rather than read, and he acknowledged the hanging as one of his main sources of inspiration. This is obvious in a number of passages, such as the lyrical account of Harold dragging the soldiers from the quicksands, when he 'Haled thy shore-swallow'd, armour'd Normans up' and Edward's deathbed scene, which involved the characters of Edith, Stigand and Harold. Most powerful was the running commentary on the battle, fought offstage, that Stigand gave to Harold's mistress. In this sequence, Tennyson effectively described the Tapestry itself: horses roll and plunge, lances snap and shiver, corpses pile up, and finally 'the arrow – the arrow! – away!'[9]

A year after the Tennysons, George Eliot visited Bayeux. She had already used embroidery and sewing as a subversive attribute that questioned the accepted role of women; her rebellious, tomboy heroine, Maggie Tulliver, in *The Mill on the Floss* (1860) appeared to find a new peace and maturity while sewing, but it was only because it gave her time to think about the books she had fought to read. Eliot and her companion G. H. Lewes took a short holiday in Normandy and Brittany in August 1865 as a much-needed break from *Felix Holt*, begun in March, but not going well. She kept a holiday journal into which she copied extracts from the inevitable Murray *Handbook*, now in its ninth edition to keep pace with the developing rail network. On 14 August, Eliot and Lewes boarded the 10 a.m. train from Caen and 'arrived at Bayeux under a grey sky, the rain already falling in sparse drops as we walked from the station towards the town'. Although Eliot enthused about the cathedral, where they spent all morning, the Tapestry received a less than cursory mention: after lunch, for which they returned to the station

restaurant, 'having previously seen the Tapestry, now at the Library' they went back to the cathedral. That was all. Perhaps she was genuinely unimpressed by a piece of needlework, but the lack of any response is curious, especially given the wealth of delightful details with which she embellished her account of the tour. Needlework, however, continued to figure as a sinister attribute in her writing, embraced, for example, by Rosamund Vincy in *Middlemarch* (1871), who hypnotised Lydgate into their disastrous marriage by deploying her musical and embroidering skills.

Charles Dickens was even less impressed. On a baking hot day in the summer of 1867, he mocked the more earnest English tourist: 'three ladies flashed by us – ladies in carmelite costumes and broad straw hats, from across the Channel like ourselves, but burdened with bags and in virtuous hot haste to accomplish their duty towards Bayeux. "They are coming from the Tapestry" we say.' Dickens found the exhibition poorly advertised – 'we see no building that bears a frontispiece of publicity' – and had to enquire where the library was from a bored woman darning a stocking, who turned out to be its concierge. He was rude about the great work, which he had previously thought to be by 'professional embroidresses commissioned by Odo, but now we have seen it, goodbye to that notion. It is certainly the work of amateurs; very feeble amateurs at the beginning and very heedless some of them too.' However, it did improve, but only, he patronisingly asserted, because 'some good-natured gentleman, with a better idea of drawing a horse than the ladies, was pressed into their service and helped them with their design'. Dickens grudgingly concluded that it was 'not beautiful, nor exquisite, nor even curious as handicraft . . . but still it makes an oddly vivid and fresh impression on us.' He noted the other exhibits (pictures, scientific and archaeological collections), then with relief went to sit in the sunshine in the place du Château, where 'no country town in England was ever drowsier in summer than Bayeux today'.[10]

The Tapestry also featured in another widely read travel series, Baedeker's *Guides to Europe*, compiled for German tourists in the 1870s and translated into English in the 1880s. The *Northern French Guide* described Bayeux, whose 8,347 inhabitants represented a considerable decline from the 12,000 recorded in the middle of the eighteenth century, as a town that 'still retains many quaint old houses which will delight the antiquarian'. It described in detail the hanging's 58 scenes, and solemnly advised visitors that 'its importance as a historical document far outweighs its interest as a specimen of the domestic art of the eleventh century'. Judging the work by

the standards of truth to nature (like Lady Tennyson), rather than by its innovation and daring (like Ruskin), the compiler disapproved of the unrealistic colour scheme, but thought that there appeared to be genuine attempts to portray Harold and William. Despite the ancient tradition, it was probably not by Matilda.[11]

Another writer who claimed to recognise authentic portraiture was the novelist Charlotte M. Yonge, a protégée of the famous historian of the Conquest, Edward Freeman. In *Cameos from English History from Rollo to Edward II* (1868), she claimed that Odo was easily recognisable by his 'broad face, large person, shaven crown and chequered red and green suit'; his distinctive spirit and expression were consistent throughout, while William and Harold also bore 'countenances which are not to be mistaken'. She confidently attributed the work to Matilda's own hands, a thank-offering for the victory and a gift for Odo. But, broken-hearted by Robert's rebellion against his father, death came before she had time to finish it. Yonge based these observations on her own facsimile of the Tapestry, which survives today.[12]

14

A South Kensington Scandal

For those unable to travel to Bayeux, it was possible, during the 1860s, to inspect the very small fragment of the Tapestry (just 8.5 by 6.5 centimetres) on exhibition in the recently opened showcase of historical and contemporary art and design, the South Kensington Museum. Displayed beside the plaster cast of Harold made from one of Charles Stothard's illicit wax impressions, the diagonal lines and a foliage scroll embroidered in red and green suggested that the piece came from the borders. In 1870, the Museum's first textile catalogue explicitly spelt out the Stothard connection, for it recorded that Eliza Stothard had snipped the fragment off in 1816, and that the Museum had bought it from the estate of John Bowyer Nicholls in 1864. The information about Eliza's theft, it claimed, was in the text that accompanied her husband's engravings published in the Society of Antiquaries' *Vetusta Monumenta* series between 1819 and 1823, which included a drawing of the piece now displayed in the Museum. Thus was established a canonical element of the Tapestry's history, although the real thief was of course Charles Stothard.

The Reverend Dr Daniel Rock, a retired Catholic priest, whose considerable antiquarian, historical and ecclesiastical expertise greatly assisted the new museum and its collections, prepared the catalogue. He sat on the committee selecting medieval works, and wrote learned articles on various aspects of art and the liturgy. But on this occasion his scholarship included a serious error, for the Stothard plates never had an accompanying text.

The controversial fragment, which the French accused Eliza Stothard of stealing. Her husband was the real culprit.

The Antiquaries had commissioned an account of the Tapestry for future use from J. R. Planché, Somerset Herald and Fellow, but rejected his draft as unsatisfactory. Collingwood Bruce cited the lack of any text as the justification for his own 1856 book, 'to supply meanwhile some little assistance to the student of history'.[1] So the basis of Rock's allegation was uncertain, but perhaps derived from information associated with the fragment when the Museum acquired it. His catalogue entry pointed out that, although tiny, the piece was valuable because it showed the nature of the material and the type of stitch. He then set it in context by discussing the whole Tapestry, whose entirely English nature he stressed, claiming that it was probably made in London (a completely novel suggestion), quite some time after Hastings, perhaps as a joint commission by Vital, Wadard and Turold. To further undermine its Frenchness, he denied any connection with Matilda because 'the coarse white linen and common worsted would never have been the materials which any queen would have chosen'. And there was further proof in the fact that she was never shown in the work. 'Surely the dullest courtier would never have forgotten such an opportunity for a compliment to his royal mistress by putting in her person.'[2]

The Museum fragment was the only portion of the Tapestry available for anyone to see for a while; in the summer of 1870, the flourishing Normandy tourist trade came to an abrupt halt on the outbreak of the Franco-Prussian War. On 19 July, France declared war on Prussia; on 4 August German troops poured over the border into Alsace, defeated the French in three

battles and began to march on Paris. The invading troops came close enough to Bayeux 'to cause most serious alarm to the authorities for the safety of their precious treasure'. (This was in a climate of such fear that the Louvre evacuated many of its paintings to Brest and hid the Venus de Milo in a secret passage.) The town's precautions could have caused almost as much damage as the soldiers, for 'the Tapestry was taken from its case so rapidly that many of the sheets of glass under which it was kept were broken, it was then tightly rolled up and packed into a cylindrical-shaped zinc case, the lid of which was soldered down. What later ensued is a secret which the authorities desire at present to keep – they do not know what kind of danger the future may have in store for the Tapestry, nor do they think that the proper moment has arrived to publish their hiding place.'[3]

The author of these words got his information directly from those involved, for he was in Bayeux just two years later, after peace had been negotiated and the Third Republic was about to replace the Second Empire. Frank Rede Fowke of the South Kensington Museum was part of the second English project to record the Tapestry for posterity, which the hazards of war had made even more urgent. But this version would no longer depend on the fallible human hand and eye of the likes of Stothard or Sansonetti. It would be created by that thoroughly modern, scientific and impartial tool, the camera.

Photographing works of art was an important new element of the museum world of the 1850s and 1860s, and it was a medium appreciated by no one more than Henry Cole, the dynamic and multi-careered director of the South Kensington Museum. Set up from the profits of the Great Exhibition of 1851, his original idea, the Museum was the most recent addition to the pantheon of free public exhibitions. (The British Museum opened in 1753, the National Gallery in 1838, the National Portrait Gallery in 1858.) It was run by a specially created government Department of Science & Art, which reported to the Privy Council on Education. Director Cole also served as the Department's Secretary for Art, so there were very close links between the Museum and the government's education policy. Cole, who was fascinated by new technologies and was already a skilled photographer, pioneered the use of the camera to record the Museum's own works and buildings, to widen the scope of its displays by exhibiting images of great works from other collections and, not least, to sell prints of all these to the public as a profitable side-line. His proactive acquisitions policy also embraced the display of reproductions and replicas

in the form of casts and photographs. By 1869 the Museum was attracting more than a million visitors a year.[4] So it was almost inevitable that the alleged Englishness of the Tapestry, the interest the fragment aroused, and the technical means at their disposal encouraged Cole and his colleagues to plan a full-sized photographic replica of the Tapestry to put on show in South Kensington.

The idea first emerged when the Reverend Rock was researching the Tapestry for his textile catalogue. Henry Austen Layard, archaeologist, diplomat and politician (whose excavations at Nineveh in the 1840s and 1850s were amongst the earliest to appreciate the contribution of photography to archaeology, and whose publications of them became a blueprint for accurate recording and printing techniques), was one of the 'great and good' on the Museum's governing body, the Council of the Department of Science & Art. The minutes of the Council meeting on 3 March 1870 reported 'Approval of Mr Layard's proposal that full-size copy of the Bayeux Tapestry be made. Mrs Cowper to estimate cost of photographing – series to be coloured by students. Rev Canon Rock to prepare memoir.' Isabel Agnes Cowper was one of the many professional women photographers whose careers are little known today, yet she was responsible for organising much of the Museum's photography as well as being one of its official photographers. She commissioned commercial photographer and publisher Joseph Cundall, whose firm already did exhibition and catalogue work for Cole, to provide estimates for the project before the Museum could approve the scheme and approach the Bayeux authorities officially.[5]

The Franco-Prussian War prevented Cundall from safely visiting Bayeux until July 1871. Then he reported promptly back to the Council on 2 August that he would need 180 glass negative plates to record the whole work, and suggested that it could be published in various ways: in a continuous roll like the original; in a loose-leaf portfolio version like the Antiquaries' Stothard set; and as a bound volume, with perhaps a less expensive version for schools and museums. He trusted the Department would 'give its sanction to the publication of this work as one of National Historical importance'. If so, it must negotiate permission from the Bayeux museum authorities, and agree to purchase from him six to eight copies of the portfolio version, each costing £50 plain or £75 hand-coloured. On the basis of this guaranteed order, the Arundel Society (which had been founded in 1848 to improve public taste by reproducing works of art and had by the 1860s become the approved publishing house for the Depart-

ment of Science & Art), agreed to produce the work 'without further cost to the Department'. Cundall proposed to use the latest techniques to record the historic textile: 'advantage will be taken of the new mechanism (and absolutely permanent) process of photography, probably that known as the "Albertype"'. This used a chemically treated plate to obtain high-quality prints. He offered to return to Bayeux to take two sample photographs, promising the additional travelling costs would not exceed £20.[6]

A week later, Cundall got the go-ahead in a letter from the secretary of the Lords of the Committee of Council on Education, which emphasised the educational and edifying nature of the mission: 'their Lordships consider that reproductions of these interesting works would be of service to the Schools of Art in the United Kingdom which are under the Science and Art Department, and of general interest to this and other countries'. So they authorised Cundall to return to Bayeux, take his test photographs and 'report what measures may be necessary to procure permission'. This was easier said than done. The Bayeux authorities raised objections on the grounds of risk to the hanging, and it took another year to persuade them to give consent. This was secured only with the aid of a substantial bribe – the gift of the Museum's fragment of the Tapestry.

Henry Cole made this offer in August 1872 in a letter to the mayor of Bayeux. Pulling out all the stops, he wrote in French, – perhaps Gallic incomprehension had been one of the problems in the negotiations – signing himself not merely director of the South Kensington Museum but 'Companion of the Bath and Chevalier of the Légion d'Honneur & & &'. He came straight to the point: some years ago, the Museum had acquired the fragment which, according to the account in *Vetusta Monumenta*, had been removed from Bayeux by a Mrs Stothard. Appreciative of the consideration being given by the guardians of the Tapestry to the photographic project, the Lords of Education begged them to accept this piece as evidence of their gratitude and in the hope that it might be restored to its original position. Cole now implored the mayor to put this offer to the municipal authorities and *again* to use his influence in enabling the project to go ahead, for the Lords of the Council cared every bit as much as Bayeux did for the safety of their monument.

It was unfortunate (though perhaps not surprising) that Cole, or whoever on his staff drafted the letter, had not double-checked the information in Rock's catalogue, but simply repeated it. However, suggesting that the piece had been removed by Eliza Stothard, and not by her husband, put a

smooth diplomatic gloss on the negotiations. This was not a calculated insult to Bayeux by a famous artist, but merely a moment of typical girlish weakness by his wife. If the authorities agreed, Cole continued, this *précieux spécimen artistique* could be in their hands within the week; for his colleague Mr Fowke was about to leave for Bayeux and could bring it with him. Bayeux swallowed the bait, and the mayor confirmed to Cole just a week later that the municipal authorities had now overcome their objections to the photographic campaign.[7]

The bearer of the fragment, Frank Rede Fowke, was intimately connected to Cole as his son-in-law and as the son of Cole's old friend and colleague, Francis Fowke, architect and engineer of the Science & Art Department. Fowke junior worked for the Department as a member of the Board of Education, where he compiled the catalogue for the 1871 International Exhibition, and the souvenir programme for the opening of the Royal Albert Hall the same year. He was going to Bayeux to undertake a preliminary study because, following the death of the Reverend Rock in November 1871, he had inherited the task of writing up the Tapestry to accompany the proposed publication of its photographs. In September 1872, he presented the fragment to the Tapestry's curator, the Abbé Laffetay, who commemorated Eliza's crime on a new label in the exhibition. His inscription repeated the 'facts' as detailed in Cole's letter to the mayor: 'A piece of the Tapestry was removed [*enlevé*, the word used by Cole, but in French an emotive term that can imply 'abducted' or even 'raped'] by Mme Stothard while her husband was busy copying it in 1816. This fragment, which was acquired by the Kensington Museum, has been returned.' So Charles Stothard was remembered for his constructive work on the Tapestry, while Eliza stood publicly accused of vandalising it. The piece was not sewn back on, but was displayed in a separate case.

Work began on the Museum's project almost immediately. One of Cundall's team, E. Dossetter, took his bulky yet fragile equipment to Bayeux (at least the train was more stable than the *diligence*), where he photographed the Tapestry between September and December 1872. The authorities agreed to take out the glass fronts of the display cases, but refused to move the Tapestry itself – this had been the most contentious issue in the negotiations – from its awkward fixed layout in the gallery, where 'the difficulty of cross-lights and dark corners had to be overcome as far as possible; nor this alone, for the brass joints of the glazing came continually in the way of the camera, and great credit is due to Mr Dossetter

for the ingenious device by which he successfully overcame the difficulties with which he had to contend'.[8] Because of the cramped conditions, Dossetter had to work with a smaller camera than Cundall first intended, and the 170 12 × 12-inch (30 × 30-centimetre) negatives had to be turned into transparencies before they could be enlarged to the 25 × 23 inches (62 × 57 centimetres) necessary to produce full-sized prints. So the whole procedure was even more complicated and costly than planned. Cundall had to account to Cole for the 'great expense of enlargement', when the Museum requested him to submit his estimates for printing in December 1872. His initial figure did not comply with the Museum's accounting system, which required the total sum, and so Fowke, on Cole's instructions, got back to Cundall at the beginning of February 1873. He suggested a revised calculation of £1,237, which included a fee of £100 to himself for writing the text for the book, which he obviously regarded as a freelance activity rather than part of his museum duties: 'I shall have had two years steady work at this memoir and I think the foregoing is a fair price. It will print, I fancy, to more than 100 pages.'[9]

The Museum approved the figures (though Cundall had slightly under-estimated his costs and put in for a further £60 in March), and printing went ahead. In order to produce the replica to go on display, the negatives were printed onto paper, the painter Walter Wilson hand-coloured them, and the whole set was mounted on strips of linen so that it became a continuous hanging like the original. The Lords of the Council presented a full-size set of the photographs and a half-sized coloured roll to Bayeux in gratitude for the town's cooperation.

Triumphantly, the Museum exhibited its facsimile in the International Exhibition of 1873. Opening on 1 May, the great industrial and artistic show extended over a huge area of South Kensington, its galleries displaying products that ranged from 'experimental cookery' to surgical instruments and the manufacture of silk. These attracted around 25,000 visitors a week, despite an admission charge of one shilling. In the Royal Albert Hall, where an organ performance took place every day at 12.00 and a concert of military music at 3.00, Room XVII of the Eastern Gallery contained the Tapestry facsimile, together with designs for architectural projects, wallpapers and stained glass, photographs and other prints, plus examples of needlework and lace. The *Official Guide* to the Exhibition was a slender pamphlet that devoted a whole paragraph to the original: 'its execution is rude but vigorous and its condition marvellous if its age is considered'. Fowke almost certainly

wrote this. He was also editor of the Official Catalogue, where the entry on the facsimile gave credits all round: 'The Bayeux Tapestry, in permanent photography, by Mr Dossetter under the superintendence of Mr Cundall. Lent by the Science and Art Department.'[10]

This was excellent publicity for the Museum. An article in *The Antiquary* for July 1873 urged readers to seize this 'admirable opportunity to make themselves acquainted with that wonderful piece of needlework' whose 'reproduction was a work of no little difficulty', owing to the poor light in the Bayeux Museum. And the *Society of Arts Journal* also commended an 'undertaking of uncommon magnitude . . . thanks to the intelligence of the English photographers, the obstacles were successfully overcome'.[11]

When the exhibition finished, the facsimile was hung around the walls of Gallery 79, part of the extensive textile galleries on the first floor. The Museum made a second joined-up version, which was put onto two spools and kept in a box where it could be viewed more compactly by winding a handle, just as the original had once been in Bayeux.[12]

For the first time, accurate images of the Tapestry were available for all to see. One example of their enlightening effect was the lively public lecture given in 1878 by historian Ella Burton, illustrated by a set of the coloured photographs in the great arcaded hall of the Edinburgh Museum of Science and Art in Chambers Street, a building designed by Fowke's architect father. Burton's aim, in a thinly disguised attack on male scholars, was to 'get away from the antiquarian approach' of those who had undertaken 'a life-long examination of mouldy documents and of ancient antiquarian relics'. In a shameless appeal to her complacent Edinburgh audience, she compared the scenery of Normandy unfavourably with that of Scotland, and declared that Bayeux's chief merit was that it looked like a Scottish town. Suspicious of the whiteness of the linen background, she suggested it might have been washed, a point that certainly made sense in view of earlier nineteenth-century descriptions of the background being the tone of 'brown holland', as noted, for example, by Eliza Stothard. But by 1876 other visitors were describing it as yellowed white (*blanc jauni*), which is how it appears today. Had it been washed during the 1842 conservation? Burton had put this question to the curator, Abbé Laffetay, who, however, denied it.

She also challenged Agnes Strickland ('I do not agree with Miss Strickland's notion that learned men have no business to know anything about the needlework') and attacked the derivative nature of the Berlin

woolwork practised by Strickland and her contemporaries: 'modern ladies who buy embroidery patterns and are proud of their servile imitation, would do well to take a look at this primitive tapestry'. She was content to attribute the work to Matilda, 'the silent broiderer of the Tapestry . . . like a ray of moonlight illuminating a dark night'. And, like Liénard's novel, she emphasised Matilda's (and therefore the Tapestry's) Flemishness. The determined Burton was the first woman to confront the issue of the nudes in the borders. She broad-mindedly pointed out that it depended on the context, for 'what is thought good taste in one century is thought bad in another', again contradicting Laffetay, who refused to attribute the work to Matilda because of the 'many scenes which decency should have omitted – how could it be thought that a woman as virtuous as William's wife could have made or commissioned such a work?' Burton concluded in unsisterly fashion by citing Eliza's Stothard's theft of the fragment as 'a warning to all British curiosity stealers on the continent'.[13]

This incident was now an established 'fact' of the Tapestry's recent history. Curator Laffetay's official guide of 1873 included a full account of the deed, although he did praise the South Kensington facsimile and expressed delight that such a faithful copy of Norman workmanship was now installed in London. His slim volume was overshadowed by Fowke's majestic survey, published in 1875 by the Arundel Society on behalf of the Council on Education. This book revealed the subtlety and beauty of Dossetter's photographs, which gave the texture of every stitch. There were two different editions, a de luxe model, with superior binding and full-sized reproductions, and an ordinaire, for museums and libraries, with the illustrations at half-size in 'autotype plates'.[14]

Fowke's well-researched text properly defined the work as a 'historical embroidery'; he described its manufacture and subject matter, and ended with a detailed appendix that summarised the current range of opinions and interpretations. His own conclusion was that it was closely contemporary to the events depicted, that it was made in England and that there was every reason to associate it with Odo and none with Matilda. Stylistically, he concluded that despite the 'crude' drawing style, unnatural colours and lack of perspective, 'the composition is always bold and spirited and is always rendered with great truth of expression'. He assumed it consisted of just two lengths of fabric, only the first of which was known to Foucault, joined together in the eighteenth century at the time it was lined. (It was not until the 1880s that Laffetay spotted there were several joins.) Prominent in

Fowke's introductory chapter was the accusation that Eliza Stothard cut off and brought home a small piece of the Tapestry.

The truth was finally revealed in 1881, with the aid of *The Times*. In August that year, it published a long review article about the latest book on the Tapestry, Jules Comte's *La Tapisserie de Bayeux (en 79 planches photo-typographiques)*, published in 1878. Comte, head of the Education Department of the Ministry of Fine Arts (*Beaux-Arts*), was the French equivalent of Henry Cole, and this was the first French publication of the Museum's photographs, although the author made no acknowledgement of their English origin. But he praised the labours of Fowke, who had spared *ni la peine ni la fatigue*, and whose text he sometimes repeated word-for-word. Comte's own interpretations included the pragmatic suggestion that the different colours of the horses' legs were not to indicate perspective, but to use up whatever wools were to hand. Too sophisticated to have been designed by Matilda, the Tapestry represented the mind of a man, a diplomat perhaps or a politician. Unlike Fowke, Comte tactfully did not refer to the returned fragment, but this became the main subject of *The Times*' article.

The reviewer began by deploring the lack of English tourists to Normandy, which meant that only an elite visitor, 'a person of a certain culture or of special tastes', would appreciate the Tapestry, despite its excellent display, no longer 'unrolled in barbarous fashion round two cylinders'. Comte's book was therefore welcome, because it 'gives to all the opportunity of making acquaintance with this unique monument almost as complete and for historical purposes as practically useful as if they studied the original'. Its half-sized 'phototypographs' were a triumph of modern technology, more truthful than the 'dull eye and heavy hand' of Stothard's engravers, and their reproduction in black-and-white was far more effective than the 'strange and bizarre' colours of the original. These, when combined with the 'uncouthness of the drawing and ignorance of perspective', might indicate 'the art of barbarians' and create an initial sensation of 'astonishment and disappointment' in the spectator, which the 'vividness and power of the representation' rapidly overcame. However, 'some rather curious designs' in the borders must cause the viewer to doubt whether the fair sex could ever have sewn the Tapestry.

The reviewer then turned to Eliza Stothard and called for forgiveness, especially considering what the English had done to publish this important monument, from Stothard's drawings down to Fowke's lavish volume. It

was disgraceful that the exhibition at Bayeux had a caption that named and shamed the lady. Even worse was the fact that the custodian was telling visitors that Madame had confessed to the theft on her deathbed. The reviewer demanded absolution for her crime: 'We are sorry that this lady should still be gibbetted in reputation in the Library at Bayeux for an offence which, however inexcusable, should now be forgotten. Impelled by a feminine instinct, she cut a small piece of the border and took it away with her . . . as the little gap had already been filled by the restorer, the original piece is now placed above it with an inscription detailing the unhappy event. Not long since, this scrap passed into the possession of the authorities of the South Kensington Museum and was by them restored to the Maire of Bayeux.'[15]

Stung by this well-intentioned piece, Eliza's nephew, Charles Kempe, defended her in a letter to *The Times* written 'to vindicate her character from an unmerited stigma'. He explained that his aunt, the former Mrs Stothard, was now the famous authoress Mrs Bray, still very much alive but, at the age of 91, reluctant to engage in public controversy. However, she had authorised him to reveal that she had wrongly been accused of the theft in the alleged *Vetusta Monumenta* article cited at Bayeux. Her husband Charles Stothard already had in his possession 'one or two small fragments taken from a ragged portion' before she ever visited the Tapestry. And his 'reverence for antiquarian works of art (which is also one of her strongest, if not one of her "feminine" instincts), was, she assured me, too strong to allow him to commit any act of spoliation'. The premature report of her demise provided her with 'mingled feelings of indignation and amusement . . . thank God she is still alive to tell the true tale'. Kempe reported that he had already requested the Bayeux authorities to remove the 'obnoxious notice', but they refused to do so until the South Kensington Museum and the Society of Antiquaries admitted that they had published false information. He now called upon these bodies to address the matter urgently.[16]

This was published on Saturday, 24 September, but Kempe had already been at work behind the scenes and went public now only because of the lack of any official response. He wrote personally to Fowke on the day *The Times* printed his letter, apologising for causing further inconvenience on top of the work he had already created in order to establish that 'the basis of the charges against Mrs Stothard, on the alleged statement in the *Vetusta Monumenta*, does not exist'. And he insisted on being informed 'how is the mistake to be remedied?' It was up to the Museum, which had committed

the original blunder in the 'official communication' – Cole's bribe to the mayor – to get the offending label at Bayeux removed, and to place the following notice in *The Times*: 'We are requested to state that the placard at Bayeux to which we called attention in a recent article has been withdrawn following the representations of the South Kensington Museum. The *Vetusta Monumenta* contains no such statement.'

Fowke received this letter on Monday, 26 September, a day when *The Times*' third leader (perhaps Kempe had a hand in it too) thundered for an ambitious campaign 'to vindicate from a false imputation a distinguished authoress, this nation, and the female sex all over the world'. (The first leader addressed more bad news from Afghanistan, the second the untimely death of American President Garfield after being shot in an attempted assassination three months earlier.) The leader-writer now twisted the previous *Times* article to attack the French. Even if Eliza had committed the theft, forgiveness of an event two generations back was long overdue, 'but the people of Bayeux are anxious to show that a guilty conscience knows no lapse of time'. And it mocked the idea of her subsequent 'miserable existence' relieved only by the alleged deathbed confession. Far from being guilt-ridden or dead, Eliza was alive, successful and happy, a National Treasure who had 'contributed more than any other woman to the amusement and instruction of her country'. If the Tapestry was so ragged that her husband had been able to remove a piece, this was entirely the fault of the French for letting it get into such a state, for it was 'not well kept and knocked about for ages' through its annual pinning up and taking down by the cathedral chapter, the rough handling of revolutionaries and transportations by Napoleon.[17]

This piece alarmed the Museum. Fowke, who had already informed Kempe privately that Cole's inaccurate letter was the basis of the attribution, received a terse memo that very day from his superior, Norman Macleod, assistant secretary to the Education Committee (Cole had retired in 1873): 'Please register and let me see the draft on which our letter to Bayeux was written when the fragment of Tapestry was returned.' Fowke replied that the information in Cole's letter came from Rock's citation of the *Vetusta Monumenta* in his 1870 textile catalogue entry, but, 'as a matter of fact, there is no text nor any writing under Plate 17' (which illustrated the fragment). This was additionally embarrassing because Fowke had uncritically repeated the error in his own book. (Fowke's note to Macleod survives in the archives of the Victoria and Albert Museum, tantalisingly

torn away at the edge where Fowke sought to defend his predecessor: 'Father Rock probably intended to make . . .' And different hands have scrawled comments all over it, a palimpsest of panic: 'To Mr Macleod on his return . . . Privately in answer to Mr Kempe's letter to him . . . Mr Kempe has written to Mr Macleod on the subject . . . As to official request being sent to *The Times* withdrawing imputation against Mrs Stothard . . .' and so on.[18]

Media pressure stirred the Museum into action. Discreet strings were pulled in London and Bayeux, and the caption was removed. Fowke acknowledged Eliza's innocence in the later editions of his book, where a footnote conceded that although she had been commonly accused – he failed to spell out that it was by his museum or his book – he now had it, on her own authority, that Charles Stothard possessed fragments before their marriage. Alas, legends are more entertaining than the truth and are sometimes impossible to erase. Even today, some authors name Mrs Stothard as the guilty party.[19]

Eliza died in 1883. The following year her autobiography was published. She had embargoed this until after her death, even though it only covered her life up to the year 1843. John Kempe, her great-nephew and godson, edited and introduced it, and wrote fondly in his introduction of her 'singular energy and vitality' in a serene old age, marred only by the false accusation. Indeed, he claimed somewhat unreasonably, this may have caused the illness that led to her premature death – at the age of 93. Although the book did not mention the Tapestry, Eliza had revealed in family conversations that in 1816 or 1817 Charles Stothard acquired not one but two fragments, probably from the (literally) mangled end, before she ever went to Bayeux. She had never even seen the piece that Charles gave to Francis Douce, which was the one that reached the museum (together with the plaster casts) in 1864 from the effects of Bowyer Nicholls, who had acquired some of the contents of the Meyrick/Douce collection. Yet she said that Stothard removed *two* pieces. What happened to the other? If it had remained in his possession, she must have known and admired it. After his death, she sold his collection of antiquities to Sir Gregory Page Turner. But Eliza was a compulsive hoarder. Her great-nephew described the astonishing clutter of objects with which she surrounded herself in the Tavistock vicarage of her second husband, from where nothing was ever thrown away. Might she not have hung on to this memory of her happiest days, a genuine souvenir of her honeymoon and her husband's greatest project?

The publicity, the publications and the photographic version drew the Tapestry to the attention of one of England's most skilled embroiderers. The facsimile in the museum at last provided definitive images, but it still gave little sense of the uneven textures and relief surfaces of the original. A woman with unique access to the right materials and a skilled workforce planned a project even more ambitious than that of the Museum: she determined to embroider an exact replica of the Tapestry.

15

The Ladies of Leek

Changing standards in taste meant that the robust and simple style of the Tapestry (denounced in 1833 by John Constable as 'almost as bad' as ancient Mexican painting) was appreciated in the 1840s and 1850s as primitive but fairly good for its time, and respected in the 1860s and 1870s, yet by the 1880s it was coming to be seen as crude again. This was due to the influence of the Aesthetic movement, which redefined decorative embroidery as 'Art-Needlework' in reaction to the horrors of Berlin work churned out by thousands of middle-class housewives who had bought the manual by Mrs Warren and Mrs Pullan and taught themselves how to reproduce *The Monarch of the Glen* or *The Last Supper* to decorate a cushion. In 1865 the architect G. E. Street (with whom William Morris trained in 1855–6), called for women to sew 'something fair and beautiful to behold instead of horrid and hideous patterns in cross-stitch for foot-stools, slippers, chair-covers and the like too common objects'. He contrasted such time-wasting endeavours with the 'industry, good taste and intellect' required to make a work like the Tapestry, whose 'vigour and honesty of expression' he held up as a model for the modern woman.[1]

The function of embroidery was expanding rapidly. A generation earlier, Elizabeth Stone had indicated needlework's moral potential to improve the lot of the poor by offering that necessary 'instruction and practice in sewing which, next to the knowledge of their catechism, is of vital importance to the future well-doing of girls in the lower stations of life'. In 1872, the

Royal School of Art-Needlework was founded to offer just such opportunities – professional training, access to good designs and a marketplace for selling work. However, the clientele was more genteel and mature than Stone had envisaged; rather than working-class girls, they were usually distressed gentlewomen suddenly forced to earn money after the death or bankruptcy of a male provider. But the connection between embroidery and gentility was retained: you could still remain a lady despite having to sew for a living.

In 1880, a titled name enticed readers to the *Handbook of Needlework*, written to define the School's principles and practice, and made more marketable because it was 'edited' by Lady Marion Alford, one of the School's aristocratic patrons. The real author was the School's Secretary, Lily Higgin. Alford herself did write a follow-up in 1886, *Needlework as Art*, inevitably dedicated to the queen, which explored the new aesthetic and rejected the Tapestry as a poor example of medieval embroidery. Despite her patriotic stance – 'the more I have seen of specimens at home and abroad, the more I have become convinced of the great superiority of our needlework in the Middle Ages' – she did not rank the Bayeux embroidery among such fine works and was even reluctant to admit its origin: 'We must claim it as English, both on account of the reputed workers and the history it commemorates, though the childish style of which it is a type is inferior in every way to the beautiful specimens which have been rescued from tombs at Durham, Worcester and elsewhere. They seem hardly to belong to the same period, so weak are the designs and the composition of the groups.' She disagreed with Collingwood Bruce's suggestion that the designer was Italian, an idea 'that seems hardly justified when we look at the simple poverty of the style'. Her only concession was that 'although coarsely worked, there is a certain "maestria" in the execution.' Firmly linking embroidery to femininity and virtue, she deplored the present-day 'total collapse of decorative needlework and the advent of the Berlin wool patterns'. The School was founded to revive the national heritage of art-needlework because 'of one thing we may be sure, that it is inherent in the nature of Englishwomen to employ their fingers'.[2]

The concept of art-needlework also had its critics. In the words of a leader in the *Daily News* for 1881, 'In the days when ladies sat at home in the needful protection of their castle walls, the long hours had to be filled up . . . modern ladies have a great deal too much to do with their time as to undertake such tasks as the Bayeux Tapestry for example.' An American,

Ella Rodman Church, made the same point, though with some regret, in *Artistic Embroidery* (1880). She found the Tapestry so intricate that 'few would have the time or inclination for such a piece of work in these days', though such ancient heirlooms recalled 'every happiness and beauty connected with the age of chivalry'.[3]

One leading practitioner of art-needlework did manage to reconcile the more critical view of the Tapestry with the creation of a modern masterpiece, a full-sized replica in linen and authentically tinted wools, every scene and every stitch copied exactly by a team of nearly 40 women. The loving attention to detail and the appreciation and understanding of the craft skills involved were worthy of William Morris. And, indeed, Elizabeth Wardle, the driving force behind the replica, knew Morris and his work very well. His inspiration and his constant striving for artistic perfection affected her own attitude to embroidery and gave her the confidence to embark on her great project.

She met Morris through his collaboration with her husband, Thomas Wardle, silk and textile manufacturer, proprietor of the firm founded by his father, Joshua Wardle & Sons of Leek, Staffordshire. By the 1870s Thomas was the most respected dyer in the country and the man who had revived and introduced to England from India the fabric of tussore silk, whose successful dyeing he had also pioneered. These skills were of great interest to Morris, who was then developing printed textiles into a major product of his own firm. He found that the modern, chemically based dyes introduced in the 1850s produced harsh colours, which were also prone to rapid fading, so he tried to re-create the organic natural dyes of the Middle Ages, whose techniques had been virtually lost. Morris became obsessed by this problem and set up an inadequately small dye-house in his premises at Queen Square, Bloomsbury. In 1875, he contacted the real expert, Thomas Wardle, through his own business manager George Wardle, who was Elizabeth's brother and therefore Thomas' brother-in-law. (Elizabeth's maiden name was also Wardle, and she was probably a distant cousin of Thomas. Her brother George was originally an artist who designed for Morris & Company. He married the 'not proven' murderess Madeline Smith, now living quietly in London as Lena Wardle, and a friend of Janey Morris. Janey's lover, Dante Gabriel Rossetti, wrote a tasteless playlet in which Madeline poisoned William Morris' coffee so that her husband could take over the firm. In fact, she became a keen member of the Socialist League that Morris founded in the 1880s.)[4]

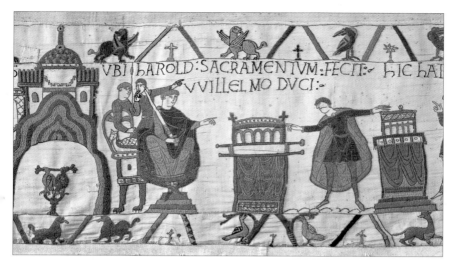

Harold's oath

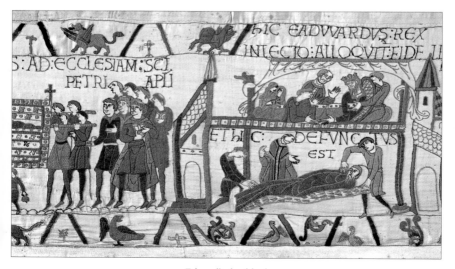

Edward's deathbed

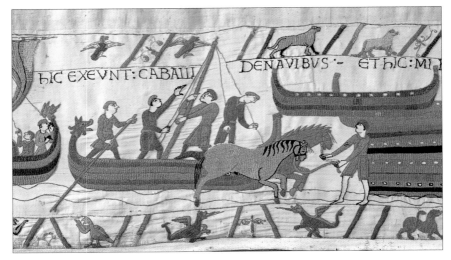

Disembarking the horses

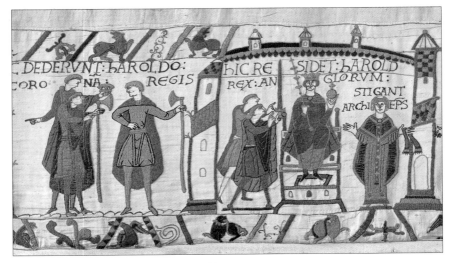

Harold's coronation

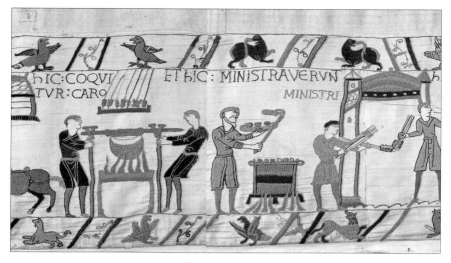

Preparing the feast

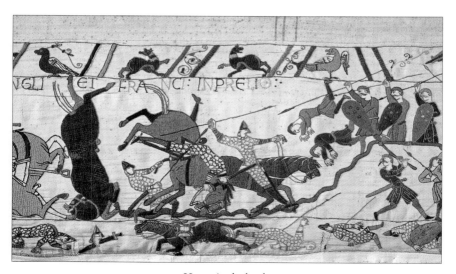

Horses in the battle

Lions on a Persian woven silk,
7th-8th century

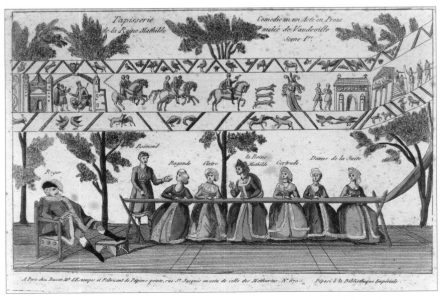

The opening scene of the Vaudeville *Tapisserie de la Reine Mathilde,* 1804

Jean-Francois Hue, *Napoleon visiting the camp at Boulogne in July 1804*,
watercolour, 1806

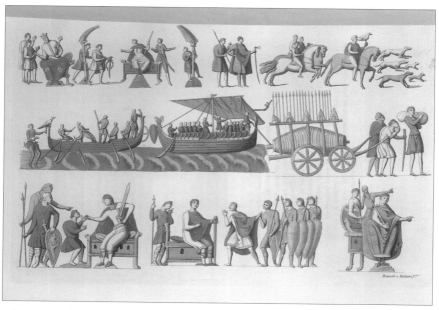

Illustrations for Jules Ferrario's *Le Costume ancien et moderne*, engraved by G. Bramatti, 1820

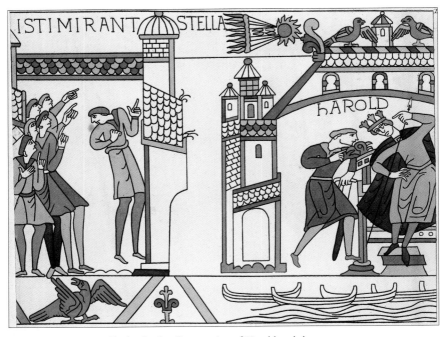

Charles Stothard's engraving of Harold and the comet

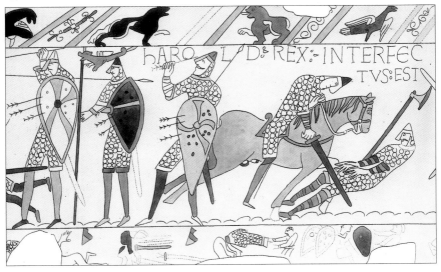

Victor Sansonetti's engraving of the death of Harold

Alfred Guillard,
*La Reine Mathilde travaillant
à la Telle du Conquest*,
oil-painting, 1849

Mary Newill, *Matilda and her ladies at work on the Tapestry*,
stained-glass window, Birmingham, 1898

Elizabeth Wardle's signature under the panel she embroidered for the Leek replica, 1885

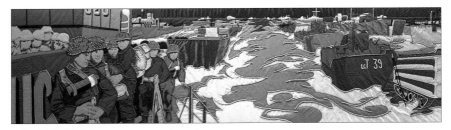

A scene from the
Overlord Embroidery, 1974

Michael Farrar Bell,
Senlac window,
Battle parish church, 1984

William's coronation,
Michael Linton's steel mosaic,
New Zealand, 1980-2005

Morris established an extraordinary collaboration with Thomas Wardle between 1875 and 1878, during visits to Leek to work with him and his men in the Hencroft dye-house. Here they experimented with natural dyes to achieve the precise effects which the demanding Morris sought in the embroidery silks, carpet wools and printed textiles that Wardle's firm was producing for Morris & Company. At other times there was a flood of letters and a constant exchange of samples. The mutually creative relationship between Morris and Wardle, who adapted Morris' block-printing methods for his own fabrics, also impacted upon Elizabeth, a dedicated and talented embroiderer. In 1875, she was aged 41, had just given birth to her thirteenth child and was the mother of eight living children. Unable so soon after childbirth to face the exuberant and famous Morris on his first visit as a house-guest in July 1875, she went to the seaside with all the family. Left in peace, Morris and Wardle almost literally immersed themselves in the dye-vats, and Morris' hands-on (or rather hands-in) approach meant that during his 'dyeing' years he permanently had dark-blue hands, causing him to joke about being banned from social events.

On his return to London, he began a remarkable correspondence with Thomas in which, although initially the pupil, his exhaustive study of the craft of dyeing turned him into the master, sternly advising the greatest specialist and rudely criticising the 'hippopotamus thumb' of one of Wardle's workmen. Impressed by Elizabeth's sewing skills, Morris advised and encouraged her, too. He sent the couple samples of traditional Cretan embroidery on linen: while Thomas should note the particular shade of green, 'Mrs Wardle will find some stitches in them worth looking at'. And he offered to design 'a special rug for her wool-work' as well as providing her with carpet patterns: 'wishing Mrs Wardle all success in finding out how to do the carpets: I shall be ready with designs as soon as she can'. At this time Morris was providing designs for the Royal School of Art-Needlework, where his former pupil, sister-in-law Bessie, may have been a tutor, in order to help them maintain their desired artistic standards. Given the skills of his wife and daughter May, he must have discussed embroidery techniques with Elizabeth during later visits, and their mutual interests turned work into friendship. Morris took Wardle on a book-buying visit to Paris and on a fishing excursion, and designed a stained-glass window for their house (now in Wightwick Manor). And Wardle recommended a weaver from France, 'the Froggy', who taught Morris how to work the loom.[5]

Life was not easy for Elizabeth. Morris made a jocular reference to the

household teeming with children during the Christmas holidays of December 1876, postponing his next visit until ' "the ruffians" (to whom I offer my congratulations on their youth, their holidays and their capacity for noise)' had gone back to school. The household was about to expand again. Yet another child was born in August 1877. Shortly before the event, Morris sent his 'respects to Master Ten when he comes [who] will certainly be like a young bear with all his troubles ahead if he has to learn blue-dyeing'. Although Elizabeth had apparently recovered enough for another visit by Morris in October, after which she had to forward the spectacles he had irritatingly left behind, the birth resulted in some kind of collapse, which turned her into a total invalid for a year. Family legend claimed that she returned to health and sanity only when Thomas brought her some embroidery to do. Morris, an expert in languishing wives, was 'very glad to hear Mrs Wardle is better; it must have been very trying for one so active to be laid up like that'.[6]

The next year she was well enough to set up a demanding new venture, the Leek School of Art Embroidery, on the model of the Royal School of Art-Needlework. (By the early 1880s there were more than 30 such establishments in Britain, the majority in London.) Sir Philip Cunliffe-Owen, Henry Cole's successor as director of the South Kensington Museum, stressed its morally improving approach in an encouraging letter. Her school 'would enable classes of females to attend of an evening; it would afford them the example of never having an idle moment, and further would help revive the great silk trade'. Owen knew Wardle since the latter's tussore silk won a gold medal in the Museum's 1873 exhibition, where the facsimile of the Tapestry was also displayed: this was perhaps when Elizabeth first saw it. The Leek School soon gained acclaim for the high quality of its products, both the sewing and the materials. It used the silks on which Wardle printed patterns, and the embroidery threads he dyed, to produce expensive domestic products such as hangings, table-cloths, bedspreads and screens, sold in its own shop in Leek and in a special section of the luxury goods shop that Wardle opened in London's Bond Street, run by Elizabeth when he was abroad or ill.[7]

Without access to such exceptional resources of materials, labour and premises – members of the School initially worked in isolation at home, but soon came together in a small workshop next to the Wardles' house – Elizabeth could never have contemplated a replica of the Tapestry. Years later her son suggested that the ultimate source was the inspiration and

friendship of William Morris, but the immediate trigger was the photographic facsimile in the South Kensington Museum, which the director, Cunliffe-Owen, showed her during a trip to London early in 1885, a visit that family lore suggested was to cure her from a bout of depression. Certainly the rather stolid image Elizabeth presented in photographs concealed a more complicated personality. Whatever the reason, the idea of embroidering a replica of the Tapestry 'so that England should have a copy of its own' became an obsession. Her aims were various. It was a challenging project, especially as she and her fellow-embroiderers were skilled at working in silk, but less familiar with the humbler worsted. The replica would be of great educational value, from a woman who had taught for the Church Missionary Society, because it could be toured (unlike the fragile and remote original) and would therefore reach a wide public. It would celebrate the historical craft of embroidery, and more specifically that of the School she had established. And it would demonstrate the quality of the Leek-based products and skills of Thomas Wardle: she was in a unique position to provide the most authentic replica possible, demonstrating not just accurate stitching, but also the medieval dyeing techniques that Wardle had learned from Morris. She would, it seemed, be as dutiful a wife as Matilda.

After an essential visit to inspect the original in Bayeux, Elizabeth set about organising her daunting task in the spring of 1885, the same year in which the Society of Antiquaries at last published in book form Volume VI of *Vetusta Monumenta*, which contained the Stothard engravings. From the start she put the whole project on a business footing by setting up a limited company, the Leek Society, separate from the Leek School, to be solely responsible for the replica, with the participants all becoming shareholders. Some of the School's members already received payment, but this was a new arrangement. Then she needed a copy of the original, which was provided by her friend Cunliffe-Owen. According to her account, 'facsimile water-colour drawings of the original Tapestry were kindly lent by the authorities of the South Kensington Museum, from which tracings were obtained, which were subsequently transferred to cloth'. She presumably meant the hand-coloured set of photographs. Miss Lizzie Allen, a member of the Society, did the tracing. 'The material on which it was worked was chosen so as to resemble the original in texture and colour as nearly as possible. The wools have all been especially dyed to match each shade the Tapestry presents at the present time.' This was her husband's contribution.

He dyed more than 100 pounds (45 kilos) of wool in the traditional manner that he had worked out with Morris, dyeing from the fleece and using only vegetable-based dyes. When in Bayeux, they had been able to spot all too easily the harsher tones of machine dyes used in the most recent repairs. So Elizabeth was able to state confidently that 'the method of applying the wool has, wherever possible, been reproduced, and those who have visited Bayeux will doubtless recognise the minutely accurate resemblance which this copy has to the original'. Morris would have been proud of her.[8]

Her workforce of 'shareholders' was a team of at least 37 women, most of whom lived in and around Leek and were already associated with the School or with Elizabeth and family; those who lived further afield, including London and Birmingham, had probably left Leek on their marriage. Elizabeth decided that each should be responsible for embroidering a section of her own, rather than making general but anonymous contributions to the whole. She allocated to them the dyed worsteds and sections of linen (25 altogether) onto which the designs had already been copied. These sections were not all of the same length but were divided according to the extent of the scene. The total length sewn was 76 yards (69 metres). Each contributor embroidered her own name below her section,

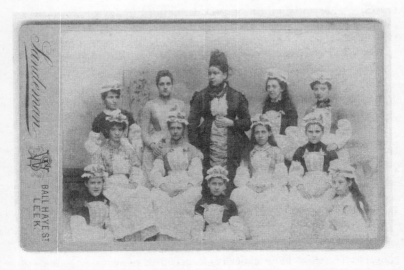

Elizabeth Wardle (centre) with some pupils from the Leek School of Embroidery.

on a strip of dark-blue linen that ran along the bottom of the replica. They probably did much of the work as a friendly communal activity (like the original), undertaken as much as possible in the School's workshop. The individual embroidery frames, each at least a metre long, would have required considerable space. Five panels bore the names of two women, and two had three names, but these were beneath the separate zones sewed, suggesting that only one person worked on a portion at any time.

Elizabeth embroidered the first section, from Edward enthroned to Harold praying at Bosham church. Other female Wardles involved were Phoebe (sister-in-law), Ellinor (niece), and daughters Edith (aged only 14) and Margaret (17). The last shared her panel with her mother, whose name also appeared beneath it. Another contributor, Mabel Challinor, married a Wardle son, and Margaret Wardle married the son of Mrs Worthington, who sewed a very short section indeed. Miss Mary Bishop, a regular paid worker at the School, was a Wardle cousin. Others had their own family links: there were Margaret and Edith Watson, Alice and Florence Pattinson, Jemima and Anne Smith, and some were also connected with the School, such as the daughter of Mrs Anne Lowe, who was the secretary of the Company's accounts. The age profile may have been quite young, because several subsequently married. Non-locals added their town of residence to their names. The standard formula was 'Anne Smith's work' at the beginning of a section, followed by a scroll or floral pattern until 'ends here' under the appropriate place, to make clear the division of responsibility. But it was interesting how, just as in the original Tapestry, some of the embroiderers adapted the marginalia of signatures and floral scrolls to express an individuality not acceptable in the meticulous copying of the main design. Elizabeth Frost must have misunderstood the instructions about putting her name on the blue strip, because she did this only after placing it at the base of her main panel – an error that Elizabeth Lunn repeated in the adjacent section. And instead of 'Lizzie Mackenzie's work', one embroiderer put 'the work of Lizzie Mackenzie'. Sarah Iliffe added '1885' after her name. Mabel Challinor, obviously a free spirit, substituted spiky, Celtic-interlace patterns for the coiling motifs preferred by the rest. Two of them would return to the subject many years later.[9]

There was one delicate issue: the blatant masculinity of the warhorses and some of the border figures. Luckily or not, the Museum's hand-coloured photographic version already shielded the sensitive viewer from the worst of these sights because the painters had already bowdlerised the more graphic

details before the facsimile could decently go on public display. It was this 'improved' set that Miss Allen had copied, although Elizabeth and her team have been frequently and quite erroneously blamed for the prudish alterations. Ironically, the South Kensington artists were more modest than the Leek ladies, for the Museum's attempt to put the most well-endowed man – the one under the Ælfgyva scene – into a pair of shorts was rightly disdained by Miss Margaret Ritchie, who chose not to sew the gratuitous extra details of the garment, but simply reproduced the outline of the figure.[10]

When the panels were all completed, Mrs Clara Bill, a German lady who ran the shop selling the School's products, joined them up. Elizabeth sewed a final inscription in a beautiful italic script, which recorded that 'This reproduction of the Bayeux Tapestry was worked at Leek in Staffordshire. The drawings were lent by the Authorities of the South Kensington Museum. 35 Ladies have been engaged on this piece of Tapestry and the name of each will be found underneath her work. E. Wardle. Whitsuntide 1886.' In smaller script beneath, her husband received his acknowledgement: 'The Worsteds were dyed in permanent colours by Thomas Wardle FCS FGS.' Finally, a printed appliqué listed the participants in alphabetical order.

The finished product was booked to go on display in Leek in June 1886,

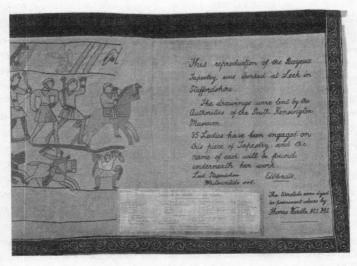

The last panel of the Leek replica. Elizabeth's inscription acknowledged the work of the group and the contribution of Thomas Wardle.

so the work had a tight deadline. Pressure on Elizabeth increased when Thomas went away for a few months from November 1885 to research sericulture in Bengal. 'Every minute of the day revolved around the making of the Tapestry,' their son recalled, adding that most of the family 'claimed, rightly or wrongly, to have had a hand in the work of the facsimile'.[11]

Elizabeth's next task was to compile a guidebook. She produced an 80-page pamphlet whose preface outlined how she had made the replica and gave full credit to all the skilled ladies of Leek. For the main text, she simply summarised Collingwood Bruce's 1856 *Bayeux Tapestry Elucidated*, which reminded readers how 'the needle of the high-born dame' could be as effective as the pen for conferring immortality. She included his brief mention of the nude figures in the margins, which 'doubtless refer to those distressing immoralities which too often attend the march of armies'.

The unveiling of the replica on 14 June 1886 caused great public interest. Soon it became a major attraction, local and then national. Just as Charles Stothard had produced a more trustworthy drawing than the previous French ones, so Elizabeth Wardle had made the Tapestry accessible to British people without the inconvenience or expense of travelling to France. Visitors to the exhibition paid an admission charge of one shilling, a season ticket cost two shillings and a family season four shillings. Demand was such that the initial two weeks were extended to four, and the admission charge reduced to threepence More than 1,200 people came.

One visitor was Lily Higgin of the Royal School of Art-Needlework, who wrote an enthusiastic review for *The Magazine of Art*. Describing the style of the original as 'quaint but full of spirit', as well as 'exceedingly interesting from the archaeological point of view', she deliberately contradicted the disparaging comments of her colleague Lady Marion Alford. If the work appeared coarse, this was only because its makers 'wanted to produce a bold general effect rather than the elaboration of detail'. And she found an excuse to have the standard dig at the French. Perhaps 'the Norman ladies were not so skilled with the needle as those of the conquered country. As the gorgeous robe worn by William at his coronation was of Anglo-Saxon workmanship, we are inclined to adopt the latter theory.' She hailed the Leek Society's project as a 'public benefit' because so few English went to Bayeux.[12]

The shareholders made a small profit from the exhibition, and realised that they would raise funds by sending the replica on tour. So it was packed into crates, accompanied by specially made supports and quantities of Elizabeth's guidebook, and dispatched around the country. In September

1886 it was in Tewkesbury, then Newcastle upon Tyne (where the Archbishop of Canterbury admired it), in October Stoke on Trent and Worcester, and in November Chester. In December, it achieved international fame when it was exhibited in New York, in the rooms of the Associated Artists' Exhibition on East Twenty-Third Street. The critic for *The Art Review* noted the achievement of the ladies from Leek in sewing this work nearly 230 feet long, with 'over 500 figures' – actually a considerable underestimate – and tried to assess it by modern standards: 'The art represented is of course primitive, the figures resembling the picture-writing of our Indians, but as a historical document the tapestry is invaluable, and this reproduction will be found extremely interesting.'[13] It then toured Germany, and returned to Britain at the beginning of May 1887, the year of the Queen's Golden Jubilee.

Later that May it was shown, admission free, for two days in the town hall at Cambridge. This 'proved most interesting and attracted large numbers of visitors' and *The Cambridge Review* praised 'the most exact imitation of the original, even to the marks and dustiness produced by time on the canvas'. Two utterly contrasting Cambridge characters gave public lectures on the original: medieval archaeologist, the Reverend G. F. Browne, president of the Cambridge Antiquarian Society, and flamboyant King's Fellow, the writer Oscar Browning, intimate of Oscar Wilde and his circle. (Virgina Woolf in *A Room of One's Own* quoted Browning's conclusion, after examining the students of Newnham and Girton, that 'the best woman was intellectually the inferior of the worst man'. What might he have said about Matilda's work?) The Cambridge visit ended with a lecture by Thomas Wardle, who had escorted the replica himself, on 'Silk, Eastern and Western' in the New Archaeology Museum, 'illustrated by diagrams, specimens of ancient and modern fabrics, and magic lantern slides'. This equally 'well and appreciatively attended' talk was presumably a useful promotion for his products. Intriguingly, the local reporter claimed that it had been Wardle's idea to reproduce the Tapestry. Was Thomas taking the advantage of his wife's absence to play up his role, or was the project assumed to be too much for a woman?[14]

After another visit to Stoke, to celebrate the twenty-first anniversary of the North Staffordshire Field Club, of which Wardle was a long-standing member, the replica spent six months at the prestigious Golden Jubilee 'Fine Art and Industrial Exhibition' at Saltaire, the model working community near Bradford established by the philanthropic Sir Titus Salt.

Princess Beatrice, the queen's youngest daughter, opened the exhibition, which included loans from her mother and from the Prince of Wales. The Leek replica took its place amongst exhibits whose purpose was 'to touch the hearts of the men and women from Yorkshire factories, who are expected to crowd the galleries'. To make sure of this, season tickets at the reduced rate of half a guinea were made available to 'the working man.'[15] Exhibited in another improving enterprise, the National Working Men's Exhibition in London, sponsored by the various City companies, the replica received a Gold Medal in 1893.

Touring continued for the next few years, and many thousands of people saw it: Elizabeth Wardle's aim of providing England with her own copy had turned into a massive mission to educate and inform. But the responsibility of organising this exhausting schedule became too onerous for the Leek Society. Although the shareholders received one or two modest dividends, the project made little money once the costs had been deducted, and even a loss at one venue.[16] So prospective borrowers were advised that they might be able to purchase the replica. This tactic worked too well in 1895 during the visit to Reading arranged by a philanthropical former mayor of the town, Alderman Arthur Hill, half-brother of the campaigner Octavia Hill, who was herself an old acquaintance of William Morris. Hill offered to buy the replica for £300 as a gift to Reading. Elizabeth Wardle democratically put this to the shareholders of the Company. Her daughter Margaret later recalled: 'We are all much ashamed to say that the vote was carried to sell it, much to my mother's surprise. She never thought we should allow such a treasured possession to be sold and leave Leek.' However, the sale produced a final dividend for the shareholders. After £51 9s 2d were deducted for expenses, each of the 110 shares was worth £2 5s 2d; 76 of these were allocated to the embroiderers in proportion to how much of the 76–yard strip they had sewn, while the remaining 34 went to the Society.[17]

On 4 July 1895, Hill wrote formally to the Free Library and Museum Committee of Reading Town Council: 'If you or the members of the Corporate Body share with me the view that this work is absolutely unique in its character and historical interest, would be an acquisition of permanent value to our new Art Gallery and the privilege of possessing it should belong to Reading, I offer the Tapestry (with its appliances and a large number of printed guides) as a gift to the Borough.' If in the future, they changed their minds, it would revert to him. The Council accepted the gift.[18]

The fame of Reading's replica even reached Queen Victoria, who wanted

to see it for herself. Alderman Hill proudly took it to Windsor Castle where, on 11 May 1896, he displayed it to the queen. It must have been his finest hour. For Victoria, it merited an extremely brief note in her journal: she had viewed 'a very curious copy of the celebrated Bayeux Tapestry which has been worked by 35 ladies in 3 years from a water colour copy of the original tapestry. The work was placed on screens, which extended half way down St George's Hall.'[19]

The following year Thomas Wardle received a knighthood for his services to the silk industry, his reputation undoubtedly enhanced by his wife's achievements and their joint involvement with the replica. Lady Wardle died in 1902. Her only other publication, after the Tapestry handbook, was another exemplary topic, *366 Easy and Inexpensive Dinners for Young Housekeepers*. This offered recipes for a year's menus of 'homely fare . . . more suitable for the Northern and Midland counties'. Was this a veiled attack on gluttonous southerners, and another example of the underlying impact of William Morris, who loved his wine and his food?

In Reading, her replica was initially hung in the Small Town Hall, and then moved to the new Art Gallery when that was completed later in 1895. Although Alderman Hill had intended it as a major attraction for the town, later curators perhaps did not agree with him; by the 1920s its dismal display, too high and too dark to be seen properly, and its poor condition shocked Elizabeth's daughter Margaret when she came to inspect it in 1927. The girl who at the age of 17 had embroidered the banquet scene with her mother was now the forceful Lady Gaunt, who protested volubly to the museum. As a result, the replica was cleaned, separated into 25 framed panels 10 feet long by 2 feet high (295 by 59 centimetres) and rehung. Various Wardles, the Mayor of Reading, A. F. Kendrick, Keeper of Textiles at the Victoria & Albert Museum, and medieval historian Frank Stenton attended the grand reopening, where Elizabeth's son Fred performed the official ceremony and paid tribute to his mother as originator and organiser. The mayor pointed out that the new exhibition relieved Reading of a guilty burden of neglect. And Kendrick politely said that his museum 'must have been asleep in some unaccountable manner' when Alderman Hill bought it for Reading. Stenton congratulated the town on possessing this uniquely important memorial, which enabled people to study the original, whose Englishness and contemporaneity to the Conquest he stressed.[20]

Soon after this, it began a new career as 'A Circulating Exhibition of a

Complete Facsimile of the Bayeux Tapestry', run on a commercial basis by the Art Exhibitions Bureau. Hired to provincial museums and galleries at a cost of four or five guineas a week for a four-week visit, the replica attracted considerable press coverage again. In 1928, for example, venues included Birmingham ('the chief object of interest in this exhibition' – *Birmingham Mail*), and Bolton, where a school party was slotted in every half-hour. The *Bolton Journal* declared that 'few exhibitions have excited more interest than the facsimile . . . day after day it is drawing visitors from a wide area' and published a humorous account by two recent visitors to Bayeux of how difficult it was to track down the original. The sub-text was that they could have stayed in Bolton and been satisfied with the replica. In York, one of the speakers at the opening ceremony, the Reverend Shaw, used the work to attack modern women. He claimed that 'ladies were not able to do as much needlework today as in olden days because they smoked too much and sewed too little', and added that the smoke in their eyes prevented them from threading the needle. To which a Mrs Cadell replied robustly that she smoked and sewed and intended to carry on doing both.[21]

In 1929, the replica toured the Midlands, but one exhibition was nearly cancelled when the curator of the Sunderland Library, Museum and Art Gallery, Charles Deas, got cold feet after comparing the Victoria and Albert photographs, published in Hilaire Belloc's 1913 *Book of the Bayeux Tapestry*, with Mrs Wardle's replica, which, he feared, 'lacks much of the spirit of the original'. Hoping the museum would bail him out of an awkward situation and enable him to cancel the loan, Deas asked if he could borrow their set of photographs instead. A. F. Kendrick curiously downplayed Elizabeth Wardle's role when he reassured Deas that 'it was made carefully under Sir Thomas Wardle's supervision . . . naturally it must lack a little of the meticulous accuracy of a full-size photograph but it gains greatly by recalling the original so much more vividly'. Kendrick added in a note to a colleague that he was 'surprised to learn that this enormous thing was to be circulated'.[22]

Local papers gave it the usual entertaining publicity. The *Burton Daily Mail* said: 'The good ladies of the eleventh century did not worry their pretty heads about such trifles as perspective and scale, thereby anticipating the modernist, futurist, cubist, post-impressionist and spiritualist school.' The *Hull Daily Mail* published a cartoon sending up local affairs in the style of the Tapestry. The *Staffordshire Weekly Sentinel* found a royal connection, reporting that Prince George, the royal family's only artistic member,

referred to the original in the speech he made at the Royal Academy dinner in May 1929. Discussing artworks that illustrated the customs of earlier times, the prince said, 'We have the Bayeux Tapestry on which, I believe, is largely founded the true story of the Battle of Hastings.'[23]

The replica toured South Africa in 1931, and for the rest of the 1930s was displayed all over England. After the war, the mission resumed, and it continued to fill the gap resulting from the refusal of the Bayeux authorities ever to loan the original. In 1953, it looked as if they were going to relent and permit a brief visit to 'the land of its origin', as Charles Gibbs-Smith, of the Victoria and Albert's Public Relations Department hopefully put it, when he got as far as compiling the draft of a booklet for the planned exhibition. But negotiations stalled and the plans came to nothing.[24] This intransigence was particularly regretted in 1966, the great anniversary year, but the replica came to the rescue again, with a hectic touring schedule to 16 different British towns from the autumn of 1965 to the summer of 1967. It fittingly spent the whole summer of 1966 in Hastings, then went on to Leek and Reading.[25]

The Art Exhibitions Bureau closed in 1968 and the replica spent more time in Reading, where there was room to display only one or two panels. But organising visits took up an unreasonable amount of curatorial time, and loans were restricted to special occasions, such as 1986, the 900th anniversary of the compilation of the Domesday Book and the centenary of the replica as well. So the museum organised a full itinerary and more than half a million people saw the work that year.[26]

In 1993, it at last became possible to view the whole replica in a permanent, purpose-built gallery in Reading Museum (with sponsorship imaginatively sought from Bayer plc and the Norman Insurance Company). It made the news again in 2001, when the Leek local authorities demanded the millennial return of the hanging that morally belonged to them. 'This is our equivalent of the Elgin Marbles,' said a Leek councillor. But a Reading spokesman declared that it was there to stay.[27]

The fate of the other great Victorian copy, the photographic version in the South Kensington Museum (renamed the Victoria and Albert Museum in 1899), was less happy. The facsimile, which belonged to the Department of Textiles and Dress, was on permanent display in Gallery 79 on the first floor, amongst many fine tapestries and embroideries. When the National Art Library swallowed up this space, the Department moved the copy to the spacious Room 45 on the ground floor (now the Toshiba Gallery of

Japanese Art). Exhibited with it were Stothard's two plaster casts. E. T. Birrell compiled the museum's *Guide to the Bayeux Tapestry* in 1914, and this was revised and updated by J. L. Nevinson and Eric Maclagan, both of the Textiles Department, in 1931. They now took a very sceptical look at the old association with Matilda and dismissed it as a late tradition not to be taken too seriously.

Tastes and displays change. During the Second World War, the museum evacuated all its contents to safety in the countryside. The 1947 reinstallation omitted the facsimile altogether. When indignant members of the public complained about the absence of the well-loved work, they received a standard reply that a second facsimile, mounted on a roller, was available for consultation in the students' room. But the letter omitted to state that this room was only open on weekdays within working hours, and was therefore inaccessible to the casual or weekend visitor. A memo from George Wingfield Digby, Keeper of Textiles, revealed that the facsimile – which he described as a fruitful source of quarrels and questions – was so popular that it was constantly in demand, but that the students' room was hard to find, and an attendant was required to unroll it. The Museum's director, who obviously did not care for it either, replied that the amount of space required was quite disproportionate to its importance, but conceded that the roller version could go on public display. The box was placed near the landing at the end of the Leighton corridor on the first floor. Here it became one of the public's favourite objects, the other being the mechanical, man-devouring Tippoo's Tiger – both precursors of the hands-on approach now integral to the modern museum experience. But visitors almost wound it to destruction. For its own protection, it was taken off exhibition in the 1980s. It is now in permanent storage, impossible to view and awaiting conservation at some unspecified future date, in the Museum's west London depot.[28]

However, Elizabeth Wardle's project can still be admired in Reading today, the ultimate expression of nineteenth-century women's responses to the Tapestry. Others had written about it, had used it as crucial evidence in the case they were arguing for the significance of embroidery and the power of a queen such as Matilda, but Mrs Wardle brought both strands together. Simultaneously patron, organiser and craftworker, she created (as well as re-created) a work of art and made an important historical source accessible to all.

16

Victorian Values

Although the queen may have been underwhelmed by the replica, reactions to the Tapestry itself helped enliven the debate over national identity in the earlier decades of her reign. This was not a new issue. Under the Hanoverians too, pre-Conquest England was presented as a Golden Age that the Norman Conquest had brutally terminated, proof that France was a threat then as now. In eighteenth-century eyes, it had been a time of heroes. King Alfred the Great even earned himself a place in the pantheon of 'British worthies', alongside luminaries such as the Black Prince, Elizabeth I and William Shakespeare in the patriotic display of statuary at Stowe. Queen Caroline's gardens at Kew exhibited more 'worthies' in a Gothick Hermitage, while the fantastical 'Merlin's cave' made its own apt reference to the first British hero, King Arthur. There was some irony in an unpopular German monarchy associating itself with a distant past when Britain was not ruled by invaders.

The post-revolutionary wars and the rise of Napoleon kept painfully alive the potential of the French to damage this cherished heritage, and the 1803 invasion threat established a template of hostility and fear for a whole generation. As a counterbalance, Victoria's marriage to Prince Albert of Saxe-Coburg-Gotha reaffirmed the Germanic connections of the English monarchy and stressed the long-standing ties that bound the two countries. The prince consort played an influential role in encouraging art and design, and drew heavily on his own cultural background to promote interest in

northern medieval art and Anglo-Saxon history. William Theed's statue (now in the National Portrait Gallery) even showed Victoria and Albert dressed, somewhat implausibly, as Anglo-Saxons, the reincarnation of ancient virtue. After the fire that destroyed the Houses of Parliament in 1834, Albert chaired the commission responsible for decorating the new building, and specified scenes from British history for the proposed mural scheme. Pre-Norman subjects were popular, giving official sanction to the concept of 1066 as a terrible watershed and to Harold as a brave, though fatally flawed, hero trying to defend his country from cruel, deceitful William and his Normans.

Benjamin Disraeli explored these issues in depth in his second novel, *Sybil, or the Two Nations* (1845), written at the time of grave social unrest culminating in the Chartist risings. He emphasised the currently underdog nature of the Anglo-Saxon heritage, trampled underfoot by latterday Normans, with resulting tensions between the Rich and the Poor, the Privileged and the People. In one passage, the virtuous heroine Sybil and her political agitator father, in a mood of despair at the state of the nation, lament that there is no present-day Harold to stand up for the people. On another occasion, she read to him from the topical and strongly pro-English *Histoire de la conquête de l'Angleterre* by Augustin Thierry. She even called her faithful bloodhound Harold.

During the 1860s and 1870s, the Tapestry's images of Harold – heroically dragging soldiers from the quicksands; agonisingly tricked by William into swearing the fatal oath; loyally obeying Edward's dying command while foreseeing his own fate; fighting bravely to the last – became even more accessible, thanks to the South Kensington Museum photographs, and he remained a national symbol. Tennyson's *Harold*, published in 1876, was a profoundly patriotic piece that focused on Harold's moral dilemma and turned him into a doomed Shakespearean hero wrestling with his conscience, and he cited the Tapestry (which he visited in 1864) as a fundamental source. One reviewer described this Harold as 'the hero and martyr of English freedom, worthy to be celebrated by an English laureate . . . [with] mighty physical strength to which the pictures of the Bayeux Tapestry bear witness'.[1]

For the ecclesiastical historian William Winters, Harold was one of the greatest Englishmen ever: hero and martyr, fine soldier, fair ruler and legislator, protector of the church, and generous patron and benefactor. Winters completely accepted the account in 'this worsted chronicle' as

historical evidence, and urged readers to visit the South Kensington Museum to see 'the finest copy that has even been taken'.[2] (However, Harold's gallantry in fighting to the death made him a negative role model for Emperor Napoleon III, who was reported to have been reading Lytton's *Harold* the night before he decided to surrender to the Prussians in September 1870.)

The Tapestry was not just an inspiration for poets and novelists, but a challenging and sometimes disconcerting source for historians, uncertain whether a work of art could really be a historical document too. During Victoria's long reign, the study of medieval history developed from an antiquarian pursuit into an increasingly professional discipline, and those working on the earlier Middle Ages commandeered the hanging as reliable evidence when it suited, though voicing fears that its pictorial nature created alarming ambiguities.

One unwritten biography that might have drawn heavily on the Tapestry was Thomas Carlyle on William the Conqueror. Although he never visited Bayeux, Carlyle got to know its famous monument in the 1840s when he was casting around for a new subject after the success of *Cromwell*. Contemplating eleventh-century England after reading Thierry's *Histoire* (with whose anti-Norman views he profoundly disagreed), he became fascinated by William and the nature of the Tapestry's evidence. In November 1845, during the temporary closure of the London Library while it moved to new premises in St James's Square, he wrote anxiously to his patroness and intimate friend, Lady Harriet Baring, to ask, 'is there among Lord Ashburton's books or yours any account of the Bayeux Tapestry . . . that immense web of ancient sampler-work . . . one of the strangest historical monuments that exist in this world and certainly the most interesting to all English persons?' Unaware of the new display, he assumed it was still stored in the cathedral. Later in the year, 'he came with his brother John to the Library of the British Museum and carefully inspected there the engraved reproduction of the Bayeux Tapestry, Anglo-Norman history in needlework. In the rude but genuine scenes . . . there was what delighted Carlyle. He had long thought the character of the Conqueror distorted by historians. Under Harold, Carlyle thought, England would have lapsed into anarchy.' The book he studied was Montfaucon's *Monuments*, which he dismissed as 'a very poor account of the Bayeux Tapestry'.[3]

Sadly, Carlyle never started on William's biography, but the Tapestry

remained in his mind. In a letter to Robert Browning in 1851, he described how reading Ducarel's *Anglo-Norman Antiquities* 'had roused all my old expectations . . . if I were to go to France, I think my next object would be Normandy, to see the Bayeux Tapestry, the grave of the Conqueror and the footsteps of those old kings of ours . . . but after all it is better to sit still'. He remained preoccupied with the nature of the heroic character, but instead turned to another famous warrior, Frederick the Great.[4]

The instability in France, and the Franco-Prussian War, made the author of *The French Revolution* aware of the risks the Tapestry continued to face. Meeting his old acquaintance Henry Cole, director of the South Kensington Museum, one day in the autumn of 1872, Carlyle announced: 'You should copy exactly the Bayeux Tapestry, which may be burnt any day. You would do more for Art than has been done in my time.' Cole recorded in his diary that Carlyle 'seemed quite amazed' when informed that the Museum was having it photographed at that very moment. Cole notified Carlyle when the facsimile went on display in the 1873 International Exhibition, and Carlyle returned warm thanks: 'I went yesterday with two companions to look at your Bayeux Tapestry in the Albert Hall and I cannot but express to you at once my very great contentment with what I saw there. The enterprise was itself a solid, useful and creditable thing, and the execution of it seems to me a perfect success for exceeding all the expectations I have entertained about it . . . I am much obliged to you for sending me to see this feat of yours . . . and very much obliged above all for your having done it and *so* done it.' Carlyle added that he hoped the negatives could provide copies for 'all British Colonies and even America itself'.

He returned to the subject once more in a conversation with Tennyson in 1879, as recorded by Tennyson's son: 'He admired *Harold*, saying that it was "full of wild pathos," and founded on the Bayeux Tapestry, which he called "a very blessed work indeed".'[5]

In the 1890s, one group of historians engaged almost too thoroughly with the hanging, arguing over the validity of its evidence in a venomous dispute almost as divisive as the Conquest itself. The issue was how much the Norman invasion had affected the English constitution, and the row revealed a clash of conservative and innovative approaches to handling source material, including dangerously selective use of the Tapestry's images. The catalyst was Edward Freeman, whose *History of the Norman Conquest* had cited the Tapestry as a key document. Freeman was a

historian of an earlier breed who had established his reputation as an 'amateur' unattached to any institution, a prolific independent scholar with a private income, who failed to receive academic recognition until 1884 when, at the age of 61, he was appointed Regius Professor of Modern History at Oxford. His view was the patriotic, Tennysonian one of the continuity of English customs, culture and character, all surviving after the Conquest, which, he claimed, had little impact on these underlying freedoms and values. Freeman's hero was Harold, not William, and his attitude was very much in the spirit of the time, the self-confident Britain of the 1860s and 1870s, which had learned to celebrate the ancient roots of its nationhood. (Significantly, the anniversary of the Battle of Hastings was virtually ignored in 1866, in contrast to the widespread festivities of 1966.)[6] But by the 1880s, scholars were coming to recognise and appreciate the Norman achievement, an attitude that Carlyle had helped to pioneer.

Freeman's chief detractor was John Horace Round, whose thesis was that the Conquest introduced feudalism as a revolutionary process that swept away all the old Anglo-Saxon structures immediately and irreversibly. Round wrote an unsigned article about him in the *Quarterly Review*, after Freeman's death in 1892. Anonymity in theory enabled academic authors to be more open, but could also serve as a cover for sheer malice, as in Round's article, which focused on Freeman's account of the Battle of Hastings and accused him of misinterpreting many details. He charged Freeman with deliberately twisting the Tapestry's evidence, thus distorting the work that he claimed to be a crucial source of evidence: such mishandling of material called into doubt his general professionalism and accuracy. By undermining Freeman's authority, Round sought to strengthen his own case.

Two younger historians sprang into print to defend their mentor from this slur. Kate Norgate was a regular contributor to the *English Historical Review*, which Freeman founded in 1886; her *England Under the Angevin Kings* was published in 1887. T. A. Archer was a historian of the Crusades. The two exposed themselves to a further vicious attack by Round, whose fluent, sarcastic tongue would have made him a media don today. For the next 12 years these three waged a savage scholarly war, sucking in other innocent victims in their claims and counter-claims, cheerfully citing or ignoring the Tapestry to prove or disprove Freeman's reading of the Battle of Hastings: drawing on Wace's *Roman de Rou*, he had argued that the English defences included wooden palisades in addition to the dense shield-wall.

Archer accepted Wace's claim that the English needed both hands to wield their massive battleaxes (and could not therefore have held shields as well), but pointed out, somewhat inconsistently, that axes were less prominent in the Tapestry's version of the battle because they were difficult to sew. And he criticised the unrealistically small size of the shields. Paradoxically, in view of Freeman's respect for it, Archer dismissed the work as 'comparatively weak evidence . . . it was wrought by women who were not on the field of battle . . . no one nowadays supposes it to have been wrought until twenty or thirty years after the battle'. He thought it more likely to be based on a later *chanson de geste*. Then he completely undermined the man he was trying to defend: 'Those who regard it as worked by Odo's orders, and by so doing turn it into a semi-official report of the battle, go much beyond their evidence.' Probably still being made at the time of Odo's departure on crusade in 1096, 'it is not merely an incomplete historic record; it is an unfinished piece of needlework'.[7]

Kate Norgate denied that Freeman had taken the alleged liberties at all, and pointed out that Round himself, as the anonymous reviewer, had also cited the hanging in a very selective manner. In his first signed response (the revelation of his name hardly surprising anyone interested in the row), Round swatted Norgate aside, quoting the same cruel words with which Freeman himself had dismissed Agnes Strickland – 'let us now return to the real world' – before proceeding to demolish Archer on the grounds of *his* inconsistency. Round then wickedly quoted Strickland's dictum that men who could not sew should not dare to discuss the work: he proposed that Archer should 'induce Miss Norgate to desert for a moment the battlefield for the distaff' so that she could explain to him the difference between an unfinished work and one whose end was missing. And Round had the last word, when the *Encyclopaedia Britannica* commissioned him to write the definitive entry on the Tapestry for its new edition of 1910.[8]

No one could have been harsher on the Victorians than the generation that followed. Morals, patriotism, taste and culture all came under the fierce scrutiny of twentieth-century standards, and those who had argued so passionately over the great national monument were dismissed by Hilaire Belloc in *The Book of the Bayeux Tapestry* (1913) as its 'slipshod, earlier and picturesque historians, with their touch of charlatanism and eye upon the public, notably Freeman'.

After the First World War, the Germanic contribution to Anglo-Saxon

culture took a lower profile (and Battenberg hastily became Mountbatten), while France was no longer seen as a threat, but as an ally. Tapestry studies reflected these shifts in attitude, and placed greater emphasis on William's role rather than Harold's. But one disturbing outcome of the Great War was the way in which Nazi historians commandeered the work to prove that the Normans were really Germans, and that William was the prototype Führer.

V

The Great Escape

17

Yuletide for Himmler

A country at war is the most dangerous place in the world for a work of art. Conditions in Occupied France – Allied bombing, Resistance attacks on key roads, bridges and railways, German retaliations, the imposition of fuel restrictions and curfews – posed grave threats to the movement of a fragile masterpiece. Yet between 1941 and 1945, the Tapestry was driven over open roads on five separate occasions, and was packed, unpacked and handled by far too many people – all anxious, though for very different reasons, to protect and preserve it. It was their very fascination and concern that repeatedly put it at risk and led to its precarious position in the heart of Paris as French and Germans fought around the Louvre in the chaotic days of liberation in August 1944. The Tapestry's survival intact, against all the odds, proved yet again that it had a charmed life.

Its experiences during the war epitomised those of many other works of art and the problems of the French in safeguarding their national heritage under invasion, occupation and looting. The greatest threat to all these monuments was not war damage, but the policies of the Third Reich. At the core of Hitler's agenda was culture as an expression of race, manifested by the acquisition and celebration of works that proved the superiority of the Aryan spirit. In the Tapestry, the Nazis recognised the heroism and brotherhood of earlier Germans, quite apart from its depiction of the conquest of England.

In Bayeux, however, its status as a famous Norman work highlighted the

problematic relationship between French and Germans in the Occupied Zone. Local people were determined to protect their treasure, but could not overstep the bounds of permissible behaviour for fear of reprisals. The Germans were constrained by their own inhibitions, reluctant to antagonise those with whom they were meant to be establishing peaceful coexistence, yet also aware of the interest that their superiors in Paris and Berlin were taking in the Tapestry.

'The story that we are going to hear is not fiction, although it has all the appearance and fascination of being so. It is true, down to the very last detail.'[1] These were the words of René Dubosq, a teacher at the seminary and a canon of Bayeux Cathedral, where powerful resentment still lingered that Napoleon had handed over 'their' relic to the municipal authorities. His book, The Bayeux Tapestry: Ten Tragic Years (1951), bearing the emotive subtitle, 'Hunted Down by the Germans, Rescued by the French', is a lively account of the Tapestry's adventures in the war. Claiming to draw upon eye-witness accounts, first-hand experiences and relevant documents, his narrative began in September 1938, when Hitler's threat to Czechoslovakia conjured up such immediate fears of invasion that the French government remanned the Maginot line and called up reservists. Throughout the regions of France, local authorities urgently reviewed security measures in the event of war.

The real power in Bayeux was the mayor, Ernest Dodeman, a former lawyer who had been in the post since 1929. As part of his civil-defence brief, he asked the municipal architect, M. Hallier, to make recommendations for the protection of Bayeux. The Tapestry was a top priority, for he had to answer to the Historical Monuments Service, which protected it as a national Historical Monument. The Hôtel du Doyen, its home since 1913, had extensive underground cellars, dry and sufficiently thick-walled to resist the anticipated bombing. The architect decided the Tapestry would be safe there, if further protected in a concrete-walled shelter erected in a corner already reinforced by thick medieval walls and vaulted ceiling. For compact storage, it should be kept rolled on a large wooden bobbin, whose shaft was 0.4 metres in diameter, with overhanging rims of 0.7 metres diameter, so that the apparatus could be wheeled without any of the fabric touching the ground. In order to monitor its condition regularly for humidity levels and moth damage, a second spool was needed so that the hanging could be wound from one to the other over a folding trestle table, which extended to a length of 4.5 metres. This unrolling was thought to be

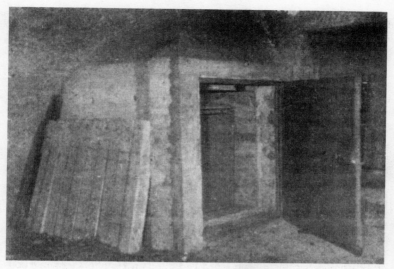

The concrete shelter erected in the cellars of the Hotel du Dôyen, Bayeux, 1939, where the Tapestry was stored at the start of the Second World War.

less damaging than the direct handling involved in folding it concertina-style in a chest, as it had been in the cathedral. Once on the spool, a locked, padded and zinc-lined wooden case 1.2 metres square would provide additional protection. The dimensions of the case determined the size of the shelter, which was to be 1.8 metres wide, secured by a reinforced, locked door 1.65 metres high by 1.4 metres wide.

On 29 September 1938, the mayor commissioned the carpenter, M. Godefroy, to make the spools, case and table, at a cost of 5,000 francs from the civil-defence budget. But Hitler signed the Munich Pact on 30 September, the threat of imminent invasion evaporated and the Tapestry remained on public display for the time being, while the equipment was made and the shelter built. These rather last-minute precautions, fortunately not immediately necessary, contrasted with the long-range policies of the Louvre, which on 27 September began evacuating its contents to the chateau of Chambord in the Loire Valley – sufficiently remote, it was hoped, from any bombing raids on Paris. This was part of an exercise whose planning had begun years earlier, although after Munich everything had to be returned to Paris.[2]

On 1 September 1939, Hitler marched into Poland. The Tapestry was

taken off exhibition, rolled onto its spool, sprinkled with moth-preventing naphthalene and crushed peppercorns, wrapped up in two sheets and taken down to the cellars, where it was sealed into its crate and locked in the shelter. It was under the immediate care of its long-standing custodian M. René Falue, 'the most friendly and well-briefed *gardien* in the world', who held all the keys.[3] In accordance with advice from M. Sauvage, head archivist and curator for the Calvados Department, the custodian aired the shelter frequently by opening the door, and regularly took the Tapestry out and unrolled it over its spools for a thorough inspection; this took two or three hours, and could only take place in the presence of at least three people, normally architect, carpenter and custodian. On 21 November 1939, for example, they spotted a moth and added more naphthalene powder.

Eight months later, in May 1940, German forces smashed their way through the Netherlands and Belgium into France, where resistance collapsed. By early June they overran and occupied Normandy. On 10 June, the French government abandoned Paris, and on 14 June, German troops marched down the Champs-Elysées. On 22 June, the Führer granted an armistice, which was signed at Compiègne in the very same railway coach in which Germany had surrendered to France in 1918, now 'liberated' by explosives from its historical exhibition hall and dragged to its original location to provide a symbolic setting to celebrate the reverses of fortune. (The wagon was later taken to Germany, where it would be destroyed by an Allied bombing raid.)

The armistice established the military administration of the Vichy regime. Bayeux was in District A, the North-West, one of the four regions of Occupied France under a military commander in Paris. There were some attempts to retain the previous local government structure, so that a department, such as Calvados, was run by a *Feldkommandantur* to parallel the prefecture. A town with a sub-prefect, like Bayeux, had an equivalent *Kreiskommandantur*. In order to ensure maximum cooperation with their German opposite numbers, many prefects and sub-prefects were replaced by more pliant successors. As for the elected mayors, the lowest cogs in the hierarchy and yet the people really responsible for absorbing the daily impact of the Occupation, only those thought not to be too opposed to the new regime retained their posts. Mayor Dodeman, who had had little option but to surrender Bayeux peacefully rather than see the inevitable destruction of his town and its citizens, was reappointed. He now found

himself in the awkward and often irreconcilable position of being the buffer zone between the new administration and the people of Bayeux. He and his council had to develop a good, yet always subservient working relationship with *Kreiskommandantur 789 – Bayeux*, under its *Kommandant*, Major Hoffmann. The mayor's dilemma would become more acute when he attempted to protect the Tapestry.

In the early days of the new regime, the occupying forces had little time to sample local attractions. But the Occupation's avowed intention was to maintain ordinary civilian life, and many *Feld-* and *Kreiskommandants*, in the earlier years at least before Gestapo domination, were professional *Wehrmacht* officers who had served in the First World War and had a genuine respect for French life and culture. As the Tapestry had put Bayeux on the map, they wished to show their appreciation by inspecting it. The mayor was the obvious person to approach. His position with regard to the Tapestry was ambiguous, for although he was administratively accountable to the Caen-based prefect of the Calvados district, designated Historical Monuments in all departments came under the Paris-based, now Vichy-run, Ministry of Fine Arts (*Beaux-Arts*, a sub-section of the Ministry of Education), which continued to operate through teams of regional inspectors who reported to the secretary-general, Louis Hautecoeur. (According to Hautecoeur's memoirs of the war years, other Vichy ministers viewed his department as rather a luxury.)[4]

The first demand to see the Tapestry came in September 1940, from a member of the local *Propagandastaffel*, the network of Nazi Propaganda Offices that Joseph Goebbels established as an integral part of the Occupation structure. The mayor avoided taking the decision himself, but referred the request to the Caen archivist, who granted permission to view on 22 September: he had little option. So the custodian had to unlock the door of the shelter, trundle the spool out of its case, attach the heavily restored end to the other spool, erect the trestle table and roll out length after length over its flat surface. News of this entertainment spread. In October, another officer, who said he was an archaeologist, received permission to take photographs, even though this meant exposing the fragile fabric to flash bulbs in an underground room. In November, a whole group of Germans inspected and photographed it, and during the next few months there were a dozen such viewings. Although some of these visitors undoubtedly wanted to see the Tapestry out of interest and curiosity, others had a more sinister agenda.

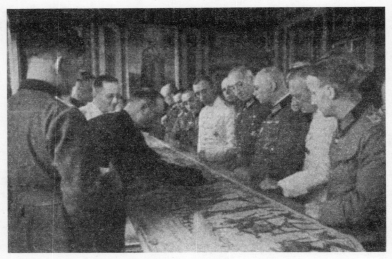

The Nazis admire the Tapestry, Bayeux, 22 June 1941.

What most fascinated them all was the scene where William's fleet crossed the Channel, the moment of the actual invasion of England. For these officers, it may have seemed a miraculous prophecy of the outcome of the campaign they were now waging, even though Hitler had by then shelved 'Operation Sea-Lion', the naval invasion of Britain he had planned for September 1940, in favour of aerial bombardment. By the early spring of 1941, he believed that Britain was close to collapse, as the Blitz delivered the onslaught intended to avenge RAF bombing of Germany and to force a devastated and demoralised country into surrender. The propaganda value of this famous work of art was well appreciated in Berlin, where Heinrich Himmler, head of the SS and of the Gestapo, realised (like Napoleon) the role it could play at a time when Britain was the only obstacle to their plans for European domination: he had to publicise the Tapestry and its message.

There was a second compelling reason for Himmler's interest which had attracted him to the Tapestry even before the start of the war: it was a magnificent example of Germanic, Aryan art and deserved to be recognised as such, whatever this might entail. Himmler projected himself as a medieval warlord presiding over the brotherhood of the SS (*Schutzstaffel*, the Führer's protection squad), a reincarnation of the glorious medieval

Order of Teutonic Knights. As the focal point for his aristocracy of warriors, concentration-camp inmates were restoring the ruined hilltop castle of the Wewelsburg, near Paderborn in Westphalia, where he decorated all the rooms in the style of the Middle Ages, hung with tapestries and textiles, armour and weapons, and filled with massive oaken furniture, and named the bedrooms after early German heroes. The great dining hall held a huge round table for Himmler and his 12 most senior officers. Its 45 by 30 metre dimensions would have dwarfed even the Tapestry. As early as 1939, a colleague reported that Himmler said he wanted a long, narrow tapestry for the personal suite of rooms that he dedicated to his namesake and special hero, Heinrich I (Henry the Fowler), who had saved Germany from the incursion of Magyar hordes in the tenth century.[5] Himmler had no scruples about furnishing his dream castle with items newly available as the countries of Europe fell before the German advance. Occupying the town that owned the famous hanging celebrating the victory of Germanic knights must have seemed like destiny.

One unit of the SS had a name that now chills the blood, the '*Ahnenerbe*' ('the Ancestral Heritage'). Himmler set up this research group in 1935 to prove the racial superiority of Germans. By 1939 it had around 40 separate divisions running scientific and historical projects across the world, from Latin America to Tibet, from ancient history to zoology, all to prove the existence of the lost Aryan master race. During the war, the occupation of so many parts of Europe provided new territories for *Ahnenerbe* scholars, who felt that they were not merely entitled to study the early art and archaeology of these areas but to reclaim and confiscate culturally significant monuments for display in a triumphant post-war Germany. After France fell, the *Ahnenerbe* forged close links with the Paris-based *Deutsches Kunsthistorisches Forschungs Institut* (Institute for Art Historical Research), a long-established and previously reputable academic body, which the SS now subverted to its own requirements. A research project on the Bayeux Tapestry, that superb example of Nordic craftsmanship, which told 'the story of the battles and victories of a Germanic prince', as one *Ahnenerbe* officer summarised it to Himmler, was just the sort of activity these institutions intended to undertake. The early medieval heroism depicted on the Tapestry was absolutely central to Himmler's vision of the SS and of himself. Not very tall, stocky, and wearing thick-lensed glasses, a man whose once-dark hair was receding fast, the *Reichsführer* preferred to identify himself with tall blond warriors. As early as July 1939, another

Ahnenerbe scholar had announced that 'the Tapestry proves that the Viking heritage and Viking customs lived on in Normandy in a relatively pure form'. By stressing the Viking origin of the Normans, the Tapestry became Germanic rather than French, and was therefore eligible to be reclaimed as a German national monument. It was significant that SS scholars generally referred to it as the Norman, rather than the Bayeux, Tapestry.[6]

So there was an ultimate goal, not expressed out loud, but certainly present in some people's minds – the removal of the Tapestry to Germany. This was the fate of many works of art plundered from defeated countries, not only because of their 'ancestral' relationships, but to fulfil Hitler's aim to create the greatest art collection in the world in Linz, his birthplace. Acquiring suitable works for this grandiose project was the specific remit of the ERR (*Einsatzstab Reichsleiter Rosenberg*), run by Alfred Rosenberg, fanatical theorist of Aryan superiority, whose bestselling *Myth of the Twentieth Century* (1930) defined the Nordic spirit and claimed that it was the foundation of Greek and Renaissance art. Rosenberg reported directly to Reichsmarschall Hermann Goering, another avid collector, who, jackal-like, snapped up works rejected from the Führer's collection, while negotiating his own acquisitions from other dubious sources. But there were meant to be proper criteria for confiscating such artworks: they must have originated in, or have some connection with, Germany (this included some of the treasures in the Louvre that Napoleon stole); be anything owned by a Jew or other declared enemy of the Reich; or be the product of 'degenerate' artists such as Picasso and Braque, which could be seized and sold off cheap to provide funds to buy more desirable works. The ERR piled up a vast storehouse of looted art in the Jeu de Paume gallery in the Tuileries, an outpost of the Louvre, which they commandeered as a staging post for mounds of antique carpets and tapestries (which Goering particularly admired), crates of gold and silver vessels and ornaments, fine furniture, small pictures temporarily hung on the walls, larger canvases propped up against them. All awaited shipment to Germany on Goering's own art-train, manned by the Luftwaffe.

The Tapestry, however, as a declared Historical Monument, was under the immediate protection of another German body with very different aims. The *Kunstschutz* (Arts & Monuments Protection squad) was attached to the *Wehrmacht*. Its official function was to implement the policy estab-

lished by the 1907 Hague Convention and successfully operated during the First World War – that in the event of war an invading force must protect culturally significant items in their own country. In defending such works, the *Kunstschutz* often found itself in conflict with the ERR and the *Ahnenerbe*, which were trying to acquire them. A civilian, Count Franz Wolff-Metternich, descendant of the nineteenth-century statesman and an art historian from Friedrich-Wilhelm University, Bonn, headed the Paris-based *Kunstschutz*. Placed in charge of protecting French art from August 1940, Wolff-Metternich took his new responsibilities very seriously, and determined to take the best possible care of the priceless items in his charge, even when it meant standing up to higher-ranking colleagues. As his second-in-command he appointed another admirably qualified academic from Bonn, Dr Hermann Bunjes, a medieval specialist who had researched Gothic sculpture and architecture in Paris. But Bunjes, unlike Wolff-Metternich, was already a member of the SS, which he had joined in 1938, initially perhaps as a career strategy and as a way of obtaining funding for his project on 'Forest and Tree in Aryan-German Spiritual and Cultural History'.

Before detaching the Tapestry from the protective control of the *Kunstschutz*, the *Ahnenerbe* had to undermine its protected status by redefining its nationality. Among the first Germans to inspect it in Bayeux in the winter of 1940 were members of that organisation, and they reported back to Berlin, to SS-Obersturmbannführer Wolfram Sievers, business manager and day-to-day head of the *Ahnenerbe*, and directly accountable to its president, Heinrich Himmler. Very early in 1941, Sievers notified the Fine Arts Ministry that the *Ahnenerbe* proposed to make a detailed scientific examination and full photographic record of the Tapestry.[7] Planning advanced during the spring of 1941, and letters passed between Sievers and Dr Bernhard von Tieschowitz of the *Kunstschutz*, one of Wolff-Metternich's assistants in Paris. Sievers confirmed that the arrangements for the detailed study of the Tapestry, which they had already discussed in Berlin, were now firmly under way: 'preparations for the photography of the Tapestry have progressed so well that the team who will be working on it will set off on 23 April. I would be grateful if you would inform the *Kreiskommandant* of Bayeux of these plans.' And he enclosed a copy of the instructions he had already sent to Major Hoffmann, notifying him that the research and teaching body of the *Ahnenerbe* was headed by Himmler, and that they would shortly be starting a project under the

direction of an SS-*Sturmbannführer* 'whose task it will be to prepare a new academic study of the Bayeux Tapestry'. So that local *Wehrmacht* staff would give their full support, he reminded them that 'the Military Commander in France [the head of the *Wehrmacht*] has given his permission for these works'. Sievers instructed Hoffmann to arrange free accommodation for a team of six people, from 25 April until 10 June, in the Lion d'Or, the best hotel in Bayeux. He also wanted the name of a good local photographer who had proper facilities and could rent out a darkroom in the evenings; as they would be using flash lighting with 'nitrofotlamps', there must be adequate voltage. Finally, he demanded a large room with suitable facilities where the work could take place. Meanwhile, he explicitly warned Hoffmann not to permit any unauthorised photography or copying of the Tapestry – Sievers must have heard about the other visits by the military over the past few months.[8]

Sievers put a respected scholar and senior SS officer, Sturmbannführer Professor Dr Herbert Jankuhn of Rostock University, in charge of the project. Jankuhn specialised in the early medieval art and archaeology of eastern Europe and of the Vikings, and his whole career was now dedicated to implementing *Ahnenerbe* policies of identifying and tracking down Aryan art and artefacts. Sievers was dealing with another member of the *Kunstschutz* staff, Dr Pfitzner (now responsible for liaising over the Bayeux project), whom he instructed to provide a car to enable Jankuhn and his extensive photographic equipment – cameras, boxes of film, developing products, which had all been sent from Berlin – to travel from Paris to Bayeux. As he understood that the *Kunstschutz* already held black-and-white prints of the Tapestry, they must supply Jankuhn with two sets.[9] But Sievers had to postpone this timetable, for Jankuhn was unable to get to France until later in May, when he went first to Paris to finalise arrangements with Bunjes.

The *Kunstschutz* was rightly alarmed by these plans, only too well aware of the likely fate of many of the items it was meant to be protecting – not just those that caught the eye of the ERR squad (for Goering's commands for the removal of artworks overrode *Wehrmacht* control), but the medieval 'Aryan' works that Himmler licensed the SS-*Ahnenerbe* to seize. It also understood the entirely subservient status of the Vichy-controlled Ministry of Fine Arts, the nominal guardian of such works. Pfitzner had already tried to spare the Tapestry from the research project by encouraging the Ministry to take a firmer line and by offering help to transfer it to a safe place.

Speaking on behalf of Wolff-Metternich, he proposed to Jean Verrier, Inspector-General of Historic Monuments for the Calvados region, that they should remove the Tapestry from its currently over-accessible location, though he did not immediately inform Verrier of the *Ahnenerbe's* plans. He suggested putting it in store with the works from the Louvre and the national museums, which were now dispersed to chateaux in the countryside.*[10]

The refuge that the *Kunstschutz* proposed for the Tapestry was the chateau of Sourches, the most isolated of all the chateaux housing the national collections. It was near Le Mans in the Sarthe department of western France and 175 kilometres from Bayeux. Pfitzner even offered to requisition the necessary petrol, by this time a rare commodity, if the Ministry had a problem getting supplies. Verrier accordingly wrote in May to his boss in Paris, Louis Hautecoeur, to request him to remind the Germans that the Ministry had ultimate responsibility for the Tapestry, and that its spool mechanism was designed for protective inspections only and not for frequent viewings. He added that he had discussed this with Pfitzner, who had confessed that it was very difficult to refuse permission to those senior German officials who demanded to see 'the Tapestry which showed the Conquest of England'. They appreciated that the removal of the Tapestry would be a very delicate matter locally, and it would be highly desirable to obtain the mayor's consent. The Ministry backed this plan. On 6 June, Jacques Dupont, another Inspector of Historic Monuments, travelled to Caen, where he persuaded the archivist, Sauvage, to approve the scheme, and then on to Bayeux, where he managed to convince Mlle Abraham, the librarian and curator. Finally, armed with the support of these local experts, he saw the mayor himself. Dodeman agreed to the plan, but only on condition that he could organise the move himself using local transport: he obviously feared that placing it directly into German hands, even those of the benevolent *Kunstschutz*, might mean that it would never be seen again, while taking it directly to Sourches would ensure that the Louvre staff there took control of it. As a further precaution to cover himself and his council, the mayor asked Dupont to provide an official letter from the Ministry confirming these arrangements. Inspector Dupont

* Pfitzner acted in an equally subversive way a year later when he gave advance but unsuccessful warning of the risk to the Ghent altarpiece, which Belgium had entrusted to French protection, but which the Germans took regardless.

returned to Paris the next day, 7 June, drafted a report and authorised the necessary letter to be sent.

But one of its own staff leaked the Kunstschutz's plan to smuggle the Tapestry out of Bayeux to the SS-Ahnenerbe. Wolff-Metternich's second-in-command, medieval art historian Bunjes, was playing a double game. With his Kunstschutz hat on, he was meant to be defending French monuments, but this role conflicted with his commitment to Nazism as an SS officer and Ahnenerbe scholar reporting directly to Himmler. His other activities included serving as a trusted aide to Goering piling up art treasures in the Jeu de Paume, something else the Kunstschutz tried to prevent, and working as cultural adviser to the German Military Command, where he dealt unsympathetically with complaints about the ERR theft of Jewish-owned works of art. On 8 June, two days after Dupont's visit, the Bayeux Kreiskommandant, Major Hoffmann, wrote a letter to the mayor, which Sievers must have drafted following Bunjes' warning.

This revealed that the highest German authorities, possibly even the Führer himself, were interested in the Tapestry and that it was to be the subject of intensive research and analysis. 'By command of the OKH [Oberkommando der Heeres, the Army High Command] Queen Matilda's Tapestry must be photographed and drawn. It will be necessary to move it to a suitable place so that it is not being continually rolled and unrolled. Therefore the Kreiskommandant has chosen the Chateau of Monceau. This project will be directed by a Professor and will take six weeks. For the Tapestry's security, it will be guarded day and night. The Tapestry must be transported to the Chateau Monceau on 10 June.'[11]

Although the mayor could not have realised the full implications, this meant that Jankuhn and his team were about to arrive in Bayeux in order to turn the town's monument into an Ahnenerbe case-study of exemplary Aryanism, under the guidance of the hydra-headed Bunjes in yet another of his roles, that of reputable academic attached to the Art Historical Institute. This was the real plot. Bunjes knew that, once redefined as a typically Germanic work, the Tapestry would be released from the protection of his Kunstschutz employers. Instead, his SS colleagues in the Ahnenerbe could return it to its alleged homeland, or his contacts in the ERR could operate the hated 'cultural exchange' scheme, whereby the French had to hand over some precious northern masterpiece in return for an item from Germany that they did not want.

Instinctively, the mayor deployed a series of delaying tactics. First, he

claimed not to have received the major's message until 9 June. He alleged that Hoffmann's interpreter and assistant Mme Chailliey, who had previously worked at the Mairie but was now attached to the *Kreiskommandantur* (a typical example of the sort of accommodations that had to be made in small towns), had forgotten to send it to him on the 8th. Then he pointed out that since the Ministry classified the Tapestry as a Historical Monument, it was not within his own power to authorise its removal. So he was forwarding Hoffmann's command to the prefect at Caen, who would contact the Ministry in Paris directly and notify the mayor of the decision: 'I will then hasten to be in touch with you,' he promised. The generally bureaucratic tone of his letter was marred only by the sarcastic last sentence: 'I would appreciate further details of the address which you provide only as "Chateau Monceau".' (Hoffmann called this bluff the very next day, pointing out, as the mayor knew full well, that the Chateau was just off the main road out of Bayeux, barely 3 kilometres away.) The mayor instructed his assistant M. Simon to take the Kommandant's letter to Caen that afternoon, and wait for a reply. In the meantime he telephoned the prefect, M. Graux, to ask for guidance. The prefect telegraphed the Ministry for urgent clarification on the line, then asked the Caen *Feldkommandant* to instruct Hoffmann, as his junior officer, to take no action until the Ministry had replied. The prefect had to use all his diplomatic skills in making such a request because the German authorities had the right to override French ones at any time. He then wrote to Hoffmann requesting a delay, a letter that Simon took back to the Bayeux Mairie that evening, to be delivered the following morning.

If the mayor had been hoping to put his feet up after dinner and con-gratulate himself on having managed to postpone things for a while, his evening was shattered when Mlle Abraham, the curator, came running to his house at 8.30 p.m. to announce that German soldiers had turned up at the home of the Tapestry's custodian and informed his wife (M. Falue being out) that they were coming to remove the Tapestry at 9 a.m. the next morning. The mayor telephoned another member of his staff, Colonel de Job, and asked him to get to the Tapestry's cellar very early the next morning; then he telephoned M. Cervotti, the commissioner of police, to brief him; then he instructed Pruneau, another of his staff, to go to the Mairie, retrieve the Caen prefect's letter from his office and take it immediately to Hoffmann at the *Kreiskommandantur*. But Hoffmann was out, so Pruneau explained the urgency to his lieutenant, who provided the alarming information that the sudden decision to move the Tapestry before

permission had been confirmed was not their choice, but the result of a command direct from Berlin. However, given their obvious unease, he guaranteed that they would not touch the Tapestry until the Ministry gave its approval. This response revealed the conflicting demands made on the occupying forces, with the *Wehrmacht*-run *Kommandanturs* trying (in this case anyway) to be sensitive to local feelings, while at the same time having to obey the irresistible orders of the SS.

Hardly reassured by this news, the mayor planned an alternative obstruction. He asked Commissioner Cervotti to retrieve the keys to the Tapestry's shelter and case from the custodian, and guard them in the police station. He was not pleased when Cervotti told him that Colonel de Job had already offered to rehang the work in its gallery in the Hôtel du Doyen to enable the Germans to record it there. Perhaps the colonel thought that keeping it in Bayeux outweighed the obvious risks of exposing it. Or perhaps he was just trying to keep in with the enemy, although his ultimate loyalties would be indicated by his death in Belsen-Bergen two years later. But the mayor refused to allow anything to happen without official authorisation and, at 9.30 that morning, he wrote a hasty note to a local representative of the Ministry, M. Paul Leroy, who lived in Bayeux, asking him to provide the necessary written consent: 'I cannot take it upon myself to move the Tapestry, because, supposing that by chance a bomb fell on the building and destroyed the work, I should be held responsible.'[12]

The *Ahnenerbe* research team had now all arrived in Bayeux and were waiting impatiently, though comfortably, in the Lion d'Or in the rue St-Jean, an eighteenth-century coaching inn with a cobbled courtyard full of geranium tubs. Leroy cunningly granted permission only for the Tapestry to be *visited* in the basement that morning; Cervotti returned the keys to the custodian; and Jankuhn and his colleagues turned up at 11 a.m., content, for the moment, just to view their prey. Meanwhile strings were being pulled in Paris. On 13 June, the secretary-general of the Ministry wrote to the mayor telling him that, in accordance with instructions from the *Kunstschutz* (presumably Bunjes, wearing all his hats), he granted permission for the group to inspect and photograph the Tapestry immediately prior to its removal to the Chateau Monceau, for full research and recording.

Although there had been little choice about it, the formalities were now complete and the project could start. Jankuhn's brief was to make a definitive study of the Tapestry for publication by the Art Historical Institute under Bunjes' supervision. The French, they claimed, had never

properly written up this monument because they did not really appreciate it; few of them visited it, and those who did were mainly academics wanting to argue with one another. All previous guides, by Laffetay and others, were cursory, and the whole world – which included all the foreign visitors who flocked to see it – had long been waiting for a proper discussion by authorities competent to deal with its technical and constructional features, affinities and dating, using the advanced scientific techniques that only German scholars had mastered. The result of their labours would bring honour to Normandy by demonstrating the 'radiance' of Viking culture.[13]

The ominous undermining of Frenchness by emphasising its Germanic roots proved that the project was not being undertaken for the purposes of altruistic scholarship or the desire to make a great work of art available to the wider world, but in order to use it as a propaganda weapon and exemplar of the Aryan spirit. It was to become 'a new building block in the spiritual foundations of the Germanic empire', as Sievers put it to Himmler. So truly 'German' a monument must inevitably be returned to its homeland.[14]

On 17 June, a small group of people, each of whom felt that he was most entitled to represent the Tapestry's interests, went to check the suitability of Chateau Monceau. They included Jankuhn for the SS and Inspector Dupont for the Ministry. But they all agreed that the location was quite unsuitable, for it was far too close to Bayeux for safety, and still dangerously near the coast at a time when RAF bombers were roaming the Channel. But 7 kilometres further inland was a much quieter spot, the huge Abbey of Juaye-Mondaye, whose sturdy construction and well-insulated wiring meant that it had already been judged safe enough to store the contents of the Bayeux Museum (all those archaeological and scientific specimens that had once been shown beside the Tapestry) and medieval manuscripts from the library at Caen.

A flurry of correspondence established the necessary security measures: the Tapestry would travel on 23 June; it must be accompanied by fire extinguishers at all times, its own custodian and three customs men would guard it in the abbey; all troops must be denied access to the building (notices to this effect were duly posted, personally signed by General von Stulpnagel, *Kommandant* of the Occupying Forces in France, a man fully aware of the looting habits of Goering's ERR, with which he had already clashed).

Meanwhile, the team was already examining the Tapestry in the panelled *salle des évêques* of the Hôtel du Doyen, extended to the maximum length

provided by the trestle table. On the eve of its removal from Bayeux, a group of some 20 *Wehrmacht* and SS officers came to admire it. These included Jankuhn's team and the *Kommandantur* staff, and they watched the story unwind – a hand-cranked, slow-moving cartoon film showing the defeat of the King of England and his army. Two surviving photographs have frozen this moment in time. Heads politely tilted, impeccably clad in their dress-jackets, sporting the insignia of the Iron Cross and medals won in an earlier war, the Nazis crowded together to study the encouraging message of the Tapestry.

Next day, 23 June, it was taken to Mondaye. The mayor had organised the move and the protective chest travelled in the back of a covered truck loaned by a local building contractor, M. Mabire, and driven by his son Jean. Also in the van were Commissioner Cervotti, four guards and fire extinguishers. An armed German policeman on a motorbike escorted them. The party arrived safely and the Tapestry was unfurled in the long, light north gallery on the first floor, where the work would take place. Members of the team worked on it every day, between 23 June and 31 July, including Sundays, from 8.30 in the morning to 9.00 in the evening, and sometimes even later, according to custodian Falue's notebook and Jankuhn's meticulous logbook,* before returning (if they were able to resolve the ongoing transport problems) to a very late dinner at the Lion d'Or.[15]

One of the team, Dr Schlabow, director of the Neumunster Museum of German National Dress and a specialist in historical textiles, needed only a few days for his examination of the fabric. He confirmed that the original wools were distaff-spun and was shocked that some of the nineteenth-century restorers used machine-made two-ply thread whose colour tones clashed badly with the originals. There were also clumsy repairs to the badly damaged end, especially the reconstruction of Harold with the arrow in his eye. He calculated the entire length to be 68.46 metres, not the 70.34 metres claimed by previous authorities.

Herbert Jeschke, an artist from Berlin, was there to copy the whole Tapestry in pen and watercolour in order to recapture the exact, subtle shades of the original and outdo the versions of Stothard and Sansonetti. Equally important was the compilation of a complete photographic record,

* Jankuhn's records of his work on the project that summer were not thought to have survived the war, but amazingly came to light after the curator of the Tapestry approached the German Embassy in Paris: Jankuhn's widow presented all her husband's documentation and photographs to Bayeux in 1994.

in colour and in black-and-white. The status of this *Ahnenerbe* project was such that Jankuhn was able to command the services of the top academic photographers of the day, Professor Richard Hamann of Marburg University and his assistants. Hamann was an art historian who pioneered the role of accurate photography as an integral method of teaching and research, and established it as a university discipline with its own department at Marburg. His particular interest was French Gothic architecture, and the German Occupation certainly provided him and his colleagues with a remarkable opportunity to build up an archive of images of great buildings and monuments. It was just as important for Hamann, whatever his opinions of the Nazi regime, to have access to the Tapestry as it was for Jankuhn to draw on his expertise, since making a full record of this key work was integral to any catalogue of western art.[16] They devised a special mechanism, a sort of platform to go above it, with an aperture through which the camera could be lowered in order to capture the details. Powerful lamps placed at different angles provided the necessary vertical or oblique lighting. Jankuhn decided to have every scene taken as a general view and in multiple close-ups, using standard 18 by 25-centimetre black-and-white plates, colour plates and transparencies.

The first photographer was Rolf Alber, whose patriotism, according to Dubosq's account, was greater than his interest in the Tapestry. On 22 June, the day before the move to the abbey, Germany invaded Russia, and Alber put in for a transfer to the eastern front. This was granted and he left the project on 29 June. He had made a start on photographing the Tapestry in colour when it was still in Bayeux, as well as in black-and-white at Mondaye. Meanwhile Jankuhn, an experienced archaeological photographer, took over. Dubosq claimed that he turned up at Prunier's, the local photographer in the rue St-Malo, with 120 plates that he wanted developed and printed immediately, and commanded Prunier to give over his entire staff and darkroom to this task. Prunier protested that he could not abandon his other commissions, and that such a small establishment could not possibly cope with such a large order, especially considering wartime restrictions. 'But you must work for the *Wehrmacht*', insisted Jankuhn. However, his logbook recounts visits to Paris to get the plates developed.

Alber's replacement photographer arrived later in July. She was Frau Uhland of the Marburg Institute, an expert in the 'trichrome' photography (a technique that produced colour prints by blending the three primary colours) that Jankuhn required. (Dubosq recounts another apocryphal

story that the requisition order had somehow failed to specify that the project was being undertaken in the strictly masculine environment of a Premonstratensian monastery, and when Frau Uhland turned up at the front gate, she was denied access to the cloistered inner zone on the first floor, to which no woman was permitted entry. As a compromise, the Tapestry had to be moved downstairs to the neutral guest area.) When she wanted to see what the couching stitches looked like from the other side, Jankuhn – despite the mayor's strict orders to Falue that none of the Germans should be allowed to handle the fabric – allowed Uhland to unpick some 50 centimetres at the top and bottom of one section of the nineteenth-century lining that concealed the back, behind the scene of Harold and Guy conversing. They took the opportunity to photograph it, and then she sewed it up again.

Jankuhn's main role was to analyse the archaeological aspects of the Tapestry – armour and weapons, costume and ships – and in this way determine its historical and cultural significance. He did this so effectively that Himmler was able to boast how the project demonstrated 'the importance which this Tapestry bears for our glorious and cultured Germanic history'.[17] Jankuhn also brought in another two experts. One was Otto Vehse, a former colleague and now professor of history at Hamburg University, whose commitment to Nazism was so great that he had abandoned earlier studies of Italian medieval history in order to concentrate on the Germanic peoples. He studied archetypes of the Führer figure, and specialised in the Vikings and their impact on Norman culture and institutions; his role was to consider the Tapestry's wider context and implications. Himmler much admired his work. The other expert was Professor Alfred Stange, a medieval art historian, who wrote an introduction and contributed a section on the artistic style of the Tapestry.

Bunjes carried on with his various duties in Paris but continued to liaise with Jankuhn, travelling to Bayeux on 23 July, for example, to inspect progress.[18] Other visitors took advantage of this remarkable opportunity to see the Tapestry close up, including Wolff-Metternich, who came to study the precious work he was trying to protect, as did the men from the Ministry, Dupont and Leroy. Others involved included the SS cameraman who came to shoot the Tapestry for two propaganda films, one of which was a documentary about the wonderful project, the other a more dangerous work of Nazi propaganda that included an invented image of the cathedral in flames. By 31 July their work was completed and the team dispersed.

Jankuhn was posted to south Russia, where, in the course of researching Gothic tribes, he plundered museum collections and sent matchless barbaric jewellery and metalwork back to Germany in the care of the SS. This delighted Himmler, but upset the ERR, which felt it should have had first call on such treasures.

On 1 August, Mabire's truck returned the Tapestry to Bayeux, where it was put back in the cellar. Bunjes travelled from Paris on 2 August to confirm its safe return, and inspected it on 3 August, when the custodian added more naphthalene balls. Bunjes was also there to check that local arrangements were in place for its longer journey to the chateau of Sourches; he had to speak to the mayor, the curator and Falue, and wrote to the military commander to confirm that they thought it would be safe to keep it in its box.[19]

The mayor formally notified the Ministry that the Tapestry was now available to be taken to Sourches and that he was awaiting their instructions; clearly he preferred dealing with his own countrymen rather than with the *Kunstschutz* representatives. But getting it there turned out to be the real problem. The Ministry wrote to the *Kunstschutz* requesting petrol for the journey, since neither the mayor nor the Caen prefect were able to requisition enough for a round trip of 350 kilometres. Although the letter pointed out that it was the *Kunstschutz* that was insisting on the move, this had no effect. Inspector Dupont informed the mayor on 6 August that the fuel-rationing section said that his demand was excessive, and that Caen must provide the petrol. Perhaps this suggested that the *Kunstschutz* had little clout when set against the greater needs of the army. But the prefecture had already used up its meagre allocation for the month, and could get no more. The mayor was in an impossible situation: commanded to move the Tapestry, but denied the means of doing so. Ever resourceful, he informed the Ministry that he had solved the problem: the Tapestry would travel in a 10cv van loaned by a local tradesman, M. Delahaye, whose engine had been converted to run on the gas produced by burning wood or charcoal. Invented in the 1920s, these *gazogènes*, wood-gas engines, really came into their own in petrol-starved France: even the German army used them later in the war.[20]

The means had been found, but it was impossible to travel without the correct papers. The vehicle and its occupants required separate sets of documents, as well as a permit signed both by the Ministry and the *Kunstschutz* allowing the movement of a Historical Monument. The long

journey to Sourches and back could in theory be made in a day if they set off early enough, but anyone travelling after the 10 p.m. curfew risked being arrested or shot. The date of 18 August was agreed for the move. On 11 August the mayor requested the Ministry to prepare the necessary paperwork, and asked the Caen prefecture for permits allowing the Tapestry's escorts, Falue and Cervotti, to travel beyond Calvados on the day.

The Ministry responded by return of post, but the papers from nearby Caen did not arrive until 10.30 on the morning of the day appointed for travel, by which time it was too late to set off. The Caen prefect sent another set dated for the following day, and a 5 a.m. start was scheduled. Falue and Cervotti turned up punctually at the Hôtel du Doyen, but there was no sign of the truck. After 45 minutes they found it a few streets away, stacked high with the necessary amounts of wood and a dozen emergency sacks of charcoal, but the driver was still struggling to get the engine started. At last the fuel started to combust, but by the time they had loaded the Tapestry and the very necessary fire-extinguisher, they were already running two hours late. Progress was unexpectedly slow, for the vehicle laboured so badly on the hills that Cervotti and Falue had to get out and push, then race to jump in again once it had passed the summit and regained momentum downhill. By 11 a.m. they were all so hungry that they stopped for a meal at Flers, some 50 kilometres from Bayeux. After the break, the engine refused to start. It took the driver another 20 minutes to get it powered up, which he only achieved by adding handfuls of charcoal to the sullenly smouldering wood which he had to poke and stir while clouds of black smoke shed sooty particles over his shiny, sweating face and filthy clothes.

It was not until five in the evening that they chugged up the drive of the chateau of Sourches, a majestic eighteenth-century building set in acres of landscaped grounds, now loaned to the Ministry by its owner, the Duc de Cars, to store the national collections. Here were kept more than 700 paintings from the Louvre, including huge canvases by Goya, Rubens, Veronese and other Old Masters, as well as priceless collections of jewellery and metalwork. Sourches was so remote that the very largest works from the Louvre had been taken there in the hope that they would not have to be moved again.

The Bayeux team did not dare turn the engine off this time but hastily unloaded the Tapestry and its kit into the care of Jean Serullaz, a member of the Louvre's Department of Paintings & Drawings, who was now deputy at Sourches to the curator, Germain Bazin. The receipt signed, they set off immediately with the optimistic hope of reaching Bayeux before curfew.

But progress got slower and slower, heavy rain fell, and by nine that evening they were only on the outskirts of Alençon, still a good distance from Bayeux, exhausted, apprehensive and very hungry. They decided to stop for the night. All the hotels and lodging houses were packed with refugees, so Cervotti guided them to the police headquarters in the Hôtel de Ville. Although his colleagues warmly welcomed him, they could not suggest any suitable accommodation until the concierge, who shared with them his modest supper of eggs and cheese, found the solution – a police cell. He found them vacancies in the section reserved for black-marketeers (who were flourishing in the face of Occupation rationing and price controls, and made a fortune providing country food and local wines to desperate Parisians or wealthy neighbours). They were released at six the next morning and reached Bayeux five hours later.

At Sourches, Serullaz stored the case containing the Tapestry in an area of the basement reserved for the most precious possessions, a wooden cellar that already contained five massive crates of very valuable paintings. Curator Bazin recorded its exact location in a careful drawing he made in

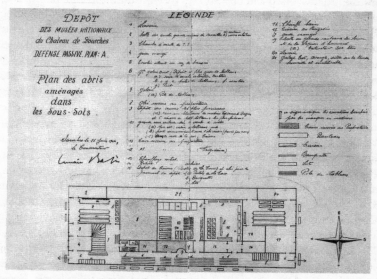

Germain Bazin's plan of the basement of the Chateau de Sourches, locating its priceless contents, June 1944. The Tapestry is item a in room 9, where the most precious works of art were stored.

225

1944.[21] It would remain here for the next three years, safe from Allied bombing – huge white letters painted on the lawn spelled out MUSÉE LOUVRE to warn passing pilots and crew – although not automatically protected from German intervention. The ERR had no compunction in taking away two major collections during this period because they were owned by Jews and therefore ineligible for *Kunstschutz* protection. If Himmler had demanded the Tapestry's removal at this time, it would have been impossible to deny him, but until Bunjes' project proved it to be a Germanic masterpiece, he had to respect *Kunstschutz* control. In Bayeux, as morale-boosting compensation for the dreadful absence of the town's cultural mascot, the municipal authorities decided to exhibit a substitute in its original home, and the cathedral's chapter house proudly displayed some of the full-sized plates that the South Kensington Museum had presented to the town in 1873.

Back in Paris, Bunjes drew together the summer's research. In the middle of September, Sievers informed him that Jankuhn would be tied up on the eastern front for at least two years, and asked him to direct the project instead. Bunjes seized the opportunity to reorganise the structure of the book about what he called the Norman (or sometimes William's) Tapestry. He also saw it as the opportunity to keep himself out of the front line: he pointed out that if he was drafted back into military service, Jankuhn would have to take over again. He envisaged a three-part study, which he outlined for Sievers' approval. Volume 1 would provide general background, describe other early tapestries, and previous research and literature. Volume II would analyse the Tapestry in detail, discuss where, when and how it was made, and cite its closest artistic parallels. Volume III would demonstrate its Nordic roots by relating it to other examples of Norman art and architecture, and would define intrusive southern or Christian features. The illustrations would be almost life-size, and reproduced in the exact colours. Over the next few months Bunjes and Sievers discussed and refined these details, for this great work of research was entirely dependent upon SS-*Ahnenerbe* approval.[22]

Sievers was delighted to spread the news of their latest research project. The significance of the Tapestry's message – a band of brave Germanic knights defeating the effete, dishonourable English and their arrogant leader – provided a marvellous propaganda opportunity for the arch-spinner Joseph Goebbels and his team. To rub in the message of dis-comfiture, Goebbels' 'English' voice, the Irishman William Joyce (who by

then had shed his Lord Haw-Haw identity), made the Tapestry the subject of one of his broadcasts. Joyce based his talks on fragments of news and gossip, as well as material that the Ministry of Propaganda fed him. In October 1941, he gloated on air that the Tapestry would be toured and exhibited to the citizens of still-neutral countries in order to warn of the imminent invasion of England. His claim that it was now in the hands of the Germans (although it was by then in Sources) was a frightening revelation of its intended future.

The broadcast produced a dignified response in *The Times* leader for 27 October: 'All things, noble and ignoble, fine and mean, are grist to Goebbel's machinery – to be perverted or pressed into the service of manufacturing evidence for the yet remaining gullible section of this world, of the might and right of the Third Reich.' The writer argued that 'the speaker for Germany' had got it all wrong: he could hardly invoke the Tapestry to predict future defeat or disgrace, because now 'most English boast of their Norman heritage'. And its scenes of daily life, and its careful crafting by Matilda provided 'a pleasing remembrance for our sock-knitting, pullover-wearing womenfolk . . . whatsoever the Nazi broadcaster, lecturer or pamphleteer may have to say, the Bayeux Tapestry speaks for itself'. The leader went on to celebrate the 'industry and piety which was a greater reality in the Middle Ages than its warlike escapades . . . the famous Tapestry will outlive the tawdry resurrection, under the name of the "new order" of that paganism of the Dark Ages which the dawning chivalry of Norman and Saxon alike had left far behind by 1066. This is the "propaganda" our Bayeux Tapestry really gets over, let the Goebbels minions do with it what they will.'[23] This inspired a letter published a couple of days later, which pointed out that an earlier dictator, Napoleon, had also harnessed the Tapestry to further his own invasion propaganda. That writer patriotically attributed the work to the hands of skilled Kentish craftsmen and not those of a Norman queen. (Adjacent letters that day contributed to a long-running correspondence on the consumption of horse-meat, and the unfair price reduction in shop-bought loaves following the general fuel shortage, because this discriminated against industrious home-bakers.)

Work continued on the Tapestry publication throughout 1942 and 1943, in Paris under Bunjes, and in Germany under Sievers and another SS academic, Hauptsturmführer Professor Dr Walther Wust, former dean of philosophy and rector of Munich University, and now the *Ahnenerbe's*

curator. Other *Ahnenerbe* projects in 1942 included Dr Sigmund Rascher's experiments into the effects of freezing and high-altitude pressures on the human body, carried out on the occupants of Dachau, and Dr August Hirt's fine collection of skulls, acquired by sacrificing some of the varied racial types at Auschwitz.

In January 1942, Sievers wrote to von Tieschowitz of the Paris *Kunstschutz* requesting access to the Tapestry to take more photographs and to check details for the copy that Jeschke was painting. Von Tieschowitz managed to put him off by pointing out, not wholly truthfully, that as Sourches was unoccupied and unheated, these projects would be more convenient when the weather was warmer. A handwritten postscript added, 'Count Metternich agrees with the above.'[24] In late March, Bunjes wrote to the custodian, M. Falue, in Bayeux to request more copies of the miniature pull-out version of the Tapestry that Falue had prepared some years earlier as a tourist souvenir. Such guides were also essential for research, and Bunjes had already marked up, measured and renumbered his own copy in red ink. He instructed Falue to post the copies to the Art Historical Institute in the rue Bonaparte, the bill to be paid on receipt, but the sceptical Norman dared to write back requesting advance payment: ten copies at 30 francs each, plus 15 francs postage. Bunjes paid up on 7 April and Falue sent him the guides.[25] In May, Fräulein Dr Lampe, a pupil of Professor Stange, having liaised with Verrier of the Ministry, took some colour photographs at Sourches. The mounting cost of the colour plates and slides alarmed Sievers and Bunjes, but their project was soon to be inspected by the highest authority.

One of the *Ahnenerbe*'s most feudal rituals was the giving and receiving of gifts, the old Germanic way of reinforcing patronage, dependency and general loyalties. By now it was an essential element of Himmler's cult of pagan medievalism. The Reichsführer even maintained a filing system – green cards for recipients and red cards for donors, which he marked up with full details of the person, the occasion and the present. Gift-exchange took place at the festivals of that earlier, purer Germany, which had replaced those of the Christian church, the summer solstice (which celebrated youth and fertility) and the winter solstice Yule, the time of the ancestors. So Wust and Sievers of the *Ahnenerbe*, the Ancestral Heritage, decided that a sample of their forthcoming publication would make a fitting present for the *Reichsführer* at the 'Turning of the Winter Sun' festivities that superseded Christmas 1942. They arranged to have a selection of the

illustrations printed and bound with a portion of the text, and in a covering letter thanked Himmler fulsomely for backing the project 'which would not have begun without your support'. By defining the Tapestry as 'new evidence for the culture-bearing power of our Germanic traditions', they were clearly reclaiming it as an entirely Nordic product. They presented the booklet to him on 24 December.[26]

Himmler, whose filing cards also noted those who failed to acknowledge gifts from him, wrote his thank-you letter on 7 January 1943:

Dear Wust, Dear Sievers
The 1942 Winter Festival gift from the *Ahnenerbe* in the form of photographs and drawings from the *Ahnenerbe* project on the Bayeux Tapestry, which you have just given me, has also provided very great pleasure because of the importance which the Bayeux Tapestry holds for our glorious and cultured Germanic history.

Even though the muses in the realms of the *Ahnenerbe* do not remain silent during war, admittedly they speak very quietly, but I know today and already see before me the great significance and blossoming of our intellectual work when the last cannon shot has been fired in the war. I look forward to this time with you, when we have peace everywhere, although it will bring a lot of work. I know that I can then build upon both your contributions in this newly begun year of 1943 as much as I have done in the past.

Heil Hitler
Heinrich Himmler[27]

In 1943, Bunjes became head of the Art Historical Research Institute. Wolff-Metternich had dismissed him from the *Kunstchutz* in 1942 because his other activities were too openly jeopardising his official function as a protector of French art. But Wolff-Metternich himself was sacked in June 1942 for being too francophile. This followed the *Kunstschutz*'s unsuccessful attempts to save the Ghent altarpiece from being taken to Germany, a theft sanctioned by Prime Minister Laval and Otto von Abetz, a former art teacher and journalist who was now German ambassador to Paris. Abetz's support for art looting had even extended to offering the embassy for temporary storage, which brought him into direct conflict with Wolff-Metternich and was one of the reasons for the latter's dismissal. Bunjes, who had influential friends and still assisted Goering and the ERR, was

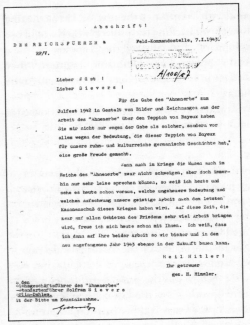

Himmler's thank-you letter to Sievers and Wust, 7 January 1943. He stressed 'the importance which the Bayeux Tapestry holds for our glorious and cultured Germanic history'.

rewarded with the rank of professor, attachment to the *Luftwaffe* by Himmler and finally to the Institute.

This body was responsible for publishing the Tapestry, through the Editions du Chêne, and Bunjes (in Jankuhn's absence) was now the official editor. But he kept changing the structure of the work. In May 1943, he drafted a 13-page document outlining progress so far, which incorporated Vehse's suggestion that there should be more stress on the political aspects of the Tapestry and its emphasis on the role of the leader, in order to strengthen the Scandinavian links. Vehse was killed in the bombing of Hamburg in July 1943. Meanwhile, Sievers was in touch with the *Kunstschutz* again to arrange for the artist Jeschke to work on his facsimile at Sourches, for *Ahnenerbe* duties in the southern Tyrol had prevented him being available any earlier. He went to Sourches in May, accompanied by a *Kunstschutz* representative, Dr Busley. They stayed in the inn at nearby St-Symphorien and came to the chateau every day.[28] Jankuhn returned from the east to Berlin in the spring of 1943, Sievers updated him on the project, and Jankuhn gave a lecture in April on 'Himmler's investigations

into the Norman Tapestry of Bayeux' as part of the cultural programme that Sievers organised for an elite group of *Ahnenerbe* members. He and two colleagues also discussed it at a seminar in August.[29]

A sycophantic article in the August 1943 edition of *Images de France* described Bunjes' project. This was a surprisingly opulent glossy magazine whose advertisements projected a luxurious Parisian lifestyle of shopping, beauty salons and auction sales, which bore no conceivable relevance to the actual conditions of Occupied Paris. The author was Suzanne Turgis, who had once written a fictionalised biography of Queen Matilda which included a detailed account of the Tapestry. Her piece lauded Bunjes and even wrongly claimed that he had accompanied it on the journey to Sourches. He had obviously given full cooperation and provided several excellent coloured plates in return for her following the *Ahnenerbe* line over its origins: she now described it as the epitome of Viking culture.[30]

Despite the war, scholars of other nationalities were also working on the Tapestry. The historian André Lejard was allowed to take photographs in July 1943 for a book, eventually published in 1946, on its role as a documentary source for the Norman Conquest. In England, it became the subject of a King Penguin (1944) by Eric Maclagan, director of the Victoria and Albert Museum. New photography was obviously not an option, but was not needed because the book used the surviving Dossetter plates in the museum, together with some coloured drawings copied from the facsimile. Maclagan's introduction reminded readers how the Tapestry had once fascinated Napoleon and was now being used by Goebbels and his minions for identical propaganda purposes.

18

Codename 'Matilda'

In the spring of 1944, when there were already massive Allied bombing raids over northern France, portents of the great invasion that was suspected, Himmler decided it was time to seize the Tapestry, that Germanic masterpiece, in a secret operation called *Sonderauftrag Bretagne* (Special Project Brittany): the Tapestry had a codename, 'Matilda', in homage perhaps to the wife of his hero Heinrich I, as well as William's queen. Bunjes worked out a plan to move the Tapestry to Germany more easily and less suspiciously if it was done in two stages. Taking it directly from Sourches to Berlin would obviously not be permitted by the *Kunstschutz* or the French authorities. But he could arrange for it to come to Paris to contribute to one of the many art exhibitions that he was organising to keep up morale and prove how much the Germans loved culture. He could obtain the necessary *Kunstschutz* permission to transport it by securing French approval first: he understood all the procedures. Once in Paris and in SS hands, it would be easy to spirit the Tapestry out of the country altogether. It was a good scheme, but the timing was wrong. On 6 June, the Allies landed on the Normandy beaches and started the push inland. This gave a sudden urgency to Bunjes' timetable.

Bayeux was the very first town that the Allied forces liberated, on 8 June. *The Times* reported their joyful advance: 'when the allied troops entered Bayeux, the streets were filled with cheering men, women and children. A British correspondent who entered the town with the troops says that the

cathedral seems to be undamaged. The tapestries were removed some time ago by the municipal authorities. No-one seemed to know where they had been taken, nor whether they had passed into the hands of the Germans.' In the heady excitement of D-Day, it was unreasonable to expect a young war correspondent to know that the work had not hung in the cathedral since before the French Revolution. Its iconic images had already played a part in the D-Day preparations. André Heintz, a young Resistance worker in Caen, inscribed postcards of the Tapestry with the message 'love and kisses' and sent them to inform other members of his cell that he had received the radio message warning that the invasion was imminent.[1]

On 14 June, General Charles de Gaulle entered Bayeux, no longer the king over the water, but President of the Provisional Government of the French Republic, as he defined himself in the communiqué he composed for the occasion, although it was doubtful that other Allied leaders agreed with this description. He set foot on French soil for the first time in four years to stake his claims to lead his country before the Americans and British could establish an interim regime. Despite the forebodings of Churchill, who had been outvoted by Eden and Attlee, de Gaulle embarked from Portsmouth on 13 June and next morning made a triumphant entry into Bayeux, where Mayor Dodeman officially welcomed him. His choice of Bayeux was significant because of its association with a monument that showed the defeat of the English by the French, the first step in the rehabilitation of his country's self-confidence. According to de Gaulle's memoirs, 'the inhabitants stood in a kind of daze, then burst into cheering or else in tears, all overwhelmed by comradeship, feeling national joy, pride and hope rise again from the depths of the abyss'.[2] He made a speech in the place du Château (subsequently renamed the place de Gaulle in honour of this event), then travelled with his entourage to Isigny, which (unlike Bayeux) had been devastated during the German withdrawal, and where bodies were still being dragged out of the rubble.

In the face of the Allied advance and German retreat, Himmler's need to get hold of the Tapestry became even more urgent, and he and Sievers devised a new version of Bunjes' plan. At the moment de Gaulle entered Bayeux, Himmler was contacting Abetz, the German ambassador in Paris. He expressed fears for the Tapestry's safety at Sourches and suggested it should be moved to some other location. On 15 June, Consul-General Gerlach, a cultural attaché from the German Embassy, went to see Georges Hilaire, current secretary-general of the Ministry of Fine Arts, and announced

that Himmler wanted the Tapestry to be moved from Sourches to the Louvre. Hilaire pointed out that the Tapestry belonged to Bayeux, and that the works held at Sourches were meant to be inviolate, but conceded that he had no particular objection and only needed time to plan the move properly. They drafted a joint memo stating that the Tapestry must be moved to the shelter of the Louvre for its greater protection, being transported at night by the SS, pending a final location elsewhere in France, possibly the chateau of Chambord. This last was a sop for the deeply suspicious *Kunstschutz*, who came under renewed pressure on 18 June when the director, Dr Bernhard von Tieschowitz, received a telegram from High Command proving that the SS and the Ministry had gone behind his back: 'The *Reichsführer-SS*, in agreement with the French Minister of Education, wishes the Matilda Tapestry to be brought to Paris immediately for safety reasons.' As the Ministry of Education controlled the fine-arts division, this showed that Himmler had gone straight to the top, to another tainted Vichy man, Education Minister Abel Bonnard (who had even proposed transferring all the contents of the chateau-depots to eastern France to ensure German 'protection').[3]

Von Tieschowitz, a professional art historian and former academic colleague of Wolff-Metternich, reported to a colleague his deep unease about the transfer of the Tapestry. Himmler's 'safety reasons' were unconvincing since, despite the increased bombing of western France, which might arguably have put the chateau of Sourches at greater risk, transporting a work of art under those conditions was infinitely worse. Bunjes' earlier pretext of requiring it for an exhibition was hardly valid considering the current military situation. Von Tieschowitz hoped that it might instead be stored in a bank vault, though such locations had proved no deterrent to determined looters in the past, but he suspected it might not be staying in Paris at all.

On the same day that von Tieschowitz received the telegram, the replica hanging in Bayeux Cathedral was inspected by members of the invasion force, 341 Battery of the 86th Field Regiment of the Royal Artillery. It was their day off, a brief respite from the slow advance through destroyed villages and the ordeal of shells and explosions, dead or injured comrades, and the consistently dreadful weather that month. Lieutenant Beck wrote the day up in his diary:

June 18: This being a Sunday it was relatively quiet and peaceful. Many of the Battery managed to visit Bayeux and have a look at the Cathedral

and the replica of the Tapestry which was on view. Many, too, sampled Calvados wine for the first time and at least one member of the Battery had to be carried back to the gun position.[4]

In Paris, despite the increasing urgency, it still took several days to organise the move. To prove that the *Kunstschutz* had granted permission, von Tieschowitz had to complete a notification form for the regional military authorities at Angers, confirming that the Tapestry was being moved on the order of the *Reichsführer-SS*. Still protesting, he had to be officially reminded by the secretary-general that 'I have the honour to inform you that the Ministry of Education has given permission for the movement of the Tapestry . . . it is absolutely essential that one of your representatives accompanies the Tapestry, under the authority of the *Kunstschutz*, otherwise anything might happen.' Perchet, the Ministry's architectural adviser, had to oversee the arrangements, which included obtaining petrol, and he consulted Inspector Jean Verrier about care of the Tapestry once it reached Paris. Verrier advised that they must check its condition on arrival and, if it really had to be exhibited, he strongly urged that this should be for no more than one day, given the speed of the Allied progress and the likelihood of bombing in the Paris region. All this time, the two main Allied fronts were inching their way southwards through Normandy and eastwards through Brittany, gradually approaching each other in a slow pincer movement that was intended to encircle Paris. Verrier argued against storage in a bank vault and insisted that the Tapestry should leave Paris altogether, after Bunjes' hypothetical exhibition, for another chateau-depot where it must again be unrolled and examined.

The date was fixed for 27 June. A typewritten document, stamped by the Military High Command, authorised SS-Hauptsturmführer Fischer, accompanied by Inspector Dupont and escort, to move the Tapestry from Sources to Paris. But despite (or perhaps even because of) the top priority given to reclaiming the work, neither Ministry nor *Kunstschutz* had notified the Louvre staff at Sources of these plans. On 27 June, at about five in the afternoon, Germain Bazin, the curator in charge of the chateau, was lying on the bed that had been moved into his office. He was laid up with a pulled calf-muscle, the result of an accident suffered a few days earlier in Paris when his customary last-minute leap over the metro ticket-barrier had ended in disaster, when he became entangled with his umbrella and fell to the ground. Bazin spent part of each month in Paris, where he taught a

course on museology in the stripped, freezing premises of the Louvre and brought black-market Sourches-made rillettes to deprived Parisian colleagues, having to pretend, as he arrived at the Gare Montparnasse, that his contraband suitcase did not look as heavy as it felt.

Recumbent but working, he was suddenly disturbed by 'arguments, barked commands and a dreadful commotion'. Then a group of Gestapo, carrying sub-machine guns, burst into his office. With them was Jacques Dupont, inspector of Historic Monuments. They had come for the Tapestry. Dupont flourished the requisition order, but Bazin pointed out that it was invalid – a brave thing to do while surrounded by gun-toting Nazis – because it had only been signed by the head of the *Kunstschutz* and lacked the necessary countersignature of the director of the Louvre. The latter's authorisation for the movement of any protected monument was a strict protocol agreed between Jacques Jaujard, the Louvre's director, and Wolff-Metternich in 1940. Dupont indignantly replied that his own presence was evidence of the director's consent. Bazin responded that he had to follow the correct procedures as he would be held responsible if anything happened to the Tapestry. (This was exactly the same argument Mayor Dodeman had used three years earlier, when he too was trying to keep it out of German hands.) Bazin refused to tell them where it was stored in that vast building, whose rooms and corridors contained hundreds of works of art, packed in crates of every size and shape, placed on racks and even propped against the walls. The Gestapo marched out, but left one soldier pointing his gun at the immobilised Bazin, who was all too well aware of his helpless state – 'it was very unpleasant to receive the Gestapo from a sick-bed!' – and thinking hard. Ten minutes later, M. Tourbat, his excitable second-in-command, returned in distress: 'Curator, I beg you to give the Tapestry to Monsieur Jacques Dupont, otherwise they are going to destroy everything here.'

Bazin knew its precise location, for only a few days earlier he had completed a plan of the cellars and their contents for Jaujard, his boss. The Tapestry was item *a* in the room he had numbered 9, *Depot of the most precious works*. He spent some agonising minutes reviewing his options. Jaujard had clearly chosen not to add his own signature to the controversial order to move the Tapestry, which was not even to be escorted by *Wehrmacht* soldiers, but, more sinisterly, by the Gestapo. At this stage in the war, reasoned Bazin, it was important to consider who was going to be in charge in the future, and Jaujard was trying to land Bazin rather than

himself with the responsibility for taking an unpopular decision. It was right that a junior officer such as himself should be sacrificed for the greater good under extreme circumstances; this was not just to save the skin of his superior, but to benefit the entire, complex institution of the Louvre. And he went on to ponder his whole career, and the fact that military service, which he had actively enjoyed in the First World War, had given him the ability to obey orders. So 'putting the safety of my own works first, I gave in.' He pragmatically revealed the Tapestry's hiding place to the Gestapo. His conclusion was that he had probably done the right thing, even though this meant it might now be on its way to Berlin. At least, this was how Bazin interpreted these events many years later, when he wrote his memoirs of the Louvre during the war, a story he was so determined to complete that he dictated the final words just a few hours before his death.[5]

So the Gestapo took the Tapestry to Paris in a period of unimaginable danger for anyone or anything on the move. After D-Day, Resistance sabotage programmes multiplied throughout France, the grid of self-contained teams that de Gaulle structured and supervised becoming increasingly confident in their tactics. The unit called the Green Plan blew up railways, the Turquoise Plan placed road blocks at main junctions, the Blue Plan took out power stations, the Violet Plan attacked tele-communications.[6] This was no time for unnecessary journeys, but for the Tapestry the usual miracles prevailed; it reached Paris safely and Dupont put it in the Louvre, devoid of contents except for a very few items of sculpture and carved stone that were simply too large to be moved. Early in July, Ministry inspectors examined it and sprinkled it with para-dichlorbenzine, another anti-moth agent, which suggested that they feared a long enclosure, then moved it to as safe and remote a spot as possible in the building's labyrinthine cellars. On 5 July, Georges Hilaire of the fine-arts division put his name to a protocol that outlined the sequence of events, mentioned Himmler's concern, confirmed that the Tapestry had suffered no deterioration due to the journey and had been delivered to Jaujard, director of National French Museums at the Louvre, in his capacity as the representative for the Historical Monuments of France.

News of the Tapestry's removal from Sourches, although not its new location, somehow leaked out. In England, so much anxiety was felt about a monument perceived to be more English than French that it led to a question in the House of Commons. On 25 July, Lady Apsley (Conservative MP for Bristol Central) asked Sir John Grigg, Secretary of

State for War, 'whether he has any information regarding the whereabouts of the Bayeux Tapestry, reported to have been removed by the Germans'. The answer was misleading: 'It is likely that the Tapestry is in store in the south of France with objects from the French National Museums.' This did not address the questioner's correct implication that the Germans had taken it, and was also wrong about its location for the past three years. The Tapestry remained in British hearts and minds during the progress of the Allies through Brittany in early August, when an erudite *Times* correspondent cited historical parallels: 'if the Bayeux Tapestry had remained in its own town, General Bradley could there have seen portrayed an invasion of Brittany by William of Normandy anticipating his own by nearly 900 years'.[7]

So concerned was Hitler by the speed of the Allied advance that on 3 August he put a new man in charge of Paris. General Dietrich von Choltitz was a Prussian, a professional soldier who had acquired his formidable reputation for ruthless loyalty by overseeing the destruction of Rotterdam and Sebastopol. Now appointed *Befehlshaber*, commander of Fortress Paris, his orders from Hitler were, in the last resort, to raze the city to the ground rather than leave anything standing in which the Allies could celebrate its recapture. Although Bunjes had thought that moving the Tapestry to Paris would make it more accessible for the planned SS transfer to Himmler in Berlin, rapid Allied movements in the first week of August, compounded by growing Resistance-fuelled disturbances (shooting Germans, wildcat strikes) in the city during the second week, quite apart from Hitler's plans for total destruction, meant that it must be seized immediately. By 16 August, the fall of Paris was so inevitable that the German Embassy was ordered to evacuate the city.

It was hardly the time for Himmler to be worrying about the Tapestry. He was still dealing with the aftermath of the July attempt on Hitler's life, the collapse of the western front and the Russian threat to the eastern front, while in France the German authorities at Vichy reported risings of the Maquis and the desertion of increasing numbers of French policemen. Arrangements for vacating Paris were being speeded up and the police were put under standing orders to withdraw with the *Wehrmacht* on 21 August. Yet Himmler could not give the Tapestry up. On 18 August, he sent a radio message to Carl Oberg, head of the Gestapo and the SS in France (whose recent promotion to *Obergruppenführer* was his reward for deporting 75,000 French Jews and taking vicious retribution against Resistance fighters).

Himmler commanded him, as part of the evacuation arrangements, to 'bring the Tapestry to a place of safety'. He did not know that GCHQ (General Communications Headquarters) at Bletchley Park was intercepting all messages to the German police in Paris.[8]

Von Choltitz would boast about his own brief involvement with the Tapestry in the memoirs of his short-lived command of the city that were serialised for three weeks in the French daily *Le Figaro* in 1949. The banner headline 'Why I did not destroy Paris in 1944' was trailed even above the paper's title. The ninth extract, a double-page spread plugged by a front-page insert: 'Hitler – "You must reduce Paris to a pile of rubble" ', was about the Tapestry.[9]

On Tuesday, 22 August, von Choltitz was working in his office in the *Wehrmacht* High Command, which occupied the luxurious Hôtel Meurice in the rue de Rivoli, a wonderful location in the smartest part of Paris, directly overlooking the Tuileries gardens. Its elegant arcaded entrance opened into a marbled hall whose mirrors reflected columns and sparkling chandeliers in fine rococo pastiche, a different world from the violence raging in the streets outside. For the past four days, encouraged by the proximity of the Allied divisions approaching from the south (which General Eisenhower had reluctantly diverted to liberate Paris from what he saw as their real mission of driving the enemy eastwards), Resistance workers and Parisians had openly risen against the German occupying forces. Now they were desperately short of ammunition and supplies to sustain their disruptive attacks. To support the beleaguered von Choltitz, a Panzer division was approaching Paris from the east; a giant mortar named 'Karl', which could fire a 2.5 tonne shell 5 kilometres, was on its way by train from Berlin; and the *Luftwaffe* had offered a night bombing raid to reduce to ruins north-east Paris, from Montmartre to La Villette, where some 800,000 people lived. On Hitler's command, mines had been laid under the Seine bridges, at all major junctions, and throughout the great buildings of Paris – Notre-Dame, the Opéra, the Madeleine. Von Choltitz had only to give the word for most of the city to be blown up. No one on his side knew that he had already committed treason by requesting the neutral Swedish consul, Raoul Nordlinger, to cross the German lines in order to urge the Allies to move on Paris faster than their enemies. Meanwhile, Parisians, scenting the end of occupation, had erected their traditional barricades of paving stones, furniture, burned-out vehicles, even scenery from the Comédie-Française, and were lobbing Molotov cocktails at the tanks crushing these barriers and firing back.

That Tuesday evening, von Choltitz was fearful that his subversive mission would be discovered, and he assumed the worst when his adjutant announced that two officers of the SS wanted to see him. In the waiting room he exchanged Sieg Heils with two senior SS men in immaculate new uniforms. One, the *Obersturmbannführer* of a Panzer division, informed von Choltitz that they were there on Himmler's orders, received through a radio message he had sent to the ominously powerful figure of Carl Oberg. But they had not come to arrest von Choltitz. 'On the orders of the *Reichsführer-SS* we have come to remove the Bayeux Tapestry to a place of safety.' The general was immensely relieved, but appreciated rather more than they did the difficulty of their task, for he had already failed to see 'this celebrated Tapestry' during the slightly calmer days at the start of his command.[10]

'Some chance!' he replied. 'Are you really intending to take it out of its shelter?'

'*Ja*, Herr General.'

'That would make me very happy. Please come with me to the balcony.' (In a later account, the general embellished this first version of the encounter by suggesting that they should also take the *Winged Victory* and the *Mona Lisa* – both of which had been removed from the Louvre in 1939 – but their alleged reply was that Himmler and the Führer only wanted the Tapestry.)[11] His first-floor balcony overlooked the rue de Rivoli and the railings of the Tuileries. If they leaned to the left, they could see the great bulk of the Louvre starting to loom a few hundred metres away. Missiles were falling all around and they could hear spurts of machine-gun fire from the direction of the Seine.

'You see,' said von Choltitz, 'the Tapestry is just down there, in the cellars of the Louvre.'

'But, Herr General, the Louvre is occupied by the enemy!'

'Of course it is, and heavily so, in order to shell the Prefecture of Police beyond.' The Prefecture was the first building to fall to the French insurgents, but had been briefly retaken by the Germans.

'But under these conditions, Herr General, how can we possibly seize the Tapestry?'

'Gentlemen, you are in charge of the best soldiers in the world. I will put five or six of my top men at your disposal and give covering fire to get you across the rue de Rivoli. Then you only have to break down one of the Louvre doors and fight your way to the Tapestry.'

The SS men appeared doubtful, then one grasped at an excuse: 'Surely

the French government evacuated the Tapestry a long time ago?'

'Not at all, the Tapestry is certainly there, but you will have to remove it by force.' And von Choltitz summoned a *Kunstschutz* officer, who confirmed that the Tapestry was definitely in the cellars, where it had only recently been placed.

'So, gentlemen,' continued von Choltitz, 'today the Tapestry can be rescued under your command.' With his years of military experience, the general had got the measure of these SS men, whom he described as 'wearing uniforms' rather than being proper soldiers. But he had at least offered enough cooperation to prevent them complaining to Himmler that a *Wehrmacht* general had thwarted SS orders; they had come up against a bloody-minded individual who had demanded that they risk their own lives. That was the last he saw of them. They set off in their two trucks, one for the Tapestry and the other apparently filled with enough cans of petrol to provide fuel for the long drive to Berlin, at a time when supplies were running out everywhere. They did not return.

Three days later, on 25 August, the Allies liberated Paris. Von Choltitz surrendered to Lieutenant Henri Karcher of the 2nd French Armoured Division, symbolically handing over a pistol, which he had to borrow from a fellow-officer as he did not possess one of his own. They marched him down the rue de Rivoli, his hands in the air, to a vehicle waiting in the place de la Concorde, while jubilant French crowds chanted '*le général boche!*' and a woman spat at him.

Meanwhile in Bayeux, no one even knew that the Tapestry had left Sources. In the wake of the Allied advance followed the Allies' own *Kunstschutz* team, the officers of the MFA&A (Monuments, Fine Arts and Archives), 'men who were formerly museum directors, librarians, archivists, painters, sculptors, archaeologists and art historians', whose job it was to try and ensure the protection of buildings and works of art under chaotic and unprecedented conditions; this was an admirable project, envisaged as early as August 1943, but which in practice led to the same sort of tensions with the Allied forces as those between the *Kunstschutz* and SS. Captain Bancel LaFarge, an architect from New York, was the first to arrive, just a week after D-Day, and set up his headquarters in Bayeux, whose virtually untouched condition did not prepare him for conditions in the rest of the region. He was astonished when the mayor asked him to check that the Tapestry was still safe in Sources, not just because the existence of this depot, with its cache of Louvre treasures, was unknown to the MFA&A,

but because they believed that Himmler already had the Tapestry. An article published earlier in 1944 to publicise the work of the Commission described how 'archaeologists and other trained experts accompanied the invading Nazi armies to select the most important works', such as the Tapestry, which had been 'removed from Bayeux in 1940 by Himmler's orders'. This piece also mentioned the SS publication project, the first study by German scholars, to prove that the Tapestry was 'a sort of German royal saga' expressing the distinctive Germanic traits of 'the joy of fighting, the love of war, and the chivalric respect of the enemy'.[12]

At the end of August, it was the mayor's turn to be astonished when LaFarge told him that the Tapestry was actually in the Louvre. Dodeman immediately notified the Secretary-General of Fine Arts that he would send a van to collect it on 9 September. But the Ministry refused permission for it to travel, on the grounds of security: Paris itself had been liberated, but the outskirts were still at risk of bombing as the Allies pursued the German army through north-eastern France.

The good news spread to England. On 1 September, *The Times* announced, via Reuters, that 'reports have reached London that the Bayeux Tapestry has been found in the Louvre in Paris'. This inspired a long leader, headed 'History in Pictures'. The writer pointed out that the Tapestry had always been used as propaganda, from the Normans to Napoleon, then discussed more generally how 'kings and conquerors' manipulated visual images to promote themselves. There was another piece on 3 October, following an encouraging story from a special correspondent about the general survival of French works of art during the war and the admirable activities of the MFA&A, despite its limited staff. 'Among the many mysteries of the war has been the fate of the Bayeux Tapestry but this has now been solved. It is in a sub-basement of the Louvre, in spite of the attempts of the Germans, with the help of the Vichy regime, to remove it.' Then it outlined fairly accurately the Tapestry's various wartime adventures, although the writer emphasised the role of the Louvre authorities, rather than General von Choltitz, in preventing its departure from Paris.[13]

Mayor Dodeman and Bayeux had to wait for their treasure. One of the curators of the Louvre visited the mayor to ask permission to display the Tapestry as part of a series of exhibitions in Paris to celebrate liberation, the revival of cultural life and the survival of France's artistic heritage. One of the other shows was a Picasso retrospective, which inspired riots because of the artist's support for the Communist Party. The reopening of the Louvre,

where the Tapestry hung in the huge Italian Primitives gallery in the wing named after Denon, was timed to coincide with the celebrations surrounding Churchill's visit to Paris on 11 November, Armistice Day. He and General de Gaulle, swallowing for the moment their great mutual hostility, headed a glorious parade of the French army down the Champs-Elysées. This created 'a vision', according to the report in next day's *Le Figaro*, 'which symbolised the liberation of France' and reclaimed the great avenue from memories of the insulting daily parade by German soldiers. Churchill did not visit the Louvre exhibition, but had long been aware of the Tapestry. On the eve of the Battle of Omdurman in 1898, he called the advancing troop of Dervishes 'the White Flags' because 'they reminded me of the armies in the Bayeux tapestries because of their rows of white and yellow standards held upright'. And in the first volume of his *History of the English-Speaking Peoples*, he referred to its 'irresistible charm', even though it gave the Norman version of events – then, as now, 'aggressors needed justification'.[14]

The next page of *Le Figaro* contained a brief notice that 'the famous Bayeux Tapestry is being exhibited in the Louvre from today until 18 December'. A few days later, on 17 November, the paper devoted a whole section of its front page to the exhibition. This was exceptional coverage considering that the paper only consisted of two broadsheet pages (because stringent paper and print rationing were still in force) devoted to war and political news – fighting on the Atlantic front, American forces advancing on the Siegfried Line – and the arts normally received a cursory mention on the back page. Written by the arts correspondent, critic André Warnod, and headed 'The Bayeux Tapestry in the Louvre', the article praised the display and pointed out that the spacious location made the narrative far easier to follow than the restricted and convoluted layout in Bayeux. After emphasising the Tapestry's artistic merit and value as a historical source, Warnod compared the propaganda attempts of Napoleon with those of the Germans, who, he rubbed in, had admired it so much, but had failed to steal it: 'thus the Tapestry, which has avoided destruction for six centuries, has been saved intact once more'.[15] The display also featured in a new magazine, *Arts de France*, a substantial monthly founded in homage to those who had suffered in the camps and the prisons, and its early articles dealt with issues of post-war reconstruction and the role of museums in rebuilding society. An article on the Tapestry exhibition redefined the work in modern critical terms: its artists were not interested in naturalism, correct

perspective or anatomy, but worked in an expressionist, stripped-down, symbolic style, with deliberately non-realist colours to achieve a decorative, two-dimensional effect.[16]

For five weeks the Tapestry remained on show in Paris (the same period of the year that Napoleon had displayed it in 1803), under far-from-ideal viewing conditions, for the building was unheated, coal being in scarce supply. Inspector Dupont compiled a short guidebook, a task more suited to a Historical Monuments man than a Louvre curator. His title, *La Tapisserie de Bayeux, dite de la Reine Mathilde*, managed to retain the traditional name, because this was 'more gallant and more poetic' than simply abandoning the old attribution. However, he stressed the Odo connection and proposed that the Tapestry was made for the 1077 consecration of the cathedral.

On 2 March 1945, the Louvre returned the Tapestry to Bayeux into the care of Mayor Dodeman and Mlle Abraham, its curator. It was insured for 3,000,000 francs during the journey, and was again escorted by Dupont, who must have recalled his previous journey from Sourches with the Gestapo. This time his companion was his colleague Jean Verrier, who had been involved in the Tapestry's protection in 1941. As the Hôtel du Doyen was still occupied by a field hospital and by the local pottery school, the Tapestry was temporarily stored in the library.

Incredibly, the SS-*Ahnenerbe* had not given up on their project. SS-Scharfführer Dr Schlabow, the textile expert on Jankuhn's 1941 team, revealed to Sievers in December 1944 how out of touch they were, for he was unaware that the Tapestry was at that moment on triumphant display in the Louvre. After reporting progress on another publication (that of the Swedish warrior cemetery at Valsgärde), despite the fact that his own museum had been bombed twice during Allied raids on Neumünster, Schlabow confessed that 'my work on the Bayeux Tapestry has had to come to a complete halt for the moment. Apart from that, the local papers had a little article a few months ago saying that the Tapestry had been kidnapped to America. Do you have any more detailed information about this?'[17]

Sievers was then desperately chasing progress for Himmler on various *Ahnenerbe* schemes. He asked 'Professor Dr Bunjes' about the Tapestry in January 1945, and received a reply as confusing as Schlabow's rumour. Bunjes wrote on paper still headed 'the German Art Historical Institute of Paris', but the address was now in Potsdam, and Bunjes confessed that 'I have evacuated the whole Institute from Paris but a small outfit still remains in France and the work carries on', which sounded rather

optimistic. He reminded Sievers that 'the Norman Tapestry was, on our request, brought from its storage space to Paris, and was put in the care of the Louvre'. He claimed that 'when the fighting got closer to Paris, I sent an order to put it in the bank vault where it is now kept'. This was a very strange interpretation of events: either Bunjes, the original mastermind of the scheme, was lying to Sievers, or perhaps he genuinely believed that the Tapestry had been transferred from the Louvre. As he would have left Paris, like all influential non-combatants, some days before 22 August (the day the SS team turned up to seize it from the Louvre), perhaps they had lied to Bunjes about their failure, in order to save their own skins.[18]

For General de Gaulle, Bayeux continued to symbolise the liberation of France. Elected president in November 1945, he returned to the town in June 1946 to deliver the speech known as the 'Bayeux Declaration', in which he outlined the constitution of the Fourth Republic and hailed Bayeux and its citizens as continuing witnesses of France's great history. In a later June, 1952, he unveiled the great monument commemorating the Normandy Landings, an enormous sculptured frieze whose style resembled that of a Roman triumphal column. His final visit was in 1960, when a newspaper reported, *Vive de Gaulle, vive Bayeux, vive la France!* In 1990, the town established its own de Gaulle Memorial Museum in the very building in which he had held the crucial meetings to discuss the new French constitution. For the Tapestry, that other potent symbol of survival, there was a new exhibition gallery on the first floor of the Hôtel du Doyen, which President Vincent Auriol opened in 1948. At last, the whole panorama could be viewed in one long scan, as it had been in the Louvre. Its wartime history made the experience even more dramatic.

As for the fate of those involved with the Tapestry during the war, Dr Bunjes – so utterly implicated by his work for Himmler and Goering – was arrested and interviewed by the MFA&A in 1945. Terrified that the extent of his involvement with the SS would be revealed, he begged to be allowed to live in Paris to work for the Arts Commission and resume his research of French Gothic sculpture. When they refused permission, he shot not only himself, but his wife and their little daughter.

Count Wolff-Metternich, sacked for being insufficiently pro-Nazi, was invited to work for the Americans and the new German government on art restoration policy, and became curator for the Rhineland-Westphalia region. In 1947, he wrote a moving account of how he had tried to interpret

his *Kunstschutz* responsibilities. Later he worked in Rome, where he studied the architecture of St Peter's.

His successor in the *Kunstschutz*, Dr von Tieschowitz, also emerged with a clean slate. Just before the liberation of Paris, he forwarded details and locations of many dispersed artworks to Wolff-Metternich, who passed them on to the MFA&A. Having proved his loyalties, he also worked on art restitution for the new German government and spent many years in France as cultural attaché to the German Embassy.

Professor Herbert Jankuhn achieved total rehabilitation as an academic and archaeologist, despite his high rank in the SS and his work for the *Ahnenerbe* looting squads. He remade his name as the excavator of Haithabu, an important Viking settlement in Denmark, and wrote prolifically on many aspects of early Germanic culture. He died an eminent scholar in 1990.

Wolfram Sievers, however, was tried at Nuremberg as the symbolic representative of the whole *Ahnenerbe* and all the crimes it had committed in the name of Aryanism. He received the death sentence.

Himmler took cyanide before he ever came to trial.

General von Choltitz was released in 1947. He provided copious accounts of his 23-day command of Fortress Paris, and is now fondly remembered as the man who personally saved the city from Hitler's intended destruction, for which he received the Légion d'Honneur. He died in 1966, the year in which he figured as one of the heroes of the epic movie *Is Paris Burning?*, which starred Jean-Paul Belmondo, Alain Delon, Orson Welles and Kirk Douglas, amongst others, and included his confrontation with the SS men. The part of von Choltitz was played by the German actor Gert Frobe, fresh from his triumph in the villainous title role of *Goldfinger*.

Apart from Jankuhn's cache of photographs (now in Bayeux), 400 black-and-white prints taken by Richard Hamann's team in 1941 also survived (now available for purchase as microfiches from the Bildarchiv Foto Marburg, Phillipps-University of Marburg). Thanks to Hamann's extensive photographic campaigns, it was possible to reconstruct accurately many of the medieval buildings of France destroyed as a result of the war. It is fortunate this was not necessary in the case of the Tapestry.

One curious piece of folklore emerged after the war: a local family hid the Tapestry from the Germans by stuffing it in coal sacks. This was already being recounted during the Liberation, and was still current in the 1980s.

Perhaps it was a composite rumour embracing earlier rescues during the Revolution and the Franco-Prussian War, for the work's every movement between 1939 and 1945 was all too well recorded.[19]

VI

Global Image

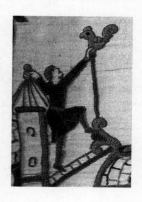

19

Literary Life

After the war, the national treasure saved from the Nazis in the town where de Gaulle inaugurated his vision of the new France attracted ever more interest. From its eighteenth-century rediscovery down to 1939, it had inspired at least 235 books and articles. By 1999 this figure had more than doubled, for the definitive bibliography up to that date listed more than 530 titles. By now, the total probably exceeds 600.[1] The 900th anniversary of the Battle of Hastings helped to generate more publicity: being able to see such a vivid and near-contemporary illustration of the most famous event in British history was far more exciting and immediate than reading about it, although the celebration became the peg for yet more publications. The 1986 commemoration of the Domesday Book also starred the masterpiece and its facsimiles. There were fresh interpretations in old media and new, for the Tapestry continued to feature in novels and poems as well as appearing on film, on the Internet and CD-Rom, and even in a video game.[2] In an age of advertising, when the best selling tool is instant recognition, its images have been harnessed to promote a wide range of goods and services. Political cartoonists have seized on the format and appreciated the subversive potential of the borders, while academics and others have applied new critical readings – no longer the old arguments about date and patron, but issues of ideology and gender, and the revelation of sub-texts, hidden meanings and conspiracy theories.

*

The Tapestry's vivid pictures and enigmatic scenes have caught the imagination of many writers, and their references all assume that the reader has an equally clear mental picture. While it has been the main subject of some works, it can also figure as a brief metaphor or even as a sort of adjective, repeatedly proving that it has become the most familiar image in the gallery of the mind's eye.

Many nineteenth- and twentieth-century novelists wrote about the Norman Conquest. Walter Scott's *Ivanhoe* (1817), a starting point for Romantic historical fiction generally, helped set the fashion and establish the anti-William tendency, for his story took place in a post-Conquest England trodden under the cruel Norman yoke. Scott knew of the Tapestry and expressed interest in Stothard's progress. In the 1830s, Charles Napier (a retired general and son of the former Lady Sarah Bunbury) intended to call the novel he was writing *Harold*. This was eventually published as *William the Conqueror, a Historical Romance*, because the prolific historical novelist Bulwer-Lytton had taken the other title. In fact, he might have borrowed not merely the name but the whole idea, for Napier had submitted his manuscript to Henry Colburn (Agnes Strickland's publisher), who forwarded it to Lytton to read. They rejected it, but significant elements would emerge in the latter's *Harold* ten years later. However, Napier did not mention the Tapestry and Lytton did.[3]

Lytton wrote *Harold: the Last of the Saxon Kings* at great speed over the winter of 1847 and it was published in June 1848. He frequently cited the Tapestry in his footnotes, among an impressive range of sources for the historical background. Borrowing from Strickland, he introduced the character of Turold, 'a dwarf misshapen in limbs but of a face singularly acute and intelligent', as Matilda's in-house designer, already sketching scenes of an earlier victory of William for her loyal needle. The novel resonated more widely with textile imagery, structured by the interventions and prophecies of the pagan priestess Hilda, who, with her attendants, metaphorically and literally wove and spun the fates of men. Contemporaries much admired *Harold*. For Lytton's friend Charles Dickens, for example, it was essential holiday reading during a stay at Broadstairs in August 1848: 'I have brought *Harold* down here and am going away now (it is very sunny and cheerful, strange to say) to lie down on the sand with him.'[4]

Historical novels were not just intended to entertain, but to educate, and to define patriotism for schoolboys, undergraduates and the reader bent on self-improvement. The Conquest remained popular, from G. A. Henty's

Wulf the Saxon, a Tale of Norman Times (1880) to the many Saxon and Norman stories published in *The Boys' Own Paper* and *The Heroes of the Middle Ages* series in the years leading up to the First World War. In the 1930s, writers as contrasted as Hilaire Belloc and John Buchan explored aspects of the period, and it has continued to attract serious historical novelists, such as Alfred Duggan, Rosemary Sutcliff, Nigel Tranter and Henry Treece. Hope Muntz's *The Golden Warrior* (1948), however, seemed to belong to the previous century in her presentation of Harold as a flawless heroic figure, yet it was founded on an impressive research background: Muntz translated and edited an edition of Guy of Amiens' *Song of the Battle of Hastings*. Novels about the Conquest now feature as an approved topic in the academic discipline of Medievalism, which emerged in America in the 1980s to study the cultural impact of the Middle Ages on later times.[5]

Few of the earlier novels mentioned the Tapestry – perhaps women's work played little part in the dramatic encounters of fighting men. When it did appear, it was to reinforce the nineteenth-century vision of its maker Matilda as a paragon of loyalty and virtue, even though most scholars no longer thought she was involved. This was the case with Suzanne Turgis' *La très véridique histoire de la bonne Mathilde* (1912), an uneasy combination of novel and biography. This Matilda commissioned the work to enhance her own status as well as that of William, for she wanted her husband to be remembered as a legitimate king rather than an illegitimate duke. Turgis compared Matilda to great embroiderers of the past, such as Penelope and Helen of Troy, and proposed that she commissioned the designs from the cultivated Lanfranc, Archbishop of Canterbury, who obtained the necessary details of the battle from Odo. However, the rude border scenes were added later by Norman ladies, whose increasingly decadent behaviour shocked the twelfth-century chronicler Orderic Vitalis. (It was on the basis of her reputation from this book that Bunjes provided the details and photographs for the 1943 article that Turgis wrote praising the *Ahnenerbe* project and stressing the Viking nature of the Tapestry.)

Elizabeth Villiers' *Love Stories of the English Queens* (1924) referred only briefly in Matilda's tale to the Tapestry, but Georgette Heyer supplied more details in *The Conqueror* (1931). Here it came as a flash of inspiration as Matilda watched William's fleet set sail across the Channel. From 'thinking how she might stitch this scene' in order to pass the time as she waited in Rouen for news, Matilda suddenly imagined a whole panorama of scenes. 'Her brain ran on, her eyes gleamed . . . it would take a long time, she

thought, but the end would justify the labour.'[6] Hilda Lewis created a more troubled, modern Matilda in *Wife to the Bastard*, astutely published in 1966. Here it was Odo's idea to commission a picture-book telling the story of Harold's perjury and the Norman victory, but when Matilda saw the charcoal drawings by a Bayeux monk-artist, she suggested they should be sewn, with inscriptions added to make everything absolutely clear. But she was too preoccupied with her unhappy marriage and feuding family to do anything about it, and only on her deathbed viewed the panels that the now imprisoned Odo had ordered in England. These images from the past helped Matilda to forgive William for his neglect, and brought peace and reconciliation. Jean Plaidy took the conventional line in *The Bastard King* (1974), where Matilda expressed loyalty and found therapy in making the Tapestry: 'she could not go into battle; all she could do was to help her husband whenever possible and recreate the story in her stitches' – words that echoed those of Collingwood Bruce writing the first full account of the work more than a century earlier.[7]

Fortunately, the Tapestry has also inspired more imaginative inter-pretations, while taking its place in the expanding genre of fiction and film about the personal stories underlying the making of masterpieces. Marta Morazzoni's *The Invention of Truth* (published in Italian in 1988, translated in 1993) is a delicate novella that moves in time between the eleventh and nineteenth centuries. It contrasts the experiences of one of the Tapestry's embroiderers with those of John Ruskin on a visit to Amiens, his farewell to France as his mind slowly disintegrates. In alternating vignettes, Morazzoni celebrates and subtly links together the making of two great works, Ruskin's *Bible of Amiens*, in which he compared the outside of the cathedral to the wrong side of a textile 'in which you find how the threads go that produce the inside, or the right-side pattern', and the Tapestry. Although Matilda is never named, but is simply 'the queen', and the location is kept anonymous, it is near enough to the coast for the young embroiderer, 'the woman from Amiens', to wade in the sea for the first time ever and transmute that experience into each passionate stitch of the trans-parent waves around William's fleet. In Morazzoni's version, the Tapestry was a project that the queen instigated to compensate for the guilt of not loving her husband. Made by the voluntary labour of 300 of France's most skilled needlewomen, it commemorated female expertise. The women (who each brought their own thimble and roll of different-sized needles) worked side by side on the already joined-up canvas, each allocated one

portion of her own to complete. The queen, a tough and sinister figure, supervised them and sewed her own section. But her pride in her own work and her jealousy of the woman from Amiens reached a climax when she secretly filled in the rudder of William's ship in the other's portion and made a mistake.

According to Peter Benson's *Odo's Hanging* (1993), it was Odo who commissioned the Tapestry from a team of Winchester nuns under the supervision of its Norman designer, the temperamental artist Turold. Told as a first-person narrative by Turold's mute assistant, Robert (who has included a self-portrait as the border boy firing a slingstone at birds), the book reveals that tensions are rife between the bullying patron and the rest. Odo imposed the inscriptions on his reluctant designer as an afterthought, and the Ælfgyva scene was a deliberate insertion, at William's command, to embarrass his over-ambitious half-brother by reminding spectators of the one love affair that had meant something to Odo, *unus clericus* ('a certain clerk'), although Turold generously left out the cruel verb, *they part*.[8]

To demonstrate its firm place in the creative imagination, the Tapestry also recurs unexpectedly in novels and stories set in modern times, at other times appearing as itself – the source of a visit or the memory of one – but sometimes a sudden startling image to trigger a particular response in the reader. No other work of art has been used quite like this.

Willa Cather, who spent much time in France, used it for a delightfully illuminating simile in *The Professor's House* (1925), a novel that describes with painful accuracy the creative processes of a writer and is shot through with images of stitching. The central character, Professor Godfrey St Peter, fearful of approaching old age, clings to the shabby, cluttered sewing room in which he has always preferred to write, and refuses to transfer to the spacious study in his grand new house: the old room was where he had created his eight-volume opus and was inseparably entwined with family moments. Cather drives this home by pointing out that when Matilda sewed the Tapestry, 'alongside the big pattern of dramatic action, she and the women carried the little playful pattern of birds and beasts that are a story in themselves; so, to him, the most important chapters of his history were interwoven with personal memories'. When the faulty gas stove in the room starts to leak, he decides to stay and let fate take its course. But Augusta, the family's sewing woman, rescues him.[9]

Aldous Huxley made a more sinister connection between the Tapestry and death in *Point Counter Point* (1928), a grim satire on modern London

life. When the debauched, amoral Maurice Spandrell decides to explore the depths of vice by committing murder, he selects as victim the Mosley-like Fascist leader Everard Webley. As Spandrell fells Webley with a club and rolls the body over with his foot, he shares his reaction with a reluctant accomplice: ' "It's a complete justification for Bishop Odo's mace", he went on dispassionately. That he should find himself recalling, at this of all moments, the comical prancings of that conscientious churchman in the Bayeux Tapestry – that too was part of the essential horror, the frivolousness of the human mind! The wandering irrelevance! Evil might have a certain dignity. But silliness . . .' Odo's 'conscientiousness' meant bearing the mace that was not supposed to draw blood, rather than the warrior's sword. But it was just as effective for bringing death.[10]

At exactly the same time, Scott Fitzgerald cited the Tapestry to measure the declining spirit of the Jazz Age. Europe now attracted the wrong sort of Americans, those 'fantastic Neanderthals . . . citizens travelling in luxury in 1928 and 1929 who had the human value of Pekinese, bivalves, cretins, goats. I remember the Judge from some New York district who took his daughter to see the Bayeux Tapestries and made a scene in the papers to advocate their segregation because one scene was immoral.' The Ælfgyva scene was obviously continuing to shock.[11]

More impassive spectators were the young couple in Pascal Lainé's *La Dentellière* (1974). Meeting on holiday in Normandy, they 'did' Bayeux as dutiful tourists. In front of the Tapestry 'Aimery read and translated to Pomme the history of William . . .', for Pomme, the doomed heroine, is a girl of humble origin and Aimery, an ambitious student from a good family, is trying to educate and improve her. His nickname for her, the Lacemaker (in homage to Vermeer's painting), suggests the loving and submissive role of women who sew – is Pomme meant to be another Matilda? But, after seducing her, Aimery tires of her, and the ending implies she may die. Women should not be so passive.[12]

Perhaps Lainé had come across René Trungy's *Le Val de Commes* (1854), an odd tragedy-cum-guidebook set in Normandy, in which another couple view the work, the lover moves on and the woman dies of a broken heart. Two whole chapters of a fairly short book are devoted to their visit to the Tapestry, which serves as Cupid for Georges de Ménars, an aspiring young civil servant on holiday, and the Baronne de Servas, a glamorous older woman. When she takes him to Bayeux, the experience transforms his blasé attitude towards life, for he learns to admire the local people and the

financial sacrifices they made to help pay for the new exhibition gallery in 1842. His initial response, that the Tapestry resembles a schoolboy's sketches, is followed by wonder at its sense of life and movement. He and the baroness agree warmly that 'this remarkable monument does not yet have the reputation that it deserves in France' and she confesses that her dream is to get the young women of Bayeux to complete the unfinished portion. Georges realises he has fallen in love with her patriotism, culture and artistic sensibilities. But it will all end in tears.[13]

For Marcel Proust, Normandy and its monuments were fundamental to *A la recherche du temps perdu*. He first heard about the Tapestry at the age of 13, when he spent the summer of 1884 obsessively reading *Histoire de la conquête* by Thierry, who remained a favourite author. An even greater influence on him was John Ruskin, many of whose works Proust claimed to know by heart, including *The Stones of Venice*, which made two admiring references to the Tapestry. Proust's translations of *The Bible of Amiens* and *Sesame and Lilies* were published in 1904 and 1906. On a convalescent holiday in Cabourg (the novel's Balbec) in 1907, Proust asked medieval art historian Émile Mâle to suggest the most interesting things to see in Normandy. Mâle's reply must have included the Tapestry, for Proust's next letter thanked him and listed the recommended places he had visited. But the truth came out in a letter to his friend Emmanuel Bibesco: 'Queen Matilda's tapestry is really interesting and beautiful. I went to Bayeux yesterday but I wasn't able to see it. I'm sure it's worth going back for.' There is no evidence that he ever did. However, a vision of it undoubtedly underlay his oblique reference to 'Queen Matilda's cavalcade' in a passage that celebrated the medieval ancestors of the Guermantes, living near Bayeux in a castle whose walls were hung with tapestries and lace.[14]

Anthony Powell cited the Tapestry in *A Question of Upbringing* (1951), the first volume of his own Proustian masterpiece, *A Dance to the Music of Time*, to give some sense of the strange postures of the housemaster Le Bas 'holding up both his hands, one a little above the other, like an Egyptian god or figure from the Bayeux tapestry.' Le Bas is the target for schoolboy mockery, an ungainly figure whom Powell also compares to a knave of playing cards, 'belonging to some highly conventionalized form of graphic art.'

A. S. Byatt has twice brought the Tapestry into her fiction. *A Whistling Woman* (2002) evoked the memory of a visit to Bayeux. Her heroine, Frederica, looks through a box of old photographs of the Elizabethan

pageant of 1953, which changed the course of her life: 'There was her old school teacher, Felicity Wells, who had died on a school trip, quite suddenly, in front of the Bayeux Tapestry, her finger raised to explain that here was the death of Harold, the last English king.' Death, nationality, identity, Proustian nostalgia are all elements of the novel, encapsulated in Frederica's sudden recall of the grotesque incident. In *Possession* (1990), Byatt used the Tapestry to indicate the seafaring, Viking history of Scarborough, where her Victorian poets, Tennysonian Randolph Ash and fey Christabel LaMotte, consummate their secret love affair in the boarding house of Mrs Cammish, 'a tall woman with the heavy-browed frown of the Northmen in the Bayeux Tapestry, who had also, in their long ships, settled this coast'. Just a fleeting reference, but one that suddenly called up the whole Nordic background of Ash's epic poetry.[15]

Novels have inspired facsimiles, just as the Tapestry has. Tom Holt has written 'sequels' to E. F. Benson's Tilling series, based on the Sussex village of Rye and its feuding inhabitants. *Lucia Triumphant* (1986) is a replica about a replica, in which the arch Lucia Pillson decides on a unifying, yet self-glorifying project to commemorate her second term as mayor. 'The instrument of her destiny would be the Tilling Tapestry (or rather embroidery) depicting the whole history of the town from mythical times down to the present day. It would be a work to rival the handicraft of the good wives of Bayeux – greater indeed than theirs by as much as the scope of her subject, which was broader and more comprehensive.' In fact, the Tilling Tapestry easily takes its place amongst the other civic 'spin-offs' that continue to be made, though, we must hope, with less dissension: Lucia's team quickly realises that embroidery is very hard work; quaint Irene upsets them by sewing a nude male; and they all cheerfully abandon the work for the new craze of Monopoly that Lucia's rival, Elizabeth Mapp, has cunningly introduced to the village. Lucia turns the completed portion into curtains and presents them to Queen Mary, who admired them on a royal visit to the town.[16]

Robert Benchley also devised a humorous treatment in a short story, *Bayeux Christmas Presents Early*, which fantasised about the discovery of a missing portion of the Tapestry in Bayeux, New Jersey. Another comic story, *Cut* by Kevin Pilley, turned the Tapestry into a medieval movie, sewn on the spot as actors posed, while an eleventh-century Mary Whitehouse complained about the gratuitous violence in the battle sequence. [17]

*

The work has also inspired poets, whose treatments have veered between the serious and the more light-hearted. The nineteenth-century Caen poet Alphonse le Flaguais produced an epic in praise of Matilda, a Penelope for modern times who 'told everything with her needle'. In two further sonnets, he extended the classical comparisons and described her work as greater and more beautiful than Homer's *Iliad*. Honoré Delauney (son of one of the Bayeux art commissioners who had helped preserve it during the Revolution) followed up the serious pamphlet in which he had attacked the Abbé de la Rue's dating with a poem that humorously imagined Matilda's ghost denouncing the abbé for daring to suggest she was not its maker. The town's historian, E. F. Chigouesnel, described the whole hanging in rhyming verse; and Jean Berthot, founder of the local literary society, wrote a poem whose final stanza translates as:

> What now remains of those victories of yesteryear?
> A woman's work. Yet nothing is more clear
> Than that the needle, in the last resort, is mightier than the spear.[18]

Meanwhile a humorous British monologue focused on Harold. Written by Marriott Edgar, and famously recited by Stanley Holloway, 'The Battle of Hastings' (1937) needed the listener to visualise the Tapestry's best-known image, of ''Arold with an eye-full of arrow, On his 'orse with his 'awk in his 'and'.[19]

In the strongest contrast, twentieth-century American poets have captured the Tapestry's fleeting, allusive, half-recalled images in words or phrases enmeshed in verse that is already pictorial. For Robert Lowell, translating and reworking earlier European poetry, the butchered bodies below the battle scenes inserted themselves into his 'From the Gibbet' (1946) (based on François Villon's 'Ballad of the Hanged Men'). This gave voice to a corpse whose flesh was withering from the bones, pecked away by birds whose sharp beaks Lowell compared to the needles that sewed the Tapestry. The horrors of conflict also concerned Adrienne Rich, who wrote 'Mathilde in Normandy' (1951) at the height of the Cold War. This put the women's point of view – that of those who have to wait at home, like Matilda and her ladies, able only to stitch away patiently while their men wage war and play politics on the other side of the sea. George Starbuck's 'A Tapestry for Bayeux' (1950s) compared the D-Day invasion to that of 1066. Derek Walcott evoked earlier wars in *Tiepolo's Hound* (2000), a verse

narrative based on the life of Pissarro and filled with references to works of art. One section dealt with the Franco-Prussian War (which drove Pissarro and Monet to London) and then with earlier battles, Poitiers, Crécy and Hastings, and he likened the Tapestry to a shroud embroidered by arrows. In his 'Bayeux' (1993/4), Alan Bates, an English poet obsessed with Proust and Normandy, managed to draw parallels between the woman and child escaping from the burning house with the situation in former Yugoslavia. Australian David Campbell's 'Bayeux Tapestry' (1976) contrasted the deeds of great warriors and ordinary men, and the refrain echoed how William rode into battle, but the ploughman in the border just kept on with his work. Less dramatically, Stephen Dobyns' nostalgic 'What you have come to expect?' (1984) recalled his boyhood self emerging from the cinema to find his 'Bayeux Tapestry' dog waiting patiently for him down the street.[20]

The Tapestry has also served dramatists. The 1803 Vaudeville operetta re-created the making of the masterpiece on stage, and the same idea lay behind *The Tapestry at Bayeux*, a whimsical one-act play for amateurs by L. du Garde Peach, a film- and BBC script-writer, who turned to medieval topics after writing the first Ladybird history books. Like the musical play, his stage-set was a room filled with embroidery frames in a castle in 1066. 'Peachey's' Matilda was 'a grim woman with a commanding personality' and the flimsy plot centred on the hostility of the three countesses whom she had ordered to embroider the Tapestry – they despised her vanity in glorifying herself by depicting the exploits of her bastard-born husband. When the rumour of William's death reached them, one lady rejoiced, 'now we shan't have to finish the beastly thing', and another added, 'let's hope it will give people in the future some idea of the sort of brute he was'. But a messenger brought news that he was alive and they had to carry on sewing.[21]

Tony Kushner made the Tapestry an oblique, yet significant motif in his 'AIDS epic', *Angels in America*. Set in New York in the late 1980s, this polemic on Reagan's era cited the Tapestry to contrast Matilda's loyalty with the cruelty of Louis Ironson in abandoning his lover Prior Walter, who is dying of AIDS. Prior traces his family name back to the Conquest and claims to have an ancestor stitched into the Bayeux Tapestry. The guilty Louis compares his growing revulsion with the devotion of Matilda, who not only waited and embroidered for William, but would have loved him

even had he returned 'mutilated, ugly, full of infection and horror'.[22]

The idea of making a radio serial out of this powerful visual icon was ambitious in the extreme. Yet *The Bayeux Tapestry*, broadcast on Radio 4 in February 2001, was an aural tour de force that combined modern reportage – commentary on the Battle of Hastings by newscaster Kirsty Wark – with Tennysonian verse spoken by Harold, earthy asides by the common man and woman, and specially composed music. Written by poet Simon Armitage and playwright Jeff Young, this tapestry of sound was a genuine innovation. Its enthusiastic reception showed that the eternal themes of divided loyalties, defeat and victory, a hero and a villain, were constantly able to entertain or move an audience, whether readers, spectators or listeners.

20

The Norman Newsreel

The Tapestry also had a role to play before the camera. Cinematologists hailed it as the very first film, a valid topic for the new genre of film theory that emerged in post-war France as the avant-garde tried to come to terms with the issues posed by the Resistance, Occupation and Liberation. The journal *La Revue du Cinéma* turned into *Les Cahiers du Cinéma* in 1951, the mouthpiece of a movement that considered the nature of realism in film, and traced cinema's roots back to earlier art forms such as the Tapestry.

Yet the English had inadvertently got there first. The *Times* leader of September 1944 celebrating the wonderful rediscovery in the Louvre described it as a 'great Norman newsreel' that anticipated the invention of Technicolor. Its ancestor was that 'film in stone', Trajan's Column. However, the designers 'must be held to have surpassed their Roman predecessors in their sense of publicity value' by using a cathedral as a giant cinema. Historical Monuments inspector Jean Verrier, fresh from his wartime struggles with the Nazis and the *Kunstschutz,* made a similar comparison in the guidebook he compiled in 1946, in which he described the Tapestry as a 'propaganda film'.[1]

The first proper cinematic analysis was Marie-Thérèse Poncet's doctoral dissertation on the modern cartoon film in relation to medieval art, which she submitted to the Sorbonne in 1951. Her supervisor, art historian Louis Réau (who had himself written on the Tapestry as far back as 1925), pointed out, with some understatement, that her work had surprised that

august institution. Poncet took the Tapestry as a key monument, the subject of the central chapter of her thesis. Her concept of this 'medieval film' was the way it continuously unrolled the subject through a sequence of images whose framing, bordering and dividing motifs prefigured those of the cinema, while the symbolic colours of medieval art stood for the lighting and sound. She examined the whole work as if it were a film script, using fashionable terms such as mise-en-scène and depth of field, focus, takes and cuts, montages and camera tracking. Like all good films, it had a prologue, main and sub-plots, romantic interest – a rather unconvincing citation of Ælfgyva as the cause of the Brittany campaign – and a denouement. Just as a film must have at least one *clou*, or really striking sequence, so the Tapestry had the Channel crossing, and then the extended climax of the battle. Adopting the *Cahiers'* cult of the *auteur*, she discussed the characteristics of the Tapestry's 'director', how he scanned panoramically or zoomed into close-up, focusing on expressions and gestures. As in a silent film, the vivid gestures served for speech, and the inscriptions were the captions. Visually, the bright patches of colour surrounded by outlines gave a sense of relief and three-dimensionality: Walt Disney's animators would ultimately adopt such devices. After this exciting debut, Poncet specialised in the history of the cinema cartoon, but later returned to the Tapestry, coining the term *dessin animédiévale* to define its dual nature as documentary and historical cartoon.[2]

Director and theorist Roger Leenhardt, whose concern to represent the real world had already made him a revolutionary documentary maker and critic in the 1930s, contributed regularly to *Les Cahiers du Cinéma*. In his documentary *La Conquête de l'Angleterre* (1955), a narrative of the Norman invasion, Leenhardt used the Tapestry to demonstrate the intersection of art with reality by combining stills from it with moving film he had shot. This is now standard procedure, particularly on television, where every other programme about the Middle Ages includes a few statutory images from the Tapestry, but it was a real innovation in the 1950s. Another crucial defender of the camera's objectivity was André Bazin, film critic and spokesman for the *nouvelle vague*. His study of the man he described as the greatest film director ever, and *Cahiers'* favourite *auteur*, Jean Renoir, quoted a perceptive comment explaining the tensions facing a director trying to reconcile his authorial intentions with the technical or aesthetic resources at his disposal: 'Renoir likes to say that in making the Bayeux Tapestry, Queen Matilda had no better reason for placing a knight in a

given spot than the chance presence of a certain clump of blue or green wool.'[3]

Its links with modern media also excited Gerald Noxon, cultural commentator and forerunner of Marshall McLuhan. In the 1930s Noxon was a member of the influential Cambridge Film Guild and after the war became a radio and TV scriptwriter and documentary maker. Noxon spoke on the cinematic properties of the Tapestry to the Society of Cinematologists in 1966, the great anniversary year, and described it as the ultimate source for story-telling in film. Cultural historian Anne Prah-Pérochon expanded these points in 1974, when she claimed that the Tapestry demonstrated cinematographic techniques nearly 1,000 years before they had been invented, devised by its *auteur*, a great draughtsman and colourist. Like a modern *cinéaste*, he adapted his story for the screen. The constant sense of movement, with one scene flowing into the next, was what distinguished it from classical narrative friezes or the fixed conventions of medieval picture cycles. So it had more in common with today's cartoons and films, sharing the same view-points and shots, wide-angled or narrow-focus, with its whole layout the equivalent of the modern montage. The borders gave a dual-screen effect, the scene-dividing trees were the equivalent of a fade, while the images of horses' hooves and the shouting, weapon-clashing warriors summoned up the sound effects – this was an epic talking picture.[4]

By the 1980s film studies had really moved on, but art historian Michel Parisse continued the old analogy, subtitling his book on the Tapestry 'A Documentary of the Eleventh Century'. He related it to the silent (rather than the talking) cinema, especially because of its 58 inscriptions, predecessors of the cinematic caption. He interpreted it as a long succession of story-board images, and claimed that the characters' postures made them look as if they were posing for stills. Buildings and trees served as frames for dramatic confrontations (rather than being fades), and clever cutting achieved flashbacks, such as in the 'messengers' sequence, where the spectator could scan five related scenes at a glance. These devices that the *auteur*-designer employed so confidently had to wait nearly a millennium for modern directors to rediscover them. Parisse presented his illustrations in black-and-white only, claiming, not wholly convincingly, that colour was a secondary part of the narrative process.[5]

The concept of the Tapestry as film received official sanction in Bayeux's new exhibition centre, completed in 1983. At the start of the explanatory section, the work is announced as '*Un Réalisation* (here translated as Art

Work): a film in 58 shots'. For those going round with the audio-guide, the very first sentence of the commentary tells visitors that they are about to see a 'naïve, primitive film'.

Just like the novels, films set in the Middle Ages have become fodder for academic Medievalism. The last gasp of the Gothic Revival coincided with the beginning of the cinema, and the Norman Conquest provided subject matter from the start. As early as 1911, *The Last of the Saxons* (Vitagraph, USA) took Harold as its hero and the Battle of Hastings as its climax. A later documentary/biopic that drew extensively on the Tapestry was *Guillaume le Conquérant* (Les Films Normands, 1987). As well as these dramatic or documentary interpretations, the commercial cinema has used the Tapestry more pragmatically in affectionate and often humorous tributes to an artwork that movie audiences were expected to recognise.[6]

Adapting its layout for introductory credit sequences showed just how successfully the original designer/artists had used pictures to tell a story. The first film version was in *The Vikings* (MGM, 1958), whose witty credits related the Tapestry's images to the film's plot. Sometimes copying directly (the boat-building sequence, the animal-prowed fleet, the bodies in the borders), sometimes creatively inspired (the Viking ships meet a storm and capsize, plunging downwards like the horses in the battle), the sequences demonstrated the genuine research underpinning the whole film: the production team spent a year working with advisers from Oslo University to obtain historical authenticity. The final credit is the scene of Harold praying at Bosham church, whose walls frame the inscription 'Protect us, O Lord, from the wrath of the Viking' in authentic Tapestry lettering. The film then swings into its opening scene, the flashback Viking raid at the core of the plot.

The Vikings credits may have provided the inspiration for the delightful title sequence to *Bedknobs and Broomsticks* (Disney Studios, 1971, very loosely based on Mary Norton's 1957 book). Tapestry scenes were again appropriate, for the film was set on the south coast of England in August 1940, and part of the story told how a benevolent witch defeated a Nazi invasion with the aid of a ghostly band of medieval warriors. The opening titles predict all this, with little submarines crossing the channel just like William's fleet, and a procession of galloping knights confronting the Germans and driving them away. The buildings ingeniously frame the names of cast and crew, and in the borders some of the original animals are wittily interspersed with those from the film, like the witch's black cat and

white rabbit. The comet appears, as do the knotted trees, and the long left-to-right scan gives the impression of the unrolling of a medieval parchment.[7]

Robin Hood, Prince of Thieves (Warner Brothers, 1990) combined the Tapestry as a model for the credits and as an actual object in the film. The titles roll against close-ups of the fabric, no details redrawn here, but a selection of the more relevant scenes to provide the background of warriors returning from the crusades – knights on horseback, a ship crossing the Channel, the advance to battle. As the film was set in the late twelfth century, it was just about plausible, stylistically, to have Maid Marion making the Tapestry. In the castle she sits at a large, authentic-looking embroidery frame, the fabric correctly stretched and laced, pushing her needle through from the back, on which we can read in reverse the inscription WILIGELM. Alas, the Sheriff of Nottingham bursts in and abducts her and she never gets back to her work.

Robin Hood's production designer, John Graysmark, was perhaps paying homage to an earlier film that also showed the hanging being made. The Abbé de la Rue would have approved of the scene in *Becket* (1964), in which his favourite candidate, the later Matilda, granddaughter of William and mother of Henry II, embroiders it in company with Henry's wife, Eleanor of Aquitaine, an inspired and witty collaboration between two powerful women. It is even curious that none of the late daters of the Tapestry ever came up with the suggestion that Eleanor devised it, for she was a great patroness of art, and certainly knew of Wace's *Roman de Rou*, a work her husband commissioned. In the film, we see both ladies working on a long strip of the fabric. Henry, angered by Becket's obstinacy, jabs a needle up and down in their pincushion, then tosses the material in the air, revealing a ship in the central portion. However, they must have been sewing out of chronological sequence, for a previous scene in the film has already revealed the panel with Odo blessing the feast after the Normans have landed in England. This fittingly hangs behind the royal dais in the banqueting sequence. Nor are the techniques correct, for each woman sews with one hand while grasping with the other a small, round embroidery frame holding just a portion of the Tapestry, which would have had a disastrous effect on the tension. The film is rich in well-researched images of contemporary art – Louis, King of France, plays chess with the Lewis set; Canterbury Cathedral crypt has authentic capitals – which were so impressive that the art directors John Bryan and Maurice Carter were nominated for an Academy Award.

Another art-direction nomination went to Franco Zeffirelli's *Hamlet* (1990), which featured the Tapestry prominently: Ophelia's chamber at Elsinore was the workshop where she and her ladies were making it. Various portions, correctly laced onto frames, are displayed about the room. Ophelia struggles to thread her needle, as Polonius, concealed in an upper balcony, watches Hamlet's confrontation with her. There is just one lapse, when she appears to be carrying a loose portion around while stitching. The Tapestry was just one aspect of the film's historical setting in a well-decorated, though not entirely consistent early medieval Britain. The arches and capitals of the palace are Romanesque, but the stone crosses in the grave-digger's scene, and the penannular brooches worn by the king and Laertes, date from 200 or 300 years earlier. And the wall-hanging in Gertrude's chamber – the arras through which Hamlet stabs Polonius – is decorated with the splendid lion from the seventh-century gospel Book of Durrow.[8]

All these reworkings and sightings give a touch of medieval authenticity to this modern medium, appealing to the cinema-goer as an easily read shorthand, a witty aside and a useful piece of scene-setting – all evidence of the Tapestry's continuing versatility and flexible function.

21

Spin-Offs

Artists working in different media and different styles have responded to the work in various ways. Like the earlier poets, some focused on Matilda at her embroidery – for example, the frontispieces to Lechaudé d'Anisy's *Antiquités Anglo-Normands* (1823) and to Agnes Strickland's *Lives of the Queens of England* (1840). Alfred Guillard's 1849 oil-painting now appropriately hangs in the room in Bayeux where the Nazis once inspected the original – in the former Hôtel du Doyen, now the Musée Baron Gérard. Mary Newill, Arts and Crafts designer and an able embroiderer herself, selected 'Queen Matilda working on the Bayeux Tapestry' as the subject of a stained-glass panel she made for a house in Birmingham in 1898.[1]

Other artists selected different moments. Stained-glass craftsman Michael Farrar Bell made the Senlac Memorial Window for Battle parish church in 1984. He showed William and Harold confronted against a background of Tapestry scenes. Ford Madox Brown depicted it as a genuine hanging in his 1848 painting of *Lear and Cordelia*, although as an obsessively accurate history painter, he conceded that 'the piece of Bayeux tapestry introduced behind King Lear is strictly an anachronism, but the costume applies in this instance, and the young men gaily riding with hawk and hound contrast pathetically with the stricken old man'.[2] F. W. Wilkin also included it in the huge canvas of the Battle of Hastings that he painted in the 1850s to hang in the Great Hall of Battle Abbey; it lies, like a prophetic vision, under the feet of the expiring Harold.

While it was an obvious topic for Victorian history painters, a far more complex interpretation may be that of the great assimilator Picasso in *Guernica* (1937), his agonised panorama of the suffering of war. Although the many studies of this work's multiple sources have not yet explicitly compared its fragmented bodies, torched house and terrified splintering horse with those in the Tapestry, he was deliberately drawing on eleventh-century images because the 'strength, intensity and sureness of vision' of Romanesque art enthralled him at this time. In 1934, he visited the museum of medieval Catalan art that had just opened in Barcelona, and in 1937 helped organise an exhibition of its works in Paris, whose catalogue was compiled by his friend Christian Zervos. In *Guernica*, painted very soon after, Picasso included details from the manuscripts on show, and its stark angular shapes recall the distorted forms of Romanesque sculpture. As his circle included the Normans Braque, Dufy and Marie Laurencin, it is hard to imagine that Picasso did not know the Tapestry, whose force, simplicity and stylized forms anticipated what he was seeking to express.[3]

Even more exciting is the way modern cartoonists have adapted the format. Applying it to so many different situations has proved the timeless, universal qualities of the work, surely the original political cartoon, whose borders reinforced the messages of the central portion far more effectively than words alone could.

The first to harness its extraordinary satirical power was John Hassall, Edwardian artist and poster designer ('Skegness is so Bracing!'), creator of Gibson girls, cheeky Cockney urchins and stout old parties, all drawn in a powerful combination of strong outlines and patches of colour – features of the Tapestry too. It was a work he knew well, and he moved into a different league with his devastating pastiche *Ye Berlyn Tapestrie*, a fold-out book whose 16 scenes extend more than 4 metres in length by 14 centimetres high. In 1915 he published this satirical commentary on the invasion of another William, the Kaiser, through Luxembourg and Belgium into northern France. The endpapers copied the original's starting scene, but instead of Edward we meet 'Wilhelm Maily Fiste', framed by border dachshunds and the German eagle. Hassall went from strength to strength, basing his cruelly effective words and images closely on his source, in which he made the most of the borders. When 'Wilhelm Teareth up ye Treatie', the compartments hold an hour-glass, scissors snipping thread and a waste-paper basket. When his infantrymen goose-step into Flanders, a procession of geese below parodies the posture. Defeated in battle, the cavalry plunge

A scene from John Hassall's *Ye Berlyn Tapestrie* (1915), which satirised Kaiser Bill's invasion of Flanders at the start of the First World War.

vertically to destruction and the borders fill with fleeing soldiers. Later, when 'Ye unsuspecting neutral gets sunk,' there are seagulls (above) and fish and crabs (below). Powerful, funny and sinister, *Ye Berlyn Tapestrie* would have been unimaginable without the original, yet is also a tour de force in its own right.[4]

In the Second World War cartoonists rapidly related the Tapestry to the D-Day landings. First off the mark was Leslie Illingworth. Just three days after D-Day, on 9 June, the *Daily Mail* published his panoramic scroll of the invasion fleet, soldiers and tanks advancing up the beaches, while Hitler, Himmler and Goebbels watched with alarm. The upper borders contained the faces of Churchill, Montgomery and Eisenhower looking down on the conflict, but the lower borders held bodies. There were similar cartoons in the *New Zealand Herald* on 14 June, and on the cover of the *New Yorker* on 15 July. In March 1948, the cover for *The Soldier* magazine was an extended Tapestry-style strip of the various battle fronts, including Africa and the Far East.[5]

After the war, the Tapestry fascinated left-wing cartoonist Vicky (Victor Weisz), a refugee from Hitler's Germany, who turned to it repeatedly in the 1950s and 1960s. It was an added bonus that two British leaders in this period were called Harold, but he had already used the format when Anthony Eden was prime minister. Like Hassall, Vicky used the borders as thoroughly as the central area to mock the issues of the day: uneasy relations between Konrad Adenauer and Pierre Mendès-France were highlighted by a dachshund and a poodle sniffing suspiciously at each other. An enthroned Khrushchev launched the sputnik, shown as the Tapestry's comet astonishing modern-dress spectators. When Vicky's Macmillan

New Zealand cartoonist Gordon Minhinnick on the D-Day landings (*New Zealand Herald*, 14 June 1944).

visited Russia in 1959, the borders held bears, lions, ballet dancers and nuclear weapons. In a 1962 cartoon, Harold Macmillan, like his earlier namesake, crossed the Channel and galloped on a horse labelled 'Common Market' to grovel for admission before a regally seated de Gaulle, while the British lion lay dead in the border. Harold Wilson's battles with his own party became another subject for satire. Vicky called his 1965 New Year's Eve cartoon '1966 and all that'. Inscribed HAROLD REX, it showed a seated Wilson received homage from a smiling Jim Callaghan, accompanied by the less happy figures of Richard Crossman and George Brown. Leslie Illingworth also mocked Wilson when he showed the trade-union leaders George Woodcock and Frank Cousins as mounted Normans firing arrows at the Saxons, Wilson and his Cabinet colleagues, while the border held the various emblems of the workers whose wages had been frozen.[6]

Nicholas Garland has cited the Tapestry as often and as wittily as Vicky, to refer to the economic battles between Britain and the rest of Europe from the 1970s onwards, starting with Harold Wilson, but effortlessly moving on to Callaghan and Mrs Thatcher. In 1976, he drew a chilly confrontation between the mounted warrior Giscard d'Estaing and Callaghan, seated on a throne, while the border displayed a sinking pound sign and a fish to symbolise the cod war between the UK and Iceland. But he celebrated the temporary rapport in 1984 between President Mitterrand and Mrs

Thatcher with Mittetrand galloping towards a chainmailed Mrs Thatcher
– 'HIC EST MAGGIE' – who has just been winged in the heart by an arrow
labelled 'Entente Cordiale' fired by a cupid in the border; the adjacent
compartment held a romantic bottle of champagne and two glasses. He
recycled the arrow idea in 1992, when Mrs Thatcher shot it into the eye of
Jacques Delors, while seated in state and clutching a copy of the Maastricht
Treaty that she had just rejected: the lower border had the very English
symbols of a cricket bat and stumps, the Houses of Parliament, a Union Jack
and a nice cup of tea. Garland's third 'arrow' cartoon was in 1994, this time
fired by Jacques Santer at John Major, with the caption 'Right in the heart
– from Europe'. The divisive effect on both British political parties became
the subject of twin cartoons by Richard Willson showing respectively a

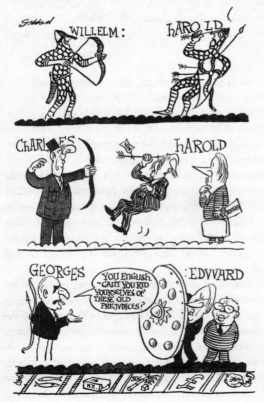

Les Gibbard used the
Tapestry to comment
on Edward Heath's
struggle to take Britain
into the Common
Market (*Guardian*,
4 September 1971).

272

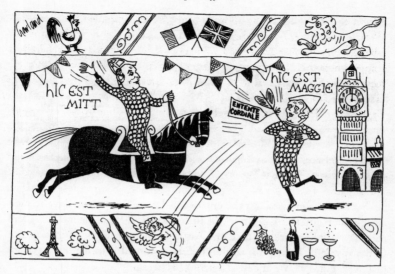

Nicholas Garland celebrated the temporary Anglo-French entente after President Mitterand agreed to Mrs Thatcher's demand for Britain's EC budget rebate (*Daily Telegraph*, 24 October 1984).

battle charge by Tory Eurosceptics shooting an arrow into John Major's eye, and Labour sceptics galloping against the pro-Europeans in their party.[7]

Rather than cross-Channel or internal party conflict, it was the name that inspired Clive Goddard's 'Byers Tapestry', four cartoons in *Private Eye* which traced the decline and fall of Transport Minister Stephen Byers in 2002. Goddard's border motifs included flame-wreathed underpants ('Liar, liar, pants on fire!'), the twin towers of the World Trade Center ('Good day to bury bad news') and a poisoned chalice, as Blair appointed Alistair Darling the new Minister of Transport.[8]

Cartoonists have also used the Tapestry as an easy frame for more general jokes about medieval or modern times. They relate it to the reporting of wars – an exhausted embroiderer stitches away at top speed in front of the fight, trying to provide instant reportage; a man labelled 'the editor' cuts out great chunks of fighting horsemen with shears; two warriors complain that this continuous tapestry coverage makes it look as if the battle is going badly; one soldier says to another, 'Don't tell me the result – I've got it on tapestry.' Normans and Saxons even fight with modern football jargon: a

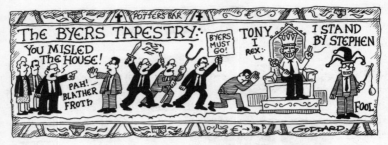

Clive Goddard mocked the scandals that dragged down Transport Minister Stephen Byers in a four-part strip, 'The Byers Tapestry' (*Private Eye*, May 2002).

fleeing Saxon confesses, 'At the end of the day we lost but we have to pick ourselves up and think positive', while a disembodied corpse moans, 'I feel gutted'. Another cartoon used the battle to mock the adventures of the Cadbury's Milk Tray hero, while the *Sun* reworked it to feature a guitar-playing popstar whose ancestor fought at Hastings.[9]

Another twist on the cartoon format was that of book illustrator Paul Kidby, who adapted the layout to illustrate *The Last Hero* by Terry Pratchett (2001). Its endpapers and several of the plates use the familiar designs to

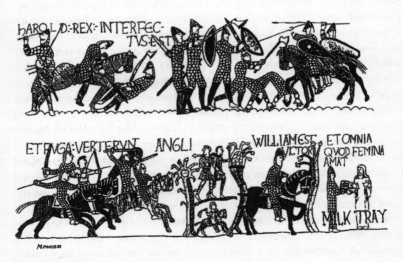

M. Pickles, Milk Tray cartoon, *Punch* 1990.

tell the story of the last campaign of the elderly warriors of the Silver Horde, evidence again of the Tapestry's versatility in being relevant even to Pratchett's cult Discworld series.

Elizabeth Wardle was the first to re-create the original as a textile, but many followed her example, working in a range of materials and extending the subject matter considerably. They all termed their narrative friezes 'tapestry' as a form of homage to the original, even though this was the one technique they did not use. There were different formats, too. Some copied a part, some the whole; others adopted the distinctive styles of drawing and lettering to show more recent people and events, or else adapted the long, narrow shape to tell histories in different techniques and media. The makers were similarly varied – amateurs or professionals, individuals or groups, the last often coming together as a deliberate community activity. The information these provide about the time spent or methods employed is an interesting (though not necessarily reliable) basis for calculating how the original project might have been tackled.[10]

The first such twentieth-century interpretation was the Broderie de Fécamp. Directly inspired by the original, which it follows closely in style and technique, as well as copying many of the border motifs, this embroidery tells in 32 scenes the local legend of how the Holy Blood of Christ reached the Normandy village of Fécamp. This, unusually, was not a group project for public viewing, but a private scheme by local antiquarian and historian Paul Leroux, who designed it to hang around his study, the first-floor gallery of a twelfth-century tower-house. The embroidery's 23-metre length (composed of three separate sections) corresponded with the measurements of the room, while its 50-centimetre width was the same as the original. Leroux also hoped it might in some small way recompense for the 28 local Renaissance tapestries destroyed during the Revolution. Mme Leroux did all the sewing, but sadly her husband never saw it completed, for he was gassed in the First World War. His younger brother finished the designs, and his widow continued work on what had now become a monument to her husband as well as to Fécamp's history, completing it in 1926. The family donated it to the local museum in 1987.[11]

As one of the many celebrations of the 1966 anniversary of the Battle of Hastings, the town commissioned the Hastings Tapestry from the Royal School of Needlework, sewn in techniques that included collage and appliqué work. This was not a replica, but a sequel. Its starting point was the

end of the battle, followed by William's coronation, then a sequence of 80 more scenes illustrating great moments in the history of the town and of Britain, via the Domesday Book, Magna Carta, Spanish Armada, Industrial Revolution, Battles of Trafalgar and Waterloo, and ending with a triumphant image of Churchill making the Victory sign to the D-Day invasion fleet. The finished work consists of 27 panels, each 9 feet long by 3 feet high (2.67 by .89 metres). Installed in the Triodome on the pier (then the largest dome in the country), hung around a huge model of the battle, it remained on show for the next 20 years. When the structure was dismantled in 1986, the hanging was put into store, although two panels are (at the time of writing) on display in Hastings town hall.

Its immediate successor was the Overlord Embroidery, which hangs in the D-Day Museum at Portsmouth. This was directly inspired by the Tapestry and the publicity that it received during the 1966 anniversary. Lord Dulverton of Batsford decided to commemorate Operation Overlord, the invasion campaign that culminated in D-Day, June 1944, by commissioning a 'Bayeux Tapestry in reverse'. A textile project with well-documented phases of manufacture, the information it provides certainly helps illuminate the processes of commissioning and producing something on this major scale. Dulverton, as instigator and patron, set up a small committee of Second World War veterans who decided how the subject matter should be selected and divided into a series of self-contained scenes. They invited a well-recommended young painter, Sandra Lawrence, to submit designs for two sample panels. Once Dulverton and his colleagues approved these, they commissioned Lawrence, in 1967, to design the whole work. She had to submit all her small-scale drawings to the committee to check the historical and practical details, and they suggested many changes at this stage. A team of 20 women from the Royal School of Needlework made the work, under the guidance of Margaret Bartlett, head of the embroidery workshop. She was a key figure, responsible for transforming Lawrence's painterly designs into a textile hanging, for selecting and ordering the materials and threads, for allocating the work, and for reporting progress to the committee, recording all these stages in her workbook. Bartlett also noted an ongoing debate with Lawrence, who did not initially appreciate the subtleties and special properties of the very different medium in which Bartlett was the expert, but who modified her style as she increasingly recognised the potentialities of fabric and thread for bringing her drawings to life.

Lawrence produced a small design for each panel, sketched in pencil with some shading. Once the committee had approved or modified this, she turned it into a full-size cartoon painted in coloured gouache on cartridge paper. The outline of each cartoon was copied on to tracing paper and transferred to the fabric by the prick-and-pounce method. The team began to sew as soon as the committee agreed the first drawings, so Lawrence was continuing to produce designs while the earlier ones were being made up. Several women worked on each panel at the same time, sitting with one

Creating the Overlord Embroidery at the Royal School of Needlework, c.1968. Sewing the Tapestry may have looked like this.

hand permanently on top and the other below. It did not matter whether they were right- or left-handed as long as they were consistent with their neighbours. They sewed from the centre of the strip out towards the margins and covered the portions not immediately being worked on with pieces of cloth to keep them clean. Always in front of them was Lawrence's full-size painting of the appropriate panel. The embroidery was some 10 metres longer and slightly wider than the Tapestry, used a wide range of techniques and incorporated cord and metal, genuine fragments from military uniforms, and silk-embroidered, photographically accurate portraits of the main protagonists, such as Churchill and Montgomery. It took almost five years to complete.[12]

Other large hangings have the same sort of history: one or more determined individuals decide that such a work is needed for a particular purpose, and with an ultimate audience in mind. A small group oversees the detailed working out of the design, checking for factual accuracy as well as artistic quality. Specialists order the materials and oversee the making to ensure that different hands work to a consistent standard. Once completed, the separate pieces are assembled, compared and if necessary altered. This was the sequence for the Jersey Occupation Tapestry, planned in 1988 to celebrate the fiftieth anniversary of the liberation of Jersey and completed in 1994. Designed by Wayne Audrain, it did not copy the medieval mannerisms of Bayeux, but followed the more modern style of the Overlord Embroidery. Originally intended to be a single piece, it grew into a collaborative and truly communal work of 12 panels, each worked by one of the island's 12 parishes to illuminate a different aspect of life under the German occupation. It now hangs in a special gallery in the Jersey Maritime Museum. Similarly, the curator of the Royston Museum (Hertfordshire) devised the idea of the Royston 'Tapestry' to show the town's history, from the Ice Age to modern times, via 1066 and even the eighteenth-century discovery of the cave whose carvings so excited William Stukeley. Two professional artists produced the design, and sewing began in 1991. Local people, museum staff and visitors all helped make the 33-metre embroidery, of wool on linen, which hangs in the museum's main gallery.

The Rhodesian National 'Tapestry' was the brainchild of the governor's lady in 1946, and was designed to hang in the House of Parliament in the former Salisbury, now Harare; 30 metres long, it celebrated the history of Rhodesia and also the female solidarity of the Women's Institutes of the country, 42 of which created panels. The different groups submitted their

ideas to a central committee, which researched them for historical accuracy, then commissioned a professional artist to turn them into designs. Using the layout of the Bayeux Tapestry as a general model, each scene was self-contained, but made effective use of narrow borders to incorporate local flora and fauna as symbols and motifs that related to the central scene. The designs were transferred to linen panels, embroidery cottons were dyed to the specified shades and each member of every group contributed to the sewing. Completed in 1963, it went on public display in the Salisbury Parliament Dining Hall, an adjacent plaque noting that the 'tapestries' were 'presented to the Nation as a Memorial to the Country's Pioneer Women'. When Rhodesia became Zimbabwe, the work was transferred to the National Museum of Bulawayo, where it hangs today.

The Fishguard Invasion Tapestry commemorates the last and least-known invasion of Britain in 1797, when 1,400 French soldiers landed on the Welsh coast and, like the Conqueror's army, pillaged for food. But locals surrounded and attacked them, and they surrendered to what they assumed to be Grenadier Guards, but were really women in their traditional Welsh dress of tall black hat and red cloak. The Fishguard Arts Society commissioned the work in 1997 to commemorate the bicentenary of the invasion; 30 metres long, with inscriptions in Welsh and English, it was sewn as a community project by 78 volunteers. Initially exhibited in a local church hall, the Invasion Tapestry will hang in the redeveloped town hall.[13]

While some embroiderers have used the Bayeux Tapestry as a model to tell a completely different story, there are others who have made a copy of the original. Pride of place for industry must go to Professor Raymond Dugan of Waterloo University, Ontario. A lecturer in French, he visited Bayeux in 1985 and decided to make his own full-sized version. He ordered the wools from France, scaled up the design onto a band of linen, and took 11 years to embroider it. Like Elizabeth Wardle's, the Dugan replica has an educational and informative mission for it has toured Canadian museums, churches and universities and has starred in exhibitions such as 'Reflections of the Conquest' (Ontario, 2002), an entire craft exhibition inspired – in some cases very loosely indeed – by the 'world of the Bayeux Tapestry'. Another Canadian replica was created by the 'Bayeux Companions', a French-Canadian group (also calling themselves the Society for Creative Anachronisms) who wear medieval dress and use archaic names. 'Sieur Thibaut de Montfort' inaugurated the project in 1991 and it was completed

in 2003. They divided the work into 16 portions, each the responsibility of one 'Tapestry-Master' and a small group of colleagues. The Museum of Civilisation in Quebec has exhibited some panels, which have also toured other Canadian venues.

The missing end of the Tapestry interested professional embroiderer Jan Messent, who made her version of the 'Finale' in 1997 in the form of a 2.4-metre panel in the exact manner of the original, using the most authentic materials possible. Like Mrs Wardle, she sewed with plant-dyed wools on linen of the correct weave and density. Following closely the text of the Anglo-Saxon Chronicle for 1066, she designed scenes showing the submission of the English at Berkhamsted, followed by William's coronation in Westminster Abbey. These took her 18 months, working entirely alone. She has suggested that the laidwork stitching technique did not require particularly skilled practitioners, and that anyone could master it in a few hours. The 'Finale' was first exhibited at William's birthplace, Falaise in Normandy, and has also appropriately been to Berkhamsted and to Battle.[14]

The Portsea Island branch of the Embroiderers' Guild created another partial replica as a local community project commissioned by the director of the D-Day Museum. A team of 27 adults and seven boys and girls (all of whose names are on the back of the work) spent 200 hours during a six-month period in 2001 working in wools naturally dyed to the tones of the original onto linen backed by calico. The one-metre panel repeats the relevant image of William's ship crossing the Channel and hangs beside the Overlord Embroidery as a fascinating point of comparison.

Other versions have copied the style or size of the original, but have balked at the sewing. The State University of West Georgia at Carrollton has a full-size copy painted in acrylics on canvas, which serves as a preliminary teaching tool for the university's Art Department summer school in Bayeux. The artist was Atlanta illustrator Margaret ReVille, who took almost a year in this commission from local judge Edd Wheeler. He presented it to the university in 1998, where the Bishop of Bayeux dedicated and blessed it.[15]

Norman sculptor Pierre Bataille set himself a real challenge when he decided to carve the entire Tapestry at full size in oak, his favourite medium. To start, he photographed every section of the original, then projected his slides directly onto 22 separate sections of wood, drew around the detail, then started to shape it. Working two hours every day, he took eight years and used up two whole trees. Its great charm is that it can be felt

as well as seen, providing a tactile experience for the visually handicapped. This masterpiece was exhibited to 300,000 visitors in the Great Hall at Winchester as part of the Domesday Book commemoration in 1986. It featured on *Blue Peter*, too.

An even stranger choice of material is metal. Yet there is a steel mosaic of the Bayeux Tapestry which has helped put the town of Geraldine, South Island, New Zealand, on the map. Michael Linton, an ingenious textile technician and proprietor of the town's knitwear shop, took nearly 25 years to create a replica, using two million tiny rectangular pieces of spring steel (off-cuts from industrial knitting machine pattern discs) that he stuck onto board then painted with enamel paints. This includes a new finale covering events between Hastings and William's coronation. This remarkable work is 46 metres long by 30 centimetres high, and weighs nearly 300 kilos. And it is not the only attraction in his shop, where tourists can also admire the world's largest knitted jumper (as attested by the *Guinness Book of Records*, 1999).[16]

And finally . . . in an exhibition in February 2004 that he called 'The Tater Gallery', Cheltenham gardener Chris Dundry included the Tapestry amongst a selection of famous works of art into which potatoes had subversively been inserted (admired in the press as 'mashterpieces'). Dundry replaced the image of Harold on his throne with a genuine King Edward.

22

Marketing the Middle Ages

Further proof of the Tapestry's versatility is the way in which commercial designers have adapted its properties of simplicity, expressiveness and not too much realism (all those things that bothered eighteenth- and nineteenth-century audiences) to turn it into a rich source for advertisements. Offering hundreds of figures – people and animals, buildings, ships and trees – it is an exceptional storehouse for those in search of a snappy image or a longer cartoon-style narrative. The more relevant to the product, the more it attracts potential customers.

As early as 1920, the Pennsylvanian 'Eagle Shirts' company used the Tapestry to stress the quality of its product. Its poster displayed a painting of Matilda and her ladies at work on the embroidery: the slogan announced: 'Representative of an Ideal Obtained' and the blurb shamelessly compared Matilda's endeavour to the equivalent standards of modern Eagle shirt-makers.[1] Another pre-war example was a Shell Petrol advertisement of 1936, which used the pun 'Battle near Hastings' to juxtapose images of fighting Normans with an innocuous map of Sussex indicating Battle, Hastings and Pevensey. In the 1940s and 1950s, Whitbread Breweries adapted appropriate scenes to decorate their series of collectable miniature Inn Sign cards: Odo as the 'Man of Kent' (the text on the back sternly warned that he was 'more Baron than Bishop'), and 'The Plough', with the border ploughman borrowed from the work that showed 'a certain incident hereabouts in the only year that every schoolboy really knows'. Regent Petrol echoed the local theme in

an advertisement in the 1963 Glyndebourne Festival programme, which showed Harold with the fatal arrow and made the tenuous connection that this happened 'not very far from Glyndebourne', just one of the many historical sites in Britain awaiting the keen motorist.

It was 1966 that the Tapestry really came into its own as an advertising icon. National and local firms seriously over-used it by endlessly recycling the familiar scenes. Although some were witty and relevant, the overall impression was deeply confusing, as William, Harold and Edward urged people to drink beer, watch television, take photographs, take out a mortgage, eat bread or even bananas. Most tasteless was Rediffusion, which marketed its four television channels with the slogan, written in Tapestry-style letters, 'Unlike King Harold, you can enjoy perfect viewing', below which the fatal arrow plummeted downwards. Guinness produced a poster that reproduced the scene where William pushes back his helmet in the heat of the battle. However, the poster's 'Eustace' no longer pointed to show that he was alive, but handed him a glass of the dark stuff. Above, an inscription in the border announced 'Battle of Hastings 1066', and below 'Bottle of Guinness 1966'. Another brewing firm, Courage, Barclay & Simonds, produced a joky poster claiming that William cried, '*Courage mes braves*' to urge on his men because he had found bottles of beer on Hastings beach; the pastiche drawing replaced the border animals with the brewery's distinctive cockerel.

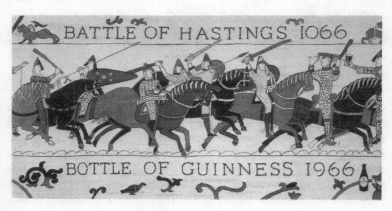

Many advertisements adapted the Tapestry during the 1966 commemorations of the Battle of Hastings, like this classic Guinness poster.

Kodak also cheerfully updated the Tapestry to show the modern processes of photographing, developing and printing, with items of photographic equipment and inscriptions reading '*Exposum Est*', and '*Cum Celerite Processum Est*'. No commercial designer would dare include Latin today, but in 1966, Hovis believed that its customers still benefited from a classical education. (Even its brand-name was a user-friendly abbreviation of *hominis vis*, meaning 'the strength of man', replacing the previous less-than-memorable 'Smith's Patent Germ Flour'). Headed '*Nihil Hominis Vis*' (No Hovis Today!), the advertisement selected appropriate scenes from the Tapestry, such as the cook removing loaves from the oven, to weave a little story that the battle of Hastings was really fought over a loaf of bread.

Hovis advertisement, 1966

Another Latin user was Horlicks, whose slogan '*Hic Est NAAFI Cum Horlix*' appeared above a drawing of Harold clutching a mug of Horlicks instead of the arrow. The anniversary also inspired local firms, who hijacked the familiar images to sell clocks and furniture, while the Hastings & Thanet Building Society turned the opening scene into Edward as a kindly branch manager giving advice to the anxious investor Harold.[2]

After 1966, the battle lost much of its relevance as an advertising peg. But the town of Hastings promoted itself from 1946 to 1970 through the character of 'Happy Harold', who participated in the resort's many delights

such as minigolf and swimming. Over the same period the town issued various editions of a Tapestry-style pamphlet whose cover announced, 'Hastings welcomes Invaders' and pictured a mail-clad soldier brandishing a crab and a smiling sun to a group of advancing holiday makers. The borders held a little train, a bather and fish, while other illustrations listed all the modern attractions, drawn in the style of the eleventh century.[3]

The work advertised more alcohol in 1977, when Newcastle Brown Ale celebrated its Golden Jubilee by inventing the 'Byker' Tapestry – a cartoon strip in the style of the original, showing how the Vikings became addicted to 'Newcassel Broon' and made peace in the north of England. The borders included racing pigeons, flat caps and whippets, and the inscriptions were in rich Geordie dialect.[4]

In the 1980s, Northern Telecom brought the work up to date in an advertisement that related it to 'another kind of tapestry, the new interlaced digital network of fibre optic cables'. Just as the original 'wove the Normans together and united the people', so NT was bringing communities together with this revolutionary technology. A clever montage showed a portion of the Tapestry with its drawn-out threads turning into bundles of wires.

The Bayer Group punned on its own name as an ingenious way of celebrating the company's 125th anniversary in 1988. It produced a 3-metre pull-out of the 'Bayer Tapestry' just like the miniature folding versions of the original, cleverly adapted to give an illustrated history of the firm since 1863. Founded, ironically, to produce the new aniline dyes that William Morris so hated, the company has become a global institution producing pharmaceuticals and petrochemicals. All its inventions – such as Agfa film (which Jankuhn used in 1941), Alka-Seltzer, the first suntan lotion, the fabric Dralon – are commemorated here in the way the original designer might have shown them, while the borders have little reminders of the products and processes, such as test tubes and paint pots. Real scenes from the Tapestry appear as well. The seed-sower from the border illustrates 'first seed dressing, 1915' and the leaping cow and falling horse promote 'Rompun', the veterinary sedative.[5]

Another good choice was the Buzz Airlines 2002 advertisement for its flights between Caen and Stansted. A photograph from the Tapestry showed two ships from the Norman fleet labouring across the Channel, with voice-balloons saying, 'Are we there yet?' and 'I need a wee-wee'. The slogan read: 'There's an easier way to travel!' But when Ryanair swallowed up Buzz in 2003, the Caen service – the most convenient way to reach

A relevant scene promoting Buzz Airlines flights to Caen in 2002. Not effective enough though because Ryanair shut them down in 2003.

Bayeux – was dropped. The latest example I have found (2005) is a flier for the journal *History Today*, which illustrates an axe-wielding Saxon warrior and some decapitated limbs to stress that taking out a subscription would save you an arm and a leg.

Other designers have used the Tapestry as an index of familiar images, a fertile source for commercial products in various media – some obviously relevant, others distinctly less so. An early example was the fabric firm of Arthur Sanderson & Co., which designed a print for its 'Eton Rural Cretonnes' range in 1922 using images of Harold, William and Edward, together with the comet and some of the buildings. Sandersons were so proud of bringing the three kings together that they published a commemorative pamphlet, which briefly outlined the whole story and attributed the embroidery of the original to 'the peasant folk of Bayeux'. The pattern stayed in their range into the 1980s.[6]

The 1966 anniversary generated many predictable products, such as the limited-edition, 22-carat gold medallions of William enthroned and on horseback, framed by motifs from the borders, by sculptor Geoffrey Davien, 'backed by an unparalleled research effort to ensure historical accuracy', as the order form announced. And David Gentleman designed a set of commemorative stamps, six different scenes from the Tapestry issued in

strip form, like a little version of the original.

It figures permanently on hundreds of 'heritage' items – scarves and tea-towels, mugs and plates, do-it-yourself embroidery kits, china thimbles, stationery products, and the like – sold in Bayeux and in historical outlets in Britain. My own favourite is William's fleet in a glass snow-storm ball (made in China). An early example of product placement was the range of jugs and bowls decorated with Tapestry motifs in gorgeously iridescent enamelled glazes by Lucien Desmant, the *fin-de-siècle* potter from Caen. More recently, firms such as Limoges, Wedgwood and Royal Doulton have used the figures on special editions of their wares: such mugs are quite popular on Ebay. While traditional Norman products like cider and cheese predictably have Battle of Hastings scenes on their labels, the most unexpected manifestation must be the logo for the Sussex group of Harley-Davidson owners – a mailclad Tapestry warrior riding on a motorbike. Formed in 2002, the '1066 HOG Chapter' sells T-shirts and badges decorated with this emblem.[7]

23

Mysteries and Histories

Recent studies of the Tapestry have gone far beyond the earlier concern with dates and details, and patriotic claims are less strident as the artistic connections between different areas – England, France and Scandinavia – are better understood. The new academic disciplines that developed in the 1960s have brought alternative readings based on structuralism and deconstruction, reception theory, Marxist ideology, semiotics, linguistics, and issues of class, race and gender.[1]

Feminist interventions, which can incorporate the recent sub-genre of 'medieval feminism', have analysed the Tapestry both as a piece of sewing and a historical text. Art historians have reviewed the role of needlework as part of a wider reassessment of the lower status of those decorative arts that women have traditionally produced. The collaborative creation of textiles is now interpreted as a statement of female skill and solidarity, inspiring the subversive New York art historians, the Guerrilla Girls, to call the Tapestry a 'mistresspiece'.[2] The dilemma is that women may have made it, but hardly feature in it: only three out of more than 600 figures in the central zone are female, and there are just two more in the borders. Those who have assimilated Derrida and Foucault understand that non-presence is also a form of presence, since absence can be the proof of deliberate exclusion. Contemporary chronicles barely mention women either, but this silence, it has been argued, positively draws attention to their lack of status at the time of the Norman Conquest. On the rare occasions they are

mentioned or, as here, pictured, it is in a hostile way that suggests male *gynephobia*, fear of women, or even *anhedonia*, a monkish eroticism that sought to denounce pleasure by showing obscene images of the female body. Another accusation is that the work displays an ambiguous attitude towards masculinity, revealing perhaps the sexual insecurity of Normans who needed to present Anglo-Saxons as effeminate; the recurrent phallic images are clearly signs of a Freudian anxiety.[3]

Studies of women in the Tapestry have centred on attempts to identify Ælfgyva, but these have succeeded in proving only that people find what they want to find and see what they choose to see. Over the last century or so, poor Ælfgyva has attracted the wildest guesswork: a romantic heroine; a rape victim; an erotic or transgressive figure; a helpless female in a masculine world; a flashback reinforcing the case for Harold or alternatively the case for William; present in England, present in Normandy; a source of virtue, a source of evil; a wife, a mother, a daughter, a sister, a queen, a princess, a courtesan, a nun, an embroiderer; or even post-modern, non-specific Woman.

Clearly connected is her companion, *unus clericus*, 'a certain clerk', who touches her face. Despite the legible gestures of the other characters, this action is harder to explain. Their apparent intimacy encourages prurient modern viewers to assume that the scene must refer to some sexual scandal well known to the first audience and literally underlined by the male nudes in the border below (which even resulted in her bowdlerisation from the Tapestry altogether, in an edition for younger readers published in 1966).[4]

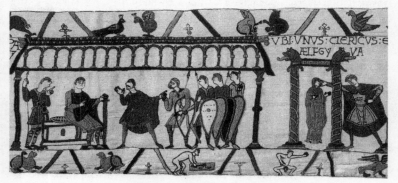

The mystery woman. Who was Ælfgyva? What does the clerk's gesture mean? The nudes below link her to the previous scene of William and Harold.

But this depends upon whether the rude border figures really referred to the couple above, or whether they just belonged to the wide range of exuberant sub-texts that appeared widely in margins and borders. The man below copies the posture of the clerk. But as the border was almost certainly designed after the main narrative, it was perhaps not a subtle allusion, but just a parody of the existing figure above.

Eighteenth-century commentators did not even think the word Ælfgyva was a proper name. Lancelot said it meant 'the Lady', and Ducarel also assumed it was a title, which he took to be 'the Queen'. So for him, the scene showed a clerk informing Matilda that William had promised one of their daughters in marriage to Harold. In the nineteenth century, most scholars thought the figure was that of the daughter, with the clerk indicating the betrothal by veiling or symbolically unveiling her. However, one eccentric commentator, uninhibited by the lack of any historical evidence, claimed the lady to be Edith, allegedly one of the hostages Edward sent to Normandy in 1052: the clerk is informing her of the release Harold has negotiated, and touches her cheek to absolve her misdeeds. A second unlikely proposal turned her into Harold's fiancée, Ealdgyth, shown apparently in England receiving news of his rescue, with the scene inserted by the Norman designer to demonstrate Harold's duplicity in becoming engaged to William's daughter too.[5]

An even more fanciful theory claimed that she was Harold's younger sister, another supposed hostage, who had been seduced by the clerk, then kidnapped by a Breton count. So the Brittany campaign was the rescue mission that Harold persuaded William to launch to get her back. An alternative version was that she had accompanied Harold on his expedition from England, reached Rouen first, and the clerk was now bringing news of her brother's safe arrival. Although these Victorian suggestions are implausible, it emerged in the twentieth century that Harold did have a younger sister named Ælfgifu. So her marriage to a Norman just might have been the subject under discussion.[6]

The first person who tentatively suggested, in the 1860s, that the scene might be a flashback to an earlier Ælfgifu – either the first consort of King Cnut, rumoured to have foisted the son of a priest on him to become the legitimate heir, or his second wife Emma-Ælfgifu, accused of having an affair with a bishop – confessed he found neither convincing and could not understand their relevance to the Tapestry. Unfortunately, his sensible cautions have not inhibited modern writers, though their interpretations

have varied alarmingly. If she was meant to be Emma, was the figure intended as a statue in a niche, to remind spectators of her great-nephew William's rightful claim to the throne? Or was she there instead to undermine his status for an English audience by recalling her punishment and disgrace? Those who agree with the latter, hostile interpretation have argued that her name was shamefully linked with not one, but two clerics. As well as her alleged affair with the Bishop of Winchester, she also formed a political liaison with the flawed Stigand, with whom she colluded to keep the crown from her own son Edward. The scene therefore rubs in Emma's guilt, while the gesticulating figure below spells out the real nature of her relationships. There was a later rumour that when Edward accused and imprisoned his mother, she proved her innocence by walking unscathed over red-hot ploughshares. This is the source for another suggestion, that the 'naked axeman' in the border below is really a blacksmith in a loincloth, who is laying a hot ploughshare on the nave of Winchester Cathedral (here shown in distorted perspective for lack of space), while the animal-headed columns indicate the Viking architecture that she and Cnut favoured.[7]

There have been equally complex claims for the other Ælfgifu, of Northampton, inserted here to deny the rights of the Scandinavian claimants to the throne of England, the matter Harold and William are discussing in the adjacent scene. She imposed two illegitimate sons on Cnut, the products of improper relationships with a cleric and with a workman (the axeman below). One of these sons, Sweyn of Norway, passed on his tenuous entitlement to the English throne to his successor, King Harold Hardrada, who invaded the north of England in 1066 and was killed by Harold Godwinson at the Battle of Stamford Bridge. But as this ended the threat from Scandinavia, and as Ælfgifu's line was wiped out, it seems hardly necessary to drag her into the story at this stage.[8]

New candidates continue to emerge. The enveloping costume and isolating setting make her a nun, perhaps the pro-Norman Abbess of Barking, receiving from the clerk the commission to make the Tapestry, for the nuns of Barking were celebrated for their needlework. Or there was Eadgifu, Abbess of Leominster, whom Harold's eldest brother Sweyn seduced or raped in 1046. As their son Hakon was one of the hostages, she was put in here to remind viewers of the subject of the talks. Alternatively, the figure represented another real Ælfgifu, this time the Abbess of Wilton, who, according to the nunnery's biographer-monk Goscelin, had been miraculously cured of blindness by the saintly foundress. The scene

allegedly shows her in Rouen with Goscelin himself, as part of a mission that Queen Edith, the patroness of Wilton, had organised to rescue Harold; the clerk identifies the abbess for posterity by touching her eyes to recall the miracle healing. The Wilton connection is ingenious, for the historical Goscelin may well have been the author whom Edith commissioned to write *The Life of King Edward*. But there is of course no evidence at all of their involvement in the events shown in the Tapestry.[9]

All that these versions seem to prove is that we still want history to be about individuals. Yet alternative suggestions, inspired by new readings of medieval literature, exclude the possibility of naming the characters at all. Might they be symbolic representatives of the new trend of increasing secularity within the church? The revival of classical learning in the late eleventh century meant that a *clericus*, or clerk, had different skills and training from a monk, being a well-educated, literate young man seeking service in aristocratic circles. Any contact between a noblewoman and a clerk so clearly expressing feelings entirely inappropriate to his office and rank would be a cause for concern, but also potentially a source of romance: disobedient young women and ambitious clerks threatened the very structure of aristocratic society. A grimmer scenario is that the archetypal name, her apparent powerlessness and the underlying sexual nature of the scene might symbolise the helpless position of all Anglo-Saxon women after the Conquest, threatened with rape and accused of bearing illegitimate children.[10]

Despite all these analyses, Ælfgyva retains her mystery today. But the first spectators certainly knew who she was.

Other aspects of the work have attracted even more exotic interpretations, and some unexpected commentators, too. The man at the heart of the Piltdown affair, Charles Dawson, may have mastered the necessary psychological skills to deceive his contemporaries as a result of his researches into the Tapestry. A solicitor from Lewes who was a passionate amateur archaeologist and palaeontologist (a Fellow of the Society of Antiquaries, and of the Royal Geological Society), Dawson first studied the work when writing his substantial *History of Hastings Castle*. In this, he included a useful chapter that provided parallel texts of all the different accounts of the Battle of Hastings, including its embroidered version.[11] While researching this material, Dawson became aware of the many discrepancies between the visual and written records of the battle, and, equally significantly,

between earlier and later recordings of the Tapestry itself. This inspired him to write two articles for *The Antiquary* (a popular monthly 'Illustrated Magazine Devoted to the Study of the Past') in 1907. Here he attacked the earlier interventions and restorations, and warned future curators and conservators of 'the heinousness of interfering with one of the most valuable contemporary records of English and Norman history'.

He claimed that Stothard's 'definitive' version already incorporated errors inserted during the eighteenth century, when the Bayeux cathedral chapter had the Tapestry lined and mended. Stothard then embellished or even falsified other details, and invented some of the inscriptions. Yet his unreliable drawings became the basis for the extensive nineteenth-century restorations. This was all *lèse-majesté*, compounded by Dawson's praise for the now generally despised Montfaucon engravings, 'by no means so inaccurate as they have been represented'. He even paid homage to Agnes Strickland – the very men whom she had advised to learn to sew before studying the Tapestry were these 'masculine cobblers' who had disgracefully practised on the original, and severely interfered with it. His harshest criticism was reserved for the scene of Harold's death. In Montfaucon's engraving, the 'arrow in the eye' was just a spear shaft above the helmet, but Stothard changed its angle and added the feathers. (This perceptive observation was eventually confirmed in 1983 when the back was examined.) Another suspect area was the border inscription restored as *Eustatius*, whose mutilated letters Dawson believed more likely to have referred to the standard-bearer *Tostein*. But, he asserted, Stothard had added Eustace's historically attested mustachios to confirm the identification.

Dawson also turned on poor Eliza Stothard, whose vindication he clearly did not support: the contentious fragment 'had been cut clean out of the upper border with a semi-lunar cut, as if hurriedly done with a pair of scissors', and yet Stothard's version showed it intact. This logic was flawed, for Stothard would have drawn it in anyway, whether he or his wife had removed it. Another unsubstantiated claim was that it was the later restorers who introduced the rude bits, 'those pictorial details where Art leaves off and the Police come in', for a good artist (like the original designer) would omit such offensive details. He seemed not to have considered that the earlier engravers might have chosen to leave them out on equally sensitive grounds, as had Collingwood Bruce in the copy that he and his schoolboys made in the 1850s.

Hastings Castle was published in 1909 and got poor reviews, particularly

from the local Sussex Archaeological Society, on the grounds that it was mainly a compilation or even a plagiarisation of other sources. Stung by these comments, Dawson immediately reissued his *Antiquary* articles as a pamphlet, 'The Bayeux Tapestry in the Hands of the "Restorers" '. This was in a period when he wrote sadly to a colleague that he was 'waiting for the big discovery that never seemed to come'.[12] Already an unpopular figure in Lewes, where he had been accused of faking medieval maps and Roman tiles, and was known sarcastically as 'the Wizard of Sussex', Dawson turned back to the flints and fossils of early man.

He later claimed it was in 1908 that he had first retrieved a fragment of an ancient humanoid skull from a gravel pit at Piltdown, Sussex, but it was not until 1912 that he began to excavate this pit, and then a second one nearby. From these, he produced the remains of what he hailed as our earliest ancestor, the missing link between man and the apes, together with an assemblage of 'contemporary' implements and animal remains. Most fellow-scholars and the national institutions accepted the authenticity of the finds and applauded his discoveries. His co-excavator, Smith Woodward of the Natural History Museum, even proposed that this Dawn Man should be christened *Eoanthropus dawsoni*.

The onset of a fatal illness late in 1915 tempered Dawson's triumph, and he died in 1916. It was not until 1953 that the finds from Piltdown were subjected to proper scientific analysis, when tests proved that the definitive jaw of early man was really that of an orang-utan, which had been deliberately stained to age it. And a clinching piece of evidence – the tooth that conveniently turned up just when doubts about the site were being voiced (spotted by the morally impeccable Jesuit priest Teilhard de Chardin, who was helping sift finds that day) – had been deliberately filed down and stained. Dawson appeared to be at the heart of this greatest of hoaxes, present when each of the finds was made, and having the knowledge and ability to doctor the evidence.

Dawson's work on the Tapestry was an attempt to win the respect of experts by challenging them. By exploring its inconsistencies and drawing attention to its allegedly fraudulent restorations, he was trying to show that an amateur scholar could outdo the professionals. The Piltdown affair was simply an extension of this process.

No one else expressed doubts about the Tapestry's authenticity until 1990, when an Oxford ethnologist and textile specialist, Robert Chenciner, suggested in a paper delightfully entitled 'The Bayeux Tapestry Shish-

Kebab Mystery', that it was an eighteenth-century copy or near-total restoration of a medieval original. Suspicious that it showed eleventh-century Normans cooking kebabs (unknown, he claimed, in France until 1722), he then discovered other discrepancies. He calculated that the 650 handlings required to suspend the Tapestry annually in the cathedral nave between 1100 and 1750 would quite literally have worn it out, because the wool would have crumbled away. What now existed was a revised version hastily commissioned by the chapter, which was embarrassed by the interest antiquarians were taking in the work as a result of reading Montfaucon. Such a reconstruction was perfectly feasible, Chenciner argued, because the rapid and basic worsted laidwork stitches (so uncharacteristic of prestigious medieval church embroidery) could be done at great speed: a modern professional embroiderer working for ten hours a day could cover an equivalent area in just 75 days. But this 'replica' got many of the details wrong – not just the intrusive kebabs but many other aspects of the costumes, armour and architecture. As with Dawson's intervention, experts soon demolished this ingenious case.[13]

Rather than challenging the fabric itself, others have detected hidden meanings and codes. In 1932, Admiral Chambers (retired) revealed an entirely unexpected symbolism. From the characters' use of gesture, he decided that the Tapestry was really a secret tract about chiromancy – not merely palmistry, but ancient beliefs banned by the Catholic church. For him, the starting scene did not show Edward sending Harold on a mission, but giving him a lecture on chiromantics, demonstrating how each finger symbolised one of the pagan gods. The scene of the woman escaping from the burning house was not a typical moment of war, because she was really a Vestal Virgin, the house was the shrine of Vesta, and the soldiers were 'quirites', the official torch-bearers at Roman marriage ceremonies. The star in the sky was not Halley's Comet, but the Blazing Star of the Cabbalists, or Magi. Chambers suggested, not so implausibly, that the general theme of the Tapestry was the acquisition and tenure of property, an acceptable interpretation in terms of the Norman land-grab. But his conclusion defined it as a 'hermeneutic cosmogony' in honour of the Creator, Hermes.[14]

Pierre Villion, a Bayeux musicologist, also turned his attention to the Tapestry's 'mysteries and symbols', interpreting it in relation to the theories of Mircea Eliade, the great historian of comparative religions. Villion published a list of all the symbols he had noted in it, and then expanded this

into a larger study, which proposed that the Tapestry was designed to lead people towards salvation through its revelation of universal signs. The tripartite structure of the fabric deliberately led upwards from the lower border, which represented the baser instincts and the subconscious, into the central zone of actions and gestures, and finally to the upper border of spiritual aspirations, Heaven and Fate. Apart from the secret language of the trees and buildings, he found many other examples of ancient signs and symbols – the spiral (energy), the circle (Heaven), the square (Earth), the chevron (water), as well as many crosses and swastikas – tracing some of these forms back to Neolithic times, and others to ancient Egypt. The animals were naturally all symbolic, as were the colours. Having established these structures, Villion translated each scene of the Tapestry into its 'real' or spiritual meaning, and concluded by relating it to the mystic numbers that he calculated in the dimensions of the cathedral's nave.[15]

The problem with this sort of universal approach is that it completely detaches the artwork being studied from the context of its production, and ignores its relevance to the times and to the patron's pragmatic need to impress contemporaries. These are fundamental factors in the design and making of the Tapestry, as in most other medieval works of art.

Another revelation of hidden meanings was David Bernstein's *The Mystery of the Bayeux Tapestry* (1986). This detected a secret code inserted by the designer to discredit William's claim, which only Anglo-Saxon viewers were capable of appreciating. Bernstein derived this from obscure allusions he found to the Old Testament account of the Babylonian conquest of the Jews, turning William into Nebuchadnezzar, King of Babylon, and Harold into the rebel Judaean king Zedekiah, blinded in punishment for breaking his oath of fealty. Bernstein scanned the Tapestry for 'eye' references, and found plenty. He concluded that the Tapestry really depicted the hostile stance of the Canterbury monks, who designed it as a text that its Norman patrons would be unable to understand. While a monkish designer might well have been able to devise such parallels – for Old Testament imagery was widespread in art and in biblical commentaries of the time – the case really hinges on the arrow in the eye. But Bernstein then tried to reinforce his argument by proving that the border scenes were also a subversive Saxon sub-text. He proposed that the Aesopean fables were there to mock William, and that the creature most often associated with him was really the winged lion of Babylon, as described in the Book of Revelation. But it is just as easy to read the fables as being critical of Harold,

Harold, and the Babylon 'lion' is really a griffin, one of the most recurrent border creatures, which accompanies Normans and English indiscriminately. The idea that Normans were too stupid to notice these 'secret' messages simply highlights the dangers of over-elaborate modern interpretation and undermines the whole function of the Tapestry, a masterpiece more likely intended to bring people together than drive them further apart.[16]

In recent years, other specialists have harnessed the work to contribute to a range of issues. An international education journal defined the Tapestry as the ideal teaching medium: quite apart from its role as historical document and medieval artefact, it contributes to the study of disciplines that include art, communications, health and physical education, home economics, languages, psychology, science and mathematics. It has become a virtually compulsory element of the British National Curriculum, providing an opportunity for Year 7 pupils to study a stimulating form of primary evidence, as well as learning to detect bias and significant omissions. A classics journal suggested that the inscriptions should be set texts for first-year Latin students, because of the range of basic nouns and verbs in present, perfect and even subjunctive tenses, as well as showing the differences between classical and medieval linguistic forms. The author of a history of paediatric medicine diagnosed 'Turold', the bearded dwarf, as an early sufferer of childhood rickets, while an alternative opinion claimed that he represented the genetic mutation of achondroplasia. Less intellectually rigorous, yet proof that the work was meant to be embedded in the nation's brains, was a question on BBC Television's National Lottery Quiz in 2002: 'The Bayeux Tapestry depicts the invasion of which group of peoples – Saxons, Vikings or Normans?' The correct answer netted £7,500.[17]

24

Bayeux Today

As visitor numbers soared during the 1960s and 1970s, the Bayeux authorities decided to create a more up-to-date exhibition space for their treasure. This involved a controversial move from the Hôtel du Doyen, its home (apart from the war years) since 1913, but provided the opportunity for full examination, cleaning and photography, from the back as well as the front. The building chosen to become the new museum was the Grand Seminary, built by the Bishop of Bayeux in the late seventeenth century, with an immaculate façade that concealed a largely destroyed interior. Plans were drawn up and building work started in 1980. Reputations were at stake here, both local and national. This was not just the most precious item in Bayeux, but one of France's most famous works, a national Historical Monument since 1840, and therefore the responsibility of the state as well as the town. Early in 1981 the Historical Monuments section of the Ministry of Culture invited a group of textile restoration specialists to inspect the hanging in order to advise on any required cleaning or repair before installation in the new premises. They were dismayed to find evidence of decaying threads and fabric, dust, hints of mould and even the scent of vinegar, suspicious evidence of decomposition, though others argued that it came from the aerosol spray used by the cleaning lady. But full testing and analysis could not take place until the Tapestry was finally taken off exhibition, and that could not happen until the new building was ready.

Georges Duval, a local architect who was also chief architect for Historical Monuments and who had restored Matilda's foundation, the Abbaye-aux-Dames at Caen, designed the new exhibition space. But an architect and a textile specialist have different agendas. These turned into major disagreements over how to clean and display the Tapestry. Duval clashed with the restorers from the Swiss Abegg Foundation, one of the bodies considered for the cleaning project, which had even offered to treat the Tapestry free of charge. As national pride was at stake, the Historical Monuments section decided to keep the commission in French hands. Here the whole business turned into French farce as malicious gossip started to circulate. At an early stage in the discussions, someone had apparently suggested that one way to clean a fragile fabric was by carefully immersing it in water: the dimensions of the Tapestry would require a massive pool and some 200 people to hold it up. The French later claimed that this proposal came from the Abegg Foundation, which the latter denied. Shocked English conservators, 'who regarded the French as inadequate caretakers of a priceless national treasure that should never have departed England', jokingly threatened to throw some of the valuable French furniture from the Wallace Collection into a pool as well. Bayeux turned into Clochemerle when the Monuments staff stood accused of deciding to proceed with this course of action. A rumour spread that they had selected the Olympic swimming pool in Paris for the dunking, but that the mayor of Bayeux and his council vetoed the project. Writing in January 1983, art critic Brian Sewell described the impasse: 'Under no circumstances would the fabric be removed anywhere, least of all to the hated capital, as even an Olympic pool was too short (by 22 yards). It could not matter that their own pool was shorter still – a hundred local women would be put into training to support the Tapestry for the five days and five nights that it would be immersed over the New Year Holiday of 1983. No-one considered the problem of how to fill a swimming-pool with pure distilled water, and no-one thought of the additional problems that would be created by the presence in that water, with the Tapestry, of a hundred human bodies that might well discharge oils, acids and fluids that have no part in the conservation of ancient fabrics.'[1]

The pool story was probably just a joke but still raises French hackles today. The Tapestry was definitely not immersed, and the restorers who undertook a second, more detailed inspection once it was off exhibition found it to be in fairly good condition after all, needing only a gentle

cleaning, during which they removed the lining in order to inspect and photograph the back. Then it was installed in the new state-of-the-art display which opened on 6 February 1983. The results of the examination, however, were not published until July 2004.[2]

The town of Bayeux has coped well and in a fairly dignified manner with this potentially destructive lodestone. There are numerous signs to the *Tapisserie*, but the building can only be reached on foot, with pedestrians following the routes indicated by brass plaques set into cobblestones or paving slabs, which are engraved with one of the Tapestry's distinctive interlaced trees. The walk from the cathedral precinct leads past the Monument des Déportés (which includes the name of Colonel de Job, Mayor Dodeman's colleague, amongst the list of those whom the Nazis sent to concentration camps) and across the little bridge over the narrow, fast-flowing River Aure, still overhung by medieval dyers' and millers' wheels. An unassuming archway leads into what looks like an old farmyard, rather than the approach to one of the world's most popular works of art. Beside the entrance to the building is a plaque provocatively inscribed 'TAPISSERIE DE LA REINE MATHILDE', although the main door announces to visitors that they are about to enter the 'CENTRE GUILLAUME LE CONQUÉRANT.'

The exhibition struggles to reconcile its virtuous mission to explain and educate with its visitors' very natural desire to go straight to the work itself.

Nobody really believes that Matilda made the Tapestry – but this is still the sign outside the Bayeux exhibition.

The ticket desk sells a leaflet that is 'in no sense a study of the Tapestry', but a guide to the whole museum, from the *Salle Guillaume* on the first floor, where a well-annotated photographic facsimile is rather defensively labelled 'not the real Tapestry', to the *Salles Mathilde* (maps) and *Odon* (short film) on the second floor. Visitors are advised to assimilate all these, via a replica of the Domesday Book and a photograph of the Prince and Princess of Wales visiting the Museum in 1987 (both already displaying ominous body language), before returning to the ground floor, where the luminous Original unfurls ahead like a great shaft of light through the darkened gallery. But the architect Duval has chosen to ignore what must have been the original designer's intention for it to hang around the internal walls of a building (whether cathedral nave or great hall) so that the spectator could stand in the centre and initially take it all in at once. Without this experience, it loses some of its meaning, especially the sense of a tale unfolding from beginning to end. The current exhibition arranges it around a hairpin bend, so that it is only possible to see one side at a time: the need to keep visitors flowing was greater than that of re-creating the proper layout. An audio-guide in 11 different languages keeps up the momentum, conducting the tour in a brisk 20 minutes. Once finished, the only exit is through the shop, in a crypt beneath the gallery, where modern

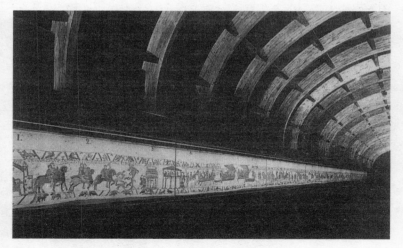

The Tapestry on display in the Centre Guillaume le Conquérant, Bayeux. The roof suggests an upturned Viking ship.

301

pilgrims can acquire relics from the shrine – the video, the slides, the tea-towel, the mouse-mat.

Visiting the Tapestry is just one element in a tourist itinerary that includes the beaches and monuments of the Normandy landings of June 1944. In a fascinating inversion, William's preparations for his great invasion fleet herald Operation Overlord, the same process, in the opposite direction, nearly 900 years later. The Tapestry's loving details of the assembly and loading of supplies – weapons and armour, wine, transport (equine) – are all paralleled in the stark photographs of mulberries and pontoons, tanks and lorries, soldiers humping their gear, in the many D-Day museums in the region. These recent records, preserved in the modern media of film and newsprint, add poignancy to the same narrative in linen and worsted. The Tapestry's border images of mangled corpses are no more or less shocking than photographs of bodies on Omaha Beach and the shattered remains of villages.

Afterword

Writing about the Bayeux Tapestry has been like rediscovering an old friend. I cannot even remember when I first became aware of the work, but it must have cropped up in primary school, when I fell in love with the Middle Ages generally and where our 'houses' commemorated England's ruling dynasties (though I was a Tudor, not a Norman). As an undergraduate, I attended lunchtime art-film sessions, and remember the rustling of paper bags as people munched their sandwiches in the dark while watching great works on screen. One film was about the Tapestry, and I can still recall the impact of the enormously magnified horses in the battle sequence, with clever camera work that made them look as if they were really moving. Most evocative was the dark horse that plunges vertically to the ground, and this must have fascinated the director too, for he repeated the image again and again. I was hooked. I took an option in medieval art, then studied the Tapestry as part of my PhD thesis, looking at the sources and connections of the menagerie in the borders. This led me into the wider study of animals in medieval art, and, though later working in other areas, I tried to keep up with the ongoing stream of Tapestry publications and research, and always felt it was there waiting for me, a sort of unfinished business.

When I had the opportunity to write this book, I was well aware of the title of one recent article, 'Is there anything more to say about the Bayeux Tapestry?' There was also the excellent advice that the antiquarian Frédéric

303

Pluquet gave himself when including the work in his *Esai historique sur la ville de Bayeux*: 'So many accounts of this monument have been published and there has been so much discussion of its origins that I must be careful not to get sucked into these endless speculations.' And he provided some useful guidelines, 'not to repeat what others have said, but only to put in what has been left out, forgotten or overlooked'. He wrote these words in 1829. If they were relevant then, how much worse might it be today?

So my self-imposed brief has been to contribute something new to Tapestry studies, to seek out what others have ignored, and I thought that a biographical format might provide an interesting approach. The outline of its known history fitted the chapter headings for writing a life – parentage, conception and birth, some wilderness years, joyful rediscovery and fame, cliff-hanging adventures, friends and foes, shifting reputation, many offspring – set against the wider background of the times, the permanently sensitive issue of Anglo-French relations. Another idea was of the Tapestry rapidly running through its allotted nine lives, yet always surviving, cat-like, for the next stage in its existence. There had been so many narrow escapes: the Calvinists sacking Bayeux Cathedral, the revolutionary mob who wanted to cut it up to cover a wagon; its journey to Paris on a baggage cart at Napoleon's command; being ripped off display and hidden from the Prussian army; trundling through wartime France on a smoky *gazogène*-fired truck; being escorted by the Gestapo to Paris as the Allies closed in; and the final closest shave of all, when the two SS officers did not quite have the courage to break into the Louvre and snatch it for Himmler.

Inseparably linked with the Tapestry's life was the need to consider the brief lives of those who got involved over the centuries, and whom it affected in so many different ways, who constantly tempted me to stray far beyond their connection with the work. Eliza Stothard was a delight, romantic and plucky, someone who deserves a biography of her own; it was thoroughly satisfying to trace the stages of her vindication. The commitment and industry of Elizabeth Wardle were a revelation, and the Reading replica a fascinating monument to visit, a major national and international attraction in its day, yet hardly known now. The remarkable lives of those tough women Emma and Edith are earning them a deserved place in medieval studies, as historians explore the role of the queen. Other intriguing characters included Napoleon's arts supremo, reformed roué Vivant Denon, and those scholars whose reckless passion for their subjects

caused eccentric and misleading interpretations of the Tapestry: William Stukeley, the Abbé de la Rue and Piltdown man Charles Dawson. The least appealing new acquaintance was Hermann Bunjes, who nearly managed to spirit the Tapestry out of France altogether, someone who hardly figures in Nazi histories, yet who was involved in so many aspects of French art during the war. More familiar names, unexpectedly encountered as Tapestry tourists, included Dickens, Ruskin and Morris.

Working on the book has involved the usual hours of slog in libraries and at the solitary desk. There have also been highlights, the researcher's Eureka moment, such as receiving an envelope of photocopied Nazi letters about the Tapestry and finding one written by Heinrich Himmler. Or, after an interminably long wait in the echoing hallway of the Archives Nationales in Paris, hoping for an official to call out the number that would entitle me to a seat in the library upstairs, finding in a bulging *Kunstschutz* file the dockets proving that Hermann Bunjes had twice taken the train from Paris to Bayeux in the summer of 1941 to inspect his prey, the Tapestry.

Managing to be in Bayeux during the week of the sixtieth anniversary of D-Day was serendipitous and wonderful. The town was *en fête* with flowers and bunting, veterans and their families strolled around, while Vera Lynn sang from loudspeakers in the streets. I stayed in the Lion d'Or, where Jankuhn and his team had lodged, and imagined their ghostly, SS-uniformed presences walking though the creaking corridors and marching down the staircase every morning. In the municipal library (in the same building that houses the Tapestry) I went further back in time to read the correspondence, in spiky, italic hands, of the brave arts commissioners who struggled to keep the work safe during the revolutionary years, even though they could not stop Napoleon taking it to Paris. This provided the boost of publicity that so infuriated the English, but ultimately resulted in the Society of Antiquaries sending Charles Stothard to Bayeux to make his copy. It was also touching to be able to handle one of these engravings, now preserved in the Guildhall Library, which someone had gone to the bother of joining up and backing in order to have their very own miniature version.

The greatest pleasure has been the Tapestry itself. Coming face to face with the real thing, among the crowd of jostling, whispering visitors, I am constantly amazed at its sense of life. No matter how familiar the images of gesticulating, vibrant figures, or how often they have been reproduced – Harold swearing on the relics, William commanding the fleet to be built,

Odo blessing the banquet, the prancing lions and pecking birds in the borders – they only truly exist here. Look at the fabric: the stone-coloured, closely woven linen whose occasional rusty marks, discolorations and patched rips are the honourable scars of its survival. These firm threads have kept it intact over all the years, despite so much handling. Look at the patches of worsted colour: people and animals, thrones and arches, sails and branches, their tones more subtle and harmonious than any reproduction on printed page or transparency, while their rippled, textured stitchwork honours the deft fingers of the original embroiderers. This is not just an illustrated story from history that can be studied in a book; it is a three-dimensional work of art, and you have to be in its presence before you begin to understand the extraordinary skills and sensitivity of those who made it. This is its appeal to modern audiences, a work of art with a life story that has transcended centuries and national boundaries. I stand in front of the dark warhorse, and I marvel.

Notes

Embroidering History

1. The Plot

1 According to the Canterbury chronicler Eadmer, writing in the early twelfth century, King Edward had sent Harold's brother Wulfnoth and nephew Hakon to Normandy in 1052 as guarantees for the good conduct of their family, the too-powerful Godwins. See Wissolik 1979.
2 See *Guy* 20–1 and *Mal.* 451 for the contrasting responses, and Owen-Crocker 1994 on contemporary fashion.
3 ASC 164. See Chapter 23 for further discussion of Ælfgyva.
4 *Guy* 11.
5 *Ord.* 179.
6 *Ord.* 177.

2. The Patron

1 *Ord.* 265.
2 ASC 145; *Mal.* 507.
3 *Jum.* 179.
4 *Ord.* 221, 230.
5 *Ord.* 313.
6 *Ord.* 173. He may also be the character on horseback holding a club in the Brittany campaign.

7 See Bridgeford 2004 for Eustace as patron. The mustachios worn by
 '*Eustatius*' appear to be an entirely nineteenth-century addition, inspired by
 his nickname 'Eustace *aux gernons*' – with the moustaches.

8 *Mal.* 353.

9 *Mal.* 471.

10 *Ord.* 225.

11 *Ed.* 123.

12 Norman chroniclers repeated this clever gloss: the marriage was 'only in
 name. It was said that both actually always remained virgin.' *Jum.* 109.

13 *Ed.* 45.

14 *Ed.* 125

15 *Mal.* 503.

16 *Mal.* 353.

17 *Ed.* 25, 65.

18 See Hart 1997 and 1999 for many Canterbury MS parallels, particularly
 with St Augustine's Abbey, where there are precedents for a large number of
 the Tapestry's motifs in the cycles produced there; he points out that
 Canterbury-trained scribes also worked in other houses.

19 See Budny 1984 and 1991, Digby 1957 and Christie 1938 for discussion and
 examples of earlier works, which had been attracting admiration since the
 seventh century.

20 Cited by Christie 1938.

21 *Ead.* 127, 129.

22 *Ord.* 269.

3. The Project

1 Cited by Forbes 1964, 31.

2 This was the weight of wool required for the full-sized replica that was sewn
 by the same stitching techniques in the nineteenth century.

3 For other speculations on the sequence of manufacture, see Koslin 1990,
 Messent 1999, Short 2000 and Owen-Crocker 2002.

 Following the conventional numbering of the Tapestry (1–58 inscribed in
 green ink on the backing cloth) the joins are as follows:

 1: between 13 and 14. The only subsequent sewing is on the right-hand
 diagonal on the lower margin.

 2: between 26 and 27/28. The visually complex sequence containing
 Edward's two-tiered deathbed and two inscriptions, one of which is unusually
 placed in the upper border. Were these two scenes originally intended to go

side by side, then changed as part of the rethink? These two sections were joined, then the seam embroidered over with the figures of a griffin, an attendant, part of the building and an inscription.

3: between 37 and 38. This join is easier to spot because, like the first one, there is virtually no over-sewing except in one of the upper-margin diagonals and in the lower-margin foliage sprig. There is a deliberately and uncharacteristically blank area in the main section, as if the designer had intended the seam to come here. The sequence of marginal animals is correct around the joins, but there is still a minute discrepancy in the measurements of the lower margin, with that of the fourth section a fraction higher than the third.

4: between 42 and 43. Less obvious, joined up and then embroidered over with a lion, the roof of a building, the kebab skewers and the diagonal in the lower border. It could have been totally concealed by the right-hand vertical of the building which runs from top to bottom of the central portion, but curiously was not: perhaps the embroidery stitching would have put too much tension on the join.

5: between 48 and 49. Just avoiding the dense mass of horses in the first advance of Normans, the join is concealed by one upper diagonal, a horse's rump and a lower diagonal.

6: in the middle of 51. Almost undetectable because heavily embroidered with a bird, shield, two horses and a lower diagonal.

7: between 55 and 56. More detectable, because there are some blank areas, with the join only being covered by the tip of a shield and a horse's rump.

8: between 56 and 57. Just before the Harold sequence; imperceptible.

4 Bedat & Girault-Kurtzeman 2004, 97. The results of the 1983 examination, which revealed that there were nine, not eight, strips of linen, were not published until 2004. The 'new' junction was the one at 56/57.

5 Staniland 1991, 13.

6 Gibbs-Smith 1973, 10, suggested it was the pressures of a looming deadline that caused some mistakes to be made in the later part of the Tapestry only.

7 Staniland 1991, 28.

8 Westminster Hall, built in the 1080s, was 73 × 20 metres; the tower of Chepstow Castle 30 × 12 metres, Bernstein 1986, 105, 212. See also Brilliant 1991 and Swanton 1995 on how the Tapestry might have been hung in such spaces.

9 Pächt 1962 recognised Canterbury as an essential source for the transmission

of classical motifs. He saw the Tapestry's gestures as signposts to the audience, showing 'the event and its interpretation' presented simultaneously. Dodwell 2000 set out the precise links with the Roman theatre. See Barasch 1976 on the veiled weeping gesture. Schmitt 1990 in a more general survey, suggested that Harold signalled his duplicity by swearing his oath on two reliquaries. But Gombrich 1982, 66, derived his posture from the blessing position. Kuhn 1992 read the Tapestry's gestures as a substitute for speaking or listening, and related them to specifically Christian symbols in order to prove that the Normans had God on their side.

10 Power 1975, 93. See Banham 1996 for the transcription of these signs. For acting monks, see Cohen 1906.

11 Tavernier 1914 thought they were father and son, but Lejeune 1969 believed them to be the same person, simultaneously designer and composer. Owen-Crocker 1998 has drawn some detailed parallels between the narrative techniques of the Tapestry and the structure of *Beowulf*. See also Scragg 1991 on the *Battle of Maldon*. Brilliant 1991 has gone into the performance aspects in detail. See also the thirteenth-century Icelandic *Edda*, which describes embroideries showing the deeds of Norse heroes.

Lost and Found

4. The Missing Years

1 '*Une tente très-longue et estroicte de telle à broderie de ymages et escripteaulx, faisans représentation du conquest d'Angleterre, laquelle est tendue environ la nef de l'église le jour et par les octaves des Reliques.*' Item 262, MS 199, Bibliothèque du Chapitre de Bayeux. Caen: Archives Départmentales-Calvados.

2 Ackerman 1930.

3 Gibbs-Smith 1973 implausibly suggested that Odo was one of the looters: he commissioned the Tapestry as a gift for Matilda at Rouen, but then reclaimed it for his own cathedral.

4 See Brown 1988 for a translation of the relevant portion of Baudri's poem, and Bond 1995 on his literary ambitions and career. Parisse 1983, 48, thought Baudri might have been describing a copy of the Tapestry that Adela commissioned.

5 Bridgeford 2004, 301–2.

6 '*Ung grant tapiz de hault lice, sans or, de l'istoire du duc Guillaume de Normandie, comment il conquist engleterre*', Michel 1854, II, 77. Before the sixteenth century the term '*haute lisse*' referred to the quality of the work, rather than

the later technical meaning of 'woven on a high loom'. See de Reyniès 2004 for a discussion of textile terminologies.

7 For Clamanges' career, see Beziers 1773 and Clamanges 1936. For the Dijon tapestries, see Thomson 1973, 93.

5. Antiquarian Approaches

1 See Foucault's biographer, Baudry 1862, ii, who described the course of his career as essential to the understanding of the workings of the vast bureaucracy that was French local government in the years before the Revolution.

2 De Boze 1731, 401.

3 Janssen 1961 suggested that one of Foucault's daughters made the drawing. However, there is no convincing reason for this, and a fellow-member of the *Académie* assumed he had commissioned a professional artist (Lancelot 1729, 743). The original drawing survives in Paris, Bibliothèque Nationale MS 102, a roll made out of 15 sheets of paper pasted together. For a description, see Hill 2004.

4 Lancelot 1729, 755.

5 See Huard 1913 for Montfaucon's correspondence.

6 Huard 1913, 366.

7 Letters of 14–7–1729 and 17–7–1729, Huard 1913, 370–3.

8 Montfaucon 1729, iii.

9 Montfaucon, 1730, 2.

10 The 1983 examination revealed that the Tapestry might first have been hung by rings attached every 8-11 centimetres to the backing strip, which were later replaced by loops. The strip was made out of 38 smaller pieces of linen of the weave normally used for shrouds. The 58 numbers were painted onto this strip. The lining of this period was replaced by another in the nineteenth century. See Bédat & Girault-Kurtzeman 2004, and Vial 2004.

11 *Mercure de France*, October 1732, 2118–19. Despite Montfaucon's redefinition of the term, de la Roque still used 'Gothic' in the negative sense: although Bayeux Cathedral was built 'in the Gothic style', it was well made.

6. The English Claim

1 Piggott 1950, 40 n.2; Evans 1956, 238 n.12.

2 Stukeley 1743.

3 Stukeley 1746.

4 Cited by Wexler 1979, 93.

5 Hume 1762, 476–7. One general work he consulted was Rapin de Thoyras' *History of England*, which however did not mention the Tapestry at all, for the volume that dealt with the Conquest was published in 1724, long before Montfaucon. But the updated 1820 edition followed Hume in locating the Tapestry at Rouen, and asserted it was made by the Empress Matilda. Thomas Carte briefly mentioned the Tapestry in his *General History of England*, a book inspired by Stukeley in tracing the rights of kings all the way back to the Druids. But Carte was sounder than Hume on the Tapestry, for he referred to 'an old set of tapestry hangings belonging to the church of Bayeux in Normandy' and its publication by Lancelot and by Montfaucon, whose conclusions he accepted without question: 'The Tapestry is as old as the time of this event and was given to that church by Mathilda, wife to William the Conqueror.' Carte 1747, 353.

6 Lyttelton 1767, 12, 353–5. Others completed the *History of England* after Lyttelton's death and it was published in 1803.

7 Barrington 1785. Other works included *Essay on the Language of Birds*, *The Probability of Reaching the North Pole*, *Observations on Mozart*, and various articles for the journal of the Hakluyt Society. He did admit, 'I have perhaps published too many things.' Walpole to William Mason, 21–12–1776, Toynbee 1904, 307.

8 Ayloffe 1775, 186.

Revolutionaries and Romantics

7. Escaping the Terror

1 Stothard 1820, 32, reporting a conversation in 1818. Pluquet 1829, writing about subsequent threats to the Tapestry, did not mention the events of 1792, but Pezet 1840 said he had been told about the rescue by Leforestier himself.

2 Letter of 4 fructidor II (21 August 1794) in Bayeux Bibliothèque Municipale, MS 138. Brown 1988, Appendix 1, quotes four letters from the correspondence of the Arts Commission and there is a fifth in Pluquet 1829, 76–77.

3 Bayeux MS 138, no.4, p. 4. The huge file of the commissioners' general correspondence, hundreds of letters carefully copied into an indexed ledger, gives some idea of the scope of their responsibilities at this time.

4 Letters of 25 thermidor (12 August 1794), 4 fructidor (21 August 1794), 23 vendemiaire III (15 October 1795), Bayeux MS 138, the latter also quoted by Pluquet 1829.

8. *The Dictator's Display*

1 Van Houts 1987 discounted the total of 3,000 ships claimed by Wace, but accepted William's Ship List, which provided a minimum figure of 776. Napoleon's total fleet was more than 2,300 ships.

2 The paper's full title was *Le Gazette National ou Moniteur Universel* and that edition also had the official date of 20 brumaire XII. But some newspapers retained the old date as well, because people still had problems with the new system.

3 Caffarelli's and Denon's letters cited by Pluquet 1829, 78, 79. The commissioners' letter of 10 frimaire XII (30 November 1803), Bayeux MS 138, no.122, p.127.

4 The gallery is in the wing of the Louvre now appropriately named after Denon. For the history of the Louvre under Napoleon, see Bazin 1959, Gould 1965 and McLellan 1994.

5 Dufraisse 1962.

6 *La Décade philosophique* XII: 2 (1804), 223–9.

7 Review quoted in Brown 1988, Appendix 1, C.

9. *Performing Propaganda*

1 Cited by Cooper 1984, 77.

2 See Muret 1865 for theatres in the Revolution and under Napoleon.

3 Horace Walpole to William Mason, 21–12–1776, in Toynbee 1904, 306.

4 Cooper 1984, 74, 76. The play was published in 1804; see Barré, Radet & Desfontaines 1804. The musical score, by Wicht, is in the Bibliothèque Nationale, Vm5 2555 (Music Dept).

5 *Le Moniteur*, 23–1–1804; *Décade philosophique* XII: 2 (1804), 242–3.

6 De Rémusat 1880, 115.

7 De Rémusat 1958, 37.

8 Cooper 1984, 78. The actor Baptiste was the strict father of the white-faced mime artist played so famously by Jean-Louis Barrault in *Les Enfants du Paradis*, that wonderful re-creation of a Parisian vaudeville theatre at the beginning of the nineteenth century.

9 See Cooper 1984, 79–80, for a detailed account of the performance. The play's authors were Coffin-Rony and Clément.

10 Laffetay 1873, 15. Denon's letter of 18–2–1804 cited by Pluquet 1829, 80–1.

11 I am most grateful to Anne Jones for telling me about the Boulogne column.

10. The Rival Camp

1 Letter of 13–3–1804 to Colonel John Frewen. East Sussex Record Office, FRE 2384/16.

2 See his four papers published in *Archaeologia* XII (1796) and XIII (1800).

3 Douce 1814. For Douce's will, see his entry in the *Dictionary of National Biography*.

4 Gurney 1817. The president was George Gordon, Earl of Aberdeen but the absences resulting from his career as Foreign Secretary, then Prime Minister, forced the Society to change its rules about appointing a president for life. See the Council Minute Books for the progress of the Tapestry project.

11. The Stothards' Story

1 See Stothard 1823 for Charles' career.

2 Bray 1884.

3 Turner 1820, 242.

4 Stothard 1823, 253.

5 One cast, of Harold enthroned, is now in the collection of the Society of Antiquaries, catalogue 109. The other three – a duplicate of Harold, a soldier and William – are now on the same piece of plaster and are in the British Museum (Dept of British and Medieval Antiquities, Meyrick Collection, 1878, 11–1.379). Two of these were previously in the South Kensington Museum, listed in catalogues by Rock 1870 and by Birrell 1914 and 1931, acquired from Meyrick's collection. See *The Gentleman's Magazine* 106.2 (1836) 381 and Jubinal 1838, 28, on the Doucean Museum. According to a French visitor in the 1830s, it was a Gothic-style chateau, with turrets and crenellations towering towards the sky, each room decorated in a different historical period. There was a huge gallery displaying the antiquities.

6 Dibdin 1821, 221.

7 See Stothard 1820 for her impressions of France.

8 Listed by Pluquet 1829, 120.

9 Bray 1884, 146.

10 Turner 1820, 234–42.

11 Dibdin 1821, 375–87. French edition 1825.

12 Estrup 1911, 38–9.

13 Amyot 1821, 88.

14 Guildhall Library, Prints & Maps section, M0008250CL. I am most grateful to John McSween for this information, and to the Library for allowing me to handle it.

15 Léchaudé d'Anisy 1823.

16 Lambert 1840 Corney 1838, 600–3. *The Gentleman's Magazine*, May 1839, 467–72.

17 Jubinal 1838. There was a two-volume version in a very limited edition of 100 copies with the engravings hand-coloured, and an only slightly less impressive single-volume edition of 333 copies with black-and-white engravings.

18 Southey 1960, 203.

19 Musgrave 1855, 281.

20 Mérimée 1847. *Bulletin Monumental* 19 (1853), 378. The 1983 examination noted 17 different-coloured wools added during this restoration.

21 *Revue Anglo-française* 1 (1840), 149–67; 168–90; 408–14. The *Revue* was a short-lived periodical whose aim was to publish historical and related discoveries proving the contacts between France, Normandy and Aquitaine. Lambert 1865, 198. Du Méril 1862.

The Gentle Touch

12. 'The Queens of England'

1 See George & Campbell 1987, on Browning's *Aurora Leigh* and Rossetti's 'The Lowest Room'.

2 Wollstonecraft 1972, 170–2.

3 Lamb 1815, 257–60. See also Burton 2003.

4 Ellis 1839, 465–70. See Parker 1984, especially Chapter 6, for a summary of eighteenth- and nineteenth-century attitudes to sewing. However, Mitchell 1996 and Maitzen 1998 have modified her rather negative image of Victorian views and shown them to be far more complex. Both relate embroidery to history writing; the former in the context of the Tapestry as well.

5 Stone 1840, 81–114.

6 *Tait's Edinburgh Magazine*, VII (November 1840), 715–23.

7 *Athenaeum*, 670 (August 1840), 675–6.

8 Wilcockson 1856, 23.

9 Pope-Hennessy 1940, 5.

10 Strickland 1852, 64–66, 93.

11 Pope-Hennessy 1940, 85.

12 The sisters divided up their 33 queens, with Agnes tackling 19 lives and Eliza 14. Their joint style was almost seamless, although Antonia Fraser, in her

introduction to the 1972 reprint of the *Lives*, defined Agnes' writing as more colourful than that of the 'drier and hard-hitting' Eliza. Their industry included ground-breaking primary research into previously unpublished documents at a time when women were banned from the State Papers room, to which the Stricklands gained access only after a lobbying campaign in the early 1840s.

13 Lambert 1842, 10–13; 1844, 37.

14 Hartshorne 1848, 2.

15 Warren & Pullan 1855, xii, 247.

16 Wilcockson 1856, 15–17.

17 Green 1849, 15. (Douce's article was in *Archaeologia* for 1812.) She followed this book with *Lives of the Queens of England of the House of Brunswick*, dangerously recent territory, which the Stricklands had declined.

18 J. M. Kemble in *Fraser's Magazine* 52 (August 1855), 135–49, cited by Maitzen 1998, 28.

19 Her novel was interesting enough for H. & C. Treacher of Brighton to publish it in English in 1858, though illustrated by the outdated Montfaucon engravings. The (anonymous) translator added an account of Matilda's tomb at Caen, extracted from a paper read to the Sussex Archaeological Society in 1846. The novel was later reissued in 1882 in Caen, no longer under the name of Madame Emma L . . . but now Mme Chuppin de Germigny.

20 Bruce 1856, 14–15. He illustrated this with a poor version of the Stothard engravings, redrawn, heavily reduced and printed in colour by Messrs Lambert of Newcastle upon Tyne. See Farrant 1997 for a full account of the travels of Bruce's panels, which went to Edinburgh, Alnwick Castle, Chichester, Lewes and Glasgow, to illustrate lectures by Bruce and colleagues. In 1884, Bruce donated the set to the Society of Antiquaries of Newcastle upon Tyne, where it is still in the Museum of Antiquities.

21 Freeman 1869, 569.

13. Visitor's Book

1 Musgrave 1855, 255.

2 Murray 1843, 79–80.

3 Links 1968, 56.

4 Ruskin, edited by Cook & Wedderburn 1893–1912: 9, 273; 10, 76; 16, 329; 20, 269, 375; 27, 186; 34, 261. The mosaic in St Mark's showed the miraculous rediscovery of the Evangelist's body from a marble pillar in the

church, watched by a procession of worshippers headed by the Doge, identified by the inscription over his head.

5 Musgrave 1855, 250–80.
6 Kelvin 1984, 20, 22, 18.
7 Gautier 1865, 22–3.
8 Hoge 1981, 212–3.
9 Tennyson 1908.
10 Dickens 1868.
11 Baedeker 1889,146–48.
12 Yonge 1868. This one-third-size hand-coloured facsimile, made perhaps from Sansonetti's 1838 drawings, is now displayed in the Miles-Smith Science wing of Mount Holyoke College, South Hadley, Massachusetts, which bought it in 1957 together with notebooks containing lectures on the Tapestry that Mark Lower, a colleague of Collingwood Bruce, gave in Lewes in 1857.

14. A South Kensington Scandal

1 Bruce 1856, ii. Planché later claimed that he declined the Society's offer, although he did publish an article in the *Journal of the British Archaeological Association*, Planché 1867.
2 Rock 1870, cxvii, 6.
3 Fowke 1875, 10.
4 Hamber 1996, 294.
5 Hamber 1996, 451, n.148, citing NAL E2, mus. 5.
6 V&A: ED84/167, 2–8–1871. The letter was addressed to the Council on Education, with a hand-written direction to 'Mr Cole'. Another hand-written comment noted, 'Approved. R. 3 August 1871.' The speedy response indicated the importance of the project.
7 Ibid. Cundall's letter of 10–8–1871, and Cole's of 23–8–1872 (in French again), acknowledging the mayor's letter of 18–8–1872.
8 Fowke 1875, 10.
9 V&A: ED84/167, 13–12–1872, 1–2–1873, 18–3–1873. Cundall initially quoted for only one set each of black-and-white and coloured, full- and half-sized prints, totalling £817, with additional sets as optional extras, the printing to be done by the Permanent Printing Company of Hereford Square. The revised total was £1,237 10s. to cover six sets at each size. Cundall's son returned the original plates to the Museum in 1893, where they still survive in a very fragile condition.

10 *Official Guide*, 23–4. *Official Catalogue* 1st edn, 108, entry no. 2897d.

11 *The Antiquary* IV, 12–7–1873, 15. *Society of Arts Journal* XXI, 14–3–1873, 12.

12 The spool version is now too fragile for display and is in store awaiting conservation. However, other joined-up versions have survived, for this was something that could be done by anyone who bought the portfolio sets of the prints.

13 See, for example, the account of a visit in *Annuaire cinq départements de l'ancienne Normandie* 43 (1877), 44. Burton 1878. Laffetay 1873, 12.

14 These were not produced by Cundall's firm but by Spencer, Sawyer & Bird. See Hamber 1996, 451, n.152, for full details. Surviving copies – for example, those in the British Library, and in the National Library of Scotland (formerly in the Advocates Library) – have book plates printed with the heading 'Science and Art Department, South Kensington Museum, presented by the Lords of the Committee of Council on Education', then the recipient's name and date, 5 October 1875, written by hand.

15 *The Times*, 31–8–1881, 10c, d.

16 *The Times*, 24–9–1881, 10f.

17 *The Times*, 26–9–1881, 9c.

18 V&A: ED84/167, letter of 24–9–1881, memo of 26–9–1881.

19 See Fowke 1913, 18, for his recantation, but Hamber 1996, 440, who repeats the allegation.

15. *The Ladies of Leek*

1 Constable cited by Finlay 2002, 417. This was in a speech to the Royal Academy in which he compared it to the pre-Columbian paintings on deerskin known as the 'Nuttall Codex'. Street gave a paper on medieval embroidery to the Durham Architectural Society, later published in that arbiter of Gothic Revival taste *The Ecclesiologist*; Street 1863.

2 Alford 1886, 356, 367, 398.

3 *Daily News*, cited by Morris 1962, 9. Church 1880, 5–6.

4 For these other Wardles, see Kapp 1994.

5 Letters of 13–4–1876, 19–4–1876, 17–11–1876; Kelvin 1984, 297, 298, 333.

6 Letters of 11–12–1876, 31–7–1877, 9–9–1878; Kelvin 1984, 338, 390, 497.

7 Schools listed in Morris 1962, appendix I. Stuart 1969, 7. Jacques 1996, 51. In 1893, the Leek School merited an article in the very first volume of *The Studio*, epitome of late-Victorian advanced taste; Parkes 1893, 196.

8 Wardle 1887, i.

9 In 1934, Alice Allen re-created her scene of Edward's funeral: this hangs in

the Nicholson Institute in Leek. And Alice Pattinson did another version of Harold's coronation. John McSween and David Hill discovered this panel in Devon and have donated it to the Whitworth Art Gallery, Manchester, where it has been conserved.

10 I am indebted to John McSween for pointing out to me the actual source of the replica, and thus vindicating Elizabeth.

11 *Reading Standard,* 25–2–1927.

12 Higgin 1887, 345, 348.

13 *The Art Review* 1.2 (1886), 12.

14 *The Cambridge Review* VIII (1886–7), 332–3, 18–5–1887 and 25–5–1887.

15 *The Times,* 3–5–1887, 3d; 7–5–1887, 5f.

16 Other venues included the Brighton Royal Pavilion (1888), where it made a loss of £11 14s 2d, Blackpool (1889), Nottingham and Derby (1890).

17 Letter of 11–11–1935, cited by Stuart 1969, 20.

18 Minutes of Council meeting, cited by Stuart 1969, 19.

19 I am most grateful to the Royal Archives at Windsor for this quotation, which appears with the permission of Her Majesty Queen Elizabeth II.

20 *Reading Standard,* 25–2–1927.

21 *Birmingham Mail,* 6–10–1928. *Bolton Journal,* 7–8–1928, 10–8–1928. *Yorkshire Post,* 28–8–1928.

22 Correspondence of 23–3–1928, 31–3–1928 in the V&A Archives, MA/2/B.

23 *Burton Daily Mail,* 5–2–1929. *Staffordshire Weekly Sentinel,* 11–5–1929.

24 The exhibition was planned for October 1963. V&A Archives, MA/2/B.

25 The other venues were Rotherham, Oldham, Aberdeen, Gateshead, Derby, Bournemouth, Bury, Hereford, Milngavie, Doncaster, Anglesey, Scunthorpe, Airdrie and Nottingham. Miami was even pencilled in, but plans fell through.

26 Later outings were in 1971 to the Lady Chapel of Chichester Cathedral; in 1975 to the crypt of Canterbury Cathedral (where one panel stayed on for two years as part of the 'Story of a Cathedral' exhibition); in 1981 to the Lady Chapel at Ely, as part of the cathedral's 900th anniversary; in 1984 to Gloucester for 'The Normans and Domesday exhibition'; in 1985, the panel with Halley's Comet was shown in the National Maritime Museum.

27 *Guardian,* 26–3–2001.

28 See extensive correspondence and memos in the V&A Archives, MA/2/B.

16. Victorian Values

1 21–12–1876, Lang & Sharman 1990, 139.

2 Winters 1877, 184–5.

3 Letter of 4–11–1845, Ryals & Fielding 1993, 42. Wilson 1925, 313, quoting the recollections of Carlyle's contemporary, literary biographer Francis Espinasse. Letter of 14–10–1848, Ryals & Fielding, 133.

4 Letter of 28–10–1851, Ryals & Fielding, 220.

5 Physick 1975, 15. Birrell 1931, 19. Roberts 2000, 546.

6 See Briggs 1966, 13; the only event he could find was a visit by the Hastings & St Leonards Philosophical Society to Battle, where J. C. Savery, who could trace his ancestry back to a Norman participant at Hastings, gave a lecture on the Tapestry. See also Hill 1958, on the concept of the 'Norman yoke' and how seventeenth-century Puritans took the perceived freedoms of Anglo-Saxon England as a model for political reform.

7 Archer 1894, 28.

8 See their various contributions to the *English Historical Review* XXXIII (1894) for this discussion, which the editor of the Review firmly closed in July 1894, but which dragged on elsewhere. See Round 1899 for a full bibliography.

The Great Escape

17. *Yuletide for Himmler*

1 Dubosq 1951, 2. The book may contain some exaggerations and inaccuracies, but it is a splendid story.

2 See Simon 1971 for a full account.

3 Turgis 1943.

4 Hautecoeur 1948.

5 Reported by Gruppenführer Tauber in September 1939; Padfield 1990, 249.

6 Sievers to Himmler, letter of 21–12–1942, BB A/100/07. Document of 8–7–1939 cited by Lemagnen 2004, 53, from the former Koblenz Archive, NS 21/vorl.807. These files have been transferred to the Berlin Bundesarchiv, hereafter BB.

7 See the document entitled '*Travaux scientifiques sur la tapisserie*', which outlined the plans for the project as at July 1941, ANF 40/573. There are two substantial files in the French Archives Nationales, Paris, hereafter ANF.

8 Undated letters written in late March or early April 1941, BB A/41/f5; A/1/161.

9 Sievers to Pfitzner, 24–4–1941, BB A/1/161.

10 See Dorléac 1993, 38–9.

11 Dubosq 1951, 34.

12 Dubosq 1951, 39.

13 See Turgis 1943 for this apologist account of Bunjes' project, which she must have received directly from his Art Historical Institute.

14 Letter of 21–12–1941, BB A/100/07.

15 Jankuhn's archive included the tiny black-covered notebook in which he compiled an account of each day's activities and progress; his scene-by-scene description of the Tapestry; all correspondence and reports; 767 black-and-white photographs; colour slides whose quality is still excellent; even the matching shade cards of the artist Jeschke. These are all in the Centre Guillaume le Conquérant, awaiting full publication. Falue's notebook also survives, in the care of his family. For an interim account, see Lemagnen 2004. This article was not available when I was completing my own version, and I have only been able to assimilate it rather briefly here. I am most grateful to Mme Lemagnen, the curator, for letting me see the Jankuhn papers. She gave a lecture on the project in Bayeux on 12–6–2004 as part of the town's commemoration of the D-Day anniversary.

16 Nagel 2000 discusses the problematic role of Marburg, like that of other German universities, during the war and reveals Hamann's previously unrecognised work for the Nazi regime.

17 Himmler to Sievers, 7–1–1943, BB A/100/07.

18 Bunjes' authorisation to travel that day by train, Paris–Bayeux return (second-class) survives; ANF 40/573, no. 66. See his memo of 16–10–1941 on the structure of the book and its contributors; BB A/1/161.

19 Letter of 14–8–1941. A memo in his notebook listed the names of those he had to see, ANF 40/573, nos 64 and 66.

20 The Musée de l'Alsace-Bossue in Sarre-Union, the birthplace of its inventor, George Imbert, is devoted to the history of the *gazogène*. There is a *gazogène* chat-room on the Internet.

21 Bazin 1992, 64–5.

22 See their correspondence from 16–9–1941 to 3–2–1942, ANF 40/573, nos 58–61. Also Bunjes' memo and book plan, dated 16–10–1941, BB A/1/161.

23 Leader in *The Times*, 27–10–1941, 5d. I have had to infer the content of Joyce's broadcast because no MI5 transcripts were made until the early months of 1943. See Martland 2003, 60–1. Letter published in *The Times*, 29–10–1941, 5e.

24 22–1–1942, BB A/1/161.

25 See ANF 40/573, nos. 43 and 44, the payment mandate stub. Bunjes' marked-up pull-out version of the Tapestry is also there.

26 Sievers and Wust to Himmler, 21–12–1942, BB A/100/07.

27 7–1–1943, BB A/100/07. Himmler's prose style was exceptionally convoluted and florid. I am extremely grateful to Dr Aya Soika for help with this and the other translations.

28 See ANF 40/573 for Bunjes' correspondence between May and July 1943, and BB A/16, 13–4–1943, for Sievers. See also Bazin 1992, 106.

29 Kater 1974, 307.

30 Turgis 1943.

18. Codename 'Matilda'

1 The Times, 9–6–1944, 4a. Stafford 2004, 131.

2 De Gaulle 1959, 233–4.

3 All the documentation is in the Kunstschutz files, folder 2, ANF 1673.

4 Lt Beck's Battery Diary, www.benjaminbeck/batterydiary/htm. I am most grateful to Benjamin Beck for permission to quote from his father's diary.

5 Bazin 1992, 106–8.

6 De Gaulle 1959, 258.

7 Hansard HC Deb, 25–7–1944, 603. The Times, 7–8–1944, 5d.

8 PRO, HW9/16, AT 1235. This is amongst a batch of GCHQ documents embargoed until May 1997, and came from a summary compiled in February 1945 of German police reports concerned with the SS 'Plunder of Artistic and Scientific Material from Occupied Countries'.

9 Le Figaro, 12–10–1944, 5.

10 Bazin 1992, 108–9, claimed that von Choltitz, accompanied by von Tieschowitz, had gone to the Louvre to check that the Tapestry was still there. Perhaps he just verified the presence of the case, which was not, however, opened for him.

11 See Collins & Lapierre 1965, 197–9, for the general's expanded version.

12 Magazine of Art 37 (February 1944), 64–68.

13 The Times, 1–9–1944, 5d, 7f; 3–10–1944, 3d.

14 Churchill 1930, 199; 1991, 123. Images of the Tapestry decorate the cover of the latest edition of The History of the English-Speaking Peoples, volume 1.

15 Le Figaro, 12/13–11–1944, 2; 17–11–1944, 1. The Times also briefly mentioned the exhibition, 17–11–1944, 3c.

16 Chevalier 1946.

17 Schlabow to Sievers, 19–12–1944. BB A/1/161.

18 Bunjes to Sievers, 21–2–1945, BB A/1/161.

19 Graham Howes, personal communication; Chutkow 1983.

Global Image

19. Literary Life

1 See Brown 1988 and 2004 for these figures.

2 *The Tigress*, a video game featuring heroine Carmen Sandiego, who foils her enemy's plan to steal the Tapestry.

3 Napier's novel was not published until after his death. See the preface written by his son, Napier 1858.

4 Letter from Dickens to Lytton, 4–8–1848, Storey & Fielding 1981, 383–4.

5 See Hamer 2003 on novels dealing with Harold's trip to Normandy; he points out how recent novelists have disappointingly steered clear of the Ælfgyva mystery.

6 Heyer 1962, 296.

7 Plaidy 1974, 199, 217. The frontispiece and one chapter heading have drawings of the Tapestry.

8 The children's story, *The Striped Ships* by Eloise McGraw (1991), describes how a young girl orphaned by the Normans regains her self-respect through helping to make the Tapestry. Two further novels awaiting publication at the time of writing (July 2005) are *Tapestry* by Philip Terry, who has used the borders as a starting point for the narration of Chaucerian tales, and *The Needle in the Blood* by Sarah Bower, who examines the relationship between male patron (Odo) and female workforce. I am most grateful to these authors for revealing their approaches to me.

9 Cather 1981, 101.

10 Huxley 1994, 389.

11 Fitzgerald 1945, 21.

12 Lainé 1974 .

13 Trungy 1854.

14 Proust's letters to Mâle of 8–8–1907 and n.d., de Billy 1930, 113, 116. Letter to Emmanuel Bibesco, Proust 1981, 255. For 'Queen Matilda's cavalcade', see *Contre Sainte-Beuve* which he was working on in 1908–09 as a preliminary sketch for *A la recherche*. Townsend Warner translation, Proust 1984, 174, 182. I am indebted to Peter Collier for working all this out.

15 Byatt 2002, 329; 1990, 278.

16 Holt 1986, 9, 21.

17 Benchley 1949. *Punch* 14–10–1987. There are many more brief citations of the Tapestry in modern novels as a figure of speech, too numerous to mention here. Some can be picked up on www.amazon.com.

18 Turgis 1912 cites all these in full.

19 Published in M. Marshall's *Book of Comic and Dramatic Monologues* (1981), 172. I am grateful to Jean Wilson for this reference.

20 'Mathilde in Normandy' was first published in *A Change of World* (1951) and is reprinted in Rich's *Collected Early Poems* (1993). Starbuck's poem appears in *The argot merchant disaster: poems new and collected* (1982) For Campbell's poem, see *Quadrant* 20 (January 1976), 10. Dobyns' poem was first published in *Black Dog, Red Dog* (1984), and reprinted in *Velocities* 1996, 175.

21 His other short plays on the period included 'The Witan Chooses Harold' and 'Invasion.'

22 Kushner 1992, 36, 64.

20. *The Norman Newsreel*

1 *The Times*, 1–9–1944, 5d. Verrier 1946, ii.

2 Poncet 1952, 65–89 and 1998.

3 See Barnouw 1993, 201–2 on Leenhardt, and Bazin 1974, 124 on Renoir.

4 Noxon 1968, Prah-Pérochon 1974.

5 Parisse 1983. See also Lewis 1999 for an even later recyling of these views. She accepts much of Parisse's terminology, and suggests that the Latin inscriptions were the equivalent of the 'voice-over.'

6 See Harty 1999 for a compilation of 600 films on the Middle Ages. The total is now much higher.

7 The designer of the *Bedknobs* credits was David Jonas, a long-standing member of the Disney Studios team, where Harper Goff, production designer for *The Vikings*, spent most of his career.

8 The production designer was Dante Ferretti. The Tapestry also appears in *El Cid* (1961) being sewn by Chimere, the right century but the wrong country, and is mentioned in *Is Paris Burning?* (1966), the film version of Collins & Lapierre's 1965 account of the liberation of Paris, which includes General von Choltitz's confrontation with the SS.

21. *Spin-Offs*

1 The Anchorage, Handsworth, Birmingham. I am most grateful to Peter Cormack for this reference.

2 Brown described the picture in detail in the catalogue he wrote when he

included the painting in his 1865 one-man show, quoted in Bendiner 1998, 134. I am most grateful to Angela Thirlwell for this reference.

3 Chipp 1988, 87. See also Blunt 1969. They recognised the Apocalype of St-Sever, the Soriguerda altarpiece, the Apocalypse Tapestry in Gerona Cathedral and the Leon Gospels, all of the 10th to 11th centuries, as possible background for *Guernica*.

4 Hassall 1915.

5 Rea Irvin drew the *New Yorker* cartoon and Frank Finch did *The Soldier* cover. A Tapestry parodist in the 1930s was Richard Q. Yardley in the *Baltimore Evening Sun* but I have failed to find an example of his work.

6 *New Statesman* 23–10–1954; *Punch* 16–10–1957; *New Statesman* 7–3–1959; *Evening Standard* 11–4–1962; *New Statesman* 31–12–1965. Vicky brought his own name into the captions too, as *Veni, Vidi, Vicky,* and *The Vicky & Alby Museum*. For Illingworth, see *Daily Mail,* 23–8–1966. Most of these cartoons can be viewed at the Centre for the Study of Cartoon and Caricature, University of Kent, http://library.kent.ac.uk/cartoons/.

7 *New Statesman* 13–12–1974; *Sunday Telegraph* 6–4–1980; *Daily Telegraph* 24–10–1984 and 1–11–1994. Wilson in *Times,* 28–4–1997.

8 *Private Eye* 6–5–02. It also inspired a pastiche by Max Schindler, *Financial Times* 1–1–2000, showing financial services over the past millennium.

9 David Smee, *Punch* 15–6–1966; Neil Bennett, *Private Eye* c.1992; Matt, *Daily Telegraph* 3–4–2003; Newman, *Spectator* 13–8–2005; Biff, *Guardian* 19–6–2004; M.Pickles, *Pick of Punch* 1990; *Sun* 12–10–2005. And there was Major Rybot of Jersey, who produced many cartoons commenting on local events in the earlier twentieth century; these are held by the Societé Jersiaise.

10 There have been other versions which are now untraceable, such as those of Mme Turgis Huart of Portsmouth, reported to have spent seven years in the 1930s embroidering a 14 yard length, and Maud Geare, who in 1948 completed a version in cotton embroidery thread in 1948, which was exhibited in Birmingham. In 1985, a member of the Alliance Française painted a version on cotton which appeared in a fund-raising exhibition in Britain, and then went to Chicago on the first leg of an American tour. There are many examples of embroideries with motifs from the Tapestry, such as kneelers for Winchester Cathedral sewn by Sybil Blunt in the 1930s; the altar frontal at Bosham Church; the banner of the Hastings branch of the Women's Peace Movement in 1978.

11 The Fécamp Embroidery can be viewed on line: http://membres.lycos.fr/

broderiedefecamp. Another embroidery in Normandy is that in the Chateau Pireau, which shows the adventures of the Normans in Sicily.

12 The Embroidery toured America then hung in the City of London at the headquarters of Whitbread & Co. before becoming the centrepiece of the D-Day Museum after this opened in 1984. Lawrence's original watercolour designs are in the Pentagon, Washington.

13 See the Rhodesian Tapestry on www14.brinkster.com/branchingout/ rhodesiantapestry. The Jersey Occupation Tapestry is on www.jerseyheritaget rust.org/sites/tapestry. Various other 'Tapestries' show local histories, for example those of Hull and Staffordshire, and the Maldon Embroidery. The Quaker Tapestry, currently in Kendal, Cumberland, is another group project which commemorates the Quaker movement in 75 narrative panels, see Greenwood 1990. The Fulford 'Tapestry' project won Lottery funding in 2005 to record the 1066 battle that preceded Hastings; see www.battleoffulford.org.uk. The original has also inspired tiled mural decoration, for example the Food Hall in the Castle Mall at Norwich, which tells the history of Norwich from medieval to modern times, and in the underpass at the junction of the Newmarket Road, Cambridge, with a local historical sequence.

14 Messent 1999. The permanent home of the 'Finale' is at Thirsk, Yorkshire, in the care of Madeira Threads (UK) Ltd, which commissioned the work and made the wools.

15 See it on www.westga.edu.

16 The website is www.1066.co.nz. I am very grateful to Chris and Liz Walker for visiting the mosaic, and to Michael Linton for sending me the CD-Rom and images of the finale.

22. Marketing the Middle Ages

1 The painting was by the late Victorian artist Edward B. Edwards.

2 I am most grateful to the History of Advertising Trust, Norwich, for finding many of these examples.

3 I am grateful to Cathy Wallings, Assistant Curator of Hastings Museum, for this information. The artist was Eric Fraser.

4 Dobson & Merrington 1977. Thanks yet again to Jack Denys.

5 The original 1988 version has been updated on line to the year 2000, see www.bayer.co.uk/tapestry.

6 Sanderson 1922. The firm also used the Tapestry's motifs in various other furnishing fabrics.

7 I am grateful to Greg Allcorn, Director of the 1066 Chapter for this information.

23. *Mysteries and Histories*

1 See for example Owen-Crocker 1998 using literary analysis to compare it with the structure of *Beowulf*, while others have related it to the *Song of Roland*; Brilliant 1991 on performance theory. Cholakian 1998 on its inherent class structures and challenging the single *auteur* concept; Lesieur 1993 citing Barthes and Kristeva to discover semiotic conflicts between text and image; Lewis 1999 on visual and textual strategies to impose the new Norman ideology.

2 Guerilla Girls 1998, 15.

3 See Caviness 2001, an e-book, for the most thorough exploration of these concepts and the identification of a 'third gender' in the Tapestry. See also Camille 1992 and 1998 on marginalia.

4 Denny & Filmer-Sankey 1966.

5 Léchaudé d'Anisy 1823; Bruce 1856; Christie 1854.

6 See Fowke 1875, and Freeman 1869, though the latter kept his options open by suggesting she might also be a daughter of William, or even the allegedly Norman mother-in-law of Harold. Wissolik 1979 has supported the 'Harold's sister' theory to argue the underlying pro-English role of the Tapestry and the influence of Eadmer and the Canterbury tradition.

7 Planché 1867 for the original suggestion. Drögereit 1959 believed the figure might be a statue. Freeman 1991 for the ploughshares case.

8 But see McNulty 1980, 1989, followed closely by Bridgeford 2004. The latter also believes the purpose was to attack the reputation of her other son Harold Harefoot, who was involved in the murder of Alfred, thus vindicating the Godwins.

9 See Prentout 1935, Campbell 1984 and Gosling 1990 for these respective claims.

10 See Bond 1995 on the development of a 'martial aristocracy', and the complicated issues of lust versus pride; also Caviness 1998 and 2001.

11 Attempted later by Drögereit 1962.

12 Cited by Weiner 1955, 188. See also Russell 2003, 123, who suggests that Dawson untruthfully claimed to have based his Tapestry articles on a French article about the restorations, and Walsh 1996, 187, who thought it was a rare example of Dawson's underivative work.

13 Chenciner 1990; *The Times* 2–10–1990; *The Observer* 30–9–1990.

14 In the *Sussex County Magazine* (1932) . . .

15 Villion 1966, 1987.

16 Bridgeford 2004 uncritically accepts this and adds further secret messages of his own. Clermont-Ferraud 2004 also claims that the Tapestry encodes subversive Anglo-Saxon propaganda.

17 Colon 1999, 5; Bridgeford 2004, 226; Carter 1986; Anderson 1986. BBC1, 20–7–2002.

24. Bayeux Today

1 '1066 and All That Filth', *Sunday Times* 7–11–1982, 1–2; Sewell 1983; Chutkow 1982. I am extremely grateful to Brian Sewell for permission to quote from his 1983 article 'Tapestry and Swimming Pools.'.

2 See the articles in Bouet, Levy & Neveux 2004, which were first presented as papers at the 1999 Cerisy Colloquium. Neveux' introduction to the long-awaited book referred to the unaccountable delay in publishing the results of the technical and scientific examination, and the conservators pointed out that they were only able to examine the back in the very limited period of just three months.

Sources and Bibliography

The prime source is of course the Tapestry itself, on permanent public display in the Centre Guillaume le Conquérant, Bayeux.

The best published photographs of it are in David Wilson's *The Bayeux Tapestry* (first published in 1985, and reprinted in 2004). These photographs were taken in 1983 when the Tapestry was off exhibition, pending its move to the new Centre. These are also the images used for the CD-Rom, *The Bayeux Tapestry, Digital Edition*, edited by M. K. Foys (2003) on which you can scroll the Tapestry forward or back or zoom in to any portion of it. The CD also has the entire versions by Foucault/Benoit, Stothard and Elizabeth Wardle, and is invaluable for making comparisons. It contains a wide-ranging bibliography.

Also very useful for giving a sense of the whole work is the miniaturised pull-out version, at a scale of one-seventh of the original (Editions Artaud, Caen, various editions).

Many other publications illustrate the whole Tapestry. Those with important texts include

- F. Stenton, ed, *The Bayeux Tapestry, a Comprehensive Survey* (London 1957), a pioneering work which contains nine specialist articles; that by Francis Wormald made the first definitive links with the Canterbury scriptoria that provide the main case for its manufacture in England.
- M. Rud, *The Bayeux Tapestry and the Battle of Hastings 1066* (Copenhagen 1983/1992 editions), places a refreshing emphasis on the Scandinavian background.
- W. Grape, *The Bayeux Tapestry: Monument to a Norman Triumph* (Munich 1994) reviews the artistic parallels with other contemporary works to suggest

the Tapestry was made in Normandy, as a genuine masterpiece of Anglo-Norman co-operation.

Fundamental to Tapestry studies and to this book is Shirley Ann Brown's *The Bayeux Tapestry, a History and Bibliography* (Woodbridge 1988). This lists and summarises almost 500 works, arranged in chronological order of their publication. By 1999, she was able to update this by over 100 more titles in the list which appears in another key work, *The Bayeux Tapestry: Embroidering the Facts of History* edited by P. Bouet, B. Levy & F. Neveux (Caen 2004) This contains 23 papers on many aspects of the work's fabric, meaning and historical context, together with previously unpublished photographs of the back of the linen.

Richard Wissolik's *Bayeux Tapesty: a Critical Annotated Bibliography* (Greensburg PA 1988) is also useful.

At the time of finishing this book, more titles are in the pipeline. George Beach's *Was the Bayeux Tapestry made in France?* argues that the work was produced in the Abbey of St-Florent of Saumur in the Loire Valley. Gail Owen-Crocker has edited *King Harold II and the Bayeux Tapestry*. Shirley Ann Brown is preparing a definitive Companion to the Tapestry, and Ian Peirce is compiling a Handbook to its military evidence.

ABBREVIATIONS
Unpublished sources

ANF – Archives Nationales Françaises
BB – Berlin Bundesarchiv
Bayeux Municipal Library
Bibliothèque Nationale, Paris
PRO – Public Record Office, Kew
Reading Museum Archive
V&A – Victoria & Albert Museum Archive

Published primary sources

ASC – *Anglo-Saxon Chronicle*, eds D. Whitelock, D. C. Douglas & L. Tucker (London 1961)

Ead – *Eadmer's History of Recent Events in England*, trans by G. Bosanquet (London 1964)

Ed. – *Vita Ædwardi Regis*, ed & trans F. Barlow (Oxford rev edn 1992)

EE – *Encomium Emmae Reginae*, ed & trans A. Campbell & S. Keynes (Cambridge rev edn 1998)

Guy – *The Carmen de Hastingae Proelio of Guy, Bishop of Amiens*, ed & trans F. Barlow (Oxford 1999)

Jum. – *Gesta Normannorum Ducum of William of Jumieges, Orderic Vitalis and Robert of Torigni*, ed E. M. C. Van Houts, 2 vols (Oxford 1992–95)

Mal. – *The Gesta Regum Anglorum of William of Malmesbury*, ed & trans R. A. B. Mynors, R. M. Thomson & M. Winterbottom (Oxford 1998)

Ord. – *The Ecclesiastical History of Orderic Vitalis*, ed & trans M. Chibnall, 6 vols (Oxford 1969–80)

Poi. – *The Gesta Guillelmi of William of Poitiers*, ed & trans R. C. H. Davis & M. Chibnall (Oxford 1998)

Bibliography

Ackerman, P., 'The Reappearance of a lost Bayeux Tapestry', *International Studio* (July 1930), 17–20

Albu, E., *The Normans in their Histories: Propaganda, Myth and Subversion* (Woodbridge 2001)

Alford, M., *Needlework as Art* (London 1886)

Avery, M., *The Exultet Rolls of Southern Italy* (Princeton 1936)

Amyot, T., 'Observations on an Historical Fact supposed to be established by the Bayeux Tapestry', *Archaeologia* XIX (1821), 88–95

Anderson, J.D., 'The Bayeux Tapestry, a 900–year-old Latin cartoon', *Classical Journal* 81 (1986), 253–57

Archer, T., 'The Battle of Hastings', *English Historical Review* XXXIII (1894), 1–41

Aulard, F., *Paris sous le Consulat: Recueil de documents* IV (Paris 1909)

Ayloffe, T., 'An historical representation of an ancient picture in Windsor Castle', *Archaeologia* III (1775), 185–229

Baedeker's Northern French Guide from Belgium and the English Channel to the Loire (Leipzig 1889)

Baines, P., *Flax and Linen* (Shire Album 133, Princes Risborough 1985)

Banham, D. ed, *Monasteriales Indicia: the Anglo-Saxon Monastic Sign Language* (Hockwold-cum-Wilton 1996)

Barakat, R., *The Cistercian Sign Language: a Study in Non-Verbal Communication* (Kalamazoo 1975)

Barasch, M., *Gestures of Despair in Medieval and Early Renaissance Art* (New York 1976)

Barlow, F., *Edward the Confessor* (New Haven & London rev edn 1997)

—— *The Godwins: The Rise and Fall of a Noble Dynasty* (Harlow 2002)

Barnouw, E., *Documentary: A History of the Non-Fiction Film* (Oxford 1993)

Barré, P-Y., Radet, J.B., & Desfontaines, F., *La tapisserie de la reine Mathilde* (Paris 1804)

Barrington, D., 'Observations on the Practice of Archery', *Archaeologia* VII (1785), reprinted in *The European Magazine* (1785)

Bates, D., 'The Character and Career of Odo, Bishop of Bayeux', *Speculum* 1 (1975), 1–20

—— *William the Conqueror* (London 1989)

Baudot, M., *Normandie Bénédictine* (Bec-Hellouin 1979)

Baudry, F., *Mémoires de Nicolas-Joseph Foucault* (Paris 1862)

Bazin, A., *Jean Renoir* (London 1974)

Bazin, G., *The Louvre* (London 1959)

—— *L'exode du Louvre 1940–1945* (Paris 1992)

Bédat, G. & Girault Kurtzeman, B., 'The technical study of the Bayeux Embroidery' in Bouet, Levy & Neveux 2004, 83–110

Benchley, R., 'Bayeux Christmas Presents Early' in *Chips off the Old Benchley* (New York 1949)

Bendiner, K., *The Art of Ford Madox Brown* (Pennsylvania 1998)

Bennett, P.E., 'Encore Turold dans la tapisserie de Bayeux', *Annales de Normandie* 30(1980), 3–13

Bernstein, D., *The Mystery of the Bayeux Tapestry* (London 1986)

Berthot, J., 'La tapisserie de la reine Mathilde – comédie en une acte et en prose', *Bulletin de la société des sciences, arts et belles-lettres de Bayeux* I (1891), 55–63

Bertrand, S., 'Etude sur la Tapisserie de Bayeux', *Annales de Normandie* x (1960), 197–206

—— *La Tapisserie de Bayeux et la manière de vivre au onzième siècle* (La-Pierre-qui-Vire 1966)

Béziers, M., *Mémoires pour servir à l'état historique et géographique du diocèse de Bayeux* (1773 edn rev by G. le Hardy, Rouen & Paris 1896)

Binski, P., *Medieval Craftsmen: Painters* (London 1991)

Birrell, F.F.L., *Guide to the Bayeux Tapestry* (1st edn 1914, 3rd edn, London 1931)

Blunt, A., *Picasso's Guernica* (London 1969)

Bond, G. A., *The Loving Subject: Desire, Eloquence and Power in Romanesque France* (Philadelphia 1995)

Bouet, P., Levy, B., & Neveux, F., eds, *The Bayeux Tapestry: Embroidering the Facts of History* (Caen 2004)

Bray, A.E., *The Life of Thomas Stothard R.A.* (London 1851)

—— *Autobiography of Anna Eliza Bray* (London 1884)

Bridgeford, A., 'Was Count Eustace II of Boulogne the patron of the Bayeux Tapestry?', *Journal of Medieval History* 25.3 (1999), 155–85

—— *1066 – The Hidden History of the Bayeux Tapestry* (London 2004)

Briggs, A., *Saxons, Normans and Victorians* (St Leonards on Sea 1966)

Brilliant, R., *Gesture and Rank in Roman Art* (New Haven 1963)

—— 'The Bayeux Tapestry: a stripped narrative for their eyes and ears', *Word and Image* 7 (1991), 99–127

Brooks, N.P. & Walker, H.E., 'The Authority and Interpretation of the Bayeux

Tapestry', *Anglo-Norman Studies* I (1979), 1–34

Brooks, S. & Eckstein, E., *Operation Overlord: the History of D-Day and the Overlord Embroidery* (Ashford 1989)

Brown, R.Allen, *The Norman Conquest*: Documents of Medieval History 5 (London 1994)

Brown, S. A., 'The Bayeux Tapestry: History or Propaganda', in *The Anglo-Saxons: Synthesis and Achievement*, eds J.D. Woods & D.A. Pelteret (Waterloo, Ontario 1985), 11–26

—— *The Bayeux Tapestry, A History and Bibliography* (Woodbridge 1988)

—— 'The Bayeux Tapestry: why Eustace, Odo and William?' *Anglo-Norman Studies* XII (1990), 7–28

—— 'The Bayeux Tapestry: A Critical Analysis of Publications 1988–1999' in Bouet, Levy & Neveux 2004, 27–48

—— & Herren, M. W., 'The *Adelae Comitissae* of Baudri of Bourgueil and the Bayeux Tapestry', *Anglo-Norman Studies* XVI (1993) 55–71

Bruce, J. Collingwood, *The Bayeux Tapestry Elucidated* (1856 edn reprinted as *The Bayeux Tapestry, the Battle of Hastings and the Norman Conquest* London 1987)

Budny, M., *The Anglo-Saxon Embroideries at Maaseik*, *Academiae Analecta* 45 (Brussels 1984)

—— 'The Byrhtnoth Tapestry or Embroidery' in *The Battle of Hastings* ed D. Scragg 1991, 263–78

Burton, E., *The Norman Conquest illustrated by the Bayeux Tapestry* (Edinburgh 1878)

Burton, S., *A Double Life: a Biography of Charles and Mary Lamb* (London 2003)

Byatt, A. S., *Possession* (London 1990)

—— *A Whistling Woman* (London 2002)

Camille, M., *Images on the Edge* (London 1992)

—— *The medieval art of love: objects and subjects of desire* (London 1998)

Campbell, M., 'Ælfgyva: the mysterious lady of the Bayeux Tapestry', *Annales de Normandie* 34 (1984), 127–45

Cannon, J. & M., *Dye Plants and Dyeing* (London 1994)

Carte, T., *A General History of England* I (London 1747)

Carter, J.M., 'The Bayeux Tapestry across the curriculum', *The Clearing House* 60.4 (1986), 314–16

Cassou, J., *Le pillage par les Allemands des oeuvres d'art et des bibliothèques* (Paris 1947)

Cather, W., *The Professor's House* (1925 edn, reprint London 1981)

Caviness, M., 'Obscenity and Alterity' in *Obscenity: Social Control and Artistic Creation in the Middle Ages* ed J. Ziolkowski (Leiden 1998) 155–75

—— *Reframing Medieval Art: Differences, Margins, Boundaries* (http://nils.lib.tufts.edu/Caviness 2001)

Cennini, C., *Il libro del arte* (*The Craftsmen's Handbook*) trans & ed D.V. Thomson (New Haven 1954)

Chambers, B.M., 'Symbolism in the Bayeux Tapestry', *Sussex County Magazine* VI (1932), 26–27, 113–15, 171–73

Chatelain, J., *Dominique Vivant Denon et le Louvre de Napoléon* (Paris 1973)

Chenciner, R., 'The Bayeux Tapestry Shish-Kebab Mystery', *Proceedings of the Oxford Symposium* 1990 , 58–64

Chevalier, D., 'La tapisserie de Bayeux', *Arts de France* 3 (1946), 73–78

Chibnall, M., *The Debate on the Norman Conquest* (Manchester 1999)

Chipp, H. B., *Picasso's Guernica: History, Transformations, Meanings* (Berkeley 1988)

Cholakian, R., 'The Bayeux Tapestry: Is there more to say?', *Annales de Normandie* 47 (1997), 43–50

—— *The Bayeux Tapestry and the Ethos of War* (New York 1998)

Christie, A., 'The Bayeux Tapestry and its uses and values as a National Historical Chronicle', *Proceedings of the Society of Antiquaries of Scotland* I (1851–54), 122–24

Christie, A. G., *English Medieval Embroidery* (Oxford 1938)

Church, E. R., *Artistic Embroidery* (*Containing Practical Instruction in the Ornamental Branches of Needlework*) (New York 1880)

Churchill, W.S., *My Early Life: a roving commission* (London 1930)

—— *The Birth of Britain: Volume 1 of the History of the English-Speaking Peoples* (first published 1956, London 1991)

Chutkow, P., 'A Scent of Scandal', *Connoisseur* 210 (May 1982), 106–7

Clamanges, D. de, *Le traité de la ruine de l'église*, ed A. Coville (reprt Paris 1936)

Clermont-Ferraud, M., *Anglo-Saxon Propaganda in the Bayeux Tapestry* (Yale 2004)

Cohen, G., *Historie de la mise-en-scène dans le théâtre religieux Français du moyen age* (Paris 1906)

Colon, A.R. & P., *Nurturing children, a History of Paediatrics* (New York 1999)

Comte, J., *La Tapisserie de Bayeux* (Paris 1878)

Cooke, K., 'Donors and Daughters: Shaftesbury Abbey's Benefactors, Endowments and Nuns c.1086–1130, *Anglo-Norman Studies* XII (1989), 29–45

Cooper, B., 'Embroidering the past: re-creation and prophesy in early nineteenth-century French national historical drama', *Clio* 14.1 (1984), 71–84

Corney, B., *Researches and Conjectures on the Bayeux Tapestry* (Greenwich 1836, 2nd edn 1838)

Cowdrey, H.E.J., 'Towards an interpretation of the Bayeux Tapestry', *Anglo-Norman Studies* X (1987), 49–65

Dawson, C., 'The Bayeux Tapestry in the hands of 'Restorers', *The Antiquary* XLIII (1907), 253–58, 288–92

—— *History of Hastings Castle* (London 1909)

De Billy, R., *Marcel Proust: lettres et conversations* (Paris 1930)

De Boze, C., 'Eloge pour Foucault', *Histoire de l'académie des inscriptions et belles-letters* V (1731), 395–99

De Brogue, E., *Bernard de Montfaucon et les Bernardins, 1715–1750* (Paris 1891)

De Gaulle, C., *War Memoirs: Unity 1942–1944* (London 1959)

De la Rue, G., *Recherches sur la tapisserie représentant la conquête de l'Angleterre par les Normands* (Caen 1824)

De Rémusat, Charles, ed by C.H. Pouthas, *Mémoires de ma vie,* (Paris 1958)

De Rémusat, Claire, trans by C.Hoey & J. Lillie, *Memoirs of Madame de Rémusat* (London 1880)

De Reyniès, N., 'Bayeux Tapestry or Bayeux Embroidery', in Bouet, Levy & Neveux 2004, 69–76

De Sanctis, M., *The Bayeux Tapestry: the City of Bayeux Tapestry and the Reading Museum and Art Gallery Facsimile* (Farnborough 1993)

Delauney, H., *L'origine de la tapisserie de Bayeux* (Caen 1824)

Denny, N. & Filmer-Sankey, J., *The Bayeux Tapestry and the story of the Norman Conquest* (London 1966)

Dibdin, T.F., *A Bibliographical, Antiquarian and Picturesque Tour in France and Germany* (London 1821)

Dickens, C., 'A Chronicle in Worsted', *All the Year Round* XIX (December 14 1867–June 6 1868), 64–65

Digby, G. W., 'Technique and Production', in *The Bayeux Tapestry* ed F. Stenton (London 1957), 37–55

Dobson, S. & Merrington, J., *The Little Newcastle Broon Ale Book* (Gosforth 1977)

Dobyns, S., *Velocities: New and Selected Poems 1966–1992* (London 1996)

Dodwell, C.R., *Anglo-Saxon Gestures and the Roman Stage* (Cambridge 2000)

Dorléac, L. B., *L'art de la défaite 1940–1944* (Paris 1993)

Douce, F., 'Translation of a Memoir on the celebrated Tapestry of Bayeux by the Abbé de la Rue', *Archaeologia* XVII (1814), 85–109

Douglas, D.C., *William the Conqueror* (London 1964)

Drögereit, R., 'Der Wandteppich von Bayeux', *Historische Zeitschrift* 188 (1959), 352–58

——— 'Bermerkungen zum Bayeux-Teppich', *Mitteilungen des Instituts für Österreichische Geschichtsforschung* 70 (1962), 257–93

Du Méril, E., 'De la tapisserie de Bayeux et de son importance historique', *Etudes sur quelques points d'archéologie et d'histoire littéraire* (Paris-Leipzig 1862)

Dubosq, R., *La Tapisserie de Bayeux dite de la reine Mathilde: dix années tragiques* (Caen 1951)

Ducarel, A. C., *Anglo-Norman Antiquities* (London 1767)

Dufraisse, R., 'La tapisserie de Bayeux, instrument de propagande anti-anglaise à l'époque napoléonienne', *Annales de Normandie* 13.4 (1962), 331–32

Edwards J., *Crewel Embroidery in England* (London 1975)

—— 'A survey of the English literature of embroidery 1840–1940', *Bulletin of the Needle and Bobbin Club* 59 (1976), 3–19

Ellis, S., *The Women of England, Their Social Duties and Domestic Habits* (London 1839)

Estrup, H., *Journal d'un voyage en Normandie* (Copenhagen 1911)

Evans, J., *History of the Society of Antiquaries* (Oxford 1956)

Farrant, J., 'John Collingwood Bruce and the Bayeux Tapestry', *Archaeologia Aeliana* XXV (1997), 109–113

Fell, C., *Women in Anglo-Saxon England* (London 1984)

Finlay, V., *Colour Travels through the Paintbox* (London 2002)

Fitzgerald, F. Scott, *Echoes of the Jazz Age* (1931, reprinted in *The Crack Up*, New York 1945)

Forbes, R.J., *Studies in Ancient Technology* IV (Leiden 1964)

Fowke, F.R., *The Bayeux Tapestry* (London 1875 revised edn 1913)

Fraser, A., introduction to reprint of 1851 edition of A. Strickland, *Lives of the Queens of England* (London 1972)

Freeman, E., 'The identity of Ælfgyva in the Bayeux Tapestry', *Annales de Normandie* 41(1991), 117–134

Freeman, E.A., *The History of the Norman Conquest of England* III (Oxford 1869)

Gally-Knight, H., *An architectural tour in Normandy with some remarks on Norman architecture* (London 1836)

Gameson, R., ed., *The Study of the Bayeux Tapestry* (Woodbridge 1997)

Gautier, T., *Quand on voyage* (Paris 1865)

Geijer, A., *A History of Textile Art* (London 1979)

George, J.A., & Campbell, S., 'The Role of Embroidery in Victorian Culture and the Pre-Raphaelite Circle', *Journal of Pre-Raphaelite Studies* VII (1987), 55–67

Gibbs-Smith, C., *The Bayeux Tapestry* (London 1973)

Gombrich, E., *The Image and the Eye* (Oxford 1982)

Gosling, J., 'The identity of the Lady Ælfgyva in the Bayeux Tapestry and some speculation regarding the hagiographer Goscelin', *Analecta Bollandiana* 108 (1990), 71–79

Gould, C., *Trophy of Conquest: the Musée Napoléon and the creation of the Louvre* (London 1965)

Grant, H., *Napoleon and the Artists* (London 1907)

Green, M.A.E., *Lives of the Princesses of England from the Norman Conquest* (London 1849)

Greenwood, J.O., *The Quaker Tapestry* (London 1990)

Guerrilla Girls, *The Guerrilla Girls Bedside Companion to the History of Western Art* (London 1998)

Gurney, H., 'Observations on the Bayeux Tapestry', *Archaeologia* XVIII (1817), 359–70

Hale, C., *Himmler's Crusade* (London 2003)

Hamber, A.J., 'A Higher Branch of the Art' – *Photographing the Fine Arts in England 1839–1880* (Amsterdam 1996)

Hamer, C., 'Harold in Normandy: History and Romance', in *Film and Fiction: Reviewing the Middle Ages* ed T. Shipley (Studies in Medievalism XII, Cambridge 2003)

Harmer, F., *Anglo-Saxon Writs* (Manchester 1952)

Harris, M. & Johnson, J., *The Journals of George Eliot* (Cambridge 1998)

Hart, C., 'The Canterbury contribution to the Bayeux Tapestry', in *Art and Symbolism in Medieval Europe (Papers of the 1997 Brugge Conference)*, ed G.de Boe & F. Verhaeghe (Zellick 1997), 7–15

—— 'The Bayeux Tapestry and Schools of Illumination at Canterbury', *Anglo-Norman Studies* XXII (1999), 117–167

Hartshorne, C.H., *English Medieval Embroidery* (London 1848)

Harty, K.J., *The Reel Middle Ages* (London 1999)

Hassall, J., *Ye Berlyn Tapestrie* (London 1915)

Hautecoeur, L., *Les beaux-arts en France, passé et avenir* (Paris 1948)

Haycock, D.B., *William Stukeley: Science, Religion and Archaeology in Eighteenth-Century England* (Woodbridge 2002)

Hermant, M., *Histoire du Diocèse de Bayeux* (Caen 1705)

Heslop, T.A., 'The Production of *de luxe* manuscripts and the patronage of King Cnut and Queen Emma', *Anglo-Saxon England* 19 (1990), 151–96

Heyer, G., *The Conqueror* (original edn 1931, London 1962)

Hicks, C., 'The Borders of the Bayeux Tapestry', *England in the Eleventh Century* (Harlaxton Medieval Studies II) ed C. Hicks (Stamford 1992)

Higgin, L., *Handbook of Embroidery, edited by Lady Marion Alford* (London 1880)

—— 'A Reproduction of the Bayeux Tapestry in Facsimile', *The Magazine of Art* 10(1887), 345–48

Hill, C., *Puritanism and Revolution* (London 1958)

Hill, D., 'The Bayeux Tapestry and its commentators: the case of Scene 15', *Medieval Life* 11(1999), 24–26

Hinsley, F.H. & Stripp, A., *Codebreakers: the inside story of Bletchley Park* (Oxford 1993)

Hoge, J., ed, *Lady Tennyson's Journal* (Charlottesville 1981)

Holt, E.G., *A Documentary History of Art, I, The Middle Ages and the Renaissance* (Princeton 1981)

Holt, T., *Lucia Triumphant* (London 1986)

Holtman, R.B., *Napoleonic Propaganda* (New York 1969)

Huard, G., 'Quelques lettres de Bénédictins Normands à Dom Bernard de Montfaucon', *Bulletin de la société des antiquaires de Normandie* XXVIII (1913), 343–75

Huneycutt, L., 'The idea of the Perfect Princess – the *Life of St Margaret* in the reign of Matilda II', *Anglo-Norman Studies* XII (1989), 81–97

Huxley, A., *Point Counter Point* (1928, London 1994)

Jacques, A., *Leek Embroidery* (Stafford 1990)

—— *The Wardle Story: Sir Thomas and Lady Wardle, A Victorian Enterprise* (Leek 1996)

Janssen, A., 'La redécouverte de la tapisserie de Bayeux', *Annales de Normandie* 11(1961), 179–95

Jubinal, A., *Les Anciennes Tapisseries Historiées* (Paris 1838)

Kapp, Y., *In search of Mr and Mrs Wardle. Footnote to a Murder Trial*. History Workshop Series (Oxford 1994)

Kater, M.H., *Das 'Ahnenerbe' der SS, 1935–1945* (Stuttgart 1974)

Kelvin, N., ed, *The Collected Letters of William Morris* (Princeton 1984)

Koslin, D., 'Turning Time in the Bayeux Embroidery', *Textile and Text* 13 (1990), 28–45

Kuhn, A., 'Der Teppich von Bayeux in seinem gebärden: versuch einer Deitung', *Studi Medievali* XXXIII (1992), 1–72

Kushner, T., *Angels in America: Part I, Millennium Approaches* (London 1992)

Laffetay, C. J. D., *Notice historique et descriptive sur la Tapisserie dite de la reine Mathilde* (Bayeux 1873)

Lainé, P., *La Dentellière* (Paris 1974)

Lamb, Mary, 'On Needlework', *The British Lady's Magazine* I (April 1815), 257–60

Lambert, E., 'Réfutation des objections faites contre l'antiquité de la tapisserie de Bayeux', *Revue Anglo-francaise* I (1840), 168–90

—— 'Nouvelles considerations sur la tapisserie de Bayeux', *Bulletin monumental* 31 (1865), 198–200

—— *Hand-book of Needlework* (London 1842)

Lambert, F., *Church Needlework* (London 1844)

Lancelot, A., 'Explication d'un monument de Guillaume le Conquérant', *Mémoires de literature tires des registres de l'Académie royale* VI (1729), 739–55

—— 'Suite de l'explication d'un monument de Guillaume le Conquérant', *ibid* VII (1732), 602–68

Lang, C.Y. & Sharman,E.F., *The Letters of Alfred, Lord Tennyson*, III: 1871–1892 (Oxford 1990)

Lasko, P., 'The Bayeux Tapestry and the representation of space' in *Medieval Art: Recent Perspectives* ed G. Owen-Crocker & T. Graham (Manchester 1998), 26–39

Lawson, M.K., 'Observations upon a scene in the Bayeux Tapestry, the Battle of Hastings and the military system of the late Anglo-Saxon state', in *The Medieval State: Essays presented to James Campbell* ed J.R. Maddicott & D.M. Palliser (London 2000)

Léchaudé d'Anisy, A.L., *Antiquités Anglo-Normandes de Ducarel* (Caen 1823)

Lecomte, L-H., *Napoléon et l'Empire racontés par le théâtre 1797–1899* (Paris 1900)

Lefebre, G., *Napoleon from 18 Brumaire to Tilsit, 1799–1807* (London 1969)

Lejeune, R., 'Le caractère de l'achevêque Turpin', *Société Roncesvals – IV Congrès International Actes et Memoires* (Heidelberg 1969) 9–21

Lemagnen, S., 'The Bayeux Tapestry', *Medieval World* 4 (Jan/Feb 1992), 3–6

—— 'The Bayeux Tapestry under German Occupation', in Bouet, Levy & Neveux 2004, 49–64

Lepelley, R., 'Contribution à l'étude des inscriptions de la Tapisserie de Bayeux', *Annales de Normandie* XIV (1964), 313–21

Lesieur, T., 'Lisible et visible dans la tapisserie de Bayeux ou la stratégie de l'ambiguité', *La Licorne* 23 (1992), 173–82

Lewis, S., *The rhetoric of power in the Bayeux Tapestry* (Cambridge 1999)

Liénard, E., *Les Broderies de la reine Mathilde* (Bayeux 1846). Translated as *The Bayeux Tapestry, an Historical Tale of the Eleventh Century* (Brighton 1858)

Ling, L., 'The Bayeux Tapestry', *Making Medieval Art*, ed. P. Lindley (Donington 2003, 104–119)

Links, J.G., *The Ruskins in Normandy* (London 1968)

Lumsden, R., *Himmler's Black Order, a History of the SS 1923–1945* (Stroud 1997)

Lyttelton, G., *History of the Life of King Henry the Second and of the age in which he lived* (London 1767)

MacCarthy, F., *William Morris: a Life for Our Time* (London 1994)

McClellan, A., *Inventing the Louvre: Art, Politics and the Origins of the Modern Museum in Eighteenth-Century Paris* (Cambridge 1994)

McNulty, J. Bard, 'The Lady Ælfgyva in the Bayeux Tapestry', *Speculum* 55.4 (1980), 659–68

—— *The Narrative Art of the Bayeux Tapestry Master* (New York 1989)

Mair, V.H., *Painting and Performance* (Honolulu 1988)

Maitzen, R.A., *Gender, Genre and Victorian Historical Writing* (New York 1998)

Marshall, M., *The Book of Comic and Dramatic Monologues* (London 1981)

Martland, P., *Lord Haw-Haw: the English Voice of Nazi Germany* (Kew 2003)

Mate, M., *Women in Medieval English Society* (Cambridge 1999)

Meaney, A.L., *Anglo-Saxon Amulets and Curing Stones* (British Archaeological Reports 96, Oxford 1981)

Messent, J., *The Bayeux Tapestry Embroiderers' Story* (Thirsk 1999)

Michel, F., *Recherches sur le commerce, la fabrication et l'usage des etoffes pendant le moyen âge*, II (Paris 1854)

Mitchell, R., 'A Stitch in Time? Women, needlework and the making of history in Victorian Britain', *Journal of Victorian Culture* 1(2) 1996, 185–202

Montfaucon, B. de, *Les Monumens [sic] de la Monarchie française* I (Paris 1729); II (Paris 1730)

Morris, B., *Victorian Embroidery* (London 1962)

Muret, T., *L'histoire par le théâtre 1789–1851: II, la Revolution, le Consulat, l'Empire* (Paris 1865)

Murray, J., *Handbook for Travellers in France* (London, 1843)

Musgrave, G., *A Ramble through Normandy* (London 1855)

Nagel, A., *Die Phillips-Universität, Marburg im Nationalsozialismus* (Marburg 2000)

Napier, C., *William the Conqueror, a Historical Romance* (London 1858)

Nicholas, L.H., *The Rape of Europa: the Fate of Europe's Treasures in the Third Reich and the Second World War* (New York 1994)

Nicolay, F., *Napoleon at the Boulogne Camp* (London 1907)

Nowinski, J., *Baron Dominique Vivant Denon, 1747–1823* (Cranbury NJ 1970)

Noxon, G., 'The Bayeux Tapestry', *Journal of the Society of Cinematologists* 7 (1967–68), 29–35

Owen-Crocker, G., 'Hawks and Horse-Trappings: the Insignia of Rank' in Scragg 1991, 220–37

—— 'The Bayeux Tapestry: Culottes, Tunics and Garters, and the Making of the Hanging', *Costume* 28 (1994), 1–9

—— 'Telling a tale: narrative techniques in the Bayeux Tapestry and the Old English epic *Beowulf*', in *Medieval Art: Recent Perspectives* eds G. Owen-Crocker & T. Graham (Manchester 1998), 40–59

—— 'The Bayeux Tapestry: invisible seams and visible boundaries', *Anglo-Saxon England* 31(2002), 257–73

Pächt, O., *The Rise of Pictorial Narrative in Twelfth-Century England* (Oxford 1962)

Padfield, P., *Himmler, Reichsführer-SS* (London 1990)

Parisse, M., *La tapisserie de Bayeux, un documentaire du XI siècle* (Paris 1983)

Parker, R., *The Subversive Stitch: Embroidery and the making of the feminine* (London 1984)

Parkes, K., 'The Leek Embroidery Society', *The Studio* I (1893), 136–40

Petropolous, J., *Art as Politics in the Third Reich* (Chapel Hill 1996)

—— *The Faustian Bargain: the Art World in Nazi Germany* (Harmondsworth 2000)

Pezet, M., 'Rapport fait au conseil municipale de Bayeux', *Bulletin monumental* VI (1840), 62–79

Physick, J., *Photography and the South Kensington Museum* (London 1975)

Piggott, S., *William Stukeley, an Eighteenth-Century Antiquary* (Oxford 1950)

Plaidy, J., *The Bastard King* (London 1974)

Planché, R., 'On the Bayeux Tapestry', *Journal of the British Archaeological Association* XXIII (1867), 134–56

Pluquet, F., *Essai historique sur la ville de Bayeux* (Caen 1829)

Poncet, M-T., *Étude comparative des illustrations du moyen age et des dessins animés* (Paris 1952)

—— *La tapisserie de Bayeux, dite de la reine Mathilde, un dessin animédiévale* (Paris 1998)

Pope-Hennessy, U., *Agnes Strickland, Biographer of the Queens of England* (London 1940)

Power, E., *Medieval Women* (ed M. Postan, Cambridge 1975)

Prah-Pérochon, A., 'Le film animé de la tapisserie de Bayeux', *Stanford French Review* 1.3(1974), 339–65

Prentout, H., 'Essai d'identification des personages inconnus de la Tapisserie de Bayeux', *Revue historique* (176 (1935), 14–23

Proust, M., *Correspondance VII 1907*, ed P. Kolb (Paris 1981)

—— *By Way of Sainte-Beuve* (1909), translated by Sylvia Townsend Warner (London 1984)

Purkis, J., *Morris, Burne-Jones and French Gothic. Being an account of a walking tour in France, July to August 1855* (London 1988, reprt 1991)

Rainbow, B., *Elizabeth Wardle and the Leek Embroidery Society, with special reference to the Replica of the Bayeux Tapestry* (Unpublished BA Honours dissertation, University of Manchester 1996)

Rich, A., *Collected Early Poems 1950–1970* (London 1993)

Roberts, A., *The Poems of Tennyson* (Oxford 2000)

Rock, D., *Textile Fabrics, a descriptive catalogue* (London 1870)

Rosen, L., *Napoleon's Opera Glass* (London 1907)

Rossi, L., *Trajan's Column and the Dacian Wars* (London 1971)

Round, J.H., 'The Battle of Hastings', *Sussex Archaeological Collections* 42 (1899), 54–63

Ruskin, J., *The Collected Works* eds E. Cook & A. Wedderburn, 39 vols (London 1903–12)

Russell, M., *Piltdown Man: the Secret Life of Charles Dawson* (Stroud 2003)

Ryals, C. & Fielding, K., *The Collected Letters of Thomas & Jane Welsh Carlyle* (Durham & London 1993–98)

Sanderson & Sons, *History of the Bayeux Tapestry* (London 1922)

Schmitt, J-C., *La raison des gestes dans l'Occident médiéval* (Paris 1990)

Scragg, D., ed *The Battle of Maldon* (Oxford 1991)

Sewell, B., 'Tapestry and swimming pools', *Art and Artists* 196 (January 1983), 28

Sheppard, T., *Illustrated Guide to the Facsimile of the Bayeux Tapestry* (Hull 1929)

Sherlock, D., 'Anglo-Saxon Sign Language', *Archaeologia Cantiana* 107 (1989) 1–27

Short, I., 'The Language of the Bayeux Tapestry Inscription', *Anglo-Norman Studies* XXIII (2000) 267–77

Simon, L., *The Battle of the Louvre: the struggle to save French art in World War II* (New York 1971)

Sollers, P., *Le cavalier du Louvre: Vivant Denon* (Paris 1995)

Southey, R., *Journals of a Residence in Portugal and a Visit to France in 1838* (Oxford 1960)

Spencer, F., *Piltdown: a scientific forgery* (London/Oxford 1990)

Stafford, D., *Ten Days to D-Day* (London 2004)

Stafford, P., *Queens, Concubines and Dowagers: the King's Wife in the Middle Ages* (London 1983)

—— 'Women in Domesday', *Reading Medieval Studies* XV (1989), 75–94

—— *Queen Emma and Queen Edith: Queenship and Women's Power in Eleventh-Century England* (Oxford 1997)

—— 'Emma: the Powers of the Queen in the Eleventh Century' in *Queens and Queenship in Medieval Europe* ed A.J.Duggan (Woodbridge 1997)

Stam, R., *Film Theory, an Introduction* (Oxford 2000)

Staniland, K., *Medieval Craftsmen: Embroiderers* (London 1991)

Stone, E., *The Art of Needlework from the Earliest Ages. Edited by the Countess of Wilton* (London 1840)

Storey, G. & Fielding K. J., eds, *The Letters of Charles Dickens*, V 1847–49 (Oxford 1981)

Stothard, E., *Letters written during a Tour through Normandy, Brittany and other parts of France in 1818* (London 1820)

—— *The Memorials of C.A. Stothard* (London 1823)

Street, G. E., 'On Medieval Embroidery', *The Ecclesiologist* XXXIV (1863), 255–80

Strickland, A., *Lives of the Queens of England*, I (first edn London 1840, facsimile reprt of 4th edn of 1851, Bath 1972)

Strutt, J., *A Complete View of the Dress Habits of the People of England* (London 1796)

Stuart, D. G., *A History of the Leek Embroidery Society* (Keele 1969)

Stukeley, W., *Palaeographica Britannica, or discourses on Antiquities in Britain. No.1, Origines Rostonianae, or an Account of the Oratory of Lady Roisia* (London 1743). *No.II, A Defence of Lady Roisia against the Calumny of Mr Parkin* (London 1746)

Swanton, M., 'The Bayeux Tapestry: Epic Narrative not stichic but stitched', in *The Formation of Culture in Medieval Britain* ed F. Le Saux (New York 1995), 149–69

Symonds, M. & Preece, L., *Needlework through the Ages* (London 1928)

Tavernier, W., 'The Author of the Bayeux Embroidery', *Archaeological Journal* 71 (1914), 171–86

Tennyson, A., *The Annotated Works of Tennyson* ed Hallam, Lord Tennyson (London 1908)

Terkla, D., 'Cut on the Norman Bias: fabulous borders and visual glosses on the Bayeux Tapestry', *Word and Image* 11 (1995), 264–90

Theophilus, *The Various Arts* ed & trans by C.R. Dodwell (Oxford 1986)

Thierry, A., *Histoire de la conquête de l'Angleterre par les Normands* (Paris 1826)

—— *et al*, 'Opinions divers sur la tapisserie de Bayeux par suite de la dissertation du M. Bolton Corney', *Revue Anglo-Francaise* I (1840), 412–14

Thompson, D.V., *The Materials and Techniques of Medieval Painting* (reprt New York 1956)

Thomson, W.G., *A History of Tapestry* (London 1973)

Toynbee, Mrs P., *The Letters of Horace Walpole* IX (Oxford 1904)

Trungy, R., *Le Val de Commes* (Paris 1854)

Turgis, S., *La reine Mathilde et la tapisserie de Bayeux* (Bayeux 1912)

——'Un beau livre en préparation: la Tapisserie de Bayeux', *Images de France* 15 (August 1943), n.p.

Turner, D., *Account of a Tour in Normandy* (London 1820)

Turner, S., *The History of the Anglo-Saxons* II (London 1802)

Van Houts, E., 'The Ship List of William the Conqueror', *Anglo-Norman Studies* X (1987), 159–83

Vasari, G., ed G. Baldwin Brown, *Vasari on Technique* (London 1907)

Verrier, J., *La broderie de Bayeux, dite tapisserie de la reine Mathilde* (Paris 1946)

Vial, G., 'The Bayeux Embroidery and its Backing Strip', in Bouet, Levy & Neveux 2004, 111–16

Villion, P., *Le Sens veritable de la 'Telle du Conquest'* (Bayeux 1966)

—— *Visions secrètes dans la tapisserie de Bayeux* (Caen 1987)

Walsh, J.E., *Unravelling Piltdown* (New York 1996)

Wardle, Mrs T., *Guide to the Bayeux Tapestry, extracted from the book written by the Reverend J. Collingwood Bruce* (London 1887)

Warren, Mrs & Pullan, Mrs, *Treasures of Needlework* (London 1855)

Weiner, J.S., *The Piltdown Forgery* (Oxford 1953)

Weir, A. & Jerman, J., *Images of Lust: Sexual Carvings on Medieval Churches* (London 1986)

Werckmeister, O., 'The Political Ideology of the Bayeux Tapestry', *Studi Medievali* XVII (1976), 535–95

Wexler, V., *David Hume and the History of England* (Philadelphia 1979)

Wilcockson, Mrs, *Embroidery, its History, Beauty and Utility, with plain instructions for learners* (London 1856)

Wilmart, W., 'Eve et Goscelin II', *Revue Benedictine* 50 (1938), 42–83

Wilson, D.A., *Carlyle on Cromwell and Others 1837–1848* (London 1925)

Winters, W., *Ecclesiastical works of the Middle ages* (Waltham Abbey 1877)

Wissolik, R., 'The Saxon Statement: Code in the Bayeux Tapestry', *Annuale Medievale* 19 (1979), 69–97

—— 'Duke William's messengers: an 'insoluble, reverse-order' scene of the Bayeux Tapestry', *Medium Aevum* 51 (1982), 102–07

—— *The Bayeux Tapestry; a critical annotated bibliography* (Greensburg PA 1990)

Wollstonecraft, M., *A Vindication of the Rights of Woman* (1st edn 1792, ed M. Krammick London 1972)

Yapp, W.B., 'Animals in medieval art: the Bayeux Tapestry as an example', *Journal of Medieval History* 13 (1987), 15–73

Yonge, C. M., *Cameos from English History, from Rollo to Edward II* (London 1868)

Yorke, B., 'Sisters Under the Skin? Anglo-Saxon Nuns and Nunneries in Southern England', *Reading Medieval Studies* XV(1989), 95–117

Acknowledgments

Much of this book is the product of teamwork, because so many people have been so generous with help and information. I put this down to the power of the Bayeux Tapestry, which has lodged itself in minds and memories in many different ways. This of course has been one of the main themes of my book, and it has been fascinating to experience it in the research process as well.

I am most grateful to the following staff and institutions: Cathy Braddock, Nicholson Institute, Leek; Elizabeth Elvin, Royal School of Needlework; Frau Langner, Berlin Bundesarchiv; Sylvette Lemagnen, Centre Guillaume le Conquérant, Bayeux; Matthew Williams, Reading Museum and Art Gallery; Chloe Veale, History of Advertising Trust; Archives Nationales, Paris; British Library at St Pancras and Colindale; Cambridge University Library; Bayeux Municipal Library; East Sussex Record Office; Guildhall Library; National Art Library; Society of Antiquaries of London; Victoria & Albert Museum Archives.

Friends and colleagues have made a rich contribution. I am especially grateful to Jack Denys, who made available to me his own wonderful collection of Tapestry ephemera, which have enlivened the final chapters. David Hill and John McSween generously provided details of some of the nineteenth-century versions, prior to their own intended publication. Philip Stevens tracked down many references and showed me how to use the remarkable search engines in the British Library. I would also like to thank Peter Collier, Janet Gilbraith, Clive Goddard, Toby Hicks, Janet

Huskinson, Anne Jones, Berthold Kress, Hermione Lee, Michael Linton, Judy Quinn, Gillian Sheail, Tim Wilson Smith, Aya Soika, Shaun Tyas, Liesbeth van Houts, Sheila Watts, Jean Wilson, and Graham Winton. My husband Gary bravely read and commented constructively on most of the text.

My agent Clare Alexander has been her usual tower of strength. I am indebted to Alison Samuel for giving me the opportunity to write this book, to everyone else at Chatto & Windus for their support, and above all to Jenny Uglow, whose own writing, quite apart from her all-embracing editorial support, has been a real source of inspiration.

Index

Abegg Foundation 299
Aberdeen, George Gordon, Earl of
 314n4
Abetz, Otto von 229, 233
Abraham, Mlle (curator) 215, 217, 244
Académie des inscriptions et belles-lettres
 70, 71–2, 73, 77, 80, 85
Adela, Countess of Blois 64
Adelaide, Queen 146
Adenauer, Konrad 270
Ælfflaed 39
Ælfgifu, Abbess of Wilton 291–2
Ælfgifu of Northampton 8, 37, 291
Ælfgyd of Buckinghamshire 37
Ælfgyva 8, 19, 60, 154–6, 263, 289,
 289–92
Ælthelsitha 37
Aesop's *Fables* 6, 10, 60, 117, 131, 296–7
Aesthetic movement 180
Æthelred, King 32
Ahnenerbe, SS- ('Ancestral Heritage')
 211–12, 213–16, 218–19, 221, 226,
 227–8, 231, 244, 246
Alber, Rolf 221
Albert, Prince Consort 196–7
Alderet of Winchester 37
Alford, Lady Marion 181, 189
Allen, Alice 318–19n9

Allen, Lizzie 185, 188
Amiens, Treaty of (1802) 95, 96, 106
Amyot, Thomas 126
Anglo-Saxon Chronicle 9, 20, 280
Anselm, Archbishop of Canterbury 38
Antiquary, The (magazine) 293, 294
Apsley, Violet Bathurst, Lady 237–8
Archaeologia see Society of Antiquaries of
 London
Archaeologia (journal) 81, 85, 87, 117,
 118, 125, 126, 132
Archer, T. A. 200, 201
Armitage, Simon, and Young, Jeff: *The
 Bayeux Tapestry* (radio broadcast)
 261
Art Exhibitions Bureau 193, 194
Art Review, The 190
Arts de France (magazine) 243–4
Arundel Society 169–70, 174
Asa, Queen: tomb 53
Associated Artists' Exhibition, New
 York (1886) 190
Athenaeum (weekly) 147
Audrain, Wayne: Jersey Occupation
 Tapestry 278
Auriol, Vincent, French president 245
Ayloffe, Sir Joseph 87–8

Baedeker: *The Northern French Guide*
164–5
Baptiste (actor) 111
Baring, Lady Harriet 198
Barking Abbey 39
Barré, Pierre-Yves, Desfontaines,
François and Radet, Jean-Baptiste
106, 113
 Bertrand du Guesclin 109
 Duguay-Trouin, Prisonnier à Plymouth
 109–10
 Girouette de St-Cloud 106
 René le Sage 106
 La Tapisserie de la Reine Mathilde 106,
 107, 108–9, 113, 116, 131, 159
Barrington, Sir Daines 87
Bartlett, Margaret 276
Basire, James 133
Bataille, Pierre 280–1
Bates, Alan: 'Bayeux' 260
Battle, East Sussex
 Great Hall, Battle Abbey 268
 Senlac Memorial Window (Battle
 church) 268
Baudri, Abbot of Bourgeuil 64–5
 To the Countess Adela 64, 65
Bayer Group: advertisement 285
Bayeux 23, 24, 63–4, 66, 86
 Cathedral 23, 25, 63, 64, 66, 67–8, 70,
 86, 94, *135*
 'Centre Guillaume le Conquérant' 22,
 264–5, 298, *300*, 300–2, *301*
 and French Revolution 91–4, 123,
 127–8, 139
 Hôtel de Luxembourg 126, 132, 159
 Hôtel de Ville 112, 117, 119, *119*,
 123, 125, 132, 159
 Hôtel du Doyen 206–7, *207*, 218,
 219–20, 244, 245, 268, 298
 Lion d'Or hotel 214, 305
 19th-century visitors to 137, 158–60,
 161–4
 in World War II 205–6, 208–9,
 232–5
Bayeux Companions (Society for
 Creative Anachronisms) 279–80
Bayeux Tapestry
 and advertising 251, 282–7
 artists' responses to 268–9, 280–1

borders 6, 9, *9*, *10*, 12, *16*, 18, 26,
 47–8, 48, 54, 57, 131; *see also*
 motifs (*below*)
cartoonists' use of 251, 269–75, *270*,
 271, *272*, *273*, *274*
carved copy 280–1
cinematic analyses of 262–5
damage to 18, 123–4, 131, 137, 138,
 168, 220, 298
dating of 23, 25, 30, 83, 87, 117, 119,
 128, 134, 136–7, 139, 150, 156
designing and drawing of 44–7
dimensions 3, 49, 220
drawings and engravings of 71, *71*, 72,
 73, 75, 76–7, *77*, *78*, 131, 135, *136*,
 137, 156, 220, 228, 293; *see also*
 under Stothard, Charles
embroidered copies and
 interpretations 162, 179, 180, 182,
 184–9, *188*, 189–94, *195*, 275–80
English claims to *81*, 83–4, 115–16,
 119–20, 139, 152, 156–7, 227
female figures in 288–9, *see also*
 Ælfgyva
and feminism 143–5, 288
and films 222, 265–7
inscriptions 4, 8, 10, 11, 12–13, 17,
 19, 26, 28, 51, 55, 56, 57, 293
joins/seams 41, 47, 48, 49, 174
linen background 40–2, 47, 54, 128,
 173
meaning and purpose 19–21
motifs 18, 46, *50*, 50–1, 54, 57–60, *58*
and novels 154–6, 252–8
nude figures 60, 102, 104, 174, 187–8,
 189, *289*, 289–90
patrons attributed to 22, 28–9, 44,
 45–6, 53; *see also* Edith, Queen;
 Matilda, Empress; Matilda, Queen;
 Odo, Bishop
photographic records of 168–70,
 171–3, 187, 194–5, 197, 198, 199,
 214, 220–2, 228, 231, 246
and poetry 259–60
radio serial 261
sign language and symbolism 4, 5,
 55–7, 295–7
stitching 3, 18, 47, *49*, 49–50, 51–2,
 52, 54

and the theatre 105, 106, *107*, 108–9, 111–12, 113, 131, 260–1
wools and dyes used in 42–4
Bazin, André: *Jean Renoir* 263–4
Bazin, Germain 224–6, *225*, 235–7
Beatrice, Princess 191
Beauclerk, Topham 107
Beck, Lieutenant Sidney 234–5
Becket (film) 266
Bedknobs and Broomsticks (film) 265–6
Beer Ferrers, Devon: church 133
Bell, Michael Farrar: Senlac Memorial Window 268
Belloc, Hilaire: *The Book of the Bayeux Tapestry* 193, 201, 253
Benchley, Robert: *Bayeux Christmas Presents Early* 258
Benedictine order 56, 59, 72, 73, 74
Benoit, Antoine 75, 76, 78
Benson, Edward, Archbishop of Canterbury 190
Benson, Peter: *Odo's Hanging* 255
Beowulf 54
Bernard, St, of Clairvaux 59
Bernstein, David: *The Mystery of the Bayeux Tapestry* 296–7
Berthot, Jean 259
Beyle, Henri 137
Bibesco, Emmanuel 257
Bill, Clara 188
Birmingham Mail 193
Birrell, E. T.: *Guide to the Bayeux Tapestry* 195
Bishop, Mary 187
Bletchley Park GCHQ xiii, 239
Blunt, Sybil 325n10
Bolton Journal 193
Bonaventure, St 46*fn*
Bonnard, Abel 234
Bosham 5, 19, 20
church altar frontal 325n10
Bouisset, Professor 93–4
Boulogne 96, 97, 113, 129, 159
Grand Army column 114
Bower, Sarah: *The Needle in the Blood* 323n8
Boze, Claude Gros de 72, 76, 85
Braque, Georges 212, 269
British Lady's Magazine, The 144

British Museum 85, 118, 168, 198
Broderie de Fécamp (embroidery) 275
Brown, Ford Madox: *Lear and Cordelia* 268
Browne, Reverend G. F. 190
Browning, Elizabeth Barrett 143
Browning, Oscar 190
Browning, Robert 199
Bruce, Reverend Dr John Collingwood 156, 293
The Bayeux Tapestry Elucidated 156–7, 167, 181, 189, 254
brushes, ink-drawing 45
Bryan, John 266
Buchan, John 253
Bulwer-Lytton, Sir Edward: *Harold* 198, 252
Bunjes, Dr Hermann 213, 214, 216, 223
directs research project on Tapestry 218, 222, 226, 227, 228, 230, 231, 253
heads Art Historical Research Institute 229–30
plans removal of Tapestry to Germany 232, 233, 238, 244–5, 305
suicide 245
Burden, Elizabeth (Bessie) 162, 183
Burgundy, Dukes of 66, 67
Burne-Jones, Edward 161, 162
Burne-Jones, Georgiana 162
Burton, Ella 173–4
Burton Daily Mail 193
Busley, Dr (*Kunstschutz* representative) 230
Buzz Airlines: advertisement 285, *286*
Byatt, A. S.
Possession 258
A Whistling Woman 257–8
Byers, Stephen 273, *274*
Byrhtnoth, Earl 37, 39
Byron, George Gordon, Lord 129

Caen 70, 86, 131–2, 158, 159, 215, 217, 219, 233, 285–6
Abbaye-aux-Dames 299
Académie 116
St-Étienne 72, 74
St-Trinité 37
Caesar, Julius 43, 97

Caffarelli, Charles 97
Cahiers du Cinéma, Les (journal) 262, 263
Calvinists, French 67–8, 72, 94
Cambacères, Jean-Jacques Régis de 100
Cambridge Antiquarian Society 190
Cambridge Review, The 190
Campbell, David: 'Bayeux Tapestry' 260
Canterbury 14, 23, 29, 39, 55
 Cathedral 29, 59, 122
 Christ Church 36, 56
 St Augustine's Abbey 27, 36, 308n18
 stone frieze 58
Carlyle, Thomas 146, 198–9, 200
Caroline, Queen 129, 196
Carte, Thomas: *General History of
 England* 312n5
Carter, Maurice 266
cartoonists *see under* Bayeux Tapestry
cartoons (drawings) 46
Cather, Willa: *The Professor's House* 255
Cennini, Cennino: *The Craftsman's
 Handbook* 44–5, 46
Cervotti (Bayeux commissaire de police)
 217, 218, 220, 224, 225
Chailliey, Madame 217
Challinor, Mabel (*later* Wardle) 187
Chambers, Admiral 295
Chanson de Roland 57
chansons de geste 57
Chaptal de Chanteloup, Jean-Antoine
 106
charcoal 44–5
Chenciner, Robert: 'The Bayeux
 Tapestry Shish-Kebab Mystery'
 294–5
Chigouesnel, E. F. 259
Choltitz, General Dietrich von 238,
 239–41, 242, 246
Church, Ella Rodman: *Artistic
 Embroidery* 182
Churchill, Winston xii, 233, 243
Clamanges, Nicolas de 67
Clovesho, Council of (747) 38
Cnut, King 8, 32, 37, 54, 58, 290, 291
Colbert, Jean-Baptiste 70
Colburn, Henry 145, 148, 150, 151, 154,
 252
Cole, Henry 168–9, 170–1, 172, 177,
 199

Comte, Jules: *La Tapisserie de Bayeux* 175
Conan, Count of Brittany 9–10, 21
Constable, John 180
Corney, Bolton Glanvill 136–7, 147,
 150
Council on Education 168, 170, 174
Courage, Barclay & Simonds: poster 283
Court Journal, The 150
Cowper, Isabel Agnes 169
Cumberland, Richard 107
 The Battle of Hastings 107
Cundall, Joseph 169–70, 171, 172, 173
Cunliffe-Owen, Sir Philip 184, 185

Daily Mail 270
Daily News 181
Davien, Geoffrey: medallions 286
Dawson, Charles 292–4, 305
 History of Hastings Castle 292, 293–4
Deas, Charles 193
*Décade philosophique, littéraire et
 scientifique, La* (weekly) 104, 109,
 111
Delahaye, Monsieur (tradesman) 223
Delauney, Honoré 135–6, 259
Delauney, Jean-Baptiste 93–4
Denon, Dominique Vivant 98, 98, 99,
 100, 101, 102, 106, 112, 113, 114,
 116, 118, 304
Desfontaines, François
 Susannah 106
 see Barré, Pierre-Yves
Dibdin, Thomas 130, 137, 159
 *A Bibliographical Antiquarian and
 Picturesque Tour of France and
 Germany* 126n6, 130–2, 146, 159
Dickens, Charles xii, 164, 252
Digby, George Wingfield 195
Dijon 66–7
Disney, Walt 263, 265
Disraeli, Benjamin: *Sybil, or the Two
 Nations* 197
Dobyns, Stephen: 'What you have come
 to expect' 260
Dodeman, Ernest, Mayor of Bayeux 206,
 208–9, 215, 233, 236, 242, 244
Domesday Book 27, 28–9, 31, 37, 194,
 251, 281, 301
Dossetter, E. 171–2, 173, 174, 231

Douce, Francis 118, 124–5, 132, 133, 154, 178
Dover Castle 27
drawing tools 44–5
Druids, the 80, 81–2, 84, 87
Dubosq, René: *The Bayeux Tapestry: Ten Tragic Years* 206, 221–2
Ducarel, Andrew: *Anglo-Norman Antiquities* 85–6, 131, 134, *135*, 146, 199, 290
Dufy, Raoul 269
Dugan, Professor Raymond 279
Duggan, Alfred 253
Dulverton of Batsford, Lord 276
du Méril, Edelestand 139
Dundry, Chris 281
Dupont, Jacques 215–16, 219, 222, 223, 235, 236, 237, 244
Durham Cathedral: tombs 59
Duval, Alexandre 110
 Édouard en Écosse 110
 Guillaume le Conquérant 110–11
Duval, Amaury 106, 110
Duval, Georges 299, 301
dyeing processes 42–4, 182, 183

Eadgifu, Abbess of Leominster 291
Eadmer (chronicler) 5n1
 History of Recent Events in England 20
'Eagle Shirts' company poster 282
Eden, Anthony 233, 270
Edgar 25
Edgar, Marriott: 'The Battle of Hastings' 259
Edith Godwinson, Queen 30–2, *34*, 35–6, 55, 290, 292, 304
 commissions *The Life of King Edward* 20, 33–6, 292
 death and burial 35
 as patron of Tapestry 29–30, 35, 36–9
Edward ('the Confessor') 4, 12, 19–20, 21, 30, 32–6
 as portrayed in Tapestry 4, 4–5, 10–11, *11*, 30, *34*, 36, 51, 55, 56
Edward III 66, 87
Edward, Prince of Wales 191
Eisenhower, General Dwight D. 239
El Cid (film) 324n8
Eliade, Mircea 295

Eliot, George 163–4
 Felix Holt 163
 Middlemarch 164
 The Mill on the Floss 163
Elizabeth I 43
Ellis, Sarah: *Women of England* 144
Ely, monastery of 37, 39
embroidery
 attitudes to 29–30, 37–8, 143–5, 146, 150–1, 180–2
 Berlin woolwork 149, 153, 173–4, 180
 crewel work 51
 and guild regulations 52–3
 histories of 145–9, 152–4
 laidwork 51–2, *52*, 54, 280
 needles and thimbles for 52
 opus anglicanum 37
Emma, Queen 8, 32, 37, 39, 58, 291, 304
 In Praise of Queen Emma 32, 33, *33*
Encyclopaedia Britannica: 'Bayeux Tapestry' 201
Enfants du Paradis, Les (film) 313n8
Engelmann, Godefroy 134
 frontispiece to Ducarel's *Anglo-Norman Antiquities* 135
English Historical Review 200
ERR (*Einsatzstab Reichsleiter Rosenberg*) 212, 213, 216, 219, 223, 226, 229
Estrup, Hector 132
Eustace, Count of Boulogne 22, 26, 26–7, 293
Exeter 31

Falue, René 208, 217, 220, 222, 223, 224, 228
feminism 143–5, 146, 288–9
Ferrers, Sir William: tomb 133
Ferretti, Dante 324n8
Figaro, Le (newspaper) 239, 243
Finch, Frank: magazine cover 270n5
Fischer, SS-Hauptsturmführer 235
Fishguard Invasion Tapestry 279
Fitzgerald, F. Scott 256
Flays, Dom Nicolas 74
Foucault, Nicolas-Joseph 70–2, 73–4, 76, 174
Fowke, Francis 171
Fowke, Frank Rede 168, 171, 172–3, 174–5, 176, 177–8

France, Marie de 117
Franco-Prussian War (1870–1) 167–8, 169, 198, 199, 247, 260
Freeman, Edward 165, 199–200, 201
History of the Norman Conquest of England 157
French Revolution 91–2, 93, 95, 99, 105–6, 116, 121, 127–8, 138, 139, 247
Frobe, Gert 246
Froissart, Jean: *Chronicles* 126, 162
Frost, Elizabeth 187
Fulford, William 161

Garfield, James A., US President 177
Garland, Nicholas: cartoons 271–2, *273*
Garrick, David 107
Gaudouin of Paris (publisher) 78
Gaulle, General Charles de 233, 237, 243, 245, 251
Gautier, Théophile 162
Geare, Maud 325n10
Gentleman, David: stamps 286–7
Gentleman's Magazine, The 115–16, 137
George III 100, 116
George IV 129, 134
George, Prince, Duke of Kent 193–4
Georges, Mlle (Marguérite-Joséphine Weimer) 112
Geraldine, South Island, New Zealand 281
Gerlach, Consul-General 233–4
Gibbard, Les: cartoon *272*
Gibbs-Smith, Charles 194
Goddard, Clive: 'Byers Tapestry' (cartoons) *273, 274*
Godefroy, M. (carpenter) 207
Godgifu 27
Godiva, wife of Earl of Mercia 39
Godwin, Earl 33, 34
Goebbels, Joseph 209, 226–7, 231
Goering, Hermann 212, 214, 216, 229
Goscelin (monk) 291–2
Gothic Revival 145, 152, 265
Graux, Monsieur (prefect) 217
Graysmark, John: *Robin Hood, Prince of Thieves* 266
Green, Mary Anne: *Lives of the Princesses of England from the Norman*

Conquest 154
Grigg, Sir John 237–8
Guiccioli, Teresa 129
Guillard, Alfred: *Matilda* 268
Guillaume le Conquérant (film) 265
Guillaume le Conquérant, duc de Normandie (melodrama) 111–12
Guinness: poster *283, 283*
Gunnhild 38
Gurney, Hudson 118–20, 146
Guy, Count of Amiens: *The Song of the Battle of Hastings* 27, 253
Guy, Count of Ponthieu 5, 6, 7, 27, 29
Gyrth Godwinson 17, 19, 37
Gytha 31

Hague Convention: on artworks 212–13
Halley's Comet 12, *13*, 65, 103, 295
Hallier, M. (architect) 206
Hamann, Professor Richard 221, 246
Hamilton, Lady Emma 101
Hamilton, Sir William 101
Hamlet (film) 267
hangings, textile 53–4
Harcourt, Bishop Louis d' 63–4
Harold Godwinson, Earl of Wessex 3, 4, 8, 20, 24, 31, 32, 36
as portrayed in Tapestry 4, 4–6, 6, 7, 8, 9, 9–11, *11*, 12, *12, 13, 17*, 17–18, 20–1, 36, 55, 56, 84, 197
Harold Hardrada, King of Norway 12, 291
Harthacnut 32
Hassall, John 269
Ye Berlyn Tapestrie 269–70, *270*
Hastings 284–5
Hastings, Battle of 3, 14, *16*, 16–18, *17*, 20, *26*, 26–7, 200–1, 251, 292
anniversaries 200, 251, 286–7
Hastings & Thanet Building Society 284
Hastings Tapestry 275–6
Hautecoeur, Louis 209, 215
Heinrich I (Henry the Fowler) 211, 232
Heintz, André 233
Henry I 38, 66
Henry II 66, 82, 83, 117
Henty, G. A.: *Wulf the Saxon, a Tale of Norman Times* 253
Herluin, Viscount of Conteville 24

Heyer, Georgette: *The Conqueror* 253–4
Higgin, Lily 189
 Handbook of Needlework 181
Hilaire, Georges 233–4, 237
Hill, Arthur 191, 192
Hill, Octavia 191
Himmler, Heinrich 210, 211, 222, 305
 desire to possess Tapestry xii, xiii–xiv, 210–11
 as head of *Ahnenerbe* 211, 213, 214, 219, 223
 receives sample publication of Tapestry 228–9, *230*
 and removal of Tapestry xiii–xiv, 226, 232, 233–4, 237, 238–9, 242
 suicide 246
History Today (journal) 286
Hitler, Adolf 207, 208, 210, 238, 239
Hitt, Dr August 228
Hoffmann, Major, Kommandant of Bayeux 209, 213–14, 216, 217
Holt, Tom: *Lucia Triumphant* 258
Horlicks: advertisement 284
Houdetot, Count d' 138
Hovis: advertisement 284, *284*
Howard, Lord Henry Molyneux 133
Huart, Madame Turgis 325n10
Hugo, Victor 137
Hull Daily Mail 193
Hume, David xii, 84–5, 87, 139
 The History of England xii, 84–5, 118, 146
Huxley, Aldous: *Point Counter Point* 255–6

Iliffe, Sarah 187
Illingworth, Leslie: cartoon 270, *271*
Images de France (magazine) 231
Imbert, Georges 321n20
ink, production of 45
International Exhibition (1873) 171, 172–3, 199
Irvin, Rea: cartoon 270n5
Is Paris Burning? (film) 246
Isigny, German withdrawal from 233

James II 70, 152
Jameson, Anna: *Memoirs of Celebrated Female Sovereigns* 150

Jankuhn, Professor Dr Herbert 214, 223, 226, 230–1, 246
 and *Ahnenerbe* project 214, 216, 218–22
Jaujard, Jacques 236, 237
Jersey Occupation Tapestry 278
Jeschke, Herbert 220, 228, 321n15
Job, Colonel de 217, 218, 300
Jonas, David 324n7
jongleurs 57
Joséphine, Empress 96, 110, 112
Journal de Paris 100, 103
Journal des Arts 104, 109
Journal des bâtiments, monuments et arts 104
Joyce, William ('Lord Haw-Haw') 226–7
Jubinal, Achille 137
 Les Anciennes Tapisseries Historiées 137
Judith, Countess 39

Karcher, Lieutenant Henri 241
Kempe, Charles 176, 177
Kempe, John 178
Kendrick, A. F. 192
Kidby, Paul 274–5
Kodak: advertisement 284
Kunstschutz (Arts & Monuments Protection squad) 212–16, 218, 223, 232, 234, 235, 246
Kushner, Tony: *Angels in America* 260–1

Lady's Magazine and Museum, The 145
LaFarge, Captain Bancel 241, 242
Laffetay, Abbé J. 171, 173, 174, 219
laidwork (embroidery technique) 51–2, 52, 54, 280
Lainé, Pascal: *La Dentellière* 256
La Londe, Romaine, Prior of St-Étienne 74–5
Lamb, Charles 144
Lamb, Mary: 'On Needlework' 144
Lambert, Édouard 138, 139
Lambert, Frances
 Church Needlework 152–3
 Hand-book of Needlework 152
Lampe, Fräulein Dr 228
Lancelot, Antoine 72, 73, 74, 76, 77, 85, 86, 290
Lanfranc, Archbishop of Canterbury 27

Larcher, Mathurin, Prior of St-Vigor 74, 75
La Roque, Monsieur de (travel writer) 78
La Rue, Abbé Gervais de 116–17, 123, 132, 133
 theories on Tapestry 117–18, 130, 134, 136, 139, 146, 150, 266, 305
Last of the Saxons, The (film) 265
Laurencin, Marie 269
Laval, Pierre 229
Lawrence, Sandra: Overlord Embroidery 276–7, 278
Layard, Henry Austen 169
Le Brisoys-Surmont (lawyer) 93
Léchaudé d'Anisy, A. 134–5
 Antiquités Anglo-Normands 268
Leek School of Art Embroidery 184, 185, 186, *186*, 187, 188
Leek Society 185, 186, 189, 191
Leenhardt, Roger: *La Conquête de l'Angleterre* 263
Lefèvre, Robert: *Denon* 98
Le Flaguais, Alphonse 259
Lejard, André 231
Leofgyd 37
Leofwine Godwinson 17, 37
Léonard-Leforestier, Lambert 92 *and fn*, 128
Leroux, Paul 275
Leroux, Madame 275
Leroy, Paul 218, 222
Lethieullier, Smart 85, 86
Lewes, G. H. 163
Lewis (artist) 131
Lewis, Hilda: *Wife to the Bastard* 254
Liénard, Emma: *Les broderies de la reine Mathilde* . . . 154–6, 174
linen, production of 40–2
Lingard, Dr John: *History of England* 148
Linton, Michael 281
Longmans (publishers) 129
looms, treadle 42
Louis VII, of France 82
Louis XIV, of France 70
Louis XV, of France 73, 75, 99
Louis XVI, of France 85, 106
Louis XVIII, of France 118
Louvre Museum, Paris xiii, 70, 92, 94, 99–100, 118, 168, 224, 241

Tapestry exhibitions 97–104, 105, 112, 115, 139 (1803–4), 242–4, 262 (1944–5)
Lowe, Anne 187
Lowell, Robert: 'From the Gibbet' 259
Lunn, Elizabeth 187
Lysons, Samuel 122, 126, 133
 (with Daniel Lysons) *Magna Britannia* . . . 122
Lyttelton, George, 1st Baron 86, 118, 139
 History of England . . . 87
 History of King Henry II . . . 86–7

Mabire, Jean 220, 223
McGraw, Eloise: *The Striped Ships* 323n8
Mackenzie, Lizzie 187
Maclagan, Eric 195, 231
Macleod, Norman 177
Macmillan, Harold 270–1
madder (*Rubia tinctoria*) 43–4
Magazine of Art, The 189
Malcolm, King of Scotland 25, 38
Mâle, Émile 257
Margaret, Queen of Scotland 37
Martin, Mr (colourist) 133
Mary, Queen (wife of James II) 152
Mathieu, Jean-Baptiste 92, 93, 94
Mathon, Marquis de 116
Matilda, Empress: as patron of Tapestry 87, 117–18, 131, 136, 266
Matilda, Queen 148
 biography of (Strickland) 148–52
 as maker of Tapestry 22, 29, 74, 77, 78, 88, 100, 101, 119, 128, 130, *135*, 136, 143, 146, 148–9, *149*, 151, 153, 156, 165, 174, 300, *300*
 patronage disputed 104, 136, 137, 147, 152, 157, 167, 227
 will 37, 63, 64
Matilda, Queen of Scotland 38
Maud, Queen 83
Mendès-France, Pierre 270
Menzies, Sutherland 148*fn*, *see* Stone, Elizabeth
Mercure de France (journal) 78
Mérimée, Prosper 138
Messent, Jan: 'Finale' 280
Meyrick, Dr Samuel: Collection 125, 137, 178

MFA&A see Monuments, Fine Arts and Archives
Michelet, Jules 138
 Le Peuple 138
Minhinnick, Gordon: cartoon 270, 271
Mitterrand, François, French President 271–2, 273
Moisson de Vaux (botanist) 93–4
Monet, Claude 260
Moniteur, Le (newspaper) 97, 100, 103, 109, 110, 162
Montfaucon, Father Bernard de 71, 73–5, 78–9, 85, 87, 116
 Antiquity Explained 73
 The Monuments of the Church 78–9
 The Monuments of the French Monarchy 73, 75–8, 78, 79, 82–3, 85, 94, 96, 101, 114, 131, 198
Monuments, Fine Arts and Archives (MFA&A) 241–2, 245, 246
Morazzoni, Marta: The Invention of Truth 254–5
Morris, Jane (née Burden) 162, 182, 183
Morris, May 183
Morris, William xii, 161–2, 180, 182, 183–4, 185, 186, 191, 192
Morris & Company 182, 183
Muntz, Hope: The Golden Warrior 253
Murray, John II 129
Murray, John III: Hand-book for Travellers in France 152, 158–9, 160
Musgrave, George 161

Napier, General Charles: William the Conqueror, a Historical Romance 252
Napoleon Bonaparte xii, 95–6, 99, 115, 116, 117, 118, 132, 196
 invasion plans 96, 97, 113, 116
 and Louvre exhibition of Tapestry 97–104, 105, 112, 115, 117, 139, 227, 244
 as reincarnation of William I 95, 96, 100, 113–14
 and theatres and theatrical performances 105–6, 110, 111, 112, 113 and fn
Napoleon III, Emperor 162, 198
National Assembly, French 91, 92

National Gallery, London 168
National Portrait Gallery, London 168, 197
National Working Men's Exhibition, London (1893) 191
Nevinson, J. L. 195
New Yorker: cartoon 270
New Zealand Herald: cartoon 270, 271
Newcastle Antiquarian Society 156
Newcastle Brown Ale: advertisement 285
Newill, Mary: 'Queen Matilda working on the Bayeux Tapestry' 268
Nicholls, John Bowyer 166, 178
Nivernois, Louis-Jules Mancini-Mazarini, Duc de 86
Nordlinger, Raoul 239
Norfolk, Bernard Howard, 12th Duke of 133
Norgate, Kate 200, 201
 England Under the Angevin Kings 200
North Staffordshire Field Club 190
Northern Telecom: advertisement 285
Noxon, Gerald 264

Oberg, Carl xiii, 238–9, 240
Odo of Conteville, Bishop of Bayeux 20, 23–4, 25, 27, 28–9, 32, 57, 66, 67
 as patron of Tapestry 22–5, 136, 139, 174, 201, 244
 as portrayed in Tapestry 12–13, 14, 15, 17, 22–3, 23, 27, 165
 Tapestry as gift for 26–7
Operation Overlord 302
 see also Overlord Embroidery
opus anglicanum 37
Orderic Vitalis: Ecclesiastical History 20, 23, 39n22, 64
Orléans, Philippe, Duc d' 73
Oseberg, Norway: Queen Asa's tomb 53–4
Overlord Embroidery 276–8, 277, 280

parchment 44, 46
Paris 96–7
 Guild of Embroiderers and Embroideresses 52–3
 theatres 105–6, 107, 108–12, 113
 Vendôme column 114

see also Louvre Museum
Parisse, Michel: *The Bayeux Tapestry* 264
Parkin, Reverend Charles 82, 83, 84
Pattinson, Alice 187
Pattinson, Florence 187
Peach, L. du Garde: *The Tapestry at Bayeux* 260
Perchet (architectural adviser) 235
Pfitzner, Dr 214–15
Philip the Bold, Duke of Burgundy 66
Philip the Good, Duke of Burgundy 67
Philippa, Queen 53
Pibrac, Abbé de 74
Pican, Pierre, Bishop of Bayeux 280
Picasso, Pablo 212, 242, 269
 Guernica 269
Pickles, M.: Milk Tray cartoon 274, *274*
Pilley, Kevin: *Cut* 258
Piltdown Man 292, 294
Pius VII, Pope 114
Pissarro, Camille 260
Plaidy, Jean: *The Bastard King* 254
Planché, J. R. 167
Pluquet, Frédéric 303–4
Poncet, Marie-Thérèse 262–3
Portsea Island 280
Powell, Anthony: *A Question of Upbringing* 257
Power, Eileen: *Medieval Women* 56
Prah-Pérochon, Anne 264
Pratchett, Terry: *The Last Hero* 274–5
'pricking and pouncing' 46
Private Eye cartoons (Goddard) 273, *274*
Proust, Marcel 257
 A la recherche du temps perdu 257
Prunier (photographer) 221
Pullan, Mrs *see* Warren, Mrs

Quarterly Review 200

Radet, Jean-Baptiste
 Susannah 106
 see Barré, Pierre-Yves
Rascher, Dr Sigmund 228
Reading
 Art Gallery 192
 Museum 194, 195
 Town Council 191
Réau, Louis 262

Rediffusion advertisement 283
Regent Petrol advertisement 282–3
Rémusat, Madame de 110
Rémusat, M. de (Superintendent des Spectacles) 105, 110–11
Renoir, Jean 263–4
ReVille, Margaret 280
Revue Anglo-française 139
Revue du Cinéma, La (journal) 262
Rheinländische Zeitung 103
Rhodesian National 'Tapestry' 278–9
Rich, Adrienne: 'Mathilde in Normandy' 259
Richard I, Count of Normandy 21
Ripault, Louis 110
Ritchie, Margaret 188
Robert, Count of Mortain 14, 24, 66
Robert I, Duke of Normandy 24
Robert II (Curthose), Duke of Normandy 65
Robin Hood, Prince of Thieves (film) 266
Rock, Reverend Dr Daniel 166–7, 169, 170, 171, 177
Rollo of Normandy 20, 132
Roncesvalles, Battle of 57
Rosenberg, Alfred 212
 The Myth of the Twentieth Century 212
Rossetti, Christina 143
Rossetti, Dante Gabriel 182
Rouen, palace at 8, 23, 25, 51, 64, 65–6, 85
Round, John Horace 200, 201
Royal School of (Art-)Needlework 181, 183, 189, 275–8, *277*
Royston, Hertfordshire: cave 82, 84
Royston 'Tapestry' 278
Ruskin, Effie (*née* Gray) 159–60
Ruskin, John xii, 159–60, 165, 254
 The Stones of Venice 160, 257
 The Storm Cloud of the Nineteenth Century 160
 The Bible of Amiens 254, 257
 Sesame and Lilies 257

St-Omer 31, 113
Sallier, François 103
Salt, Sir Titus 190
Saltaire: Fine Art and Industrial Exhibition 190–1

Sanderson (Arthur) & Co.: pattern 286
Sansonetti, Victor: copy of Tapestry 136, 137
Sauvage, M. (curator) 208, 215
Schlabow, Dr 220, 244
Scott, Sir Walter 129, 134
 Ivanhoe 151, 252
Serullaz, Jean 224–5
Sewell, Brian 299
Shaftesbury: nunnery 39
Shell Petrol advertisement 282
Sievers, SS-Obersturmbannführer Wolfram 213
 heads Ahnenerbe study of Tapestry 213–14, 226, 227, 228, 230–1, 244–5
 presents Himmler with sample publication 228–9, 230
 and removal of Tapestry 216, 219, 233
 trial and death sentence 246
Simon, Monsieur 217
Sloane, Sir Hans 85
Smith, Anne 187
Smith, Jemima 187
Smith, Madeline (Lena Wardle) 182
Smith-Woodward, Sir Arthur 294
Socialist League 182
Society of Antiquaries of London 80–1, 87, 134, 176
 Fellows 85, 87, 116, 118
 Stothard's work for 120, 122–6, 124, 125, 130, 132–3, 151
 see also Archaeologia; Vetusta Monumenta
Society of Arts Journal 173
Soldier, The (magazine) 270
Sources, Château de 215, 223–4, 225, 225–6, 227, 228, 230, 233–4
Southey, Robert 137
South Kensington Museum 168, 194
 photographic facsimile of Tapestry 168–73, 194–5, 197, 198, 199
 and Tapestry fragment 166, 167, 167, 176–8
Staffordshire Weekly Sentinel 193
Stange, Professor Alfred 222, 228
Starbuck, George: 'A Tapestry for Bayeux' 259
Stenton, Frank 192

Stigand, Archbishop of Canterbury 12, 111, 291
Stone, Elizabeth 145, 147–8
 The Art of Needle-Work from the Earliest Ages 145–7, 152, 180
 Hugues the Wer-Wolf 145
Stothard, Charles 121–2, 126, 132, 133
 copies Bayeux Tapestry 120, 121, 122–3, 125, 125–6, 127, 129, 293
 copies Palace of Westminster murals 133, 134
 cuts fragments from Tapestry 123–4, 166, 167, 167, 176, 178
 discovers 'lost' Plantagenet monuments 123, 125
 engravings of Tapestry drawings 132, 133, 151, 156, 166
 wax impressions and plaster casts of Tapestry 124, 124–5, 166
Stothard, Eliza (née Kempe, later Bray) 122, 127, 304
 autobiography 134, 178
 death 178
 and death of husband 133–4
 Letters written during a Tour through Normandy . . . 126–7, 128, 129, 145, 173
 marriage and honeymoon in France 123, 126–7
 her Memoirs . . . of Charles Stothard 134
 and theft of Tapestry fragments 122, 124, 166, 170–1, 174, 175–6, 177–8, 293
Stothard, Robert 134
Stothard, Thomas 121, 123, 125
Street, G. E. 180
Strickland, Agnes 149–50, 151, 173–4, 201, 293
 The Lives of the Queens of England 148–9, 149, 150–2, 156, 157, 252, 268
 Victoria from her Birth to her Bridal 151
Strickland, Eliza 150, 152
Strutt, Joseph: A Complete View of the Dress Habits of the People of England 88
Stukeley, William xii, 80, 81, 81–4, 87, 118, 305

Stulpnagel, General Karl Heinrich von 219

Sunderland Library, Museum and Art Gallery 193

Sussex Archaeological Society 294

Sutcliff, Rosemary 253

Sweyn of Norway 291

Taillefer (jongleur) 57

Tait's Edinburgh Magazine 147

Talma (tragedian) 112

Tapisserie de la Reine Mathilde, La (musical play) *see* Barré, Pierre-Yves

Teilhard de Chardin, Pierre de 294

Tennyson, Alfred, Lord 162–3
 Harold 163, 197, 199, 200

Tennyson, Lady Emma 162–3, 165

Tennyson, Hallam, 2nd Baron 199

Terry, Philip: *Tapestry* 323n8

Thatcher, Margaret 271–2, 273

Théâtre du Vaudeville, Paris 106, *107*, 108–9

Theed, William: *Victoria and Albert* 197

'Theophilus': *On the Various Arts* 44, 45

Thierry, Augustin: *Histoire de la conquête de l'Angleterre par les Normands* 151, 197, 198

Thomas of Ely 37

Tieschowitz, Dr Bernhard von 213, 228, 234–5, 246

Times, The 175, 176, 177, 178, 227, 232–3, 238, 242, 262

Tomlinson, Reverend Robert 116

Tostig Godwinson 12, 34

Tourbat, Monsieur 236

Tranter, Nigel 253

Treece, Henry 253

Trungy, René: *Le Val de Commes* 256–7

Turgis, Suzanne 231
 La très véridique histoire de la bonne Mathilde 253

Turner, Dawson 129–30, 154

Turner, Sir Gregory Page 134, 178

Turold 6, 22, 28, 28, 29, 57, 151, 157, 167, 252, 297

Uhland, Frau (photographer) 221–2

Vehse, Otto 222, 230

Vere, Lady Roisia de 82, 83

Verrier, Jean 215, 228, 235, 244, 262

Vetusta Monumenta series 166, 170, 176, 177, 185

Vicky (Victor Weisz) 270–1

Victoria, Queen 151–2, 190, 191–2, 196, 198

Victoria and Albert Museum, London 177, 194–5, 197, 231
 see also South Kensington Museum

Vikings 29, 53, 57, 132, 214, 219, 253

Vikings, The (film) 265

Villiers, Elizabeth: *Love Stories of the English Queens* 253

Villion, Pierre 295–6

Visconti, Professor Ennio Quirino 100–2
 Notice historique sur la tapisserie brodée . . . 100, 101–2, 103, 113, 114, 116, 131

Vital 22, 28, 29, 167

Wace, Robert: *Roman de Rou* 20, 57, 64, 66, 111, 117, 200–1, 266

Wadard 22, 28–9, 167

Wade, William, Archbishop of Canterbury 82

Walcott, Derek: *Tiepolo's Hound* 259–60

Walpole, Horace 87

Waltham Abbey 139

Wardle, Edith 187

Wardle, Elizabeth 182, 183–4, *186*, 304
 replica of Bayeux Tapestry 182, 184–9, *188*
 her replica on tour 189–84
 366 Easy and Inexpensive Dinners for Young Housekeepers 192

Wardle, Ellinor 187

Wardle, Fred 192

Wardle, George 182

Wardle, (Joshua) & Sons 182

Wardle, Margaret 187, 191, 192

Wardle, Phoebe 187

Wardle, Sir Thomas 182–3, 184, 185–6, 188, *188*, 189, 190, 192, 193

Wark, Kirsty 261

Warnod, André 243

Warren, Mrs, and Pullan, Mrs: *Treasures of Needlework* 153, 180

Watson, Edith 187
Watson, Margaret 187
weld (*Reseda luteola*) 43
Wellington, Arthur Wellesley, Duke of
 118
Westminster Abbey 11–12, 18
Wewelsburg castle, Westphalia 211
Wheeler, Edd 280
Wherwell: nunnery 39
Whitbread Breweries: Inn Sign cards 282
Wicht (composer) 107
Wilcockson, Mrs: *Embroidery, its History,
 Beauty and Utility* 153–4
Wilde, Oscar 190
Wilhelm II, Kaiser 269
Wilkin, F. W.: *The Battle of Hastings*
 268
William I ('the Conqueror') 3, 9, 19–20,
 24–5, 27, 64, 72
 and Edith 30, 31–2, 34, 35
 Napoleon as reincarnation of 95, 96,
 100, 113–14
 and Odo 14, 23–4, 25, 27
 as patron of Tapestry 22
 as portrayed in Tapestry 5–6, 9, 10,
 12, 21, 26, 26–7, 36, 51, 55, 57
 will 63, 64
William IV 146, 151
William of Jumièges: *Deeds of the
 Norman Dukes* 19
William of Malmesbury: *Deeds of the
 English Kings* 20, 84

William of Poitiers: *Deeds of William*
 19–20, 23, 27, 30, 31–2, 37
William Rufus 25
Willson, Richard: cartoons 272–3
Wilson, Harold 271
Wilson, Walter 172
Wilton: nunnery 38, 291–2
Winchester 31, 32, 35, 36, 39, 42, 281
 Cathedral kneelers 325n10
 Old Minister stone frieze 58
Winckelmann, J.-J. 101
Winters, William 197–8
woad (*Isatis tinctoria*) 43
Wolff-Metternich, Count Franz 213,
 216, 222, 228, 229, 234, 245–6
Wollstonecraft, Mary: *A Vindication of
 the Rights of Woman* 143–4, 150
Woolf, Virginia: *A Room of One's Own*
 190
worsted, production of 42–4
Wulfnoth Godwinson 37
Wust, Hauptsturmführer Professor Dr
 Walther 227, 228–9

Yonge, Charlotte M. 165
 *Cameos from English History from Rollo
 to Edward II* 165
York 24, 42
Young, Jeff *see* Armitage, Simon

Zeffirelli, Franco: *Hamlet* 267
Zervos, Christian 269